PENGUIN CLASSICS

DISCOURSES

SIR JOSHUA REYNOLDS (1723–92) was born in Devon, the son of a clergyman. He was apprenticed to Thomas Hudson, the portrait painter, in London and studied in Italy from 1750 to 1752; on his return to London he quickly became the most successful portrait painter of his age, painting many of the celebrated men and women of the day. His ambition was to raise the status of the painter in England and this he achieved by helping to found the Royal Academy. From 1769 until his death he served as the Academy's first president. He was also a friend of Dr Johnson, and one of the founders of the 'Club'. Reynolds's first literary works were three essays published in the *Idler* (1759) and his *Discourses*, delivered to the Academy students between 1769 and 1790, are his most significant achievement as a writer. In them he supported the traditional values of academic art and stressed the importance of the study of the great masters of the past.

PAT ROGERS is DeBartolo Professor in the Liberal Arts at the University of South Florida. He was educated at Cambridge where he gained a double first in English and went on to obtain a Ph.D. and Litt.D. He has held teaching posts at the universities of Cambridge, London, Wales and Bristol. His books include *Grub Street* (1972), *The Augustan Vision* (1974), *Eighteenth-Century Encounters* (1985) and *Literature and Popular Culture in Eighteenth-Century England* (1985), as well as works on Swift, Pope, Defoe, Fielding and Johnson. He is editor of *The Oxford Illustrated History of English Literature* (1987) and advisory editor of *The Blackwell Companion to the Enlightenment* (forthcoming).

SIR JOSHUA REYNOLDS

DISCOURSES

EDITED WITH AN
INTRODUCTION AND NOTES BY

PAT ROGERS

PENGUIN BOOKS

PENGUIN BOOKS

Published by the Penguin Group
Penguin Books Ltd, 27 Wrights Lane, London w8 5tz, England
Penguin Books USA Inc., 375 Hudson Street, New York, New York 10014, USA
Penguin Books Australia Ltd, Ringwood, Victoria, Australia
Penguin Books Canada Ltd, 10 Alcorn Avenue, Toronto, Ontario, Canada M4V 3B2
Penguin Books (NZ) Ltd, 182–190 Wairau Road, Auckland 10, New Zealand

Penguin Books Ltd, Registered Offices: Harmondsworth, Middlesex, England

This edition first published 1992
3 5 7 9 10 8 6 4 2

Introduction and notes copyright © Pat Rogers, 1992
All rights reserved

The moral right of the editor has been asserted

Printed in England by Clays Ltd, St Ives plc

For Linn Dietrich

CONTENTS

DISCOURSES

PREFACE

Two hundred years after his death, Joshua Reynolds continues to stand out as a major figure in the history of British art. He was the first president of the Royal Academy, and a notable exhibition held at the Academy in 1986 (previously shown in Paris) demonstrated the range, depth and skill of his painting. The show also helped to reveal his significance within a wider European scheme. It was for the Academy that he delivered his fifteen *Discourses*, which constitute the first major body of artistic theory produced in England. Moreover, the lectures can now be seen as contributing to a general process of artistic revaluation and codification that was taking place in Reynolds's lifetime, which has been termed 'the ordering of the arts'. His coadjutors in this process include Samuel Johnson and Thomas Warton in the realm of literature, John Hawkins and Charles Burney in music, and Horace Walpole in art history. All these men were well known to Reynolds, and all except Walpole were members of that extraordinary 'Club', sometimes known as the Johnson Club, but actually owing its foundation and continued development chiefly to Reynolds. It is the aim of this edition to do as much justice as possible to the many facets – social and literary as well as artistic – of Reynolds.

Numerous editions of the *Discourses* have been published since the first collected set, produced in 1797 by Edmond Malone, another prominent member of the Club. I have naturally profited wherever I could from my predecessors, and am

particularly indebted to the editions by Roger Fry and by
Robert R. Wark (see Further Reading). This edition, how-
ever, differs in that it supplements the aspect of art history
with fuller biographic and contextual information, with the
intention of placing Reynolds more squarely within the cul-
ture of his time, and locating his endeavour within a broader
intellectual scheme. In this, as in other respects, I have been
aided by the work of the late F. W. Hilles, notably his seminal
study *The Literary Career of Sir Joshua Reynolds* (see Further
Reading). My debt to other students of Reynolds, including
biographers and critics of his theory, will be apparent through-
out. My hope is that the *Discourses* will resonate a little more
clearly to modern ears if we read of Reynolds within the
context of his age, his personal and social situation, and of his
key place within the world of eighteenth-century art, as the
taste for painting grew and as a new market bred a new pro-
fession.

The 'Ironical Discourse' (Appendix A) is printed by per-
mission of Yale University, the copyright holder. I am grate-
ful to Irene Adams, Rachel McLellan and Claude Rawson for
obtaining permission.

INTRODUCTION

behind) who seemed unable to hear and diverted themselves with conversation and impertinent discourses more audible than that of poor Pataleon.

Other accounts survive to confirm the broad truth of this narrative. For it is the occasion which gave to his daughter Fanny (the novelist, who was at this time Keeper of the Robes to Queen Charlotte) which best conveys the atmosphere of this charged occasion.

I

ON 10 December 1790, the twenty-second anniversary of the foundation of the Royal Academy, the man who had been president throughout its formative years rose to address the students on their prize-giving day. This was Sir Joshua Reynolds, now aged sixty-seven, about to present the last of his fifteen official lectures to the assembled body. A vivid account of the occasion has been left by the musical historian Dr Charles Burney:

After dinner I went to Somerset House to hear Sir Joshua's farewell discourse. He had given me a ticket in the morning, and had my name put on a very good seat in the evening. There were fewer people of fashion and dilettanti there than usual, though a crowd of young artists and mixtures. Sir Joshua had but just entered the room, when there happened a violent and unaccountable crack which astonished everyone present. But no inquiry was made or suspicion raised of danger till another crack happened, which terrified the company so much that most of them were retreating towards the door with great precipitation, while others call out, 'Gently! Gently!' – or mischief will be anticipated. Well – no account arriving of the cause of this alarm – we looked at each other (I mean those who had the courage or folly, if you will, to stay) as much as to say, 'Won't *you* go first, and show the example?' But nobody had the courage to leave Sir Joshua in sight of two or three hundred people, and we stayed in spite of prudence and the suggestion of fear till the whole of an excellent discourse was read to a very turbulent audience (I mean of young students, and others

behind) who seemed unable to hear and diverted themselves with conversation and peripatetic discourses more audible than that of poor Sir Joshua.[1]

Other accounts survive to confirm the broad truth of this narrative, but it is the description Burney gave to his daughter Fanny (the novelist, who was at this time Keeper of the Robes to Queen Charlotte) which best conveys the atmosphere of this charged occasion:

[Edmund] Burke was there ... After the discourse was over, we had a great deal of talk about the cracks and other things. He and I went up to Sir Joshua to thank him for our entertainment – and he said we had paid him the highest possible compliment by staying perhaps at the risk of our lives – for the arches of the building which had already given way two years ago, rendered our present danger much more serious. As we were descending (Mr Burke ... Boswell, Seward, Sir Joshua and others) Barry the painter met us on the stairs, and said that our danger had been very real, and our escape fortunate; for he had been examining the room under the exhibition room and found that the chief beam had given way! Why it did not go further, especially after the second crack, I know not – perhaps from the company dispersing, which before was collected to a crowd around the tribune. But we are universally abused by our friends for our foolhardy complaisance to Sir Joshua in not making the best of our way out at the first warning.[2]

Long afterwards a slightly different version of events emerged in Samuel Rogers's table talk.[3] He had been forced to sit in a far corner of the room, so his view was more distant than Burney's. The young poet, however, adds one valuable touch. He tells us that after uttering his concluding words on Michelangelo (see end of Discourse XV), Sir Joshua descended from the rostrum while Burke went up to him and quoted lines from the eighth book of *Paradise Lost*:

> The angel ended, and in Adam's ear
> So charming left his voice, that he a while
> Thought him still speaking, still stood fixed to hear.[4]

The delicacy of the compliment lies in the fact that Sir Joshua is thus compared to Raphael, and dubbed an archangel among painters. Nor was this Burke's last response, for soon afterwards he raised in Parliament the state of the fabric of Somerset House, and deplored the condition of a building 'which was intended to remain to posterity a monument of public taste and munificence'.[5]

This scene is a cameo of the late eighteenth century. It tells us some fairly trivial things but also makes some important points. We gather, correctly, that Reynolds was a poor public speaker whose words often could not be heard – he was deaf himself, and spoke too quietly. It shows us that for two centuries or more student manners have remained as informal as they are today. It suggests that public buildings were not very secure places to be in in the 1790s – only a year or two later (perhaps in March 1791, more likely in February 1795) a chandelier collapsed during a concert, thereby giving one of Haydn's London Symphonies a hazardous première and a lasting nickname, the 'Miracle'. More seriously, it shows us the social context of Reynolds's famous lectures. We learn that, along with students[6] and staff, prominent figures from outside the Academy attended: Edmund Burke, the great orator; James Boswell, the author, on the eve of publishing his great biography; Charles Burney, the pioneer of the history of music – to cite only those who happen to be named. (In fact ever since the third Discourse in 1770, the Academy had decided to reserve twelve seats at the front for distinguished outsiders.) We can discern that, even without the drama of this final oration, the lecture furnished not just an Academy occasion but something of a national event. Finally,

it is worth noting the characteristic sang-froid of Reynolds himself, calmly moving on to the presentation of prizes and then to the delivery of his lecture, despite the shock of the structural collapse at the outset of proceedings. A cool customer, one might rightly surmise; and that has been part of the trouble. The *Discourses*, like Reynolds the man, have been more admired than loved, and that too because they have been supposed to be clinical, dry and most un-British in their abstract concern for the grand style. Yet this is only partly true, and it is worth starting with the melodrama of Sir Joshua's last address (a melodrama he probably rather enjoyed) in an attempt to define the character of the criticism and of the author behind it.

2

The Royal Academy provided a *raison d'être* for the *Discourses* and a platform from which Reynolds could mount the first sustained body of art criticism in the language. Such an institution had been a long time coming. It was the resultant of numerous pressures within the artistic profession and an evolving society. During the last two or three generations there had been marked developments in the learned professions, while new careers had grown up in civil and military areas. As for the arts, both literature and music had seen the advent of a broad public and a new servicing 'trade' to cater to their needs. As the art market increased, fuelled by the tastes acquired by the upper class on their Grand Tour, so opportunities for painters rose in equal measure. Artists became more cohesive as a body, centring on London, with small pockets in provincial towns, notably Bath. There were, however, two glaring omissions: the lack of a dominant official institution to set standards, and a

dearth of professional training. The Royal Academy was designed to plug both gaps.

The English naturally looked first to Italy, where the tradition of the *accademia* was already well established. Giorgio Vasari had helped to set up the Accademia del Disegno in Florence (1562), partly with the aim of freeing artists from the strict confines of the guild. There was, incidentally, a Company of Painters and Stainers in London from the time of Queen Elizabeth, but this was a craft guild of artisans (such as heraldic artists) which declined in importance over the years. Rome followed Florence with the Accademia di S. Luca (1593), which gained papal support and helped to bring together the large number of painters working there. Meanwhile in France an even more influential body arose with the Académie Royale (1648), whose influence grew especially after 1663, when Charles Lebrun became its director. The Académie imposed a rigid orthodoxy of taste, controlled education and gave artistic activity a new definition within French culture. It was this as much as anything that men like Reynolds desired to see transferred to English soil. But he and his fellow reformers also wished to see the status of the profession enhanced, economic opportunities widened and a more systematic course of education set up. As the church declined in importance, especially in Protestant countries, and the court ceased to act as the great locus of artistic patronage, new secular bodies had to be devised to keep pace with the new role of the arts within the state.

English concern had focussed on the issue of education. Basic instruction on the Continent had grown up around the studios of masters who had given their apprentices firsthand training. This was how Reynolds himself had learnt his trade at the hands of Thomas Hudson. But the workshop tradition was coming to seem too piecemeal, hit and miss and

unsystematic. More and more, the need was felt for collective guidance and communally imposed standards. Few in England wanted things to become as regimented as they had turned in France under the Académie. Reynolds himself was conscious of what he regarded as the mistakes of foreign academies. In the year after the foundation of the English institution, he wrote to the artist James Barry in Rome asking the younger man to make notes on the regulations in use in continental bodies (see Discourse I, note 7). His hope was that the Royal Academy would avoid the high degree of abstraction associated with French training, and that students would aim for lifelike effects rather than idealized forms. A small departure was that the London system allowed the use of female models, under strict controls. Nevertheless, in broad outline the English academy was modelled on its continental forebears, and its various tasks were complicated chiefly by historical circumstances, political tensions and personal rivalries.

The first serious attempt to set up a regular body in England came after various abortive efforts ending in Sir Godfrey Kneller's Academy of St Luke in 1711. Sir James Thornhill, Serjeant-Painter to the king, founded a school from his home in Covent Garden in 1724, attended by William Hogarth, who took it over in St Martin's Lane in 1734. The St Martin's Academy remained the prime focus of artists in London for a generation. Meanwhile a provincial drawing-master named William Shipley arrived in the capital and founded the Society for the Encouragement of Arts, Manufactures and Commerce (Society of Arts) in 1754. Shipley's brother Jonathan later became a rather radical bishop, the friend of Benjamin Franklin as well as Reynolds, and a member of the Club. In 1756 both Reynolds and Samuel Johnson were elected to the society, whose varied

programme included a kind of unionization of artists. More-
over it acquired some spacious premises in the Strand, which
gave the first possibility of adequate exhibition room. (Pre-
viously the nearest to a public gallery had been the Foundling
Hospital, where some of Hogarth's great paintings had gone
on show.) A group of artists from the St Martin's Lane
School attempted first to set up something like an academy in
conjunction with the Society of Dilettanti, a group of well-
bred connoisseurs who had developed a taste for virtu on
their Italian travels. This attempt (1753–55) came to nothing,
and the St Martin's group then turned to the Society of Arts.
Under the leadership of the excellent painter Francis
Hayman, they managed to obtain the use of the great room in
the Strand. The negotiations took place in 1759–60, with a
committee of artists under Hayman which included Reynolds,
the architect William Chambers and the painter Richard
Wilson; an official letter of approach on their behalf to the
Society of Arts was written by none other than Samuel John-
son. So the way was clear for the first true public exhibition
of pictures ever held in England, at the surprisingly late date
of 21 April 1760. Reynolds himself had four pictures on
show. An elaborate puff that appeared in the press for the
exhibition, giving Reynolds special prominence, may well
have been written by David Garrick.

This was a good start, and exhibitions continued with every
prospect of success in the next few years. But already the
splits which eventually rent all these activities were becoming
apparent. An independent group known as the Society of
Artists of Great Britain (to be carefully distinguished from
the Society of Arts) held an exhibition at Spring Gardens in
1761. This independent group creamed off the best of the
artists, including Reynolds. For a few years the Society of
Artists held a dominant position, and it was there that many

of Reynolds's finest portraits were seen for the first time. For
the 1762 show the catalogue preface was written by Johnson
at the invitation of his friend Reynolds. That year the star
painting on exhibit was Reynolds's wonderfully compressed
morality, showing Garrick between the Muses of Tragedy
and Comedy. Next year the society met on St Luke's Day at
their informal headquarters in the Turk's Head tavern, which
was within months to become the home of the Club. Most of
the best-known artists attended, though not Gainsborough,
who was still based in Bath. The dinner is not by any means a
trivial aspect of the matter, since the Academy was to make
much of its annual feast, and since Reynolds's rise owed
much to his social skills, as well as his eminence in his pro-
fession.

Such were the current rivalries that the independent group
could not keep matters to themselves. The painters loyal to
the Society of Arts founded yet another body, the Free
Society of Artists. Their membership was less distinguished,
but they had a nuisance value and served to dilute the talent
available. In 1764, the year of Hogarth's death, the stronger
body applied for a charter and in January 1765 became the
Incorporated Society of Artists, which at least makes it easier
to keep the two groups separate. Reynolds was invited to
become a director, but declined; the presidency was assumed
instead by Francis Hayman. So the 1760s passed with loyal-
ties divided between the Incorporated Society and the Free
Society, a paradigm of the still contentious and irresolute
state of the profession.

Indeed, one more fissure had to form before the pattern
settled and the Academy could emerge. The pretext was an
obscure quarrel among the Incorporated Society in 1768 over
an exhibition held in honour of the king of Denmark. Amid
much backbiting and legal manoeuvres the bulk of the direc-

tors were ousted by a pressure group headed by the draughts-
man Joshua Kirby, who supplanted Hayman as president.
Reynolds and Gainsborough were invited to replace the
ejected directors, but both declined. The result was a mass
exodus from the Incorporated Society, and a fresh impetus
towards a proper English academy. The leading spirit here
was William Chambers, an architect whom Reynolds had
first encountered in Paris when he was returning from the
Continent in 1752. It appears that in November 1768 Cham-
bers waited on the king on behalf of the disillusioned fugitives
from the Incorporated Society. Unlike Reynolds, Chambers
had acquired respect and influence from the king, and his
representations found a willing ear. He told George III that
'many artists of reputation . . . were very desirous of establish-
ing a society that should more effectually promote the arts of
design than any other yet established, but they were sensible
that their design could not be carried into execution without
his majesty's patronage'.[7] The last clause is crucial, for what
distinguished the new undertaking was its bid for patronage
from the top. Only if the body were granted a royal im-
primatur would it carry the kind of authority which Cham-
bers, Reynolds and their group were seeking.

The pace of events now became rapid: an instrument of
intent was drawn up and signed by the king on 10 December,
generally regarded as the moment of inception for the Acad-
emy. Reynolds was naturally one of the thirty-six Academ-
icians named in the instrument, but otherwise he took a back
seat in the negotiations. Meetings were held at the home of
the sculptor Joseph Wilton, and Reynolds ostentatiously
stayed away. This was probably a good tactic. According to
the later version of events supplied by Benjamin West, Cham-
bers himself hoped – and probably expected – to become
president. But others felt that the post should go to a painter,

and it was decided to approach Reynolds. The reason given
may or may not be genuine: Reynolds was a more agreeable
man than the pushy Chambers, and in any case his record of
achievement was indisputably higher than that of Chambers,
who had dabbled in chinoiserie to good and dubious effect.

The polite ballet of hesitations and scruples continued in a
vein not far short of comedy, as Reynolds affected to cry
'Nolo episcopari' and emissaries were sent out to tempt him:

Mr West was the person appointed to call on [Reynolds] to bring
him to a meeting at Mr Wilton's, where an offer of the presidency
was made to him, to which Mr Reynolds replied that he desired to
consult his friends Dr Johnson and Mr Burke upon it. This hesita-
tion was mentioned by Sir William Chambers to the king, who from
that entertained a prejudice against Reynolds, for both were then
disliked by the king, the latter particularly on political accounts.[8]

It did not take long for Reynolds to overcome his doubts. On
14 December the first meeting of the new body was held, and
Joshua Reynolds was elected the first president of the Royal
Academy. For some time Chambers remained, in Reynolds's
own words, 'vice-roy' over him, and in the following February
there was even a rumour that he would be forced to resign.
The trouble passed, though the king and the president were
never on the most intimate terms.

The constitution laid out in the instrument of foundation
provided for forty full members of the Academy. Prominent
names listed were Chambers (the Treasurer), Hayman,
Wilton, Gainsborough, West, Richard Wilson, the water-
colourist Paul Sandby, the engraver Francesco Bartolozzi and
the portraitist Francis Cotes. Johann Zoffany's name was
soon added. Unusually and progressively, two women artists
were included: Angelica Kauffmann and Mary Moser. There
were to be four regular paid professors (see Discourse I, note
8), as well as a body of overseers and certain honorary appoint-

ments involving no labours or responsibilities. Friends of Reynolds – Johnson, Oliver Goldsmith and the Italian journalist Giuseppe Baretti – were to monopolize the honorary posts.

A few months later the president consolidated his position when he went to St James's to be knighted by the king, on 21 April 1769. Thus his own standing as the most notable living English painter was publicly recognized at the moment when the long-delayed Academy finally took shape, and the place of English art within the community stood ready for fresh definition. It was at this juncture that the *Discourses* first came before the world, and it is within this social context that their intellectual contribution must be assessed.

There is one particularly good index of Reynolds's fortunate positioning with regard to the Academy and to the course of events in English art generally. This can be seen if a contrast is drawn with William Hogarth, the greatest painter of the preceding generation. Hogarth had a long quarrel with the St Martin's Lane School, which finally resulted in a breach by the mid-1750s. He was briefly a member of the Society of Arts, perhaps hoping for a more favourable climate for his idiosyncratic ideas, but he soon resigned. He then turned to the new independent Society of Artists and was represented in their Spring Gardens exhibition of 1761. But it was too late, and he died three years later in an embittered state, distrustful of all institutions, fiercely jealous and suspicious of outsiders. His 'apology for painters' remained long unpublished, and its views swam directly against the current that was to bring Reynolds to the head of the profession. Hogarth thought, for example, that there were very few talented artists at any one time and their numbers should be strictly limited. Enough painters would spring up without any sort of official encouragement. The Society of Arts he

considered misbegotten, partly because a trading nation, such as Britain had become and which the society supported, was inimical to the cause of art, which flourished best in a theocratic system. And so on. It is easy to see why Hogarth failed to make friends and influence his colleagues, whilst Reynolds – polite, discreet, tactful, seemingly compliant and self-effacing – so often got his own way.

One more consideration may be listed which shows how Reynolds seized on the chance provided by the Academy platform. We know that he wrote with reluctance, and more than once contrasted his relative facility with the brush to his slowness to take up the pen (see, for example, his letter to Boswell of 1 October 1782).[9] But he realized that his mission could not be completed unless he communicated his ideas verbally, and he set himself to master the art of literary composition. By 1777 he could be praised for having attained equal distinction in two fields ('Paints with a pen, and with a pencil writes!'),[10] and Mrs Thrale could note that he was 'sufficiently puffed up with the credit he has acquired for his written Discourses, a praise he is more pleased with than that he obtains by his profession'.[11] So he produced the lectures on time, at first annually on the anniversary of the Academy's birthday, and from 1772 biennially. He prepared his draft carefully, using folders on various topics which he assembled during his reading. A fair copy of the lecture was then made by an assistant – for the fourth to sixth Discourse this task was carried out by his pupil James Northcote. After delivery the text was studiously prepared for the press and, early in the New Year, would be issued as a dignified pamphlet of twenty or thirty pages. Copies would be sent to Reynolds's friends and also to influential figures in the nation. This is the sort of attention to detail and eye for the main chance which may explain his success in life, and which equally has

made Reynolds less attractive to subsequent ages. Northcote remarked that 'Sir Joshua was always cautious to preserve an unblemished character, and careful not to make any man his enemy'.[12] It is a way of conducting oneself that is utterly remote from the modern image of the rebellious self-driven artist, unaware of the social niceties as he or she struggles for expression. More to the point, it requires a degree of discipline that would have been impossible alike to the fractious Hogarth, the capricious Gainsborough, the surly Wilson and even, just a little later, the moody Turner.

3

For a long time Boswell saw Reynolds as the subject of a second great biography, a possibility which led Mrs Piozzi (formerly Thrale) to advise Bishop Thomas Percy, 'Let us be careful of our health, my Lord, or he will write *our* lives too.'[13] Among the notes Boswell assembled with this end in view was the record of a conversation he had with the painter in the last weeks of his life, that is on 20 December 1791. Boswell reports that young Joshua gained an early taste for drawing and copying from tomes like Jacob Cats's book of emblems. He then proceeds: 'When he read Richardson's *Principles of Painting*, he was struck with admiration for the art – thought it beyond all others – thought Raphael beyond Pope and all eminent persons – "and indeed" (said he smiling . . .) "I have indulged that notion all along."'[14] Here we see a crucial moment of epiphany, in which the youthful Reynolds catches the ambition to devote himself to art, and identifies the role of the painter as that of an eminent person – not the grovelling tradesman to which Hogarth thought he had been reduced.

The author who had so influenced this impressionable boy

was Jonathan Richardson the Elder, a portrait painter and writer on artistic subjects. The book of his mentioned in Boswell's note is *An Essay on the Theory of Painting* (1715); Samuel Johnson's life of Cowley suggests that it was Richardson's *Two Discourses on the Art of Criticism, as it Relates to Painting* (1719) which inspired in Reynolds 'the first fondness for his art'.[15] Whichever is true, there can be no doubt that Richardson remained a potent figure for the younger man. Richardson's best-known pupil was Thomas Hudson, to whom in turn Joshua would be apprenticed. And at the very end of Reynolds's life, when the booksellers issued a collected edition of Richardson's works in 1792, they inscribed the dedication to Reynolds. It was a suitable gesture, for Richardson could be seen as founder of the English school of art criticism which had come to full flowering in the *Discourses*. The earlier body of criticism, Lockian in its insistence on clear and distinct ideas, seeks to discriminate, sort and explain the typical undertakings of eighteenth-century aesthetics. It was an example Reynolds did not forget, though his writings are analytic over a shorter duration: instead of writing the kind of monographic essay which Richardson dealt in, he spread his coverage over a number of separate lectures, each devoted to a limited part of his field.

In a celebrated passage of the *Theory of Painting*, Richardson had asserted that the time was ripe for a young painter to seize his chance and set out to equal the great masters of the past. He clearly had in mind a great historical painter, and an English one at that: a Milton, he might have said, of the visual arts. More than any other individual, Reynolds caught the spirit of this challenge, and kept before his eyes the possibilities of greatness in the heroic branches of art. It was, perhaps, an illusion: just as the epic could only be produced in literature by now as parody (*The Dunciad*) or

through transformation into modern guises (*Tom Jones*), so Reynolds was able in practice to excel in allusive recastings of the mythological (*Garrick between Tragedy and Comedy*) or visions of contemporary greatness (*Admiral Keppel*). But as a critic, if not as a practising painter of historical subjects, he managed to keep alive Richardson's ideas of the high calling of the artist and the nobility of his most appropriate subject-matter. Apart from all else, Richardson's work is a defence of painting as a language quite as deep and penetrating as anything to be found in literature, and to such teachings Reynolds was a willing disciple.

At the heart of Richardson's doctrine is this emphasis on the 'dignity' of the medium, which made it worthy of 'the name of a liberal art, and ranks it as a sister of poetry'.[16] Equally important for his successor was Richardson's statement of the generalizing and normative aspect of art: 'The business of the painter is not only to represent Nature, but to make the best choice of it; maybe to raise, and improve it from the commonly, or even rarely seen, to what never was, or will be in fact, though we may easily conceive it might be.'[17] This sentence starts off looking like orthodox neoclassical theory, but the longer it goes on the further the mode seems to move away from the Aristotelian to the Platonic. A comparable wavering is apparent at moments in the *Discourses*, especially in the seventh. It should be added that Richardson has a clear sense of the civic value of encouraging the development of taste in genteel young persons, and sees an educative role for the arts within the polity, a view Reynolds would have shared because of his faintly republican and humanist outlook.

In his biography Northcote gives us a truly Boswellian glimpse into the dynamics of the relationship between Reynolds and Johnson (a topic for a later part of this

introduction), and strangely it arises à propos of Jonathan
Richardson. Northcote tells us that Richardson's work came
up for the discussion one day at Sir Joshua's over dinner:

'Ah!' said Johnson, 'I remember, when I was at college I by chance
found that book on my stairs: I took it up with me to my chamber,
and read it through, and truly I did not think it possible to say so
much on the art.' Sir Joshua, who could not hear distinctly, desired
of one of the company to be informed what Johnson had said; and it
being repeated to him so loud that Johnson heard it, the Doctor
seemed hurt, and added, 'But I did not wish, Sir, that Sir Joshua
should have been told what I then said.'[18]

Northcote recounts the story to show Johnson as more 'inof-
fensive', that is Reynolds-like, than he is generally given
credit for. But its wider interest lies in the fact that Reynolds
could still look on Richardson as a rival and a cause for
possible jealousy, even when the *Discourses* were well under
way. (They must have been, because Northcote did not reach
London until July 1771.)

No other direct line can be traced so clearly as that between
Richardson and the *Discourses*. Clearly Reynolds was in touch
with the mainstream of art criticism deriving from Italian
humanism of the Renaissance, a tradition which goes back to
Alberti's treatise on painting (*Della pittura*, 1435). Behind
this again lay a certain amount of theory deriving from the
ancients, but apart from a few scattered sources such as
Pliny's *Natural History* the visual arts had seldom lain at the
centre of aesthetic debate in antiquity. The influence came
rather from rhetorical and oratorical works by Cicero, Quin-
tilian, Horace and (increasingly) the proponent of the sublime,
known to later ages as Longinus. For Reynolds the essential
story emerged in the sixteenth century with works such as
Leonardo's *Trattato della pittura* (first published in 1651),
where the most likely influence concerns the emphasis on

painting as a liberal art rather than a mere mechanical exercise. This is a theme Reynolds stresses in more than one Discourse.

Rather closer in time was a body of French work, including treatises by Roger de Piles which Reynolds owned and cited in his text; the widely known *Réflexions sur la poésie, la peinture et la musique* (1719) by the Abbé Du Bos; and above all the Latin work of a French painter, that is the versified treatise *De arte graphica* (1668) by Charles-Alphonse Dufresnoy. Reynolds himself was to contribute notes to the translation by his friend William Mason, which appeared in 1783. But Reynolds knew it from very much earlier, and almost certainly first encountered it in the famous English version (1695) by John Dryden, which contains a remarkable 'parallel between poetry and painting', which is easily the most stimulating treatment in English before that of Reynolds. Of course, Reynolds must also have been acquainted with contemporary works, ranging from the Abbé Batteux's *Beaux-arts réduits à un même principe* (1746) to the humdrum *Inquiry into the Beauties of Painting* (1760) by Daniel Webb. In his survey of Reynolds's library, F. W. Hilles was able to track down a number of disparate works of virtu and connoisseurship, as well as William Chambers's *Treatise on Civil Architecture* (1759) – the standard work on the use of the orders of architecture by an early friend who was to become an edgy associate of Reynolds at the Royal Academy. It was Hilles, too, who showed that much of Reynolds's apparent learning is borrowed at second hand from sources in his possession such as Franciscus Junius's *Painting of the Ancients* (English translation, 1638); and the lively, rather superficial *Essay on Painting* (English translation, 1764), dedicated to the Society of the Arts by a cosmopolitan friend of Frederick the Great and Voltaire – Francesco Algarotti.

This is not an exhaustive list of Reynolds's reading: it is clear from many references in the text that he had studied Vasari's classic *Vite* (see Biographical Index). It is possible that he knew the autobiography of Benvenuto Cellini, though this work had only surfaced in 1728 and was not translated into English until 1771. Like others who have spent long periods in Italy, Reynolds does not seem to have been all that fluent or eager in reading Italian when substitutes were available, which was not really true in the case of Vasari. A number of other books can be identified in the text of the *Discourses*, and I have duly identified these in the notes. But it would be wrong to suggest that Reynolds was a mere eclectic, as the atomistic evidence of chance citations might erroneously indicate. Reynolds was engaged on a largely new task and his incidental borrowings should not lead us to suppose that he was simply collating and consolidating. He remembered Dryden's preface to Dufresnoy, but he paid very little attention to Hogarth's *Analysis of Beauty* (1753), and instead drew more on the philosophical and literary branch of aesthetics, represented by Adam Smith's *Theory of Moral Sentiments* (1759), Edmund Burke's *Philosophical Enquiry into the Origins of our Ideas of the Sublime and Beautiful* (1757) and Johnson's various works, including the *Preface to Shakespeare* (1765). Since these are all in some measure Club productions, though they partly antedate the Club, I shall defer discussion, but the tendency of Reynolds to direct his aesthetic away from the purely visual and perceptual towards the philosophic and psychological is very much in consonance with his age.

All this discussion of Reynolds's models and his reading does of course leave out one crucial influence – Reynolds was a most assiduous student of paintings and his ruling ideas in the *Discourses* were the product of his lifelong attention to what was visible in a canvas. Quite apart from his prolonged

stay in Italy, when (as he told Northcote) he confined himself to the Capella Sistina for some months, he was an assiduous collector throughout his years in London. He made trips to Flanders and Paris to attend sales and visit galleries; he left detailed descriptions of the pictures he had seen in various locations. Nobody – not even a painter – can see always with an innocent eye, and there were cultural imperatives which underlay neoclassical emphasis on the high style. Nevertheless, it can be said that Reynolds espoused the 'grand' manner for reasons that have to do with art – ordonnance, organization, formal coherence – as much as with politics; and equally that his depreciation of the 'ornamental' style has at its root a distaste for the glaring effects, displaced accents and tonal discontinuities of much mannerist and baroque art. Hence his steady adherence to the view that the Roman, Florentine and Bolognese schools represented the purest streams of painting and the highest level of achievement. By comparison the Venetian, Dutch, Flemish and French schools represented a decline.

Naturally this pattern is not so monolithic that Reynolds cannot believe the evidence of his senses and celebrate the virtues of a Titian or a Poussin. He is lucid in setting out the categories and in explaining his preferences, but he is never the prisoner of his own categories. To a modern reader the oddest feature is his almost total blindness to quattrocento and earlier art. His scheme makes no allowance whatever for Giotto or van Eyck, Bosch or Botticelli, but this is simply a reflection of the general state of knowledge and taste of the time.[19] In the event it makes less difference to the cogency of his evaluations than one might expect, since a totally lost continent can have little bearing on the exploration of domestic terrain. It is amusing that the Pre-Raphaelite Brotherhood should have dubbed Reynolds 'Sir Sloshua', as much

perhaps for the sobriety and worldliness of his portraits as for his historical views. But he has outlived their scorn, and whatever the merits of the Pre-Raphaelite painters they produced no body of criticism which can rank with his *Discourses*.

A further way of approaching the intellectual content of the work is to follow up what Reynolds says in the last Discourse of 'establishing the rules and principles of our art on a more firm and lasting foundation than that on which they had formerly been placed' (see p. 322). By far the most challenging discussion of this effort to put 'the whole art into order' is that of Lawrence Lipking, in *The Ordering of the Arts in Eighteenth-Century England*. The aim of this book is to place Reynolds in the context of parallel 'orderings' of a body of historical art, conducted almost simultaneously in music, art and literature. Almost all the significant figures in this process were members of the circle shared by Johnson and Reynolds, and I shall return to this aspect of the *Discourses* when looking at the influence of this group. For the moment, it is worth isolating other aspects of the case which Lipking mounts with considerable skill. He contends that the dialectic of the separate lectures does not produce a true unity, so disparate are the aims (to establish a canon, to ennoble the profession, to ascertain the psychological basis of artistic appeal, and so on). He shows with great cogency that the lectures could hardly amount to a progressive course of instruction, as has been alleged, since even the tardiest student would have been unable to stay such a protracted course over twenty-one years. In addition, Lipking reveals a number of the contradictions which beset such a diverse set of aims; and he makes useful observations on the complex attitude towards history implicit in the lectures.[20]

Clearly the *Discourses* are lacking in unity in a very straight-

forward way: no reader can fail to observe that they vary in length, in scope, in mode of approach, in tone and in the use of exemplary detail. We can set aside Discourse IX, a short speech to commemorate the opening of new rooms at Somerset House, a somewhat ungrateful task performed with decent seriousness but with a little of the accents of Auden's schoolmaster about it. Predictably, Discourse I is largely introductory in character. By contrast Discourse XV, though it does contain a review of the former lectures, ends on an assertive and innovative note with its rhapsodic tribute to Michelangelo. Discourse XIV is obviously a special case, with its lengthy appraisal of Gainsborough. Perhaps the weakest item is Discourse X, on sculpture: though Reynolds, like other visually educated persons of his time, had studied antique sculpture with great respect, it is not a subject which brings out his most vivid writing. The most impressive lectures are probably Discourse III, on 'the great leading principles of the Grand Style'; Discourses VI and XI, on the currently hot issues of genius, originality and imitation, where Reynolds had Edward Young more directly in his sights than has been realized (see notes to these items); Discourse VIII, on the psychological roots of taste; and the final Discourse. A lecture useful in its day which now holds less appeal is Discourse XII, with its essentially pedagogic concerns.

It used to be common to argue that the *Discourses* show a gradually increasing tendency towards a 'Romantic' outlook, with more emphasis as they proceed on feeling, on associative rather than rational ingredients in aesthetic pleasure, and on a new reliance on imagination as the key factor in response. Robert Wark in his edition[21] successfully opposed this view, and further evidence may be brought against it. Those who propounded the older view tended to say that Reynolds turns progressively away from Raphael to Michelangelo, as though

this were a shift in his affinities late in life. In fact Northcote
quotes a letter from Edmund Burke to James Barry, dating
from as early as 1766, with the passage, 'I found that Rey-
nolds's expectation of what would be your great object of
attention [in Rome] would be the works of Michel Angelo,
whom he considers the Homer of painting.'[22] Nor is it likely
that anyone would shut himself up in the Sistine Chapel 'for
some months', with so much Raphael in the offing, if he did
not intend to make a special study of Michelangelo. It is of
course true that Reynolds devoted a lot of his time in Rome
to studying Raphael, and he retained even more than the
conventionally high estimate of Raphael's art for the rest of
his life. But there is no sign of a major change of heart.[23]

Again, it is hard to see that Reynolds had ever had any
doubt that the imagination was a crucial faculty, though as it
happens the *Discourses* make this most explicit in later years.
Reynolds once wrote that 'arts have little to do with reason.
They address themselves to another faculty; their whole com-
merce is with the imagination.'[24] This is developed in Dis-
course XIII (see p. 295):

The great end of all [the] arts is, to make an impression on the
imagination and the feeling. The imitation of nature frequently does
this. Sometimes it fails, and something else succeeds. I think there-
fore the true test of all the arts is not solely whether the production
is a true copy of nature, but whether it answers the end of art, which
is to produce a pleasing effect upon the mind.

This recognition of the pleasure principle stems from the
writer's flexible, human and alert sense of realities. For all his
fondness for abstract reasoning, Reynolds was an empiricist
in the end: 'A painter should form his rules from pictures,
rather than from books or precepts; this is having information
at first hand – at the fountain head.'[25]

Most of the ideas in the *Discourses* would have looked fam-

iliar to Dryden, Dufresnoy and Jonathan Richardson. What was new was the clarity and verve of the prose; the fresh infusion of aesthetic currents deriving from the later generation of David Hume, Joseph and Thomas Warton, Adam Smith and Edmund Burke; and the sweeping range of vision which incorporated art history within a broad system of ideals and beliefs. When Reynolds writes in the penultimate paragraph of Discourse XIII, 'Upon the whole, it seems to me, that the object and intention of all the Arts is to supply the natural imperfection of things, and often to gratify the mind by realizing and embodying what never existed but in the imagination', he is giving only the slightest twist to orthodox doctrine. He does the same in Discourse IX, when he says, 'The Art which we profess has beauty for its object; this it is our business to discover and to express; the beauty of which we are in quest is general and intellectual; it is an idea that subsists only in the mind; the sight never beheld it, nor has the hand expressed it' (see pp. 230–31). At times one notices certain similarities between the views of Reynolds and those on realist literature of the modern Hungarian critic Georg Lukács, though of course Reynolds would not have foreseen the Marxist interpretation of art: 'What makes a type a type is not its average quality, nor its mere individual being, however profoundly conceived; what makes it a type is that all the humanly and socially essential determinants are present on their highest level of development, in the ultimate unfolding of the possibilities latent in them.'[26] For Reynolds, as for Lukács, the archetypal is also the most realistic way of rendering complex human essence.

4

Reynolds has been the victim of his own success. This is

partly because, reversing the opinion of Samuel Smiles, our own age regards any unclouded success as poor material for the biographer: we are interested in the setbacks and personal lesions. Since Reynolds followed a career of almost unbroken advancement, his story lacks the undulations of life led in the modernist way. There are two other factors augmenting this pattern. First, Reynolds was largely the laureate of the successful, and though he painted some excellent pictures of aristocrats, as well as of women, his special forte lay in delineating the upwardly mobile male – politicians, soldiers and sailors, writers, actors and others who had managed to climb the greasy pole along with him. It is this facility which makes him a remarkable historian of the Hanoverian age, with its expanding horizons, commercial bustle and cultural efflorescence. Allan Ramsay was his superior in depicting certain fashionable sitters, Gainsborough outdid him in delicate socialite studies, but for sturdy self-made men like Colonel Tarleton, assiduous climbers like William Chambers or nabobs like George Clive, there was no one to touch Reynolds. Second, his smooth and urbane personality makes it seem as if he knew all along he could not possibly fail. We may even be repelled by the absence of rough edges in his character; we look for the grain and find only a polite, civilized and unruffled demeanour. We are cruelly cheated of our desire for a hidden life of anxiety and self-doubt – or at least we seem to be.

It is so easy to imagine that he was always Sir Joshua Reynolds, PRA, and could never have been anything less. In fact his origins were modest, and his background as the son of a poor Devon schoolmaster is readily forgotten. (Less so to contemporaries, since the writer Ellis Cornelia Knight recalled his marked Devon accent.) This matches the broad Midlands vowels of his friend Samuel Johnson, the Scottish

brogue of James Boswell, and the odd Irish twang of Oliver
Goldsmith. Here is a pointer to a significant fact about the
culture of Hanoverian London: it was to a large extent created
by incomers. The typical pattern is a provincial boyhood with
no great affluence, modest schooling without a privileged spell
at Oxford or Cambridge, and arrival in London with no
obvious advantages beyond ambition and talent. Once again
the chief figures of the Club back up the evidence. Johnson was
the son of an unsuccessful Staffordshire tradesman; Goldsmith
deserted his home village in County Longford so completely
that his roots are lost; Burney was the son of an irresponsible
itinerant musician from Shropshire named Macburney;
Burke's Irish family were notoriously hard to place (many
thought him a Jesuit mole in English society); R. B. Sheridan
was the son of an Irish elocution teacher and actor. It is true
that Boswell was the son of a judge, but he was a Scot, and
came up to London in 1762, the very year when Scots were
most unpopular in the capital because of the hated Lord Bute.
Adam Smith was another Scot of humble origins, Edmond
Malone another Irishman. The only one among this group to
have attended one of the great English schools was Sheridan, at
Harrow, but he promptly eloped with a singer. Nobody among
them saw the inside of an Oxbridge college except Johnson,
and he was obliged to drop out because of poverty. Surrounding
the Club, too, were an odd collection of exiles and emigrés –
the Corsican Pasquale Paoli, the Italian Giuseppe Baretti,
John Paradise (son of the Consul at Salonica, and married to a
girl from Virginia), and that honorary London luminary Ben-
jamin Franklin. The two women who were closest to the Club
at various times, Fanny Burney and Hester Thrale, both ended
up marrying foreigners. As for Reynolds, the only artist who
penetrated his reserve and actually exchanged paintings with
him was the Swiss Angelica Kauffmann.

The pattern holds true more widely, however, and that is
why Reynolds's immediate circle is a reliable mirror of the
Hanoverian world. The same modest provincial background
is found in the case of painters (the East Anglian Thomas
Gainsborough, the Scot Allan Ramsay, the Welshman Rich-
ard Wilson, and further emigrés such as Giovanni Battista
Cipriani, Jean-François Rigaud and Francesco Bartolozzi). It
applies equally to writers: Laurence Sterne, an Irishman con-
demned to rural obscurity in Yorkshire; the proud Scotsman
Tobias Smollett; and (for a while a London figure) David
Hume. In other areas of national life, though the great offices
of state were still dominated by the aristocracy and higher
gentry, there came thrusting through from more or less no-
where figures such as Warren Hastings, Sir Joseph Banks
(only two generations removed from sordid land-dealing and
corrupt borough-mongering in Grimsby), James Cook and
Colonel Isaac Barré. It is noteworthy that the most radical
political activist, that is Reynolds's socializing friend John
Wilkes, was nurtured in more comfortable and more metro-
politan surroundings than almost anyone else mentioned.

Reynolds, then, had a long way to travel from Plympton,
where he was born in 1723, and his father's schoolroom. He
had the kind of loving but improvident and slightly ineffective
father who seems incident to some men of genius (Hogarth
and Dickens, for example). At one stage young Joshua was
destined for a career as a country apothecary, but his talent
for art, and perhaps more important his ambition to get ahead,
precluded this choice. At the age of seventeen he made his
first decisive move when he went up to London as an ap-
prentice to Thomas Hudson, formerly the pupil and now the
son-in-law of Jonathan Richardson. Hudson was for a while
the most fashionable portrait painter in the capital. After the
rise of Reynolds he lost favour and was a total back-number

by the time of his death in 1779. But as a fellow-Westcountry-
man he must have been a supportive figure for the boy reach-
ing London (the biggest city in England by a factor of ten).
His library contained useful books such as a translation of the
famous work of the antiquarian Bernard de Montfaucon, *An-
tiquity Explained, and Represented in Sculptures* (1725), as
well as casts of the *Apollo Belvedere* (see Discourse III, note
17) and *Antinous*. He will never enjoy again the renown he
briefly possessed, but an exhibition at Kenwood in 1979 dis-
played his far from contemptible talents. Habitually we think
of Reynolds's formative spell as the years in Italy, which
Hudson visited in 1752 with the sculptor Louis François
Roubiliac, encountering his former student Reynolds (accord-
ing to one story) on the passage of the Alps as they travelled
in opposite directions. We should recognize that the years
with Hudson were almost as important for the young artist: a
letter from the boy's father in 1744 reports that 'Joshua by
his master's means is introduced into a club composed of the
most famous men in their profession'[27] (probably Old Slaugh-
ter's in St Martin's Lane, which included Hogarth in its
number). Moreover, the scholarly Reynolds would have
gained as well as the clubbable Reynolds, for Hudson collec-
ted old masters and had a special interest in Italian art of the
sixteenth and seventeenth centuries. This, added to his facility
in depicting high-achievers like Handel, Garrick and Lord
Hardwicke, must have left its impress on his apprentice.

After this Reynolds had two spells in Devon and London,
not quite marking time for he painted his first individual
paintings, including a sensitive self-portrait in about 1746.
But it was his journey to Italy which made the big difference.
Reynolds was fortunate in a chance acquaintance he struck
up with Captain Augustus Keppel, later a famous admiral
and an abiding friend of Reynolds. Keppel happened to be en

route to the Mediterranean in 1749 when he made an un-scheduled landfall at Plymouth and met the young artist. He offered free passage to Reynolds, and two of the painters' sisters loaned him enough money for living expenses. Hence he could spend three years abroad, in the hothouse of European art. In later years he would criticize connoisseurs and grand tourists, since 'instead of examining the beauties of the works of fame, and why they are esteemed, they only inquire the subject of the picture and the name of the painter, the history of a statue and where it is found, and write that down. Some Englishmen, while I was in the Vatican ... scarcely ever looked at the paintings the whole time.'[28]

His own approach was much more disciplined. He found himself, as he wrote home to his patron Lord Edgcumbe, 'at the height of my wishes, in the midst of the greatest work of art that the world has produced'.[29] Typically, he did not waste a second, spending long periods copying and contemplating Michelangelo, Raphael, Titian, Guido and many others. In fact the least copying was done of the artist who made the greatest impression, Michelangelo, for Reynolds was at first not attuned to Raphael and preferred to pass whole days walking up and down the Sistine Chapel, breathing in the spirit and form of Michelangelo's work. The effect this was to have on his own work as a painter is oblique and sometimes hard to spot; the effect it had on his general artistic attitudes is evident on almost every page of the *Discourses*.

But it was not all solemn study. There was time for some caricatures of milords visiting the fleshpots of Rome, a form in which he seems to have anticipated his friend Thomas Patch; and one larger *jeu d'esprit*, a parody of Raphael's *School of Athens*, in which aristocratic *flâneurs* sit in for the peripatetics. Meanwhile, Reynolds as always kept his evenings free

for sociable enjoyment, and made some valuable contacts among the well-heeled British fraternity in Rome. By 1752 it was time to move on, and after a visit to Naples he made his way northwards through Florence, Bologna, Venice and Milan. After pausing for his first visit to Paris, where he met a man of great consequence in his later life, the architect William Chambers, he returned to England in October 1752.

Now after the long years of disciplined preparation came the bid for success, and again Reynolds went about his purposes with dedication and discipline. By 1753 he had moved into respectable quarters in Great Newport Street with his sister Frances as housekeeper; according to one state-ment, he painted 120 pictures during his first year in London. At first his prices were moderate, though far from the rock-bottom level: twelve guineas for a head and forty-eight guineas for a full-length portrait. He quickly sized up the taste of the town and began to achieve prominence; by the mid-1750s any published account of the London art scene mentions Reynolds as a notable figure. His first major impact was made with the dramatic picture of Commodore Keppel (1752/3), with the heroic subject set against a stormy sky and a tumultuous sea. Other early pictures such as that of Captain Orme (1756) show that he had by now acquired an individual style particularly well adapted to the portrayal of character rather than merely social position.

These too were the years of the struggles towards an En-glish academy, a process we have already charted: Reynolds was active in these societies, but never allowed their politics to distract him from his central mission as an artist. 'Were I in your place,' he was to tell James Barry in 1769, 'I would consider myself as playing a great game, and never suffer the little malice and envy of my rivals to draw off my attention from the main object.'[30] The same striking but faintly

disconcerting image occurs in Northcote's conversations with Hazlitt: 'Sir Joshua always despised malicious reports; he knew they would blow over: at the same time, he as little regarded exaggerated praise. Nothing you could say had any effect, if he was not satisfied with himself. He had a great game to play and only looked to the result.'[31] Northcote goes on to praise the equanimity of temper, arising from self-knowledge, which resulted. It is the very obverse of the post-Romantic 'artistic temperament', and it is what enabled Reynolds to get so far so quickly. An unkind observer might say that he rose without trace; such a comment would not have disturbed him unduly.

Scarcely less crucial than his success as a painter was a series of meetings which were to bring Reynolds equal renown in literary circles. His first encounter with Samuel Johnson cannot be dated with absolute precision, but it probably took place around 1755 or 1756; according to Northcote, the venue was the home of the two Miss Cotterells, neighbours of Reynolds. This was one of the decisive events in Reynolds's life, and its consequences are more fully explored below (pp. 43–7). At roughly the same time he met Edmund Burke, just about to publish his first significant work, the essay on the sublime and the beautiful; Reynolds had exhibited a touch of the sublime in his *Keppel* and was equally adept in the beautiful, as seen in the delicious unfinished picture of the infant Duchess-to-be of Devonshire and her mother (1759). A lifelong ally, the poet William Mason, came into Reynolds's sphere at the same date, and along with Mason the latter's friend Horace Walpole, whom Reynolds began to paint in 1757. Walpole was a major taste-maker in the arts, and his *Anecdotes of Painting in England* were to supplement in the historical and antiquarian line the critical pronouncements of the *Discourses*. Year by year Walpole recorded his responses to new pictures by Reynolds at the Academy exhibition, sometimes

by way of notes in his catalogue to the exhibition, sometimes in letters to his artistically inclined correspondents like Mason. It is from Walpole that we get the clearest idea of the changing fortunes of Reynolds over the years. He compares and contrasts Reynolds and Ramsay in 1759; two years later he is one of several who take special note of *Garrick between Tragedy and Comedy*; in 1771 he terms Reynolds 'our best painter' – and so on, right up to the last years.

So the artist went on in his unruffled way. He met Oliver Goldsmith around 1762, and within two years was a prime mover in the foundation of the Club, with Goldsmith another founder-member. The sudden notoriety of *Tristram Shandy* brought Laurence Sterne to sit for Reynolds, and the image of a wonderfully sardonic and almost satanic clergyman was widely distributed in engraved form. The year 1766 saw the arrival from Italy of Angelica Kauffmann, who wrote back to her father that Reynolds was 'one of my kindest friends and is never done praising me to everyone'.[32] The stories current then and now that the two had a romantic liaison are not founded on solid evidence, but then we have little idea whether Reynolds's seemingly blameless life was a product of his great discretion or of sexual coldness. During the autumn of 1768 he went to Paris, ostensibly to visit galleries and collections, perhaps also to keep out of the limelight whilst the Incorporated Society split up and the way was paved for the Academy. However much is owed to his foresight, Reynolds played his part well; he was back in time to gain election as first president of the new institution on 14 December. Twenty years before he had been virtually unknown; now, aged only forty-five, he stood at the pinnacle of his profession, both as practising painter and as public spokesman for the arts.

In describing the events of the next two decades, it is sometimes difficult to avoid the accents of a vapid theatrical

autobiography, so relentless is the march of Reynolds in his halcyon years. For example, 1769 saw the first two Discourses delivered to considerable public interest; the knighthood in April; then in September a meeting with James Boswell. Next in 1770 followed the third Discourse, and a warm dedication from Goldsmith attached to a great work of literature, *The Deserted Village*. And so on, year by year. Honours began to flow – a doctorate from Oxford, membership of the Academy of Florence, an invitation to design a window for the chapel of New College, a location very close to the heartland of the English establishment for a mere painter from a small town in Devon. The first seven Discourses were collected in 1778, Baretti translated them into Italian, and there was a German version before long. All this time Reynolds continued to move among the good and the great, passing freely from the grand saloons of Blenheim to the cramped informality of London taverns where the Club gathered; from there to the rather stiff assemblies of Elizabeth Montagu, and then to the looser-tongued occasions hosted by Hester Thrale. When Fanny Burney brought out *Evelina* in 1778, Reynolds acquired a new literary enthusiasm and a new friend. All the while he was bringing out portraits demonstrating insight and high painterly skill, with an increasing tendency towards delicate or amusing 'fancy' pictures. And the regular flow of Discourses at the Academy went on.

Possibly the apogee was reached with the opening of new quarters at Somerset House in 1780, a symbolic act of building upon the past which had metaphoric overtones not just for the Academy but also for the president himself. But the first clouds had started to appear. Goldsmith had died in 1774, and then Garrick in 1779. The death of the former upset him so much that, for once, he could not keep up his painting schedule, being unable to carry on with a portrait

of Burke because he was blinded by tears. Reynolds had quite a severe illness in 1782–3, around the time that William Mason's translation of Dufresnoy appeared with notes by Sir Joshua. In December 1784, just three days after Reynolds gave his twelfth Discourse, came the death of Samuel Johnson – not unexpected, but a severe blow to the ageing Reynolds. Some sort of rally emerged, with a second visit to the low countries to study Dutch and Flemish art in 1785. A commission from the Empress Catherine to supply a picture for St Petersburg reflects in part the growing fame of the *Discourses*, which Princess Dashkov wanted to translate into Russian. But the picture proved laborious to complete, and overall it is not a success, as was seen when it left the Hermitage for the Academy exhibition in 1986. At last the heroic energy and sense of mission were beginning to fail; the death of Gainsborough in 1788 brought a noble tribute from Reynolds to a fellow-painter (see Discourse XIV), but must also have served as a *memento mori*.

Then a true calamity struck in June 1789, a personal blow to match the huge national shock created by the French Revolution a matter of days later. Reynolds was forced to stop painting through impaired vision and by August it was clear the sight of his left eye had been lost for good. The cause may have been disease of the optic nerve, or possibly a detached retina. He managed to struggle on for a time, completed one last Discourse, witnessed the outcry about Burke's *Reflections on the Revolution in France*, and underwent an unpleasant quarter of an hour in Academy politics, which led to his brief resignation (soon rescinded) from the presidency. By the time that Boswell produced his *Life of Samuel Johnson* in May 1791, with its fulsome dedication to Reynolds, the sight in the other eye had almost gone: there are touching accounts by Boswell and Fanny Burney of his sad condition. Reynolds

died on 23 February 1792, prompting a fine tribute from Burke (see Appendix D) and occasioning a funeral of immense pomp at St Paul's, with a massive cortège setting out from Somerset House.[33] Today there are perhaps few people who would relish the thought of such a funeral, or indeed welcome the idea that it would be appropriate to their spell on earth. In the case of Reynolds, however, it was an apt recognition of his place in national life, his success in a public arena and his dedication to public causes. We can hardly conceive of a worthwhile creative artist who also occupies the role of a sort of minister of culture (the example of André Malraux is not altogether reassuring). A state funeral for Reynolds was also a gathering of his friends from the aristocracy – the pallbearers were three dukes, two marquises, three earls, one viscount and one mere baron; but alongside these figures and the Archbishop of York were the Academicians in number, as well as Boswell and Bennet Langton, Burke and Malone, John Philip Kemble, the actor (also representing, no doubt, his sister Mrs Siddons), and scores of other prominent people.

Reynolds indeed had played the great game to marked effect. What he felt about the shape of his life can be gauged best from some remarks passed on by Dr Burney, who heard a conversation when several peers were discussing the nature of happiness. Reynolds was evidently goaded from his accustomed caution in this area:

It is not the man who looks around him from the top of a high mountain at a beautiful prospect on the first moment of opening his eyes, who has the true enjoyment of that noble sight: it is he who ascends the mountain from a miry meadow, or a ploughed field, or a barren waste; and who works his way up to it step by step; scratched and harassed by thorns and briars; with here a hollow, that catches his foot; and there a clump that forces him all the way back to find

out a new path; – it is he who attains to it through all that toil and
danger; and with the strong contrast on his mind of the miry
meadow, or ploughed field, or barren waste, for which it was ex-
changed – it is he, my lords, who enjoys the beauties that suddenly
blaze upon him. They cause an expansion of ideas in harmony with
the expansion of the view. He glories in its glory; and his mind opens
to conscious exaltation.[34]

The *Discourses* show how the mind of Reynolds expanded
with his increasing absorption in the great art of the past, and
they are consciously delivered from the lofty perch of the
president's chair. To perform well in this exalted role
required more than having got on in the world; it needed,
too, a mode of thinking which had scarcely surfaced in previ-
ous art criticism. Here the crucial input was that of the group
centring round the Club. Reynolds could learn from the liter-
ary example of Burney, Edward Gibbon, Adam Smith, the
Wartons, Thomas Percy and others. And vitally he had the
immediate inspiration and guidance of two great men, John-
son and Burke.

5

Reynolds, one might say, knew what he was doing when he
proposed the formation of the Club in early 1764. It is also
indicative that he was the most regular attender when the
Club expanded from its original nucleus of just nine. From
1775, when reliable attendance figures begin, to 1788, he was
present on 152 occasions (the figures for 1785–6 are missing,
but unlikely to alter the position). The nearest total to this is
that of Gibbon with eighty-eight; Johnson scores thirty-one;
Boswell (who was often absent in Scotland in earlier years)
twenty-seven; Adam Smith twenty-two; Sheridan twenty-one;
Charles James Fox seventeen; Burke a rather miserly sixteen;

Garrick (who died in 1779) twelve. Edmond Malone scores seventeen on just two years of recorded membership, and at the end of Reynolds's life would have been his closest rival in terms of frequency of attendance. All this goes to show that Reynolds was more than the founder of the Club; he was its heart, and for much of its duration the society would have folded without him – it came close to this on occasions, as it was. Reynolds was notoriously selective in his pastimes, as he was so conscious of the value of his time. That he gave so many evenings to the Club is the strongest proof that he set immense store by its existence. Above all he wanted to keep in good repair the friendships that came with its membership.

Naturally Reynolds took different things from the varied gallery of luminaries who made up the Club. Along with the seemingly lighthearted chatting, which amounted to the higher gossip, there were opportunities to exchange ideas on serious themes. Even with Boswell, the most ready among the group to turn to facetiousness, Reynolds often discussed matters of weight. We know, for example, most about his views on marriage from a conversation reported by Boswell in March 1788; other participants were Malone and John Courtenay, who had combined with Reynolds and Boswell to form the 'Gang', a convivial splinter group of the Club. Of course, Boswell being Boswell, there was generally a good time in the offing. Even when he composed a fulsome tribute to the deceased president, in April 1792, trading on his honorary post in the Academy, he promptly went off to a tavern with the Academicians and regaled them with a song in honour of Sir Joshua's successor, Benjamin West. To be sure, Northcote told Hazlitt that there was a concealed motive behind the willingness with which Reynolds bore the importunities of his Club colleagues: 'This was what made him

submit to the intrusions of Boswell, to the insipidity of Malone, and to the magisterial dictation of Burke: he made sure that out of these three one would certainly write his life, and ensure him immortality that way.'[35] This is absurd in the case of Burke, imperceptive in the case of Malone (who gave Reynolds sterling assistance), and not quite the full truth even in the case of Boswell.

Besides this little group, Reynolds had extensive contacts with Edward Gibbon. The historian was shy in company, and several of his fellow-members found him hard going. Only Reynolds managed to bring him out. The engagement books show many occasions when the two men spent a relaxed evening together, and indeed Gibbon seems to have been the surprising choice Reynolds made to replace his former boon companion, Oliver Goldsmith. Then there was Charles James Fox, who shared a taste for theatre-going; Reynolds was a regular at first nights, and developed a particular admiration for Mrs Siddons, one fruit of which was the masterly portrait of the Tragic Muse. Despite his deafness, he could be found in the orchestra stalls, trumpet to his ear, with his eyes glued to the greatest actress of her day. Long association with Garrick, Goldsmith, George Colman and Sheridan had given him an informed interest in drama; his protracted study of Shakespeare had benefited from his alliance with Johnson, and when Malone's edition appeared in 1790, he was one of its keenest readers. In fact Malone incorporated some conjectures which Reynolds had given him. Yet another Clubman, George Steevens, had produced the main edition of Shakespeare between those of Johnson and Malone (in 1773) – the taste for such frequent recensions was amazing. Somehow Reynolds contrived to keep up good relations with Steevens, a sly and conniving individual. Then there was Thomas Percy, famous alike for his *Reliques of English Poetry* – without

which there would have been no *Lyrical Ballads* – and for his brush with Johnson, chronicled in Boswell's great *Life*. Percy was another provincial made good, the son of a Shropshire grocer who became an Irish bishop.

So the list continues: civilized grandees like Sir William Hamilton, whose second wife, Emma, may have been painted by Reynolds in earlier days; the cosmopolitan and intelligent Lord Palmerston (father of the Victorian statesman); the agreeable Lord Lucan; the versatile diplomat George Macartney; the well-travelled scientist Joseph Banks – to whom Reynolds owed his introduction to Omai, a Tahitian he depicted in a memorable portrait (see Discourse VII, note 39). There were lawyers like Robert Chambers, John Dunning and Sir William Jones, who unravelled the relation of Sanskrit to European languages. There were doctors like George Fordyce and Richard Warren. And there were churchmen, too, like James Douglas, Bishop of Salisbury, and Thomas Barnard, Bishop of Killaloe, who became chaplain to the Academy and addressed some amusing verses on Club matters to 'Sir Joshua Reynolds & Co.'. That was how the Club must have seemed to many, with Sir Joshua ruling the roost. But the founder and unofficial chairman did not always get his own way. Candidates he proposed for election, including General Burgoyne, were blackballed, a fate that also met some of Johnson's proposals. There are grounds for suspecting that it was Boswell who was responsible for excluding Philip Metcalfe, a close ally of Sir Joshua in later years, who was his companion on trips to the low countries and served as an executor. Reynolds himself may possibly have ensured that William Chambers was not admitted.

Clearly there was abundant stimulation in such company, any number of ways by which Reynolds could pursue his dedicated course of self-improvement, opportunities to plug

gaps in his education. The *Discourses* are in large part the work of an autodidact, but one who had acquired a wide circle of advisers and expert witnesses to hand. The most crucial group were the inner circle of scholars and writers who are directly quoted in the text of the *Discourses*, for they were also the men who made the Club tick in its first quarter of a century.

In particular, the relations of Reynolds and Charles Burney were closer than has been realized. It is to Burney that we owe some characteristic insights into his friend, such as the account of Reynolds on the ascent through life, quoted above (see p. 34). Moreover, we know how much Reynolds enjoyed the company of Charles's daughter, the novelist Fanny Burney. There was even a suggestion, however ill founded it may have been, that Sir Joshua intended to propose marriage to Miss Burney. He certainly exerted himself to get her released from her soul-destroying post at court, and when he died she felt as though she had lost a father. Finally, it should be noted that the entire account of Metastasio in Discourse XII derives immediately from Burney's travel diaries (see Discourse XII, note 7), a fact which has been concealed up till now. The relevant portions appeared in Burney's published volumes, rather than in the extensive passages suppressed; but one can hardly doubt that Reynolds would have spoken to his friend on these matters by the time he came to prepare the twelfth Discourse in 1784. We know that the German tour, which included this encounter with Metastasio in Vienna, 'was honoured with the approbation of the blue-stocking families at Mrs Vesey's and Mrs Montagu's and Sir Joshua Reynolds's, where I was constantly invited and regarded as a member' (from Burney's suppressed introduction to his tours).[36] It was also the German tour which brought Burney the full-hearted admiration of Johnson.

Thus, the citation of Burney's passage on Metastasio, even in its concealed form, shows the close interdependence of the Club in their literary undertakings.[37]

This is more than a matter of vague impression. It was recognized in his own time that Burney had undertaken in his *History of Music* the task of 'regulating and correcting the public taste in music, as Sir Joshua Reynolds had done in a sister art'.[38] The correspondences between the arts formed a cliché of eighteenth-century criticism, and they are reflected in Discourse XIII. A number of parallels between this particular musician and his friend the painter have been pointed out by Burney's modern biographer, Roger Lonsdale, including the ambition to be 'accepted as a "man of letters" rather than as a mere "musician" [or, in the case of Reynolds, painter]'.[39] Lonsdale makes another pertinent observation: 'Nothing struck his contemporaries more than the manner in which, by proving himself an accomplished writer and a polished and elegant member of "polite society", Burney not only transcended his profession but simultaneously elevated it, in the same way as Garrick and Reynolds had won respect for the exponents of their arts by their own achievements and social demeanour.'[40] Johnson himself had said that Garrick made his profession respectable; it was a key part of the Club's collective enterprise, as here broadly defined, to elevate mechanical occupations into dignified professions, and thus to re-position the arts within society. As well as those just mentioned, other Club luminaries such as Burke, Gibbon, Percy (as antiquarian collector) and Adam Smith may be said to have raised the standing of their particular branch of inquiry. Wordsworth went so far as to assert that Percy's *Reliques* had by themselves 'redeemed' English poetry. Nevertheless, it was Reynolds who performed the most dramatic act of transformation. This owed most to his skill as a painter

and to his deportment in fashionable company; but it could
not have taken place in the same way had it not been for the
existence of the well-bred, learned and methodical series of
Discourses.

The collective purpose embodied in the activities of Club
members can best be gauged from a remarkable book by
Lawrence Lipking, to which I have already referred.[41] In his
survey of 'the ordering of the arts', Lipking identifies six key
works published in England between 1762 and 1790. These
are: in the fine arts, Horace Walpole's *Anecdotes of Painting
in England* (1762–80) and the *Discourses*; in music, the histor-
ies of Sir John Hawkins (1776) and Charles Burney (1776–
89); and in literature, *The History of English Poetry* (1774–81)
by Thomas Warton, and the *The Lives of the English Poets*
(1779–81) by Johnson. All these authors except Walpole
belonged to the Club. Even the founder-member Hawkins,
who defected quite soon, after a quarrel, seems to have been
on intimate terms with Reynolds at one stage; Hawkins's
daughter Laetitia Matilda reports some conversations at
which she was present as a girl.[42]

The circle might be extended in various ways. First, Lip-
king identifies a number of important forebears of these
writers, including James Harris, author of *Hermes* (1751), a
radical philosophy of art which left its mark on his friend's
thinking in the *Discourses*. Second, alongside Thomas Warton
we should place his brother Joseph, whose poetry and criti-
cism – especially his revaluation of Pope's claims to greatness
– marked a major swing in taste. Finally, in a looser sense we
can detect the same process of 'ordering' – that is, historical
assessment, codification and analytic description – in other
books by Club authors, including Adam Smith's *Inquiry into
the Nature and Causes of the Wealth of Nations* (1776), the
first systematic survey of economics; Gibbon's *History of the*

Decline and Fall of the Roman Empire (1776–88), the most comprehensive and philosophically coherent account of the passing of the ancient world; and Boswell's *Life of Samuel Johnson*, a work which transformed the art of biography by expanding its scope and redesigning its architecture. At the furthest extreme one can even detect genuine, if less immediate, links with Burke's *Reflections*, in its wholesale vision of rampant revolutionary zeal in the world of politics, and with Malone's own editorial work, bringing together the scattered fragments of Shakespeare, Dryden and of Joshua Reynolds to form a concerted *oeuvre*. Without pushing these latter two cases too hard, it is possible to see the collective energies of the Club as combining in a massive reappraisal of the main course followed by English culture.[43] It was an age of heroic enterprise: Ephraim Chambers's *Cyclopedia* (1728) and Johnson's *Dictionary* (1755) had led the way, and now in the space of thirty years the artistic map was drawn anew with fresh colour and definition. Among the major Club authors, Reynolds was the first to start and the last to finish. He took the baton directly from Johnson and passed it on to his colleagues.

Beyond a shadow of doubt the two decisive influences on Reynolds were those of Burke and, even more crucially, Johnson. It is significant that these were the two men to whom gossip attributed the true authorship of the *Discourses*. The suggestion that Burke wrote them was given some credence by Horace Walpole (who thought that the attribution to Johnson was implausible because they 'had none of Johnson's awkward pedantic verbosity and want of grace').[44] But Malone emphatically denied this supposition, though he agreed that Burke may have occasionally been asked to read over the manuscript to give hints for improvement – if so, no evidence can be found in surviving manuscripts. The boot is

on the other foot: we know that Burke submitted his *Reflections* to Reynolds for criticism prior to their publication. The extent of Burke's profound admiration for his friend shines out in several places. Apart from his eloquent obituary, printed in Appendix D, there is a heartfelt tribute in Burke's last major work, *A Letter to a Noble Lord* (1796), in which he speaks of knowing the painter 'for many years without a moment of coldness, of peevishness, of jealousy, or of jar, to the day of our final separation'.[45] Elsewhere he termed Reynolds 'the first Master in Europe'. In return Reynolds expressed his indebtedness to Burke's width of mind and comprehensive knowledge: in his opinion, Burke had 'a more exact judgment' even than his revered Johnson, and ultimately Burke 'was the superior character'.

This is a surprising verdict, in view of the evidence which proves the scale of Reynolds's veneration for Johnson. Indeed, it was partly the painter's readiness to confess his obligations to Johnson which for a time lent colour to the stories that the *Discourses* were really the other man's work. An observer as well placed as Bennet Langton, a founder-Clubman and close friend of both men, is said to have remarked when Johnson died, 'We shall now know whether he has or has not assisted Sir Joshua in his *Discourses*.'[46] But Sir John Hawkins's son recalled Johnson himself saying that he never did more than substitute one or two words in the text;[47] and the surviving manuscripts bear this out, as, for example, tiny changes in Discourse XI (see note 6). In fact, Reynolds had contributed to the mystery by an injudicious step. When Boswell's *Life of Samuel Johnson* was going through the press, Boswell wrote to Malone in January 1791 that he had been forced to cancel a leaf because Sir Joshua had changed his mind and would not now allow mention of the fact that Johnson had written the dedication to the *Discourses*. This was unduly defensive:

Johnson had acquired a 'knack' for such dedications, and had supplied one to the queen for Burney's *History of Music*. It would have been better for his reputation if Reynolds had made a clean breast of the matter.

The most direct statement he made on the point did not appear until after his death, when Malone printed this testimony in the *Works*, in what he describes as an extra undelivered discourse:

Whatever merit [the *Discourses*] have must be imputed in a great measure to the education which I may be said to have had under Dr Johnson. I do not mean to say, though it would certainly be to the credit of these discourses if I could say it with truth, that he contributed even a single sentiment to them; but he qualified my mind to think justly. No man had, like, the faculty of teaching inferior minds the art of thinking.[48]

Reynolds specifically relates this faculty to Johnson's powers as a conversationalist, and though today we rightly look to Johnson the writer as a more significant presence, it must be acknowledged that for Reynolds, as for others, the key pedagogy often took place in oral discussion – hence, once more, the importance of Club gatherings. This is not to say that the painter did not draw directly from his friend's published writings: the annotations to this edition are intended to bring out, more fully than ever before, the close study of works such as the *Rambler* and the *Preface to Shakespeare*, which emerges from the text of the *Discourses*. There are references to the *Preface* in Sir Joshua's planned essay on Shakespeare,[49] but a more pervasive influence can be found in the *Discourses*, especially the eighth and thirteenth.

It would take far more space than is available to set out the full nature of this relationship, for when Johnson not long before his death wrote to Reynolds as his 'oldest and kindest friend',[50] he was stating no more than the truth. If one man

consulted the other on accepting a royal pension, then the same happened in reverse when the presidency of the Academy was to be filled. If Johnson was 'always proud of [his] ... approbation',[51] as he wrote to Sir Joshua just two months before he died, then Reynolds could consider himself as 'one of his [Johnson's] school',[52] implying a fervent addiction to truth above all else. There are many characteristic and revelatory stories – Johnson lending Reynolds a copy of *The Lives of the English Poets*, which he was unable to get back; Gibbon describing the painter as the author's 'oracle'; Reynolds telling Malone that Boswell had not written in sufficiently 'warm and hearty' terms of his friend in the *Journal of a Tour of the Hebrides*; Johnson saying he would rather give up even Reynolds's society than meet Laurence Sterne again, as he had done at the artist's home; and very many more.

Naturally, with two such distinguished men of strong beliefs, relations were not absolutely unclouded at all times. Reynolds told Dr Burney that he was occasionally pained by the domineering manner of both Johnson and Burke, but he 'knew their value so much to exceed their imperfections, that he never let them know how much they wounded his feelings by their loud voice and unguarded expressions'.[53] Perhaps this was more in manner than matter, though there were some authentic grounds of disagreement. Amongst these was the issue of strong drink. Boswell records exchanges on the topic in April 1776 and April 1778, the latter containing a delightful moment: 'I was at this time myself a water-drinker, upon trial, by Johnson's recommendation. JOHNSON. "Boswell is a bolder combatant than Sir Joshua: he argues for wine without the help of wine; but Sir Joshua with it." '[54] F. W. Hilles found unpublished notes among Reynolds's papers which continue the dialogue further. Johnson thought that Reynolds in 1775 had 'taken too much to strong liquor',[55]

whereas 'Sir Joshua stood up in defence of drinking a cheerful glass and regretted that Dr Johnson had left it off.'[56] Most of these arguments were good-humoured, and there was never a serious breach. The suggestion made by Mrs Thrale in 1777 that Sir Joshua no longer cared about Johnson, and was now attached to the company of infidels, probably exaggerates; there may be a little more in her contention that the criticism of Thomas Gray in the *The Lives of the English Poets* had angered Reynolds, who 'affected' (that is, admired) the sublime, of which Gray was an exponent.[57]

More important than these small ups and downs in everyday life was the lasting respect which subsisted year by year. As regards the *Discourses*, the deepest congruity lies in a common desire to 'establish principles: to improve opinion into knowledge' (*Rambler*, 92) and the effort to find 'principles of judgment on unalterable and evident truth' (*Rambler*, 208). Here is the lesson Reynolds imbibed from his master, which already underlies the *Idler* papers he wrote for Johnson (see Appendix B) and which provides the *Discourses* with their basic intellectual design.

Both Malone and Burke recognized the decisive part which Johnson played in the mental education of his friend. They placed their emphasis slightly differently, however. In the *Works* Malone had quoted Reynolds himself to indicate the nature of his debt to Johnson. When he received his set of the *Works*, Burke wrote an interesting letter of acknowledgement to Malone (4 May 1797). Since this is a detailed response of perhaps the best-qualified reader for the first full collection of the *Discourses*, it is essential to quote what Burke says at length:

I have received your valuable present; very valuable indeed from what it contains of your own, as well as of the works of our inestim-

able friend. Your life of him is worthy of the subject, which is to say a great deal. I have read over not only that Life but some part of the Discourses with an unusual sort of pleasure, partly because being faded a little on my memory they have a sort of appearance of novelty, partly by reviving recollections mixed with melancholy and satisfaction. The Flemish Journal I had never seen before – you trace in that everywhere the spirit of the Discourses supported by new examples: he is always the same Man, the same philosophical, the same artist-like critick, the same sagacious observer, with the same minuteness without the smallest degree of trifling. I found but one thing material, which you have omitted in his life – you state very properly how much he owed to the writings and conversation of Johnson; and nothing shews more the greatness of Sir Joshua's parts than his taking advantage of both; and making some application of them to his profession, when Johnson neither understood, nor desired to understand any thing of painting, and had no distinct idea of its nomenclature even in those parts which had got most into use in common Life: but though Johnson had done very much to enlarge and strengthen his habit of thinking, Sir J. did not owe his first rudiments of speculation to him. He has always told me, that he owed his first dispositions to generalize – and to view things in the abstract to old Mr Mudge, prebendary of Exeter and brother to the celebrated mechanick of that name. – I have seen myself Mr Mudge the clergyman at Sir Joshua's house.[58]

Burke goes on to suggest that from this man, the Reverend Zachariah Mudge, Reynolds imbibed his basically philosophic cast of mind, and that 'on conversing . . . with Mr Mudge I found great traces of Sir Joshua Reynolds in him and . . . much of the manner of the master'.[59] Whilst it is evident that Reynolds had some taste for conceptual reasoning before he met Johnson in his early thirties (a meeting in which the Mudge family of Devon may have played some part), it is only in the *Idler* papers that this bent is first expressed in serious composition. For whatever reason, Burke is clouding the issue; and Malone is stating a more central fact about Reynolds's development.

It is not, however, that Reynolds was wholly dependent on the Club for social outlets. He saw a good deal of the Johnson circle in the Streatham world presided over by Hester Thrale, though she once observed the 'he and I never much loved one another'.[60] Predictably, he was more welcome than the overbearing Doctor in the bluestocking sets, especially those led by Elizabeth Montagu; he had other women friends in this orbit, notably Fanny Burney and Hannah More. His theatrical interests led him to cultivate actresses, most prominently Frances Abington, the first and possibly greatest Lady Teazle in *The School for Scandal*. But he also knew the leading courtesans of the day, such as Kitty Fisher and the Countess della Rena. (There were stories linking him with such women in a more compromising way, but these cannot be regarded as more than idle gossip.) At the same time, his male friends certainly included rakes such as John Wilkes, with whom he passed many a spirited evening; the family of the diarist William Hickey; and for that matter the raffish Boswell, who took him along to executions as one species of diversion.

His friend William Mason once remarked that there was no dining with Reynolds, he was so surrounded by wits (that is, men about town). He was at one stage a frequent guest of the fencing-master Domenico Angelo, whose lively parties included Sheridan, Wilkes, Gainsborough, J. C. Bach, the transvestite adventurer D'Éon, Bartolozzi and other free spirits. Not satisfied with having founded the most famous club of the century, Sir Joshua retained enough energy at sixty-five to join the new Eumalian Club. It 'did not suit him', Boswell reports, to join the new Essex Head Club started by Johnson in 1783 – but that was because James Barry, now an adversary, was a member.[61] As his biographers Leslie and Taylor observe, 'Sir Joshua's unflagging relish for society shows the same vitality of enjoyment as his sustained feeling

for his art, and proves him . . . to have been truly genial.'[62] There were also the Society of Dilettanti, the Devonshire Club, the Royal Society, and the Company of Painters, to whose feast he took Boswell despite the risk that his companion might break out in a comic song at any moment. He was blackballed for White's, and pined to enter Almack's gaming club. He was a bad whist player but a keen one, a rare clue as to the hidden contradictions in his nature. He went to masquerades with Gibbon, or the Pantheon, the pleasure gardens at Ranelagh – there was always an excuse for a night out. He was not fond of the country, finding his real subject-matter as well as his pleasures in the town; his house at Richmond was a retreat adequately insulated from any pressures of city living. Most of the time he operated from Leicester Fields, the scene of convivial dinner-parties as well as the site of his daily stint of work in the studio.

The range of his activities is surprising. At one time or another we find him with Burke and Burney watching the ascent of the balloonist Vincenzo Lunardi; playing twenty questions with Hannah More and Lord Palmerston; at a Whig dining club run by the Scottish mafia who circulated in London; acting bravely and resolutely during the Gordon riots; spilling snuff at Blenheim; lending money to Burke for his financially embarrassed brother (the debt was cancelled in his will); presiding at the Academy dinner on the king's birthday, with a twenty-one gun salute from ships on the Thames; attending the Catch Club; and generally seeking places where he could find 'the superior zest of London conversation'.[63] Of course, this was partly a release from his grinding routine in the studio, which often began at 6.00 a.m. and continued till early evening. Small wonder that he did not propose painters for the Club, and that even when a celebratory dinner was held after he received his knighthood the guests included

Johnson, Burke, Langton, William Jones, Thomas Percy and Robert Chambers – but no artist.

At the same time he helped and encouraged young painters: he was among the very first to recognize the genius of George Stubbs; he encouraged John Singleton Copley when the American arrived in London; and he maintained good relations with George Romney and Thomas Lawrence at the end of his life. With a clear conscience he could preside at Academy functions, Boswell and William Chambers on either flank, 'with a most convivial glee', despite occasional brushes with men like James Barry and Richard Wilson. For that matter, he also gave assistance to the young writer George Crabbe, and quietly did much on behalf of his Devon relatives, especially his nephew Samuel, whose father had proved unsatisfactory. He subscribed to the poems of the Bristol milkwoman Ann Yearsley. Reynolds advised the Duke of Portland about acquiring the famous vase now known by that name; he wrote to the Prince of Wales on behalf of Joseph Warton's desire for a post at St Cross; he served, as mentioned, as a pallbearer at Gainsborough's funeral. It is to his credit that he stood by the dramatist Samuel Foote when the latter was ostracized on account of a homosexual scandal, and that he attended a dinner at Langton's in support of the campaign against slavery.

The view of his character held by a charitable friend and a more critical acquaintance is broadly similar. For the first, we can turn to Fanny Burney, who observed that what Johnson termed the 'inoffensiveness' of Reynolds was anything but insipidity. She also described him as 'though well-read and deeply studious, as easy and natural in discourse as if he had been merely a man of the world'[64] – a revealing touch for the published lectures, which combine learning with a conscious 'ease' of manner.[65] For Fanny Burney, he was 'gay though

contemplative, and flew from indolence, though he courted
enjoyment'.[66] A slightly more searching profile is offered us
by Mrs Thrale, when she drew up a list of the qualities of her
friends in 1778. Reynolds comes off better than most, with
scores of blank for religion and morality (Reynolds notori-
ously never went to church, and offended his sister by paint-
ing on Sundays); nought out of twenty for scholarship (an
absurd under-valuation); fourteen for general knowledge;
twelve for person and voice; ten for manner; none for wit and
humour, but ten for good humour.[67] Less demanding obser-
vers gave Sir Joshua high marks for his mild and lively con-
versation. What they meant was that he had much to impart
but did not hog the attention of those present. It was all part
of his carefully acquired public manner, which had brought
him favour as a society painter and the active respect of his
fellow-artists. He would never have had the chance to deliver
his considered view of art, through the medium of the Acad-
emy Discourses, if he had not learnt how to make his way in
the world.

6

By the time that last Discourse was given in 1790, Reynolds
stood at the summit of the art world. The price he could
command for a full-length portrait had gradually risen from
fifty guineas to two hundred, the rate he charged in his last years.
Since the death of Johnson, he was perhaps the most universally
respected figure in any field of British culture. When he died in
1792 he had few remaining worlds to conquer, though his
pictures had not attained the popularity abroad he would have
wished, especially in France. Some indication of his standing
comes from a poem which Wordsworth wrote in 1814, adopting
the voice of the patron Sir George Beaumont, and ending,

> . . . with grief and pride,
> Feeling what England lost when Reynolds died.[68]

A year of two later Jane Austen attended an exhibition or-
ganized by Beaumont, as did Constable – this was one of the
first one-man shows ever held. Thomas Lawrence continued
to revere his mentor, and for many the glamour had not
faded, although some of Reynolds's pigments had begun to
grow faint even in his lifetime.

But elsewhere things were on the move. William Blake had
annotated the first volume of the collected *Works*, containing
the first eight Discourses, with comments of stinging hostility.
These remain the most famous adverse reaction which the
Discourses have ever met. With the insight of implacable hatred,
Blake went to the heart of the work, recognizing that the ethos
in which it had its root was the high eighteenth-century disposi-
tion, over which Newton and (often explicitly) Bacon presided.
It is possible to regard Blake's comments as quite wrong-
headed and yet to admire the precision with which he moves
again and again to the central issue raised by Reynolds, discern-
ing the inner logic of the text more clearly than some professed
admirers.[69] Blake made his marginalia about 1808; within a few
years William Hazlitt was to begin a number of essays critical of
Reynolds, most interestingly in his *Table Talk* (1821–2). One
commentator has argued that 'in the fiercer encounters between
Reynolds and Hazlitt, individuality appears as one convenient
index of the rival claims of an art founded on accommodation
with the audience, which values propriety, and an art aimed at
the conversion of the audience, which values power.'[70] Cer-
tainly the neoclassical ideal of general nature had small appeal
for the Romantics, and Reynolds sank further in reputation in
the heyday of John Ruskin, who wrote that he was 'born to
teach all truth by his practice and all error by his doctrine'.[71]

It was not until Roger Fry showed a means of reconciling Reynolds's ambitious claims for historical painting with the more modest scope of his practice in portraiture that things began to mend. Today we can see that Reynolds was an artist of exquisite gifts, primarily as a colourist but also in terms of composition and of choosing poses, drapery and backgrounds best fitted to bring out the social and psychological identity of his sitters. We can also see that his doctrine is not as irrelevant as the nineteenth century believed: the lesson that we should look closely at the greatest paintings is one that applies to the general gallery visitor as well as to the aspiring painter. As we re-define our own relation to the masterpieces of the Renaissance, we find Reynolds much more helpful than we expected, consistently asking searching questions and directing our attention to basic issues in the appreciation of art: for example, the discussion of borrowing motifs in Discourse VI, a topic directly relevant to Reynolds's own habits as a painter.

The *Discourses*, then, proceed, from someone occupying a special and privileged position: that of a critic who was also an artist of great distinction; the founder-president of the major new institution which gave him a platform; and a man whose background and training uniquely equipped him for his task. As we have seen, he was also fortunately placed by reason of his close contacts with other leading figures in British culture. Many scholars now believe that there was after all an English Enlightenment, overlapping with the better-known Scottish movement. It differed from its French counterpart in being less instrumental, less avowedly secularist, more conservative in philosophic outlook. Nevertheless, it is possible without straining the evidence to identify such an Enlightenment in the art, architecture and literature (less so, perhaps, the music) which came out of England in the lifetime

of Reynolds. One thinks of Robert Adam's designs for Kedleston; Capability Brown's layout of the grounds at Bowood; a succession of philosophic and critical works including Burke's *Sublime and Beautiful*; and many works of literature, from *Clarissa* to *The Life of Samuel Johnson* – all works in different fields embodying a new humanism and a new sense of the pleasurable. In this notable group the *Discourses* of Reynolds merit a central place, as the first English writing about art that gives us that subtle aroma of cultivated enjoyment which marks the relegation of Augustan connoisseurship in favour of taste, feeling and full-hearted personal response.

NOTES TO THE INTRODUCTION

(Except where otherwise stated, the place of publication for the works cited here is London. See the list on p. 365 for any abbreviations used.)

1. *LC*, pp. 182–3 (spelling and presentation modernized).
2. *LC*, pp. 182–3.
3. P. W. Clayden, *The Early Life of Samuel Rogers* (1887), pp. 113–14. For another account, see Whitley, II. 134–5.
4. Milton, *Paradise Lost*, VIII. 1–3.
5. For Burke's role in the restoration of Somerset House, see J. Harris, *Sir William Chambers* (1970), pp. 96–106.
6. Among the students present was probably J. M. W. Turner, who had begun classes at the Academy in the previous year and had been allowed to enter Reynolds's studio and copy pictures. He later owned the Discourses as published in Malone's edition of the *Works* (1797).
7. Whitley, I. 248.
8. Northcote, I. 165–7.
9. This item, not in *Letters*, is quoted in *Portraits*, pp. 16–17; it is also printed in *The Correspondence of James Boswell with Certain Members of the Club*, ed. C. N. Fifer (1976), pp. 127–8.
10. *LC*, p. xiii.
11. *LC*, p. xvi.
12. Northcote, I. 251.
13. *Thraliana*, II. 835.
14. *Portraits*, p. 21.
15. *Lives of Poets*, I. 2.
16. Jonathan Richardson, *An Essay on the Theory of Painting* (1715), p. 123. The best discussion of Richardson's importance for Reynolds is to be found in L. Lipking, *The Ordering of the Arts in Eighteenth-Century England* (Princeton, 1970), pp. 109–26.

17. Jonathan Richardson, *An Essay on the Theory of Painting*, p. 123.

18. Northcote, I. 251.

19. The poet Thomas Gray drew up a chronological list of painters for his own use, when in Italy with Horace Walpole. His friend William Mason printed this with the translation (1783) of Dufresnoy's *De arte graphica* (1668) and Malone reproduced it in the *Works* of Reynolds (III. 283–323). The list runs from Giotto (*c*. 1266–1337) to Carlo Maratti (1625–1713), but only the first dozen on the list died before 1480, and the overwhelming majority date from the sixteenth and seventeenth centuries. Neither Botticelli, Bosch nor van Eyck is mentioned.

20. L. Lipking, *The Ordering of the Arts in Eighteenth-Century England* (see note 16), pp. 164–207.

21. *Discourses on Art*, ed. R. R. Wark (New Haven, 1975).

22. Northcote, I. 155.

23. It is true that Reynolds was always learning, and he was willing to adapt his views in the light of what he encountered. Though he never visited Italy after the age of thirty, his own growing collection of old masters served to expand his visual horizons. He was a friend of the dealer Noel-Joseph Desenfans, whose collection formed the basis of the Dulwich Gallery (for the contents of this collection, see Hazlitt's essay 'The Dulwich Gallery' in the *London Magazine*, January 1823). Reynolds was also closely acquainted with the connoisseur Sir George Beaumont and the third Duke of Richmond, who opened his own gallery of sculptures in 1758 and later presented the casts to the Society of Artists.

24. *Portraits*, p. 108.

25. See also James Farington's comments in his 'memoir' *Works* (1819), I. cclxxxiv.

26. Georg Lukács, *Studies in European Realism*, tr. Edith Bone (1950), p. 6.

27. L/T, I. 28.

28. L/T, I. 51.

29. *Letters*, p. 7.

30. *Letters*, p. 17. For Barry's response, see Northcote, I. 192–8.

31. William Hazlitt, *Conversations with James Northcote, R.A.*, ed. E. Gosse (1894), p. 267.

NOTES TO THE INTRODUCTION

32. R. Fletcher, *The Parkers at Saltram 1769–89* (1970), p. 76; see also A. Hartcup, *Angelica* (1954), pp. 40–42.

33. Sir William Chambers, who in 1791 had vetoed a proposal by Reynolds and Benjamin West for the Academy to contribute a hundred guineas towards the memorial to Johnson, this time tried to block the use of the Academy for the lying in state of Reynolds. For once the king intervened on behalf of Reynolds.

34. Quoted from Fanny Burney's *Memoirs of Dr Burney* (1832) in R. Lonsdale, *Dr Charles Burney: A Literary Biography* (Oxford, 1965), p. 484.

35. William Hazlitt, *Conversations with James Northcote* (see note 31), p. 68.

36. Burney, I. xxx.

37. As well as Burney's tours, the travel diaries of Gibbon and Boswell are used in the Notes to the *Discourses*, as it seems likely that Reynolds later compared notes with his friends on their experiences abroad. Since the tour to Italy was such a central educative experience for the eighteenth-century male, I have also used the travels of Smollett (whom Reynolds probably met) and Joseph Spence, the antiquarian and friend of Pope, who survived until 1768. A few citations are made from Hester Piozzi, though her tour in 1784–7 postdates most of the *Discourses*.

38. Quoted from the *Critical Review* (1783) in R. Lonsdale, *Dr Charles Burney* (see note 34), p. 270.

39. *Dr Charles Burney*, p. viii.

40. *Dr Charles Burney*, p. 479.

41. See p. 20 of Introduction and note 16.

42. Laetitia Matilda Hawkins, *Gossip about Dr Johnson and Others*, ed. F. H. Skrine (1926), pp. 69–76.

43. One branch of knowledge not adequately covered in all these undertakings was architecture, perhaps through jealousy on the part of Reynolds. It is noteworthy that Johnson supplied a preface for the official guide to the Academy buildings, written by Giuseppe Baretti in 1781. It has been suggested that Chambers stood on the fringe of the whole Johnson circle, having owed his commission to rebuild Somerset House to the energetic campaign by Burke to create 'an object of national splendour as well

as convenience'. See M. R. Brownell, *Samuel Johnson's Attitude to the Arts* (1989), pp. 137–49.

44. *LC*, p. 137. For Johnson's own disclaimer, see Laetitia Matilda Hawkins, *Gossip about Dr Johnson and Others* (see note 42), p. 72. Northcote denied that Burke played any part in the composition of the *Discourses* (see Northcote, II. 315).

45. Edmund Burke, 'A Letter to a Noble Lord', *The Works of Edmund Burke* (Boston, 1839), vol. IV, p. 322. See also Northcote, II. 211.

46. Laetitia Matilda Hawkins, *Gossip about Dr Johnson and Others* (see note 42), p. 72.

47. *Gossip about Dr Johnson and Others*, p. 72. See *LC*, pp. 134–41 for a full discussion of the issue.

48. *Works*, I. xxix–xxx.

49. Published for the first time in *Portraits*, pp. 107–22.

50. *The Letters of Samuel Johnson*, ed. R. W. Chapman (Oxford, 1952), III. 230.

51. *The Letters of Samuel Johnson*, III. 230.

52. *Portraits*, p. 66 (Reynolds's character sketch of Johnson is printed on pp. 66–80).

53. Quoted from Burney's unpublished memoirs in J. Hemlow, 'Dr Johnson and the Young Burneys' in *New Light on Dr Johnson*, ed. F. W. Hilles (New Haven, 1959), p. 331.

54. *LSJ*, III. 41. 328.

55. *LSJ*, II. 292.

56. *LC*, p. 150.

57. *Thraliana*, I. 80.

58. *The Correspondence of Edmund Burke*, vol. IX, ed. R. B. McDowell and J. A. Woods (Cambridge, 1970), pp. 326–7.

59. *The Correspondence of Edmund Burke*, pp. 326–7.

60. *The Piozzi Letters*, ed. E. A. Bloom and L. D. Bloom (Newark, Delaware, 1989–), I. 312. For Hester Thrale's reservations about Reynolds, see *Thraliana*, I. 382; II. 728–9, 836. She was concerned that Reynolds treated his sister Frances unfairly (see *The Piozzi Letters*, II. 49).

61. *LSJ*, IV. 254.

62. Boswell termed Reynolds 'quite a man of the world' (*LSJ*, III. 375).

63. Quoted from Boswell's journal for 4 December 1787 in *James Boswell: The English Experiment 1785–1789* , eds. I. S. Lustig and F. A. Pottle (1986), p. 158.

64. Fanny Burney, *Memoirs of Dr Burney* (1832), I. 343.

65. *Memoirs of Dr Burney*, II. 365.

66. *Memoirs of Dr Burney*, I. 330–31.

67. *Thraliana*, I. 330.

68. Wordsworth, 'Written at the Request of Sir George Beaumont, Bart., and in his Name', ll. 14–15. For the circumstances, see Margaret Greaves, *Regency Patron: Sir George Beaumont* (1966), p. 16.

69. A selection of some of the more scathing marginalia is included in the Notes to the *Discourses*. For a complete citation, see *The Complete Poetry and Prose of William Blake*, ed. G. Keynes (1969). It may be worth pointing out that Blake knew Reynolds personally. According to one anecdote, he called on Reynolds when he was a young man, with a sample of his work, and was advised to go on with less extravagance and more simplicity. An account of another exchange has it that Reynolds asked Blake whether, as reported, he despised oil painting, to receive the answer, 'No Sir Joshua, I don't despise it; but I like fresco better.' He later copied Reynolds's Royal Academy ceiling for an engraving. It is likely that some of Blake's dislike for the ideas of the *Discourses* may have been caused by the treatment he had received from the Academy, of which Reynolds was the figurehead and spokesman, but the difference is in a larger sense a matter of ideology and doctrine. For fuller details, see Mona Wilson, *The Life of William Blake*, 3rd edn (1971).

70. David Bromwich, *William Hazlitt: The Mind of a Critic* (New York, 1983), p. 202.

71. Quoted in G. M. Young, *Daylight and Champaign* (1937), p. 205.

FURTHER READING

(*Except where otherwise stated, the place of publication is London. See the list on p. 365 for any abbreviations used.*)

WORKS BY REYNOLDS

Discourses, ed. R. Fry (1905).

Discourses on Art, ed. R. R. Wark (New Haven, 1975).

Portraits by Sir Joshua Reynolds, ed. F. W. Hilles (1952). Contains sketches of Johnson, Goldsmith and Garrick, plus the 'Ironical Discourse' and other new material by JR.

The Works of Sir Joshua Reynolds, Knt., ed. Edmond Malone, 2 vols. (1797); rev. edn, 3 vols. (1798). See A Note on the Text, p. 70.

LETTERS

Letters of Sir Joshua Reynolds, ed. F. W. Hilles (Cambridge, 1929). Prints over 150 letters then known; Dr Brian Allen has in preparation a new edition containing several fresh letters.

BIOGRAPHY

Joseph Farington, *The Diary of Joseph Farington*, ed. K. Garlick and A. Macintyre, in progress (New Haven, 1978–). Replaces edition by J. Greig, 8 vols. (1923–8).

 Memoir of JR in *Works* (see above), 5th edn (1819).

R. Fletcher, *The Parkers at Saltram 1769–89* (1970). Based on the home and papers of the Parker family, friends of JR who lived at Saltram near Plymouth.

William Hazlitt, *Conversations with James Northcote, R.A.*, ed. E. Gosse (1894).

F. W. Hilles, *The Literary Career of Sir Joshua Reynolds* (Cam-

bridge, 1936). An outstanding work of scholarship which provides essential prolegomena to any study of the *Discourses*.

D. Hudson, *Sir Joshua Reynolds: A Personal Study* (1958). An excellent compact biography.

C. R. Leslie and T. Taylor, *Life and Times of Sir Joshua Reynolds*, 2 vols. (1865). Still the fullest compendium of information on JR.

James Northcote, *The Life of Sir Joshua Reynolds*, 2 vols. (1818). First-hand and gossipy.

S. M. Radcliffe (ed.), *Sir Joshua's Nephew* (1930). Letters from the confusingly named Samuel Johnson, son of JR's sister Elizabeth.

J. T. Smith, *Nollekens and his Times*, abridged edn (1949). Contains many anecdotes concerning JR.

GENERAL WORKS ON REYNOLDS

E. H. Gombrich, 'Reynolds's Theory and Practice of Imitation' in *Norm and Form* (1966), pp. 129–36.

F. W. Hilles, 'Horace Walpole and the Knight of the Brush' in W. H. Smith (ed.), *Horace Walpole: Writer, Politician, and Connoisseur* (New Haven, 1967), pp. 141–67.

N. Penny, *Reynolds* (1986). A sumptuous catalogue for the most representative exhibition of JR's works ever held – at the RA, January–March 1986.

E. K. Waterhouse, *Reynolds* (1973). A short but valuable introduction which supplements a fuller study of 1941.

E. Wind, *Hume and the Heroic Portrait*, ed. J. Anderson (Oxford, 1986). Includes four essays on JR.

THE CLUB

James Boswell, *The Correspondence of James Boswell with Certain Members of the Club*, ed. C. N. Fifer (1976). Contains letters to and from JR, and also Boswell's correspondence with Bennet Langton, Thomas Percy, Adam Smith, Joseph and Thomas Warton, and other friends of JR.

The Correspondence of James Boswell with David Garrick, Edmund Burke, and Edmund Malone, ed. P. S. Baker et al. (1986).

The Life of Samuel Johnson, ed. G. B. Hill and L. F. Powell, 6 vols. (Oxford 1934–64).

Fanny Burney, *Diary and Letters of Madame D'Arblay*, ed. C. Barrett, 7 vols. (1842–6). Contains much about JR.

F. W. Hilles (ed.), *The Age of Johnson* (New Haven, 1949). Contains essays on all leading members of the Club, including JR.

M. Hyde, *The Thrales of Streatham Park* (Cambridge, Mass., 1976). The extended Johnson circle at Streatham, in which JR figured.

D. Mannings, 'Reynolds, Garrick and the Choice of Hercules', *Eighteenth-Century Studies*, XVIII (1984), 259–83.

Hester Thrale, *Thraliana: The Diary of Mrs Hester Lynch Thrale* ed. K. C. Balderston, 2nd edn, 2 vols. (Oxford, 1951). Much material on JR by a shrewd observer.

BACKGROUND

J. Barrell, *The Political Theory of Painting from Reynolds to Hazlitt* (New Haven, 1986).

W. J. Bate, *From Classic to Romantic* (Cambridge, Mass., 1946).

J. H. Hagstrum, *The Sister Arts* (Chicago, 1958). Instructive on the links between painting and poetry.

J. Harris, *Sir William Chambers: Knight of the Polar Star* (1970).

L. Lipking, *The Ordering of the Arts in Eighteenth-Century England* (Princeton, 1970). An excellent study of historical and theoretical approaches to art, including that of JR.

S. H. Monk, *The Sublime: A Study of Critical Theories in XVIIIth Century England* (Ann Arbor, Mich., 1960). Still the best treatment of an important issue.

I. Pears, *The Discovery of Painting* (New Haven, 1988). On the rise of interest in the visual arts in England (1680–1768).

W. T. Whitley, *Artists and their Friends in England 1700–1799*, 2 vols. (1928). A miscellaneous but fascinating grab-bag of material, with extensive sections on the RA and on JR himself.

TABLE OF DATES

(See the list on p. 365 for any abbreviations used.)

1723 *16 July* JR born at Plympton, Devon, son of Revd Samuel Reynolds, master of Plympton Grammar School.

1729 *10 May* Frances Reynolds (sister) born.

1740 *13 October* JR travels to London, to begin apprenticeship with Thomas Hudson.

1742 *8–13 March* JR attends Earl of Oxford's sale for Hudson and briefly meets Alexander Pope.

1743 JR leaves Hudson and returns to Plymouth. Begins painting in Plymouth Dock (Devonport).

1744 JR goes back to London (*summer*).

1749 *11 May* JR sails from Plymouth on his way to Italy. *19 August* reaches Minorca.

1750 *25 January* JR sails for Leghorn en route to Rome.

1750–52 JR in Rome, studying work of the masters and engaging in social life.

1752 *April* short visit to Naples; then (*3 May*) JR leaves Rome for Florence, Bologna, Parma, Mantua, Ferrara and Venice (*24 July*).
 August JR leaves for Milan, Turin, travelling via Lyons to Paris; reaches London (*16 October*) after absence of three and a half years.

1753 JR settles in London after holiday in Devon; rents house in Great Newport Street and begins

successful career as portraitist. Portrait of Commodore Keppel helps to make his name.

c.1755–6 JR supports attempts to found an academy of painters; meets Samuel Johnson, Edmund Burke, David Garrick, William Mason and others. Socializes with John Wilkes.

1756 *1 September* elected to the Society of Arts.

1757 JR's first painting of Johnson completed; paints Horace Walpole. Burke's *Sublime and Beautiful* published (*21 April*).

1759 *September–November* JR writes three *Idler* papers on art.

1760 *21 April* opening of first public exhibition, organized by Society of Arts with assistance of JR and Johnson.

 3 July JR acquires forty-seven years' lease on house in Leicester Fields, his studio for rest of his life. JR's portrait of the newly famous Laurence Sterne is engraved and becomes widely known.

1761 JR paints *Garrick between Tragedy and Comedy*.

1762 JR and Johnson visit Devon together (*16 August–26 September*); JR meets Oliver Goldsmith. Johnson consults JR over his pension from the government.

1763 Benjamin West moves to London from Rome; meets JR, Johnson, Burke and Goldsmith.

1764 The Club founded (first meeting possibly *16 April*). JR the 'first mover'.

 Summer JR suffers illness, possibly slight stroke.

 26 October William Hogarth dies.

 JR and Johnson resign from Society of Arts.

1765 *January* Incorporated Society of Artists receives royal charter; JR refuses to become director but remains member.

1766 *May* JR elected to Society of Dilettanti.

June Angelica Kauffmann arrives in London, soon friendly with JR (portraits later exchanged).

This year was possible date of first meeting of JR and the Thrales.

1768 *9 September–23 October* JR visits Paris with Richard Burke (brother of Edmund).

10 December official foundation of RA.

14 December JR elected first president of RA.

1769 *2 January* opening of the RA: JR delivers Discourse I.

21 April JR knighted.

26 April–27 May first RA exhibition. Painters represented include JR, Thomas Gainsborough, Giovanni Battista Cipriani, Benjamin West, Angelica Kauffmann, Francis Cotes and Nathaniel Dance.

6 June JR and Gainsborough expelled from Incorporated Society of Artists.

26 September James Boswell meets JR at Goldsmith's.

October Giuseppe Baretti arrested for murder, visited in prison by JR, who gives bail of £500 with Burke and Garrick; tried at Old Bailey and acquitted (*20 October*) after defence testimonies by JR, Johnson, Burke, Garrick and others.

11 December Discourse II.

1770 *26 May* publication of Goldsmith's *Deserted Village*, dedicated to JR.

14 December Discourse III.

1771 *14 January* Life School of RA opened.

23 April first RA dinner, JR presiding, attended by Johnson and Goldsmith.

West's *Death of Wolfe* first exhibited at RA (*late April*); causes controversy.

July James Northcote begins stay as J R's pupil.

13 August–6 September J R in Paris for sale of pictures.

10 December Discourse IV.

1772 J R's new house at Richmond, by Sir William Chambers, completed.

September J R elected alderman of Plympton.

10 December Discourse V.

1773 *15 March* J R attends first night of Goldsmith's *She Stoops to Conquer*, with Johnson, Burke and others.

9 July J R awarded honorary degree of Doctor of Civil Law by University of Oxford.

4 October J R sworn in as mayor of Plympton.

1774 *4 April* death of Goldsmith.

10 December Discourse VI.

1775 J R elected member of the Florentine Academy.

1776 Publication of Adam Smith's *Wealth of Nations*; first instalment of Edward Gibbon's *Decline and Fall of the Roman Empire*; and first instalment of Charles Burney's *History of Music* (J R a subscriber).

12 May Northcote leaves J R's tutelage.

10 December Discourse VII.

1777 J R begins work on New College Chapel window (to 1780).

Frances Reynolds leaves J R's house some time this year.

8 May J R attends first night of Sheridan's *School for Scandal*, containing a tribute to him.

1778 *January* publication of Fanny Burney's *Evelina*, admired by J R, who becomes friend of the author.

1786 JR commissioned by Catherine the Great to paint
 an historical picture for St Petersburg.
 11 December Discourse XIII.

1787 Duke of Rutland's set of *Seven Sacraments* by
 Nicolas Poussin exhibited at the RA, along with
 annual show, on initiative of JR; it causes wide-
 spread interest.

1788 *February* JR attends trial of Warren Hastings.
 3 August death of Gainsborough; JR pallbearer at
 funeral (*9 August*).
 10 December Discourse XIV.

1789 *13 July* JR forced to stop painting by eye defect,
 probably detached retina. Sight lost in left eye (*late
 August*).

1790 *11 February* JR resigns as president of RA in dis-
 pute over the professorship of Perspective; with-
 draws resignation (*16 March*).
 21 May death of Thomas Warton.
 17 July death of Adam Smith.
 9 September Boswell reads JR's dialogues on John-
 son.
 16 October press reports that JR virtually stopped
 painting.
 1 November Burke's *Reflections on the Revolution in
 France* published (previously read in manuscript to
 JR).
 10 December Discourse XV.

1791 *16 May* Boswell's *Life of Samuel Johnson* pub-
 lished, dedicated to JR.
 4 June JR attends RA dinner; last public appear-
 ance.
 5 November JR makes his will.
 27 November JR fears loss of sight in right eye also.

1792 *23 February* death of JR.

25 February Burke's tribute (see Appendix D).

3 March JR's funeral at St Paul's Cathedral, attended by a host of notabilities.

1794 *16 January* death of Gibbon.

1795 Sales of JR's collection begin.

19 May death of Boswell.

1796 *10 March* death of William Chambers.

1797 *2 March* death of Horace Walpole.

7 April death of William Mason.

28 April JR's *Works* published, edited by Edmond Malone.

9 July death of Burke.

A NOTE ON THE TEXT

(See the list on p. 365 for any abbreviations used.)

Eᴀᴄʜ of the fifteen Discourses was published separately as a short pamphlet (except that the ninth, running to no more than five pages, appeared together with the tenth in 1781). The first seven Discourses were collected in 1778. The full set of fifteen appeared for the first time in the *Works*, edited by Malone in two volumes (1797). A second edition appeared in 1798, this time in three volumes. For full bibliographical details, see *LC*, pp. 277–300.

The text of this edition is based on a copy of the *Works* (1798) in my possession. Both in spelling and in punctuation Reynolds's prose is close to modern usage, and the typography of the 1798 edition is also comparatively modern (the long *f* had been abandoned in 1798). I have therefore engaged in minimal alteration. A few misprints are silently corrected and one or two usages brought into line with modern practice. But the final *k* is retained in words such as *philosophick*, since this was already becoming obsolete, and the *k*s are restored in the *Works*. Hilles (*LC*, p. 193) pointed out that Reynolds would have known of Samuel Johnson's preference for the doubled consonant in this case, as quoted in Boswell's *Life* (*LSJ*, IV. 31).

There is no separate textual apparatus. Variants are recorded in the relevant note where there are significant departures; these chiefly take the form of short passages added or

deleted in the *Works*. JR had begun to revise the *Discourses* for a new edition some time before his death (see LC, pp. 190–94). The extent of Malone's editorial changes is uncertain, but the signs are that he acted in a conservative manner. The text of the 'Ironical Discourse' is taken from the transcript by Hilles in *Portraits*, pp. 127–46, by permission of Yale University.

DISCOURSES

TO THE KING[1]

THE regular progress of cultivated life is from necessaries to accommodations, from accommodations to ornaments. By your illustrious predecessors were established marks for manufactures, and colleges for science: but for the arts of elegance, those arts by which manufactures are embellished, and science is refined, to found an Academy was reserved for Your Majesty.[2]

Had such patronage been without effect, there had been reason to believe that Nature had, by some insurmountable impediment, obstructed our proficiency;[3] but the annual improvement of the exhibitions which Your Majesty has been pleased to encourage, shows that only encouragement had been wanting.

To give advice to those who are contending for royal liberality, has been for some years the duty of my station in the Academy; and these Discourses hope for Your Majesty's acceptance, as well-intended endeavours to incite that emulation which your notice has kindled, and direct those studies which your bounty has rewarded.

May it please Your MAJESTY,

Your MAJESTY'S

Most dutiful servant,

and most faithful subject,

[1778] JOSHUA REYNOLDS

CONTENTS

DISCOURSE I

DISCOURSE II

DISCOURSE III

DISCOURSE IV

TO THE MEMBERS OF THE ROYAL ACADEMY

THAT you have ordered the publication of this discourse, is not only very flattering to me, as it implies your approbation of the method of study which I have recommended; but likewise, as this method receives from that act such an additional weight and authority, as demands from the Students that deference and respect, which can be due only to the united sense of so considerable a BODY of ARTISTS.

I am,

With the greatest esteem and respect,

GENTLEMEN,

Your most humble,

and obedient Servant,

JOSHUA REYNOLDS

DISCOURSE I[1]

THE ADVANTAGES PROCEEDING FROM THE INSTITUTION OF A
ROYAL ACADEMY.—HINTS OFFERED TO THE CONSIDERATION OF
THE PROFESSORS AND VISITORS;—THAT AN IMPLICIT OBEDI-
ENCE TO THE RULES OF ART BE EXACTED FROM THE YOUNG
STUDENTS;—THAT A PREMATURE DISPOSITION TO A MASTERLY
DEXTERITY BE REPRESSED;—THAT DILIGENCE BE CONSTANTLY
RECOMMENDED, AND (THAT IT MAY BE EFFECTUAL) DIRECTED
TO ITS PROPER OBJECT.

GENTLEMEN,

AN Academy, in which the Polite Arts may be regularly
cultivated, is at last opened among us by Royal Munificence.[2]
This must appear an event in the highest degree interesting,
not only to the Artist, but to the whole nation.

It is indeed difficult to give any other reason, why an
empire like that of BRITAIN should so long have wanted an
ornament so suitable to its greatness, than that slow pro-
gression of things, which naturally makes elegance and refine-
ment the last effect of opulence and power.

An Institution like this has often been recommended upon
considerations merely mercantile; but an Academy, founded
upon such principles, can never effect even its own narrow
purposes. If it has an origin no higher, no taste can ever be
formed in manufactures; but if the higher Arts of Design
flourish, these inferior ends will be answered of course.

We are happy in having a Prince,[3] who has conceived the design of such an Institution, according to its true dignity; and who promotes the Arts, as the head of a great, a learned, a polite, and a commercial nation; and I can now congratulate you, Gentlemen, on the accomplishment of your long and ardent wishes.

The numberless and ineffectual consultations which I have had with many in this assembly to form plans and concert schemes for an Academy,[4] afford a sufficient proof of the impossibility of succeeding but by the influence of MAJESTY. But there have perhaps, been times, when even the influence of MAJESTY would have been ineffectual; and it is pleasing to reflect, that we are thus embodied, when every circumstance seems to concur from which honour and prosperity can probably arise.

There are, at this time, a greater number of excellent artists than were ever known before at one period in this nation; there is a general desire among our Nobility to be distinguished as lovers and judges of the Arts; there is a greater superfluity of wealth among the people to reward the professors; and, above all, we are patronized by a Monarch, who, knowing the value of science and of elegance, thinks every art worthy of his notice, that tends to soften and humanise the mind.[5]

After so much has been done by HIS MAJESTY, it will be wholly our fault, if our progress is not in some degree correspondent to the wisdom and generosity of the Institution: let us show our gratitude in our diligence, that, though our merit may not answer his expectations, yet, at least, our industry may deserve his protection.

But whatever may be our proportion of success, of this we may be sure, that the present Institution will at least contribute to advance our knowledge of the Arts, and bring us

nearer to that ideal excellence, which it is the lot of genius always to contemplate, and never to attain.

The principle advantage of an Academy is, that, besides furnishing able men to direct the Student, it will be a repository for the great examples of the Art. These are the materials on which Genius is to work, and without which the strongest intellect may be fruitlessly or deviously employed. By studying these authentic models, that idea of excellence which is the result of the accumulated experience of past ages, may be at once acquired; and the tardy and obstructed progress of our predecessors may teach us a shorter and easier way. The Student receives, at one glance, the principles which many Artists have spent their whole lives in ascertaining; and, satisfied with their effect, is spared the painful investigation by which they came to be known and fixed. How many men of great natural abilities have been lost to this nation, for want of these advantages! They never had an opportunity of seeing those masterly efforts of genius, which at once kindle the whole soul, and force it into sudden and irresistible approbation.

Raffaelle, it is true, had not the advantage of studying in an Academy; but all Rome, and the works of Michael Angelo in particular, were to him an Academy. On the sight of the Capella Sistina, he immediately from a dry, Gothic, and even insipid manner, which attends to the minute accidental discriminations of particular and individual objects, assumed that grand style of painting, which improves partial representation by the general and invariable ideas of nature.[6]

Every seminary of learning may be said to be surrounded with an atmosphere of floating knowledge, where every mind may imbibe somewhat congenial to its own original conceptions. Knowledge, thus obtained, has always something more popular and useful than that which is forced upon the mind

by private precepts, or solitary meditation. Besides, it is generally found, that a youth more easily receives instruction from the companions of his studies, whose minds are nearly on a level with his own, than from those who are much his superiors; and it is from his equals only that he catches the fire of emulation.

One advantage, I will venture to affirm, we shall have in our Academy, which no other nation can boast. We shall have nothing to unlearn. To this praise the present race of Artists have a just claim. As far as they have yet proceeded, they are right. With us the exertions of genius will henceforward be directed to their proper objects. It will not be as it has been in other schools, where he that travelled fastest, only wandered farthest from the right way.

Impressed, as I am, therefore, with such a favourable opinion of my associates in this undertaking, it would ill become me to dictate to any of them. But as these Institutions have so often failed in other nations;[7] and as it is natural to think with regret, how much might have been done, I must take leave to offer a few hints, by which those errors may be rectified, and those defects supplied. These the Professors and Visitors may reject or adopt as they shall think proper.[8]

I would chiefly recommend, that an implicit obedience to the *Rules of Art*, as established by the practice of the great MASTERS, should be exacted from the *young* Students. That those models, which have passed through the approbation of ages, should be considered by them as perfect and infallible guides; as subjects for their imitation, not their criticism.

I am confident, that this is the only efficacious method of making a progress in the Arts; and that he who sets out with doubting, will find life finished before he becomes master of the rudiments. For it may be laid down as a maxim, that he who begins by presuming on his own sense, has ended his

studies as soon as he has commenced them. Every op-
portunity, therefore, should be taken to discountenance that
false and vulgar opinion, that rules are the fetters of genius;[9]
they are fetters only to men of no genius; as that armour,
which upon the strong is an ornament and a defence, upon
the weak and mis-shapen becomes a load, and cripples the
body which it was made to protect.

How much liberty may be taken to break through those
rules, and, as the Poet expresses it,

To snatch a grace beyond the reach of art.[10]

may be a subsequent consideration, when the pupils become
masters themselves. It is then, when their genius has received
its utmost improvement, that rules may possibly be dispensed
with. But let us not destroy the scaffold, until we have raised
the building.

The Directors ought more particularly to watch over the
genius of those Students, who, being more advanced, are
arrived at that critical period of study, on the nice manage-
ment of which their future turn of taste depends. At that age
it is natural for them to be more captivated with what is
brilliant, than with what is solid, and to prefer splendid negli-
gence to painful and humiliating exactness.

A facility in composing, – a lively, and what is called a
masterly, handling of the chalk or pencil, are, it must be
confessed, captivating qualities to young minds, and become
of course the objects of their ambition. They endeavour to
imitate these dazzling excellencies, which they will find no
great labour in attaining. After much time spent in these
frivolous pursuits, the difficulty will be to retreat; but it will
be then too late; and there is scarce an instance of return to
scrupulous labour, after the mind has been debauched and
deceived by this fallacious mastery.

By this useless industry they are excluded from all power of advancing in real excellence. Whilst boys, they are arrived at their utmost perfection; they have taken the shadow for the substance;[11] and make the mechanical felicity the chief excellence of the art, which is only an ornament, and of the merit of which few but painters themselves are judges.

This seems to me to be one of the most dangerous sources of corruption; and I speak of it from experience, not as an error which may possibly happen, but which has actually infected all foreign Academies.[12] The directors were probably pleased with this premature dexterity in their pupils, and praised their dispatch at the expense of their correctness.

But young men have not only this frivolous ambition of being thought masters of execution, inciting them on one hand, but also their natural sloth tempting them on the other. They are terrified at the prospect before them, of the toil required to attain exactness. The impetuosity of youth is disgusted at the slow approaches of a regular siege, and desires, from mere impatience of labour, to take the citadel by storm. They wish to find some shorter path to excellence, and hope to obtain the reward of eminence by other means than those, which the indispensable rules of art have prescribed. They must therefore be told again and again, that labour is the only price of solid fame, and that whatever their force of genius may be, there is no easy method of becoming a good Painter.[13]

When we read the lives of the most eminent Painters, every page informs us, that no part of their time was spent in dissipation.[14] Even an increase of fame served only to augment their industry. To be convinced with what persevering assiduity they pursued their studies, we need only reflect on their method of proceeding in their most celebrated works. When they conceived a subject, they first made a variety of

sketches; then a finished drawing of the whole; after that a more correct drawing of every separate part, – heads, hands, feet, and pieces of drapery; they then painted the picture, and after all retouched it from the life. The pictures, thus wrought with such pains, now appear, like the effect of enchantment, and as if some mighty Genius had struck them off at a blow.

But, whilst diligence is thus recommended to the Students, the Visitors will take care that their diligence be effectual; that it be well directed, and employed on the proper object. A Student is not always advancing because he is employed; he must apply his strength to that part of the art where the real difficulties lie; to that part which distinguishes it as a liberal art; and not by mistaken industry lose his time in that which is merely ornamental. The Students, instead of vying with each other which shall have the readiest hand, should be taught to contend who shall have the purest and most correct outline; instead of striving which shall produce the brightest tint, or curiously trifling, shall give the gloss of stuffs, so as to appear real, let their ambition be directed to contend, which shall dispose his drapery in the most graceful folds, which shall give the most grace and dignity to the human figure.

I must beg leave to submit one thing more to the consideration of the Visitors, which appears to me a matter of very great consequence, and the omission of which I think a principal defect in the method of education pursued in all the Academies I have ever visited. The error I mean is, that the students never draw exactly from the living models which they have before them. It is not indeed their intention; nor are they directed to do it. Their drawings resemble the model only in the attitude.[15] They change the form according to their vague and uncertain ideas of beauty, and make a drawing rather of what they think the figure ought to be, than of what it appears. I have thought this the obstacle that has

stopped the progress of many young men of real genius; and I very much doubt whether a habit of drawing correctly what we see, will not give a proportionable power of drawing correctly what we imagine. He who endeavours to copy nicely the figure before him, not only acquires a habit of exactness and precision, but is continually advancing in his knowledge of the human figure; and though he seems to superficial observers to make a slower progress, he will be found at last capable of adding (without running into capricious wildness) that grace and beauty, which is necessary to be given to his more finished works, and which cannot be got by the moderns, as it was not acquired by the ancients, but by an attentive and well compared study of the human form.

What I think ought to enforce this method is, that it has been the practice (as may be seen by their drawings) of the great Masters in the Art. I will mention a drawing of Raffaelle, *The Dispute of the Sacrament*, the print of which, by Count Cailus, is in every hand.[16] It appears, that he made his sketch from one model; and the habit he had of drawing exactly from the form before him, appears by his making all the figures with the same cap, such as his model then happened to wear; so servile a copyist was this great man, even at a time when he was allowed to be at his highest pitch of excellence.

I have seen also Academy figures by Annibale Caracci, though he was often sufficiently licentious in his finished works, drawn with all the peculiarities of an individual model.

This scrupulous exactness is so contrary to the practice of the Academies, that it is not without great deference, that I beg leave to recommend it to the consideration of the Visitors; and submit to them, whether the neglect of this method is not one of the reasons why Students so often disappoint

expectation, and, being more than boys at sixteen, become less than men at thirty.

In short, the method I recommend can only be detrimental where there are but few living forms to copy; for then students, by always drawing from one alone, will by habit be taught to overlook defects, and mistake deformity for beauty. But of this there is no danger; since the Council[17] has determined to supply the Academy with a variety of subjects; and indeed those laws which they have drawn up, and which the Secretary[18] will presently read for your confirmation, have in some measure precluded me from saying more upon this occasion. Instead, therefore, of offering my advice, permit me to indulge my wishes, and express my hope, that this institution may answer the expectation of its ROYAL FOUNDER; that the present age may vie in Arts with that of LEO the Tenth;[19] and that *the dignity of the dying Art* (to make use of an expression of Pliny)[20] may be revived under the Reign of GEORGE THE THIRD.

DISCOURSE II[1]

THE COURSE AND ORDER OF STUDY.—THE DIFFERENT STAGES OF
ART.—MUCH COPYING DISCOUNTENANCED.—THE ARTIST AT
ALL TIMES AND IN ALL PLACES SHOULD BE EMPLOYED IN LAY-
ING UP MATERIALS FOR THE EXERCISE OF HIS ART.

GENTLEMEN,

I CONGRATULATE you on the honour which you have just received. I have the highest opinion of your merits, and could wish to show my sense of them in something which possibly may be more useful to you than barren praise. I could wish to lead you into such a course of study as may render your future progress answerable to your past improvement; and, whilst I applaud you for what has been done, remind you how much yet remains to attain perfection.

I flatter myself, that from the long experience I have had, and the unceasing assiduity with which I have pursued those studies, in which, like you, I have been engaged, I shall be acquitted of vanity in offering some hints to your consideration. They are indeed in a great degree founded upon my own mistakes in the same pursuit. But the history of errors, properly managed, often shortens the road to truth. And although no method of study, that I can offer, will of itself conduct to excellence, yet it may preserve industry from being misapplied.

In speaking to you of the Theory of the Art, I shall only consider it as it has a relation to the *method* of your studies.

Dividing the study of painting into three distinct periods, I shall address you as having passed through the first of them, which is confined to the rudiments; including a facility of drawing any object that presents itself, a tolerable readiness in the management of colours, and an acquaintance with the most simple and obvious rules of composition.

This first degree of proficiency is, in painting, what grammar is in literature, a general preparation for whatever species of the art the student may afterwards choose for his more particular application. The power of drawing, modelling and using colours, is very properly called the Language of the art; and in this language, the honours you have just received prove you to have made no inconsiderable progress.

When the Artist is once enabled to express himself with some degree of correctness, he must then endeavour to collect subjects for expression; to amass a stock of ideas, to be combined and varied as occasion may require. He is now in the second period of study, in which his business is to learn all that has been known and done before his own time. Having hitherto received instructions from a particular master, he is now to consider the Art itself as his master. He must extend his capacity to more sublime and general instructions. Those perfections which lie scattered among various masters, are now united in one general idea, which is henceforth to regulate his taste, and enlarge his imagination. With a variety of models thus before him, he will avoid that narrowness and poverty of conception which attends a bigoted admiration of a single master, and will cease to follow any favourite where he ceases to excel. This period is, however, still a time of subjection and discipline. Though the Student will not resign himself blindly to any single authority, when he may have the advantage of consulting many, he must still be afraid of trusting his own judgment, and of deviating into any track where he cannot find the footsteps of some former master.

The third and last period emancipates the Student from subjection to any authority, but what he shall himself judge to be supported by reason. Confiding now in his own judgment, he will consider and separate those different principles to which different modes of beauty owe their original. In the former period he sought only to know and combine excellence, wherever it was to be found, into one idea of perfection: in this he learns, what requires the most attentive survey, and the most subtle disquisition, to discriminate perfections that are incompatible with each other.

He is from this time to regard himself as holding the same rank with those masters whom he before obeyed as teachers; and as exercising a sort of sovereignty over those rules which have hitherto restrained him. Comparing now no longer the performances of Art with each other, but examining the Art itself by the standard of nature, he corrects what is erroneous, supplies[2] what is scanty, and adds by his own observation what the industry of his predecessors may have yet left wanting to perfection. Having well established his judgment, and stored his memory, he may now without fear try the power of his imagination. The mind that has been thus disciplined, may be indulged in the warmest enthusiasm, and venture to play on the borders of the wildest extravagance. The habitual dignity which long converse with the greatest minds has imparted to him, will display itself in all his attempts; and he will stand among his instructors, not as an imitator, but a rival.

These are the different stages of the Art. But as I now address myself particularly to those Students who have been this day rewarded for their happy passage through the first period, I can with no propriety suppose they want any help in the initiatory studies. My present design is to direct your view to distant excellence, and to show you the readiest path

that leads to it. Of this I shall speak with such latitude, as
may leave the province of the professor uninvaded; and shall
not anticipate those precepts, which it is his business to give,
and your duty to understand.

It is indisputably evident that a great part of every man's
life must be employed in collecting materials for the exercise
of genius. Invention, strictly speaking, is little more than a
new combination of those images which have been previously
gathered and deposited in the memory: nothing can come of
nothing:[3] he who has laid up no materials, can produce no
combinations.

A Student unacquainted with the attempts of former adven-
turers, is always apt to over-rate his own abilities; to mistake
the most trifling excursions for discoveries of moment, and
every coast new to him, for a new-found country. If by chance
he passes beyond his usual limits, he congratulates his own
arrival at those regions which they who have steered a better
course have long left behind them.

The productions of such minds are seldom distinguished
by an air of originality:[4] they are anticipated in their happiest
efforts; and if they are found to differ in any thing from their
predecessors, it is only in irregular sallies, and trifling con-
ceits. The more extensive, therefore, your acquaintance is
with the works of those who have excelled, the more extensive
will be your powers of invention, and what may appear still
more like a paradox, the more original will be your concep-
tions. But the difficulty on this occasion is to determine what
ought to be proposed as models of excellence, and who ought
to be considered as the properest guides.

To a young man just arrived in Italy, many of the present
painters of that country are ready enough to obtrude their
precepts, and to offer their own performances as examples of
that perfection which they affect to recommend.[5] The

Modern, however, who recommends himself as a standard, may justly be suspected as ignorant of the true end, and unacquainted with the proper object, of the art which he professes. To follow such a guide, will not only retard the Student, but mislead him.

On whom then can he rely, or who shall show him the path that leads to excellence? The answer is obvious: those great masters who have travelled the same road with success are the most likely to conduct others. The works of those who have stood the test of ages, have a claim to that respect and veneration to which no modern can pretend.[6] The duration and stability of their fame is sufficient to evince that it has not been suspended upon the slender thread of fashion and caprice, but bound to the human heart by every tie of sympathetick approbation.

There is no danger of studying too much the works of those great men; but how they may be studied to advantage is an inquiry of great importance.

Some who have never raised their minds to the consideration of the real dignity of the Art, and who rate the works of an Artist in proportion as they excel or are defective in the mechanical parts, look on theory as something that may enable them to talk but not to paint better; and confining themselves entirely to mechanical practice, very assiduously toil on in the drudgery of copying; and think they make a rapid progress while they faithfully exhibit the minutest part of a favourite picture. This appears to me a very tedious, and I think a very erroneous method of proceeding. Of every large composition, even of those which are most admired, a great part may be truly said to be *common-place*. This, though it takes up much time in copying conduces little to improvement. I consider general copying as a delusive kind of industry; the Student satisfies himself with the appearance of doing something; he

falls into the dangerous habit of imitating without selecting, and of labouring without any determinate object; as it requires no effort of the mind, he sleeps over his work: and those powers of invention and composition which ought particularly to be called out, and put in action, lie torpid, and lose their energy for want of exercise.

How incapable those are of producing any thing of their own, who have spent much of their time in making finished copies, is well known to all who are conversant with our art.

To suppose that the complication[7] of powers, and variety of ideas necessary to that mind which aspires to the first honours in the Art of Painting, can be obtained by the frigid contemplation of a few single models, is no less absurd, than it would be in him who wishes to be a Poet, to imagine that by translating a tragedy he can acquire to himself sufficient knowledge of the appearances of nature, the operations of the passions, and the incidents of life.

The great use in copying, if it be at all useful, should seem to be in learning to colour; yet even colouring will never be perfectly attained by servilely copying the model before you. An eye critically nice, can only be formed by observing well-coloured pictures with attention: and by close inspection, and minute examination, you will discover, at last, the manner of handling, the artifices of contrast, glazing, and other expedients, by which good colourists have raised the value of their tints, and by which nature has been so happily imitated.

I must inform you, however, that old pictures, deservedly celebrated for their colouring, are often so changed by dirt and varnish, that we ought not to wonder if they do not appear equal to their reputation in the eyes of unexperienced painters, or young students. An artist whose judgment is matured by long observation, considers rather what the picture once was, than what it is at present. He has by habit

acquired a power of seeing the brilliancy of tints through the cloud by which it is obscured. An exact imitation, therefore, of those pictures, is likely to fill the student's mind with false opinions; and to send him back a colourist of his own formation, with ideas equally remote from nature and from art, from the genuine practice of the masters, and the real appearances of things.

Following these rules, and using these precautions, when you have clearly and distinctly learned, in what good colouring consists, you cannot do better than have recourse to nature herself, who is always at hand, and in comparison of whose true splendour the best coloured pictures are but faint and feeble.

However, as the practice of copying is not entirely to be excluded, since the mechanical practice of painting is learned in some measure by it, let those choice parts only be selected which have recommended the work to notice. If its excellence consists in its general effect, it would be proper to make slight sketches of the machinery and general management of the picture. Those sketches should be kept always by you for the regulation of your style. Instead of copying the touches of those great masters, copy only their conceptions. Instead of treading in their footsteps, endeavour only to keep the same road. Labour to invent on their general principles and way of thinking. Possess yourself with their spirit.[8] Consider with yourself how a Michael Angelo or a Raffaelle would have treated this subject: and work yourself into a belief that your picture is to be seen and criticised by them when completed. Even an attempt of this kind will rouse your powers.

But as mere enthusiasm will carry you but a little way,[9] let me recommend a practice that may be equivalent to, and will perhaps more efficaciously contribute to your advancement, than even the verbal corrections of those masters themselves,

could they be obtained. What I would propose is, that you should enter into a kind of competition, by painting a similar subject, and making a companion to any picture that you consider as a model. After you have finished your work, place it near the model, and compare them carefully together. You will then not only see, but feel your own deficiencies more sensibly than by precepts, or any other means of instruction. The true principles of painting will mingle with your thoughts. Ideas thus fixed by sensible objects, will be certain and definitive; and sinking deep into the mind, will not only be more just, but more lasting than those presented to you by precepts only; which will always be fleeting, variable; and un-determined.

This method of comparing your own efforts with those of some great master, is indeed a severe and mortifying task, to which none will submit, but such as have great views, with fortitude sufficient to forego the gratifications of present vanity for future honour. When the Student has succeeded in some measure to his own satisfaction, and has felicitated himself on his success, to go voluntarily to a tribunal where he knows his vanity must be humbled, and all self-approbation must vanish, requires not only great resolution, but great humility. To him, however, who has the ambition to be a real master, the solid satisfaction which proceeds from a con-sciousness of his advancement (of which seeing his own faults is the first step,) will very abundantly compensate for the mor-tification of present disappointment. There is, besides, this alleviating circumstance. Every discovery he makes, every acquisition of knowledge he attains, seems to proceed from his own sagacity; and thus he acquires a confidence in himself sufficient to keep up the resolution of perseverance.

We all must have experienced how lazily, and consequently how ineffectually, instruction is received when forced upon

the mind by others. Few have been taught to any purpose, who have not been their own teachers. We prefer those instructions which we have given ourselves, from our affection to the instructor; and they are more effectual, from being received into the mind at the very time when it is most open and eager to receive them.

With respect to the pictures that you are to choose for your models, I could wish that you would take the world's opinion rather than your own. In other words, I would have you choose those of established reputation, rather than follow your own fancy. If you should not admire them at first, you will, by endeavouring to imitate them, find that the world has not been mistaken.[10]

It is not an easy task to point out those various excellencies for your imitation, which lie distributed amongst the various schools. An endeavour to do this may perhaps be the subject of some future discourse. I will, therefore, at present only recommend a model for style in Painting, which is a branch of the art more immediately necessary to the young Student. Style in painting is the same as in writing a power over materials, whether words or colours, by which conceptions or sentiments are conveyed. And in this Ludovico Caracci (I mean in his best works) appears to me to approach the nearest to perfection. His unaffected breadth of light and shadow, the simplicity of colouring, which, holding its proper rank, does not draw aside the least part of the attention from the subject, and the solemn effect of that twilight which seems diffused over his pictures, appear to me to correspond with grave and dignified subjects, better than the more artificial brilliancy of sunshine which enlightens the pictures of Titian: though Tintoret thought that Titian's colouring was the model of perfection, and would correspond even with the sublime of Michael Angelo; and that if Angelo had coloured like Titian, or Titian

designed like Angelo, the world would once have had a perfect painter.

It is our misfortune, however, that those works of Caracci which I would recommend to the Student, are not often found out of Bologna. The *St Francis in the midst of his Friars, The Transfiguration, The Birth of St John the Baptist, The Calling of St Matthew, The St Jerome, The Fresco Paintings* in the Zampieri palace,[11] are all worthy the attention of the Student. And I think those who travel would do well to allot a much greater portion of their time to that city, than it has been hitherto the custom to bestow.

In this art, as in others, there are many teachers who profess to show the nearest way to excellence; and many expedients have been invented by which the toil of study might be saved. But let no man be seduced to idleness by specious promises. Excellence is never granted to man, but as the reward of labour. It argues indeed no small strength of mind to persevere in habits of industry, without the pleasure of perceiving these advances; which, like the hand of a clock, whilst they make hourly approaches to their point, yet proceed so slowly as to escape observation. A facility of drawing, like that of playing upon a musical instrument, cannot be acquired but by an infinite number of acts. I need not, therefore, enforce by many words the necessity of continual application; nor tell you that the port-crayon[12] ought to be for ever in your hands. Various methods will occur to you by which this power may be acquired. I would particularly recommend, that after your return from the Academy, (where I suppose your attendance to be constant), you would endeavour to draw the figure by memory. I will even venture to add, that by perseverance in this custom, you will become able to draw the human figure tolerably correct, with as little effort of the mind as is required to trace with a pen the letters of the alphabet.

That this facility is not unattainable, some members in this Academy give a sufficient proof. And be assured, that if this power is not acquired whilst you are young, there will be no time for it afterwards; at least the attempts will be attended with as much difficulty as those experience, who learn to read or write after they have arrived to the age of maturity.

But while I mention the port-crayon as the Student's constant companion, he must still remember, that the pencil[13] is the instrument by which he must hope to obtain eminence. What, therefore, I wish to impress upon you is, that whenever an opportunity offers, you paint your studies instead of drawing them. This will give you such a facility in using colours, that in time they will arrange themselves under the pencil, even without the attention of the hand that conducts it. If one act excluded the other, this advice could not with any propriety be given. But if Painting comprises both drawing and colouring, and if by a short struggle of resolute industry, the same expedition is attainable in painting as in drawing on paper, I cannot see what objection can justly be made to practice; or why that should be done by parts, which may be done all together.

If we turn our eyes to the several Schools of Painting, and consider their respective excellencies, we shall find that those who excel most in colouring, pursued this method. The Venetian and Flemish schools, which owe much of their fame to colouring, have enriched the cabinets of the collectors of drawings, with very few examples. Those of Titian, Paul Veronese, Tintoret, and the Bassans, are in general slight and undetermined. Their sketches on paper are as rude as their pictures are excellent in regard to harmony of colouring. Correggio and Baroccio have left few, if any finished drawings behind them. And in the Flemish school, Rubens and Vandyck made their designs for the most part either in

colours, or in chiaro-oscuro. It is as common to find studies
of the Venetian and Flemish Painters on canvass, as of the
schools of Rome and Florence on paper. Not but that many
finished drawings are sold under the names of those masters.
Those, however, are undoubtedly the productions either of
engravers or their scholars who copied their works.

These instructions I have ventured to offer from my own
experience; but as they deviate widely from received opinions,
I offer them with diffidence; and when better are suggested,
shall retract them without regret.

There is one precept, however, in which I shall only be
opposed by the vain, the ignorant, and the idle. I am not
afraid that I shall repeat it too often. You must have no
dependence on your own genius. If you have great talents,
industry will improve them, if you have but moderate abilities
industry will supply their deficiency. Nothing is denied to
well-directed labour: nothing is to be obtained without it.[14]
Not to enter into metaphysical discussions on the nature or
essence of genius, I will venture to assert, that assiduity
unabated by difficulty, and a disposition eagerly directed to
the object of its pursuit, will produce effects similar to those
which some call the result of *natural powers*.

Though a man cannot at all times, and in all places, paint
or draw, yet the mind can prepare itself by laying in proper
materials, at all times, and in all places. Both Livy and Plu-
tarch, in describing Philopœmen,[15] one of the ablest generals
of antiquity, have given us a striking picture of a mind always
intent on its profession, and by assiduity obtaining those
excellencies which some all their lives vainly expect from
nature. I shall quote the passage in Livy at length, as it runs
parallel with the practice I would recommend to the Painter,
Sculptor, and Architect.[16]

'Philopœmen was a man eminent for his sagacity and

experience in choosing ground, and in leading armies; to
which he formed his mind by perpetual meditation, in times
of peace as well as war. When, in any occasional journey, he
came to a strait, difficult passage, if he was alone, he con-
sidered with himself, and if he was in company he asked his
friends, what it would be best to do if in this place they had
found an enemy, either in front or in the rear, on the one side
or on the other. "It might happen," says he, "that the enemy
to be opposed might come on drawn up in regular lines, or in
a tumultuous body, formed only by the nature of the place."
He then considered a little what ground he should take; what
number of soldiers he should use, and what arms he should
give them; where he should lodge his carriages, his baggage,
and the defenceless followers of his camp; how many guards,
and of what kind, he should send to defend them; and whether
it would be better to press forward along the pass, or recover
by retreat his former station; he would consider likewise
where his camp could most commodiously be formed; how
much ground he should enclose within his trenches; where he
should have the convenience of water, and where he might
find plenty of wood and forage; and when he should break up
his camp on the following day, through what road he could
most safely pass, and in what form he should dispose his
troops. With such thoughts and disquisitions he had from his
early years so exercised his mind, that on these occasions
nothing could happen which he had not been already ac-
customed to consider.'

I cannot help imagining that I see a promising young
painter equally vigilant, whether at home or abroad in the
streets, or in the fields. Every object that presents itself, is to
him a lesson. He regards all Nature with a view to his pro-
fession; and combines her beauties, or corrects her defects. He
examines the countenance of men under the influence of

passion; and often catches the most pleasing hints from sub-
jects of turbulence or deformity. Even bad pictures them-
selves supply him with useful documents; and, as Lionardo
da Vinci has observed, he improves upon the fanciful images
that are sometimes seen in the fire, or are accidentally
sketched upon a discoloured wall.[17]

The Artist who has his mind thus filled with ideas, and his
hand made expert by practice, works with ease and readiness;
whilst he who would have you believe that he is waiting for
the inspirations of Genius, is in reality at a loss how to begin;
and is at last delivered of his monsters, with difficulty and
pain.[18]

The well-grounded painter, on the contrary, has only
maturely to consider his subject, and all the mechanical parts
of his art follow without his exertion. Conscious of the dif-
ficulty of obtaining what he possess, he makes no pretensions
to secrets, except those of closer application. Without conceiv-
ing the smallest jealousy against others, he is contented that
all shall be as great as himself, who have undergone the same
fatigue; and as his pre-eminence depends not upon a trick, he
is free from the painful suspicions of a juggler,[19] who lives in
perpetual fear lest his trick should be discovered.

DISCOURSE III

―――

THE GREAT LEADING PRINCIPLES OF THE GRAND STYLE.—
OF BEAUTY.—THE GENUINE HABITS OF NATURE TO BE
DISTINGUISHED FROM THOSE OF FASHION.

GENTLEMEN,

It is not easy to speak with propriety to so many Students of
different ages and different degrees of advancement.[1] The
mind requires nourishment adapted to its growth; and what
may have promoted our earlier efforts, might retard us in our
nearer approaches to perfection.

The first endeavours of a young Painter, as I have remarked
in a former discourse, must be employed in the attainment of
mechanical dexterity, and confined to the mere imitation of
the object before him. Those who have advanced beyond the
rudiments, may, perhaps, find in reflecting on the advice
which I have likewise given them, when I recommended the
diligent study of the works of our great predecessors; but I at
the same time endeavoured to guard them against an implicit
submission to the authority of any one master however excel-
lent: or by a strict imitation of his manner, precluding them-
selves from the abundance and variety of Nature.[2] I will now
add, that Nature herself is not to be too closely copied. There
are excellencies in the art of painting beyond what is
commonly called the imitation of nature; and these ex-
cellencies I wish to point out. The Students who, having

passed through the initiatory exercises, are more advanced in the art, and who, sure of their hand, have leisure to exert their understanding, must now be told, that a mere copier of nature can never produce any thing great; can never raise and enlarge the conceptions, or warm the heart of the spectator.

The wish of the genuine painter must be more extensive: instead of endeavouring to amuse[3] mankind with the minute neatness of his imitations, he must endeavour to improve them by the grandeur of his ideas; instead of seeking praise, by deceiving the superficial sense of the spectator, he must strive for fame, by captivating the imagination.

The principle now laid down, that the perfection of this art does not consist in mere imitation, is far from being new or singular. It is, indeed, supported by the general opinion of the enlightened part of mankind. The poets, orators, and rhetoricians of antiquity, are continually enforcing this position; that all the arts receive their perfection from an ideal beauty, superior to what is to be found in individual nature. They are ever referring to the practice of the painters and sculptors of their times, particularly Phidias, (the favourite artist of antiquity,) to illustrate their assertions. As if they could not sufficiently express their admiration of his genius by what they knew, they have recourse to poetical enthusiasm: they call it inspiration; a gift from heaven. The artist is supposed to have ascended the celestial regions, to furnish his mind with this perfect idea of beauty. 'He,' says Proclus*,[4] 'who takes for his model such forms as nature produces, and confines himself to an exact imitation of them, will never attain to what is perfectly beautiful. For the works of nature are full of disproportion, and fall very short of the true

* Lib.2. in Timæum Platonis, as cited by Junius de Pictura Veterum. R.

standard of beauty. So that Phidias, when he formed his Jupiter, did not copy any object ever presented to his sight; but contemplated only that image which he had conceived in his mind from Homer's description.' And thus Cicero, speaking of the same Phidias: 'Neither did this artist,' says he, 'when he carved the image of Jupiter or Minerva,[5] set before him any one human figure, as a pattern, which he was to copy; but having a more perfect idea of beauty fixed in his mind, this is steadily contemplated, and to the imitation of this, all his skill and labour were directed.'

The Moderns are not less convinced than the Ancients of this superior power existing in the art; nor less sensible of its effects. Every language has adopted terms expressive of this excellence. The *gusto grande* of the Italians, the *beau ideal* of the French, and the *great style*, *genius*, and *taste* among the English, are but different appellations of the same thing.[6] It is this intellectual dignity, they say, that ennobles the painter's art; that lays the line between him and the mere mechanick; and produces those great effects in an instant, which eloquence and poetry, by slow and repeated efforts, are scarcely able to attain.

Such is the warmth with which both the Ancients and Moderns speak of this divine principle of the art; but, as I have formerly observed, enthusiastick admiration seldom promotes knowledge.[7] Though a Student by such praise may have his attention roused, and a desire excited, of running in this great career; yet it is possible that what has been said to excite, may only serve to deter him. He examines his own mind, and perceives there nothing of that divine inspiration, with which he is told so many others have been favoured. He never travelled to heaven to gather new ideas;[8] and he finds himself possessed of no other qualifications than what mere common observation and a plain understanding can confer.

Thus he becomes gloomy amidst the splendour of figurative declamation, and thinks it hopeless to pursue an object which he supposes out of the reach of human industry.

But on this, as upon many other occasions, we ought to distinguish how much is to be given to enthusiasm, and how much to reason. We ought to allow for, and we ought to commend that strength of vivid expression, which is necessary to convey, in its full force, the highest sense of the most complete effect of art; taking care, at the same time, not to lose in terms of vague admiration, that solidity and truth of principle, upon which alone we can reason, and may be enabled to practise.

It is not easy to define in what this great style consists;[9] nor to describe, by words, the proper means of acquiring it, if the mind of the Student should be at all capable of such an acquisition. Could we teach taste or genius by rules, they would be no longer taste and genius. But though there neither are, nor can be, any precise invariable rules for the exercise, or the acquisition of these great qualities, yet we may truly say, that they always operate in proportion to our attention in observing the works of nature, to our skill in selecting, and to our care in digesting, methodizing, and comparing our observations. There are many beauties in our art, that seem, at first, to lie without the reach of precept, and yet may easily be reduced to practical principles. Experience is all in all; but it is not every one who profits by experience; and most people err, not so much from want of capacity to find their object, as from not knowing what object to pursue. This great ideal perfection and beauty are not to be sought in the heavens, but upon the earth. They are about us, and upon every side of us. But the power of discovering what is deformed in nature, or in other words, what is particular and uncommon, can be acquired only by experience; and the whole beauty and

grandeur of the art consists, in my opinion, in being able to get above all singular forms, local customs, particularities, and details of every kind.

All the objects which are exhibited to our view by nature, upon close examination will be found to have their blemishes and defects. The most beautiful forms have something about them like weakness, minuteness, or imperfection. But it is not every eye that perceives these blemishes. It must be an eye long used to the contemplation and comparison of these forms; and which by a long habit of observing what any set of objects of the same kind have in common, has acquired the power of discerning what each wants in particular. This long laborious comparison should be the first study of the painter, who aims at the greatest style. By this means, he acquires a just idea of beautiful forms; he corrects nature by herself, her imperfect state by her more perfect. His eye being enabled to distinguish the accidental deficiencies, excrescences, and deformities of things, from their general figures, he makes out an abstract idea of their forms more perfect than any one original; and what may seem a paradox, he learns to design naturally by drawing his figures unlike to any one object. This idea of the perfect state of nature, which the Artist calls the Ideal Beauty, is the great leading principle by which works of genius are conducted. By this Phidias acquired his fame. He wrought upon a sober principle what has so much excited the enthusiasm of the world; and by this method you, who have courage to tread the same path, may acquire equal reputation.

This is the idea which has acquired, and which seems to have a right to the epithet of *divine*; as it may be said to preside, like a supreme judge, over all the productions of nature appearing to be possessed of the will and intention of the Creator, as far as they regard the external form of living

beings. When a man once possesses this idea in its perfection, there is no danger but that he will be sufficiently warmed by it himself, and be able to warm and ravish every one else.[10]

Thus it is from a reiterated experience, and a close comparison of the objects in nature, that an artist becomes possessed of the idea of that central form, if I may so express it, from which every deviation is deformity.[11] But the investigation of this form, I grant, is painful, and I know but of one method of shortening the road; this is, by a careful study of the works of the ancient sculptors; who, being indefatigable in the school of nature, have left models of that perfect form behind them, which an artist would prefer as supremely beautiful, who had spent his whole life in that single contemplation. But if industry carried them thus far, may not you also hope for the same reward from the same labour? We have the same school opened to us that was opened to them; for nature denies her instructions to none, who desire to become her pupils.

This laborious investigation, I am aware, must appear superfluous to those who think every thing is to be done by felicity, and the powers of native genius. Even the great Bacon[12] treats with ridicule the idea of confining proportion to rules, or of producing beauty by selection. 'A man cannot tell, (says he,) whether Apelles[13] or Albert Durer were the more trifler: whereof the one would make a personage by geometrical proportions; the other, by taking the best parts out of divers faces, to make one excellent. The painter, (he adds,) must do it by a kind of felicity, . . . and not by rule.'*[14]

It is not safe to question any opinion of so great a writer, and so profound a thinker, as undoubtedly Bacon was. But he

* ESSAYS, p. 252. edit. 1625.

studies brevity to excess;[15] and therefore his meaning is some-
times doubtful. If he means that beauty has nothing to do
with rule, he is mistaken. There is a rule, obtained out of
general nature, to contradict which is to fall into deformity.
Whenever any thing is done beyond this rule, it is in virtue of
some other rule which is followed along with it, but which
does not contradict it. Every thing which is wrought with
certainty, is wrought upon some principle. If it is not, it
cannot be repeated. If by felicity is meant any thing of chance
or hazard, or something born with a man, and not earned, I
cannot agree with this great philosopher. Every object which
pleases must give us pleasure upon some certain principles:
but as the objects of pleasure are almost infinite, so their
principles vary without end, and every man finds them out,
not by felicity or successful hazard, but by care and sa-
gacity.[16]

To the principle I have laid down, that the idea of beauty
in each species of beings is an invariable one, it may be
objected, that in every particular species there are various
central forms, which are separate and distinct from each other,
and yet are undeniably beautiful; that in the human figure,
for instance, the beauty of Hercules is one, of the Gladiator
another, of the Apollo another; which makes so many different
ideas of beauty.[17]

It is true, indeed, that these figures are each perfect in their
kind, though of different characters and proportions; but still
none of them is the representation of an individual, but of a
class. And as there is one general form, which, as I have said,
belongs to the human kind at large, so in each of these classes
there is one common idea and central form, which is the
abstract of the various individual forms belonging to that
class. Thus, though the forms of childhood and age differ
exceedingly, there is a common form in childhood, and a

common form in age, which is the more perfect, as it is more remote from all peculiarities. But I must add further, that though the most perfect forms of each of the general divisions of the human figure are ideal, and superior to any individual form of that class; yet the highest perfection of any human figure is not to be found in any one of them. It is not in the Hercules, nor in the Gladiator, nor in the Apollo; but in that form which is taken from all, and which partakes equally of the activity of the Gladiator, of the delicacy of the Apollo, and of the muscular strength of the Hercules. For perfect beauty in any species must combine all the characters which are beautiful in that species. It cannot consist in any one to the exclusion of the rest: no one, therefore, must be predominant, that no one may be deficient.

The knowledge of these different characters, and the power of separating and distinguishing them, is undoubtedly necessary to the painter, who is to vary his compositions with figures of various forms and proportions, though he is never to lose sight of the general idea of perfection in each kind.

There is, likewise, a kind of symmetry, or proportion, which may properly be said to belong to deformity. A figure lean or corpulent, tall or short, though deviating from beauty, may still have a certain union of the various parts, which may contribute to make them on the whole not unpleasing.

When the Artist has by diligent attention acquired a clear and distinct idea of beauty and symmetry; when he has reduced the variety of nature to the abstract idea; his next task will be to become acquainted with the genuine habits of nature, as distinguished from those of fashion. For in the same manner, and on the same principles, as he has acquired the knowledge of the real forms of nature, distinct from accidental deformity, he must endeavour to separate simple chaste nature, from those adventitious, those affected and forced airs or actions, with which she is loaded by modern education.

Perhaps I cannot better explain what I mean, than by reminding you of what was taught us by the Professor of Anatomy,[18] in respect to the natural position and movement of the feet. He observed, that the fashion of turning them outwards was contrary to the intent of nature, as might be seen from the structure of the bones, and from the weakness that proceeded from that manner of standing. To this we may add the erect position of the head, the projection of the chest, the walking with straight knees, and many such actions, which we know to be merely the result of fashion, and what nature never warranted, as we are sure that we have been taught them when children.

I have mentioned but a few of those instances, in which vanity or caprice have contrived to distort and disfigure the human form; your own recollection will add to these a thousand more of ill-understood methods, which have been practised to disguise nature among our dancing-masters, hair-dressers, and tailors, in their various schools of deformity.*[19]

However the mechanick and ornamental arts may sacrifice to fashion, she must be entirely excluded from the Art of Painting; the painter must never mistake the capricious challenging for the genuine offspring of nature; he must divest himself of all prejudices in favour of his age or country; he must disregard all local and temporary ornaments, and look only on those general habits which are every where and always the same;[20] he addresses his works to the people of every country and every age, he calls upon posterity to be his spectators, and says with Zeuxis, *in æternitatem pingo*.[21]

* 'Those,' says Quintilian, 'who are taken with the outward show of things, think that there is more beauty in persons, who are trimmed, curled, and painted, than uncorrupt nature can give; as if beauty were merely the effect of the corruption of manners.' R.

The neglect of separating modern fashions from the habits of nature, leads to that ridiculous style which has been practised by some painters, who have given to Grecian Heroes the airs and graces practised in the court of Lewis the Fourteenth; an absurdity almost as great as it would have been to have dressed them after the fashion of that court.[22]

To avoid this error, however, and to retain the true simplicity of nature, is a task more difficult than at first sight it may appear. The prejudices in favour of the fashions and customs that we have been used to, and which are justly called a second nature,[23] make it too often difficult to distinguish that which is natural from that which is the result of education; they frequently even give a predilection in favour of the artificial mode; and almost every one is apt to be guided by those local prejudices, who has not chastised his mind, and regulated the instability of his affections by the eternal invariable idea of nature.

Here then, as before, we must have recourse to the Ancients as instructors. It is from a careful study of their works that you will be enabled to attain to the real simplicity of nature; they will suggest many observations which would probably escape you, if your study were confined to nature alone. And, indeed, I cannot help suspecting, that in this instance the ancients had an easier task than the moderns. They had, probably, little or nothing to unlearn, as their manners were nearly approaching to this desirable simplicity; while the modern artist, before he can see the truth of things, is obliged to remove a veil, with which the fashion of the times has thought proper to cover her.

Having gone thus far in our investigation of the great style in painting; if we now should suppose that the artist has found the true idea of beauty, which enables him to give his works a correct and perfect design; if we should suppose also,

that he has acquired a knowledge of the unadulterated habits of nature, which gives him simplicity; the rest of his task is, perhaps, less than is generally imagined. Beauty and simplicity have so great a share in the composition of a great style, that he who has acquired them has little else to learn. It must not, indeed, be forgotten, that there is a nobleness of conception, which goes beyond any thing in the mere exhibition even of the perfect form; there is an art of animating and dignifying the figures with intellectual grandeur, of impressing the appearance of philosophick wisdom, or heroick virtue. This can only be acquired by him that enlarges the sphere of his understanding by a variety of knowledge, and warms his imagination with the best productions of ancient and modern poetry.

A hand thus exercised, and a mind thus instructed, will bring the art to a higher degree of excellence than perhaps it has hitherto attained in this country. Such a student will disdain the humbler walks of painting, which, however profitable, can never assure him a permanent reputation. He will leave the meaner artist servilely to suppose that those are the best pictures, which are most likely to deceive the spectator. He will permit the lower painter, like the florist or collector of shells, to exhibit the minute discriminations, which distinguish one object of the same species from another; while he, like the philosopher, will consider nature in the abstract, and represent in every one of his figures the character of its species.[24]

If deceiving the eye were the only business of the art, there is no doubt, indeed, but the minute painter would be more apt to succeed; but it is not the eye, it is the mind which the painter of genius desires to address; nor will he waste a moment upon those smaller objects which only serve to catch the sense, to divide the attention, and to counteract his great design of speaking to the heart.

This is the ambition which I wish to excite in your minds; and the object I have had in my view, throughout this discourse, is that one great idea which gives to painting its true dignity, which entitles it to the name of a Liberal Art, and ranks it as a sister of poetry.[25]

It may possibly have happened to many young students, whose application was sufficient to overcome all difficulties, and whose minds were capable of embracing the most extensive views, that they have, by a wrong direction originally given, spent their lives in the meaner walks of painting, without ever knowing there was a nobler to pursue. Albert Durer, as Vasari has justly remarked,[26] would probably have been one of the first painters of his age, (and he lived in an era of great artists,) had he been initiated into those great principles of the art, which were so well understood and practised by his contemporaries in Italy. But unluckily having never seen or heard of any other manner, he, without doubt, considered his own as perfect.

As for the various departments of painting, which do not presume to make such high pretensions, they are many. None of them are without their merit, though none enter into competition with this universal presiding idea of the art. The painters who have applied themselves more particularly to low and vulgar characters, and who express with precision the various shades of passion, as they are exhibited by vulgar minds, (such as we see in the works of Hogarth,) deserve great praise; but as their genius has been employed on low and confined subjects, the praise which we give must be as limited as it object. The merry-making or quarrelling of the Boors[27] of Teniers; the same sort of productions of Brouwer, or Ostade, are excellent in their kind; and the excellence and its praise will be in proportion, as, in those limited subjects, and peculiar forms, they introduce more or less of the

expression of those passions, as they appear in general and more enlarged nature. This principle may be applied to the Battle-pieces of Bourgognone, the French Gallantries of Watteau, and even beyond the exhibition of animal life, to the Landscapes of Claude Lorraine, and the Sea-Views of Vandervelde. All these painters have, in general, the same right, in different degrees, to the name of a painter, which a satirist, an epigrammatist, a sonneteer, a writer of pastorals, or descriptive poetry, has to that of a poet.

In the same rank, and perhaps of not so great merit, is the cold painter of portraits. But his correct and just imitation of his object has its merit. Even the painter of still life, whose highest ambition is to give a minute representation of every part of those low objects which he sets before him, deserves praise in proportion to his attainment; because no part of this excellent art, so much the ornament of polished life, is destitute of value and use. These, however, are by no means the views to which the mind of the student ought to be *primarily* directed. Having begun by aiming at better things, if from particular inclination, or from the taste of the time and place he lives in, or from necessity, or from failure in the highest attempts, he is obliged to descend lower, he will bring into the lower sphere of art a grandeur of composition and character, that will raise and enoble his works far above their natural rank.

A man is not weak, though he may not be able to wield the club of Hercules;[28] nor does the man always practice that which he esteems the best; but does that which he can best do. In moderate attempts there are many walks open to the artist. But as the idea of beauty is of necessity but one, so there can be but one great mode of painting; the leading principle of which I have endeavoured to explain.

I should be sorry, if what is here recommended, should be

at all understood to countenance a careless or undetermined manner of painting. For though the painter is to overlook the accidental discriminations of nature, he is to exhibit distinctly, and with precision, the general forms of things. A firm and determined outline is one of the characteristics of the great style in painting; and let me add, that he who possesses the knowledge of the exact form which every part of nature ought to have, will be fond of expressing that knowledge with correctness and precision in all his works.

To conclude; I have endeavoured to reduce the idea of beauty to general principles: and I had the pleasure to observe that the Professor of Painting[29] proceeded in the same method, when he showed you that the artifice of contrast was founded but on one principle. I am convinced that this is the only means of advancing science; of clearing the mind from a confused heap of contradictory observations, that do but perplex and puzzle the student, when he compares them, or misguide him if he gives himself up to their authority; bringing them under one general head, can alone give rest and satisfaction to an inquisitive mind.

DISCOURSE IV[1]

GENTLEMEN,

THE value and rank of every art is in proportion to the
mental labour employed in it, or the mental pleasure produced
by it. As this principle is observed or neglected, our profession
becomes either a liberal art, or a mechanical trade. In the
hands of one man it makes the highest pretensions, as it is
addressed to the noblest faculties: in those of another it is
reduced to a mere matter of ornament; and the painter has
but the humble province of furnishing our apartments with
elegance.

This exertion of mind, which is the only circumstance that
truly ennobles our Art, makes the great distinction between
the Roman and Venetian schools. I have formerly observed
that perfect form is produced by leaving out particularities,
and retaining only general ideas: I shall now endeavour to
show that this principle, which I have proved to be metaphysi-
cally just, extends itself to every part of the Art; that it gives

what is called the *grand style*, to Invention, to Composition, to Expression, and even to Colouring and Drapery.[2]

Invention in Painting does not imply the invention of the subject; for that is commonly supplied by the Poet or Historian. With respect to the choice, no subject can be proper that is not generally interesting. It ought to be either some eminent instance of heroick action, or heroick suffering. There must be something either in the action, or in the object, in which men are universally concerned, and which powerfully strikes upon the publick sympathy.[3]

Strictly speaking, indeed, no subject can be of universal, hardly can it be of general, concern; but there are events and characters so popularly known in those countries where our Art is in request,[4] that they may be considered as sufficiently general for all our purposes. Such are the great events of Greek and Roman fable and history, which early education, and the usual course of reading, have made familiar and interesting to all Europe, without being degraded by the vulgarism of ordinary life in any country. Such too are the capital subjects of scripture history, which, beside their general notoriety, become venerable by their connection with our religion.

As it is required that the subject selected should be a general one, it is no less necessary that it should be kept unembarrassed with whatever may any way serve to divide the attention of the spectator.[5] Whenever a story is related, every man forms a picture in his mind of the action and expression of the persons employed. The power of representing this mental picture on canvass is what we call invention in a Painter. And as in the conception of this ideal picture, the mind does not enter into the minute peculiarities of the dress, furniture, or scene of action; so when the Painter comes to represent it, he contrives those little necessary concomitant circumstances in

such a manner, that they shall strike the spectator no more than they did himself in his first conception of the story.

I am very ready to allow, that some circumstances of minuteness and particularity frequently tend to give an air of truth to a piece, and to interest the spectator in an extraordinary manner. Such circumstances therefore cannot wholly be rejected: but if there be any thing in the Art which requires peculiar nicety of discernment, it is the disposition of these minute circumstantial parts; which, according to the judgment employed in the choice, become so useful to truth, or so injurious to grandeur.

However, the usual and most dangerous error is on the side of minuteness; and therefore I think caution most necessary where most have failed. The general idea constitutes real excellence. All smaller things, however perfect in their way, are to be sacrificed without mercy to the greater.[6] The Painter will not inquire what things may be admitted without much censure; he will not think it enough to show that they may be there; he will show that they must be there; that their absence would render his picture maimed and defective.

Thus, though to the principal group[7] a second or third be added, and a second and third mass of light, care must be taken that these subordinate actions and lights, neither each in particular, nor all together, come into any degree of competition with the principal: they should merely make a part of that whole which would be imperfect without them. To every kind of painting this rule may be applied. Even in portraits, the grace, and, we may add, the likeness, consists more in taking the general air, than in observing the exact similitude of every feature.

Thus figures must have a ground whereon to stand; they must be clothed; there must be a back-ground; there must be light and shadow; but none of these ought to appear to have

taken up any part of the artist's attention. They should be so managed as not even to catch that of the spectator. We know well enough, when we analyze a piece, the difficulty and the subtilty with which an artist adjusts the back-ground, drapery, and masses of light; we know that a considerable part of the grace and effect of his picture depends upon them; but this art is so much concealed,[8] even to a judicious eye, that no remains of any of these subordinate parts occur to the memory when the picture is not present.

The great end of the art is to strike the imagination.[9] The Painter therefore is to make no ostentation of the means by which this is done; the spectator is only to feel the result in his bosom. An inferior artist is unwilling that any part of his industry should be lost upon the spectator. He takes as much pains to discover,[10] as the greater artist does to conceal, the marks of his subordinate assiduity. In works of the lower kind, every thing appears studied, and encumbered; it is all boastful art, and open affectation. The ignorant often part from such pictures with wonder in their mouths, and indifference in their hearts.

But it is not enough in Invention that the Artist should restrain and keep under all the inferior parts of his subject; he must sometimes deviate from vulgar and strict historical truth, in pursuing the grandeur of his design.

How much the great style exacts from its professors[11] to conceive and represent their subjects in a poetical manner, not confined to mere matter of fact, may be seen in the Cartoons of Raffaelle.[12] In all the pictures in which the painter has represented the apostles, he has drawn them with great nobleness; he has given them as much dignity as the human figure is capable of receiving; yet we are expressly told in Scripture they had no such respectable appearance; and of St Paul in particular,[13] we are told by himself, that his

bodily presence was *mean*. Alexander is said to have been of a low stature: a Painter ought not so to represent him. Agesilaus was low, lame, and of a mean appearance: none of these defects ought to appear in a piece of which he is the hero.[14] In conformity to custom, I call this part of the art History Painting; it ought to be called Poetical, as in reality it is.[15]

All this is not falsifying any fact; it is taking an allowed poetical licence. A Painter of portraits, retains the individual likeness; a Painter of history, shows the man by showing his actions. A Painter must compensate the natural deficiencies of his art. He has but one sentence to utter, but one moment to exhibit. He cannot, like the poet or historian, expatiate, and impress the mind with great veneration for the character of the hero or saint he represents, though he lets us know at the same time, that the saint was deformed, or the hero lame. The Painter has no other means of giving an idea of the dignity of the mind, but by that external appearance which grandeur of thought does generally, though not always, impress on the countenance; and by that correspondence of figure to sentiment and situation, which all men wish, but cannot command. The Painter who may in this one particular attain with ease what others desire in vain, ought to give all that he possibly can, since there are so many circumstances of true greatness that he cannot give at all. He cannot make his hero talk like a great man; he must make him look like one. For which reason, he ought to be well studied in the analysis of those circumstances which constitute dignity of appearance in real life.

As in Invention, so likewise in Expression, care must be taken not to run into particularities. Those expressions alone should be given to the figures which their respective situations generally produce. Nor is this enough; each person should also have that expression which men of his rank generally

exhibit. The joy, or the grief of a character of dignity is not to be expressed in the same manner as a similar passion in a vulgar face. Upon this principle, Bernini, perhaps, may be subject to censure. This sculptor, in many respects admirable, has given a very mean expression to his statue of David, who is represented as just going to throw the stone from the sling; and in order to give it the expression of energy, he has made him biting his under-lip.[16] This expression is far from being general, and still farther from being dignified. He might have seen it in an instance or two; and he mistook accident for generality.

With respect to Colouring, though it may appear at first a part of Painting merely mechanical, yet it still has its rules, and those grounded upon that presiding principle which regulates both the great and the little in the study of a painter. By this, the first effect of the picture is produced; and as this is performed, the spectator as he walks the gallery, will stop, or pass along. To give a general air of grandeur at first view, all trifling, or artful play of little lights, or an attention to a variety of tints is to be avoided; a quietness and simplicity must reign over the whole work; to which a breadth of uniform, and simple colour, will very much contribute. Grandeur of effect is produced by two different ways, which seem entirely opposed to each other. One is, by reducing the colours to little more than chiara oscuro, which was often the practice of the Bolognian schools; and the other, by making the colours very distinct and forcible, such as we see in those of Rome and Florence; but still, the presiding principle of both those manners is simplicity. Certainly, nothing can be more simple than monotony;[17] and the distinct blue, red, and yellow colours which are seen in the draperies of the Roman and Florentine schools, though they have not that kind of harmony which is produced by a variety of broken and

transparent colours, have that effect of grandeur which was
intended. Perhaps these distinct colours strike the mind more
forcibly, from there not being any great union between them;
as martial music, which is intended to rouse the nobler
passions, has its effect from the sudden and strongly marked
transitions from one note to another, which that style of music
requires; whilst in that which is intended to move the softer
passions, the notes imperceptibly melt into one another.

In the same manner as the historical Painter never enters
into the detail of colours, so neither does he debase his concep-
tions with minute attention to the discriminations of Drapery.
It is the inferior style that marks the variety of stuffs. With
him, the cloathing is neither woollen, nor linen, nor silk,
satin, or velvet: it is drapery; it is nothing more. The art of
disposing the foldings of the drapery makes a very consider-
able part of the Painter's study. To make it merely natural, is
a mechanical operation, to which neither genius nor taste are
required; whereas, it requires the nicest judgment to dispose
the drapery, so that the folds shall have an easy communica-
tion, and gracefully follow each other, with such natural negli-
gence as to look like the effect of chance, and at the same time
show the figure under it to the utmost advantage.

Carlo Maratti was of opinion, that the disposition of drap-
ery was a more difficult art than even that of drawing the
human figure; that a Student might be more easily taught the
latter than the former; as the rules of drapery, he said, could
not be so well ascertained as those for delineating a correct
form. This, perhaps, is a proof how willingly we favour our
own peculiar excellence. Carlo Maratti is said to have valued
himself particularly upon his skill in this part of his art; yet in
him, the disposition appears so ostentatiously artificial,[18] that
he is inferior to Raffaelle, even in that which gave him his
best claim to reputation.

Such is the great principle by which we must be directed in the nobler branches of our art. Upon this principle, the Roman, the Florentine, the Bolognese schools, have formed their practice; and by this they have deservedly obtained the highest praise. These are the three great schools of the world in the epic style. The best of the French school, Poussin, Le Sueur, and Le Brun, have formed themselves upon these models, and consequently may be said, though Frenchmen, to be a colony from the Roman school. Next to these, but in a very different style of excellence, we may rank the Venetian, together with the Flemish and the Dutch schools; all professing to depart from the great purposes of painting, and catching at applause by inferior qualities.

I am not ignorant that some will censure me for placing the Venetians in this inferior class, and many of the warmest admirers of painting will think them unjustly degraded; but I wish not to be misunderstood. Though I can by no means allow them to hold any rank with the nobler schools of painting, they accomplished perfectly the thing they attempted. But as mere elegance is their principal object, as they seem more willing to dazzle than to affect, it can be no injury to them to suppose that their practice is useful only to its proper end. But what may heighten the elegant may degrade the sublime.[19] There is a simplicity, and I may add, severity, in the great manner, which is, I am afraid, almost incompatible with this comparatively sensual style.

Tintoret, Paul Veronese, and others of the Venetian school, seem to have painted with no other purpose than to be admired for their skill and expertness in the mechanism of painting, and to make a parade of that art, which, as I before observed, the higher style requires its followers to conceal.

In a conference of the French Academy,[20] at which were present Le Brun, Sebastian Bourdon, and all the eminent

Artists of that age, one of the Academicians desired to have their opinion on the conduct of Paul Veronese, who, though a Painter of great consideration, had, contrary to the strict rules of art, in his picture of Perseus and Andromeda,[21] represented the principal figure in shade. To this question no satisfactory answer was then given. But I will venture to say, that if they had considered the class of the Artist, and ranked him as an ornamental Painter, there would have been no difficulty in answering – 'It was unreasonable to expect what was never intended. His intention was solely to produce an effect of light and shadow; every thing was to be sacrificed to that intent, and the capricious composition of that picture suited very well with the style which he professed.'

Young minds are indeed too apt to be captivated by this splendour of style; and that of the Venetians is particularly pleasing; for by them, all those parts of the Art that gave pleasure to the eye or sense, have been cultivated with care, and carried to the degree nearest to perfection. The powers exerted in the mechanical part of the Art have been called *the language of Painters*; but we may say, that it is but poor eloquence which only shows that the orator can talk. Words should be employed as the means, not as the end: language is the instrument, conviction is the work.

The language of Painting must indeed be allowed these masters; but even in that, they have shown more copiousness than choice, and more luxuriancy than judgment. If we consider the uninteresting subjects of their invention, or at least the uninteresting manner in which they are treated; if we attend to their capricious composition, their violent and affected contrasts, whether of figures or of light and shadow, the richness of their drapery, and at the same time, the mean effect which the discrimination of stuffs gives to their pictures; if to these we add their total inattention to ex-

pression; and then reflect on the conceptions and the learning of Michael Angelo, or the simplicity of Raffaelle, we can no longer dwell on the comparison. Even in colouring, if we compare the quietness and chastity of the Bolognese pencil[22] to the bustle and tumult that fills every part of a Venetian picture, without the least attempt to interest the passions, their boasted art will appear a mere struggle without effect; *a tale told by an idiot, full of sound and fury, signifying nothing.*[23]

Such as suppose that the great style might happily be blended with the ornamental, that the simple, grave and majestic dignity of Raffaelle could unite with the glow and bustle of a Paolo, or Tintoret, are totally mistaken. The principles by which each is attained are so contrary to each other, that they seem, in my opinion, incompatible, and as impossible to exist together, as that in the mind the most sublime ideas and the lowest sensuality should at the same time be united.

The subjects of the Venetian Painters are mostly such as give them an opportunity of introducing a great number of figures; such as feasts, marriages, and processions, public martyrdoms, or miracles. I can easily conceive that Paul Veronese, if he were asked, would say, that no subject was proper for an historical picture, but such as admitted at least forty figures: for in a less number, he would assert, there could be no opportunity of the Painter's showing his art in composition, his dexterity of managing and disposing the masses of light and groups of figures, and of introducing a variety of Eastern dresses and characters in their rich stuffs.

But the thing is very different with a pupil of the greater schools. Annibale Caracci thought twelve figures sufficient for any story;[24] he conceived that more would contribute to no end but to fill space; that they would be but cold spectators of the general action, or to use his own expression, that they would be *figures to be let*. Besides, it is impossible for a

picture composed of so many parts to have that effect so indispensably necessary to grandeur, that of one complete whole. However contradictory it may be in geometry, it is true in taste, that many little things will not make a great one. The Sublime impresses the mind at once with one great idea; it is a single blow: the Elegant indeed may be produced by repetition; by an accumulation of many minute circumstances.[25]

However great the difference is between the composition of the Venetian, and the rest of the Italian schools, there is full as great a disparity in the effect of their pictures as produced by colours. And though in this respect the Venetians must be allowed extraordinary skill, yet even that skill, as they have employed it, will but ill correspond with the great style. Their colouring is not only too brilliant, but, I will venture to say, too harmonious, to produce that solidity, steadiness, and simplicity of effect, which heroic subjects require, and which simple or grave colours only can give to a work.[26] That they are to be cautiously studied by those who are ambitious of treading the great walk of history is confirmed, if it wants confirmation, by the greatest of all authorities, Michael Angelo. This wonderful man, after having seen a picture by Titian, told Vasaro, who accompanied him* 'that he liked much his colouring and manner;' but then he added, 'that it was a pity the Venetian painters did not learn to draw correctly in their early youth, and adopt a better *manner of study*.'[27]

By this it appears, that the principal attention of the Ven-

* Dicendo, che molto gli piaceva il colorito suo, e la maniera; mà che era un peccato, che a Venezia non s'imparasse da principio a disegnare bene, e che non havessano que' pittori miglior modo nello studio. Vas. tom. iii. p. 226. Vita di Tiziano.

etian painters, in the opinion of Michael Angelo, seemed to be engrossed by the study of colours, to the neglect of the *ideal beauty of form*, or propriety of expression. But if general censure was given to that school from the sight of a picture of Titian, how much more heavily and more justly would the censure fall on Paolo Veronese, and more especially on Tintoret? And here I cannot avoid citing Vasari's opinion of the style and manner of Tintoret. 'Of all the extraordinary geniuses,*' says he, 'that have practised the art of painting, for wild, capricious, extravagant, and fantastical inventions, for furious impetuosity and boldness in the execution of his work, there is none like Tintoret; his strange whimsies are even beyond extravagance, and his works seem to be produced rather by chance, than in consequence of any previous design, as if he wanted to convince the world that the art was a trifle, and of the most easy attainment.'[28]

For my own part, when I speak of the Venetian painters, I wish to be understood to mean Paolo Veronese and Tintoret, to the exclusion of Titian; for though his style is not so pure as that of many other of the Italian schools, yet there is a sort of senatorial dignity about him, which, however awkward in his imitators, seems to become him exceedingly. His portraits alone, from the nobleness and simplicity of character which he always gave them, will entitle him to the greatest respect, as he undoubtedly stands in the first rank in this branch of the art.

* Nelle cose della pittura, stravagante, capriccioso, presto, e resoluto, et il più terrible cervello, che habbia havuto mai la pittura, come si può vedere in tutte le sue opere; e ne' componimenti delle storie, fantastiche, e fatte da lui diversamente, e fuori dell' uso degli altri pittori: anzi hà superato la stravaganza, con le nuove, e capricciose inventioni, e strani ghiribizzi del suo intelleto, che ha lavorato a caso, e senza disegno, quasi monstrando che quest' arte è una baia.

It is not with Titian, but with the seducing qualities of the two former, that I could wish to caution you against being too much captivated. These are the persons who may be said to have exhausted all the powers of florid eloquence, to debauch the young and unexperienced; and have, without doubt, been the cause of turning off the attention of the connoisseur and of the patron of art, as well as that of the painter, from those higher excellencies of which the art is capable, and which ought to be required in every considerable production. By them, and their imitators, a style merely ornamental has been disseminated throughout all Europe. Rubens carried it to Flanders: Voet to France; and Lucca Giordano, to Spain and Naples.

The Venetian is indeed the most splendid of the schools of elegance; and it is not without reason, that the best performances in this lower school are valued higher than the second-rate performances of those above them; for every picture has value when it has a decided character, and is excellent in its kind. But the student must take care not to be so much dazzled with this splendour, as to be tempted to imitate what must ultimately lead from perfection. Poussin, whose eye was always steadily fixed on the Sublime, has been often heard to say, 'That a particular attention to colouring was an obstacle to the student, in his progress to the great end and design of the art; and that he who attaches himself to this principal end, will acquire by practice a reasonable good method of colouring.'*[29]

Though it be allowed that elaborate harmony of colouring,

* Que cette application singuliere n'etoit qu'un obstacle pour empêcher de parvenir au veritable but de la peinture, & celui qui s'attache au principal, acquiert par la pratique une assez belle maniere de peindre. Conference de l'Acad. Franc.

a brilliancy of tints, a soft and gradual transition from one to another, present to the eye, what an harmonious concert of musick does to the ear, it must be remembered, that painting is not merely a gratification of the sight. Such excellence, though properly cultivated, where nothing higher than elegance is intended, is weak and unworthy of regard, when the work aspires to grandeur and sublimity.[30]

The same reasons that have been urged to show that a mixture of the Venetian style cannot improve the great style, will hold good in regard to the Flemish and Dutch schools. Indeed the Flemish school, of which Rubens is the head, was formed upon that of the Venetian; like them, he took his figures too much from the people before him. But it must be allowed in favour of the Venetians, that he was more gross than they, and carried all their mistaken methods to a far greater excess. In the Venetian school itself, where they all err from the same cause, there is a difference in the effect. The difference between Paolo and Bassano seems to be only, that one introduced Venetian gentlemen into his pictures, and the other the boors of the district of Bassano, and called them patriarchs and prophets.

The painters of the Dutch school have still more locality. With them, a history-piece is properly a portrait of themselves; whether they describe the inside or outside of their houses, we have their own people engaged in their own peculiar occupations; working or drinking, playing or fighting. The circumstances that enter into a picture of this kind, are so far from giving a general view of human life, that they exhibit all the minute particularities of a nation differing in several respects from the rest of mankind. Yet, let them have their share of more humble praise. The painters of this school are excellent in their own way; they are only ridiculous when they attempt general history on their own narrow principles,

and debase great events by the meanness of their characters.[31]

Some inferior dexterity, some extraordinary mechanical power is apparently that from which they seek distinction. Thus, we see, that school alone has the custom of representing candle-light not as it really appears to us by night, but red, as it would illuminate objects to a spectator by day. Such tricks, however pardonable in the little style, where petty effects are the sole end, are inexcusable in the greater, where the attention should never be drawn aside by trifles, but should be entirely occupied by the subject itself.

The same local principles which characterize the Dutch school extend even to their landscape painters; and Rubens himself, who has painted many landscapes, has sometimes transgressed in this particular. Their pieces in this way are, I think, always a representation of an individual spot, and each in its kind a very faithful but a very confined portrait. Claude Lorrain, on the contrary, was convinced, that taking nature as he found it seldom produced beauty. His pictures are a composition of the various draughts which he had previously made from various beautiful scenes and prospects. However, Rubens in some measure has made amends for the deficiency with which he is charged; he has contrived to raise and animate his otherwise uninteresting views, by introducing a rainbow, storm, or some particular accidental effect of light. That the practice of Claude Lorrain, in respect to his choice, is to be adopted by Landscape painters in opposition to that of the Flemish and Dutch schools, there can be no doubt, as its truth is founded upon the same principle as that by which the Historical Painter acquires perfect form. But whether landscape painting has a right to aspire so far as to reject what the painters call Accidents of Nature, is not easy to determine. It is certain Claude Lorrain seldom, if ever, availed himself of

those accidents; either he thought that such peculiarities were contrary to that style of general nature which he professed, or that it would catch the attention too strongly, and destroy that quietness and repose which he thought necessary to that kind of painting.

A Portrait-painter likewise, when he attempts history, unless he is upon his guard, is likely to enter too much into the detail. He too frequently makes his historical heads look like portraits; and this was once the custom amongst those old painters, who revived the art before general ideas were practised or understood. An History-painter paints man in general; a Portrait-painter, a particular man, and consequently a defective model.

Thus an habitual practice in the lower exercises of the art will prevent many from attaining the greater. But such of us who move in these humbler walks of the profession, are not ignorant that, as the natural dignity of the subject is less, the more all the little ornamental helps are necessary to its embellishment. It would be ridiculous for a painter of domestick scenes, of portraits, landscapes, animals, or still life, to say that he despised those qualities which has made the subordinate schools so famous. The art of colouring, and the skilful management of light and shadow, are essential requisites in his confined labours. If we descend still lower, what is the painter of fruit and flowers without the utmost art in colouring, and what the painters call handling; that is, a lightness of pencil that implies great practice, and gives the appearance of being done with ease? Some here, I believe, must remember a flower-painter whose boast it was, that he scorned to paint for the *million*: no, he professed to paint in the true Italian taste; and despising the crowd, called strenuously upon the *few* to admire him.[32] His idea of the Italian taste was to paint as black and dirty as he could, and to leave all

clearness and brilliancy of colouring to those who were fonder of money than immortality. The consequence was such as might be expected. For these petty excellencies are here essential beauties; and without this merit the artist's work will be more short-lived than the objects of his imitation.

From what has been advanced, we must now be convinced that there are two distinct styles in history-painting: the grand, and the splendid or ornamental.

The great style stands alone, and does not require, perhaps does not so well admit, any addition from inferior beauties. The ornamental style also possesses its own peculiar merit. However, though the union of the two may make a sort of composite style, yet that style is likely to be more imperfect than either of those which go to its composition. Both kinds have merit, and may be excellent though in different ranks, if uniformity be preserved, and the general and particular ideas of nature be not mixed. Even the meanest of them is difficult enough to attain; and the first place being already occupied by the great artists in each department, some of those who followed thought there was less room for them, and feeling the impulse of ambition and the desire of novelty, and being at the same time perhaps willing to take the shortest way, endeavoured to make for themselves a place between both. This they have effected by forming an union of the different orders. But as the grave and majestick style would suffer by an union with the florid and gay, so also has the Venetian ornament in some respect been injured by attempting an alliance with simplicity.

It may be asserted, that the great style is always more or less contaminated by any meaner mixture. But it happens in a few instances, that the lower may be improved by borrowing from the grand. Thus if a portrait-painter is desirous to raise

and improve his subject, he has no other means than by approaching it to a general idea. He leaves out all the minute breaks and peculiarities in the face, and changes the dress from a temporary fashion to one more permanent, which has annexed to it no ideas of meanness from its being familiar to us. But if an exact resemblance of an individual be considered as the sole object to be aimed at, the portrait-painter will be apt to lose more than he gains by the acquired dignity taken from general nature. It is very difficult to ennoble the character of a countenance but at the expense of the likeness, which is what is most generally required by such as sit to the painter.[33]

Of those who have practised the composite style, and have succeeded in this perilous attempt, perhaps the foremost is Correggio. His style is founded upon modern grace and elegance, to which is superadded something of the simplicity of the grand style. A breadth of light and colour, the general ideas of the drapery, an uninterrupted flow of outline, all conspire to this effect. Next to him (perhaps equal to him) Parmegiano has dignified the genteelness of modern effeminacy, by uniting it with the simplicity of the ancients and the grandeur and severity of Michael Angelo. It must be confessed, however, that these two extraordinary men, by endeavouring to give the utmost degree of grace, have sometimes perhaps exceeded its boundaries, and have fallen into the most hateful of all hateful qualities, affectation. Indeed, it is the peculiar characteristick of men of genius to be afraid of coldness and insipidity, from which they think they never can be too far removed. It particularly happens to these great masters of grace and elegance. They often boldly drive on to the very verge of ridicule; the spectator is alarmed, but at the same time admires their vigour and intrepidity:

Strange graces still, and stranger flights they had,

. .

Yet ne'er so sure our passion to create,
As when they touch'd the brink of all we hate.[34]

The errors of genius, however, are pardonable, and none even of the more exalted painters are wholly free from them; but they have taught us, by the rectitude of their general practice, to correct their own affected or accidental deviation. The very first have not been always upon their guard, and perhaps there is not a fault, but what may take shelter under the most venerable authorities; yet that style only is perfect, in which the noblest principles are uniformly pursued; and those masters only are entitled to the first rank in our estimation, who have enlarged the boundaries of their art, and have raised it to its highest dignity, by exhibiting the general ideas of nature.

On the whole, it seems to me that there is but one presiding principle, which regulates, and gives stability to every art. The works, whether of poets, painters, moralists, or historians, which are built upon general nature, live for ever; while those which depend for their existence on particular customs and habits, a partial view of nature, or the fluctuation of fashion, can only be coeval with that which first raised them from obscurity. Present time and future may be considered as rivals, and he who solicits the one must expect to be discountenanced by the other.[35]

DISCOURSE V[1]

GENTLEMEN,

I PURPOSE to carry on in this discourse the subject which I
began in my last. It was my wish upon that occasion to incite
you to pursue the higher excellencies of the art. But I fear
that in this particular I have been misunderstood. Some are
ready to imagine, when any of their favourite acquirements in
the art are properly classed, that they are utterly disgraced.
This is a very great mistake: nothing has its proper lustre but
in its proper place. That which is most worthy of esteem in
its allotted sphere, becomes an object, not of respect, but of
derision, when it is forced into a higher, to which it is not
suited; and there it becomes doubly a source of disorder, by
occupying a situation which is not natural to it, and by putting

down from the first place what is in reality of too much magnitude to become with grace and proportion that subordinate station, to which something of less value would be much better suited.

My advice in a word is this: keep your principal attention fixed upon the higher excellencies. If you compass them, and compass nothing more, you are still in the first class. We may regret the innumerable beauties which you may want; you may be very imperfect: but still, you are an imperfect artist of the highest order.

If, when you have got thus far, you can add any, or all, of the subordinate qualifications, it is my wish and advice that you should not neglect them. But this is as much a matter of circumspection and caution at least, as of eagerness and pursuit.

The mind is apt to be distracted by a multiplicity of objects; and that scale of perfection which I wish always to be preserved, is in the greatest danger of being totally disordered, and even inverted.

Some excellencies bear to be united, and are improved by union; others are of a discordant nature; and the attempt to join them, only produces a harsh jarring of incongruent principles. The attempt to unite contrary excellencies (of form, for instance) in a single figure, can never escape degenerating into the monstrous, but by sinking into the insipid; by taking away its marked character, and weakening its expression.

This remark is true to a certain degree with regard to the passions. If you mean to preserve the most perfect beauty *in its most perfect state*, you cannot express the passions, all of which produce distortion and deformity, more or less in the most beautiful faces.

Guido, from want of choice in adapting his subject to his ideas and his powers, or from attempting to preserve beauty

where it could not be preserved, has in this respect succeeded very ill. His figures are often engaged in subjects that required great expression: yet his Judith and Holofernes, the daughter of Herodias with the Baptist's head, the Andromeda, and some even of the Mothers of the Innocents, have little more expression than his Venus attired by the Graces.[2]

Obvious as these remarks appear, there are many writers on our art, who, not being of the profession, and consequently not knowing what can or cannot be done, have been very liberal of absurd praises in their descriptions of favourite works. They always find in them what they are resolved to find. They praise excellencies that can hardly exist together; and above all things are fond of describing with great exactness the expression of a mixed passion, which more particularly appears to me out of the reach of our art.

Such are many disquisitions which I have read on some of the Cartoons and other pictures of Raffaelle, where the Criticks have described their own imaginations; or indeed where the excellent master himself may have attempted this expression of passions above the powers of the art; and has, therefore, by an indistinct and imperfect marking, left room for every imagination, with equal probability to find a passion of his own. What has been, and what can be done in the art, is sufficiently difficult; we need not be mortified or discouraged at not being able to execute the conceptions of a romantick imagination. Art has its boundaries, though imagination has none. We can easily, like the ancients, suppose a Jupiter to be possessed of all those powers and perfections which the subordinate Deities were endowed with separately. Yet, when they employed their art to represent him, they confined his character to majesty alone. Pliny, therefore, though we are under great obligations to him for the information he has given us in relation to the works of the ancient

artists, is very frequently wrong when he speaks of them, which he does very often in the style of many of our modern connoisseurs. He observes, that in a statue of Paris, by Euphranor, you might discover at the same time three different characters; the dignity of a Judge of the Goddesses, the Lover of Helen, and the Conqueror of Achilles.[3] A statue in which you endeavour to unite stately dignity, youthful elegance, and stern valour, must surely possess none of these to any eminent degree.

From hence it appears, that there is much difficulty as well as danger, in an endeavour to concentrate in a single subject those various powers, which rising from different points, naturally move in different directions.

The summit of excellence seems to be an assemblage of contrary qualities, but mixed, in such proportions, that no one part is found to counteract the other. How hard this is to be attained in every art, those only know, who have made the greatest progress in their respective professions.

To conclude what I have to say on this part of the subject, which I think of great importance, I wish you to understand, that I do not discourage the younger Students from the noble attempt of uniting all the excellencies of art; but suggest to them, that, beside the difficulties which attend every arduous attempt, there is a peculiar difficulty in the choice of the excellencies which ought to be united. I wish you to attend to this, that you may try yourselves, whenever you are capable of that trial, what you can, and what you cannot do; and that, instead of dissipating your natural faculties over the immense field of possible excellence, you may choose some particular walk in which you may exercise all your powers: in order that each of you may become the first in his way. If any man shall be master of such a transcendant, commanding, and ductile[4] genius, as to enable him to rise to the highest, and to stoop to

the lowest, flights of art, and to sweep over all of them un-
obstructed and secure, he is fitter to give example than to
receive instruction.

Having said thus much on the *union* of excellencies, I will
next say something of the subordination in which various
excellencies ought to be kept.

I am of opinion, that the ornamental style, which in my
discourse of last year I cautioned you against considering as
principal, may not be wholly unworthy the attention even of
those who aim at the grand style, when it is properly placed
and properly reduced.

But this study will be used with far better effect, if its
principles are employed in softening the harshness and mitigat-
ing the rigour of the great style, than if it attempt to stand
forward with any pretensions of its own to positive and original
excellence. It was thus Ludovico Caracci, whose example I
formerly recommended to you,[5] employed it. He was ac-
quainted with the works both of Correggio and the Venetian
painters, and knew the principles by which they produced
those pleasing effects which at the first glance prepossess us
so much in their favour; but he took only as much from each
as would embellish, but not over-power, that manly strength
and energy of style, which is his peculiar character.

Since I have already expatiated so largely in my former
discourse, and in my present, upon the *styles* and *characters*
of Painting, it will not be at all unsuitable to my subject if I
mention to you some particulars relative to the leading prin-
ciples, and capital works of those who excelled in the *great
style*; that I may bring you from abstraction nearer to practice,
and by exemplifying the positions which I have laid down,
enable you to understand more clearly what I would enforce.

The principal works of modern art are in *Fresco*, a mode of
painting which excludes attention to minute elegancies: yet

these works in Fresco, are the productions on which the fame
of the greatest masters depends: such are the pictures of
Michael Angelo and Raffaelle in the Vatican; to which we
may add the Cartoons; which, though not strictly to be called
Fresco, yet may be put under that denomination; and such
are the works of Giulio Romano at Mantua.[6] If these perform-
ances were destroyed, with them would be lost the best part
of the reputation of those illustrious painters; for these are
justly considered as the greatest efforts of our art which the
world can boast. To these, therefore, we should principally
direct our attention for higher excellencies. As for the lower
arts, as they have been once discovered, they may be easily
attained by those possessed of the former.

Raffaelle, who stands in general foremost of the first paint-
ers, owes his reputation, as I have observed, to his excel-
lence in the higher parts of the art; his works in *Fresco*,
therefore, ought to be the first object of our study and atten-
tion. His easel-works stand in a lower degree of estimation:
for though he continually, to the day of his death, embellished
his performances more and more with the addition of those
lower ornaments, which entirely make the merit of some
painters, yet he never arrived at such perfection as to make him
an object of imitation. He never was able to conquer perfectly
that dryness, or even littleness of manner, which he inherited
from his master.[7] He never acquired that nicety of taste in
colours, that breadth of light and shadow, that art and manage-
ment of uniting light to light, and shadow to shadow, so as to
make the object rise out of the ground with the plenitude of
effect so much admired in the works of Correggio. When he
painted in oil, his hand seemed to be so cramped and
confined, that he not only lost that facility and spirit, but I
think even that correctness of form, which is so perfect and
admirable in his Fresco-works. I do not recollect any pictures

of his of this kind, except perhaps the Transfiguration,[8] in which there are not some parts that appear to be even feebly drawn. That this is not a necessary attendant on Oil-painting, we have abundant instances in more modern painters. Ludovico Caracci, for instance, preserved in his works in oil the same spirit, vigour, and correctness which he had in Fresco. I have no desire to degrade Raffaelle from the high rank which he deservedly holds: but by comparing him with himself, he does not appear to me to be the same man in Oil as in Fresco.

From those who have ambition to tread in this great walk of the art, Michael Angelo claims the next attention. He did not possess so many excellencies as Raffaelle, but those which he had were of the highest kind. He considered the art as consisting of little more than what may be attained by sculpture: correctness of form, and energy of character. We ought not to expect more than an artist intends in his work. He never attempted those lesser elegancies and graces in the art. Vasari says, he never painted but one picture in oil, and resolved never to paint another, saying, it was an employment only fit for women and children.[9]

If any man had a right to look down upon the lower accomplishments as beneath his attention, it was certainly Michael Angelo; nor can it be thought strange, that such a mind should have slighted or have been withheld from paying due attention to all those graces and embellishments of art, which have diffused such lustre over the works of other painters.

It must be acknowledged, however, that together with these, which we wish he had more attended to, he has rejected all the false, though specious ornaments, which disgrace the works even of the most esteemed artists; and I will venture to say, that when those higher excellencies are more known and cultivated by the artists and the patrons of arts, his fame and credit will increase with our increasing knowledge. His name

will then be held in the same veneration as it was in the enlightened age of Leo the Tenth:[10] and it is remarkable that the reputation of this truly great man has been continually declining as the art itself has declined. For I must remark to you, that it has long been much on the decline, and that our only hope of its revival will consist in your being thoroughly sensible of its deprivation and decay. It is to Michael Angelo, that we owe even the existence of Raffaelle: it is to him Raffaelle owes the grandeur of his style. He was taught by him to elevate his thoughts, and to conceive his subjects with dignity. His genius, however, formed to blaze and to shine, might, like fire in combustible matter, for ever have lain dormant, if it had not caught a spark by its contact with Michael Angelo; and though it never burst out with *his* extraordinary heat and vehemence, yet it must be acknowledged to be a more pure, regular, and chaste flame. Though our judgement must upon the whole decide in favour of Raffaelle, yet he never takes such a firm hold and entire possession of the mind as to make us desire nothing else, and to feel nothing wanting. The effect of the capital works of Michael Angelo perfectly corresponds to what Bouchardon said he felt from reading Homer; his whole frame appeared to himself to be enlarged, and all nature which surrounded him, diminished to atoms.[11]

If we put these great artists in a light of comparison with each other, Raffaelle had more Taste and Fancy; Michael Angelo more Genius and Imagination.[12] The one excelled in beauty, the other in energy. Michael Angelo has more of the poetical Inspiration; his ideas are vast and sublime; his people are a superior order of beings; there is nothing about them, nothing in the air of their actions or their attitudes, or the style and cast of their limbs or features, that reminds us of their belonging to our own species. Raffaelle's imagination is

not so elevated; his figures are not so much disjoined from our own diminutive race of beings, though his ideas are chaste, noble, and of great conformity to their subjects. Michael Angelo's works have a strong, peculiar, and marked character: they seem to proceed from his own mind entirely, and that mind so rich and abundant, that he never needed, or seemed to disdain, to look abroad for foreign help. Raffaelle's materials are generally borrowed, though the noble structure is his own. The excellency of this extraordinary man lay in the propriety, beauty, and majesty of his characters, the judicious contrivance of his Composition, his correctness of Drawing, purity of Taste, and skilful accommodation of other men's conceptions to his own purpose. Nobody excelled him in that judgement, with which he united to his own observations on Nature, the energy of Michael Angelo, and the Beauty and Simplicity of the Antique. To the question therefore, which ought to hold the first rank, Raffaelle or Michael Angelo, it must be answered, that if it is to be given to him who possessed a greater combination of the higher qualities of the art than any other man, there is no doubt but Raffaelle is the first. But if, as Longinus thinks,[13] the sublime, being the highest excellence that human composition can attain to, abundantly compensates the absence of every other beauty, and atones for all other deficiencies, then Michael Angelo demands the preference.

These two extraordinary men carried some of the higher excellencies of the art to a greater degree of perfection than probably they ever arrived at before. They certainly have not been excelled, nor equalled since. Many of their successors were induced to leave this great road as a beaten path, endeavouring to surprise and please by something uncommon or new. When this desire of novelty has proceeded from mere idleness or caprice, it is not worth the trouble of criticism;

but when it has been the result of a busy mind of a peculiar complexion, it is always striking and interesting, never insipid.

Such is the great style, as it appears in those who possessed it at its height: in this, search after novelty, in conception or in treating the subject, has no place.

But there is another style, which, though inferior to the former, has still great merit, because it shows that those who cultivated it were men of lively and vigorous imagination. This, which may be called the original or characteristical[14] style, being less referred to any true archetype[15] existing either in general or particular nature, must be supported by the painter's consistency in the principles which he has assumed, and in the union and harmony of his whole design. The excellency of every style, but of the subordinate styles more especially, will very much depend on preserving that union and harmony between all the component parts, that they may appear to hang well together, as if the whole proceeded from one mind. It is in the works of art as in the characters of men. The faults or defects of some men seem to become them, when they appear to be the natural growth, and of a piece with the rest of their character. A faithful picture of a mind, though it be not of the most elevated kind, though it be irregular, wild, and incorrect, yet if it be marked with that spirit and firmness which characterise works of genius, will claim attention, and be more striking than a combination of excellencies that do not seem to unite well together; or we may say, than a work that possesses even all excellencies, but those in a moderate degree.

One of the strongest-marked characters of this kind, which must be allowed to be subordinate to the great style, is that of Salvator Rosa. He gives us a peculiar cast of nature, which, though void of all grace, elegance, and simplicity, though it

has nothing of that elevation and dignity which belongs to the grand style, yet, has that sort of dignity which belongs to savage[16] and uncultivated nature: but what is most to be admired in him, is, the perfect correspondence which he observed between the subjects which he chose, and his manner of treating them. Every thing is of a piece: his Rocks, Trees, Sky, even to his handling, have the same rude and wild character which animates his figures.

With him we may contrast the character of Carlo Maratti, who, in my opinion, had no great vigour of mind or strength of original genius. He rarely seizes the imagination by exhibiting the higher excellencies, nor does he captivate us by that originality which attends the painter who thinks for himself. He knew and practised all the rules of art, and from a composition of Raffaelle, Caracci, and Guido, made up a style, of which the only fault was, that it had no manifest defects and no striking beauties; and that the principles of his composition are never blended together, so as to form one uniform body original in its kind, or excellent in any view.

I will mention two other painters, who, though entirely dissimilar, yet by being each consistent with himself, and possessing a manner entirely his own, have both gained reputation, though for very opposite accomplishments. The painters I mean, are Rubens and Poussin. Rubens I mention in this place, as I think him a remarkable instance of the same mind being seen in all the various parts of the art. The whole is so much of a piece, that one can scarce be brought to believe but that if any one of the qualities he possessed had been more correct and perfect, his works would not have been so complete as they now appear. If we should allow him a greater purity and correctness of Drawing, his want of Simplicity in Composition, Colouring, and Drapery, would appear more gross.[17]

In his Composition his art is too apparent. His figures have expression, and act with energy, but without simplicity or dignity. His colouring, in which he is eminently skilled, is notwithstanding too much of what we call tinted.[18] Throughout the whole of his works, there is a proportionable want of that nicety of distinction and elegance of mind, which is required in the higher walks of painting: and to this want it may be in some degree ascribed, that those qualities which make the excellency of this subordinate style, appear in him with their greatest lustre. Indeed the facility with which he invented, the richness of his composition, the luxuriant harmony and brilliancy of his colouring, so dazzle the eye, that whilst his works continue before us, we cannot help thinking that all his deficiencies are fully supplied.

Opposed to this florid, careless, loose, and inaccurate style, that of the simple, careful, pure, and correct style of Poussin, seems to be a complete contrast. Yet however opposite their characters, in one thing they agreed; both of them always preserving a perfect correspondence between all the parts of their respective manners: insomuch that it may be doubted whether any alteration of what is considered as defective in either, would not destroy the effect of the whole.

Poussin lived and conversed with the ancient statues so long, that he may be said to have been better acquainted with them than with the people who were about him. I have often thought that he carried his veneration for them so far as to wish to give his works the air of Ancient Paintings. It is certain he copied some of the Antique Paintings, particularly the Marriage in the Aldobrandini-Palace at Rome, which I believe to be the best relique of those remote ages that has yet been found.[19]

No works of any modern have so much of the air of Antique Painting as those of Poussin. His best performances have a

remarkable dryness of manner, which though by no means to be recommended for imitation, yet seems perfectly correspondent to that ancient simplicity which distinguishes his style. Like Polidoro he studied the ancients so much that he acquired a habit of thinking in their way, and seemed to know perfectly the actions and gestures they would use on every occasion.

Poussin in the latter part of his life changed from his dry manner to one much softer and richer, where there is a greater union between the figures and ground; as in the Seven Sacraments in the Duke of Orleans's collection;[20] but neither these, nor any of his other pictures in this manner, are at all comparable to many in this dry manner which we have in England.

The favourite subjects of Poussin were Ancient Fables; and no painter was ever better qualified to paint such subjects, not only from his being eminently skilled in the knowledge of the ceremonies, customs, and habits of the Ancients, but from his being so well acquainted with the different characters which those who invented them gave to their allegorical figures. Though Rubens has shown great fancy in his Satyrs, Silenuses, and Fauns, yet they are not that distinct separate class of beings, which is carefully exhibited by the Ancients, and by Poussin. Certainly when such subjects of antiquity are represented, nothing in the picture ought to remind us of modern times. The mind is thrown back into antiquity, and nothing ought to be introduced that may tend to awaken it from the illusion.

Poussin seemed to think that the style and the language in which such stories are told, is not the worse for preserving some relish of the old way of painting, which seemed to give a general uniformity to the whole, so that the mind was thrown back into antiquity not only by the subject, but the execution.

If Poussin in imitation of the Ancients represents Apollo driving his chariot out of the sea by way of representing the Sun rising, if he personifies Lakes and Rivers, it is nowise offensive in him; but seems perfectly of a piece with the general air of the picture. On the contrary, if the Figures which people his pictures had a modern air or countenance, if they appeared like our countrymen, if the draperies were like cloth or silk of our manufacture, if the landscape had the appearance of a modern view, how ridiculous would Apollo appear instead of the Sun; an old Man, or a Nymph with an urn, to represent a River or a Lake?[21]

I cannot avoid mentioning here a circumstance in portrait-painting, which may help to confirm what has been said. When a portrait is painted in the Historical Style, as it is neither an exact minute representation of an individual, nor completely ideal, every circumstance ought to correspond to this mixture. The simplicity of the antique air and attitude, however much to be admired, is ridiculous when joined to a figure in a modern dress. It is not to my purpose to enter into the question at present, whether this mixed style ought to be adopted or not; yet if it is chosen 'tis necessary it should be complete and all of a piece: the difference of stuffs, for instance, which make the cloathing, should be distinguished in the same degree as the head deviates from a general idea. Without this union, which I have so often recommended, a work can have no marked and determined character, which is the peculiar and constant evidence of genius. But when this is accomplished to a high degree, it becomes in some sort a rival to that style which we have fixed as the highest.

Thus I have given a sketch of the characters of Rubens and Salvator Rosa, as they appear to me to have the greatest uniformity of mind throughout their whole work. But we may add to these, all those Artists who are at the head of a

class, and have had a school of imitators from Michael Angelo
down to Watteau. Upon the whole it appears that, setting
aside the Ornamental Style, there are two different modes,
either of which a Student may adopt without degrading the
dignity of his art. The object of the first is, to combine the
higher excellencies and embellish them to the greatest ad-
vantage: of the other, to carry one of these excellencies to the
highest degree. But those who possess neither must be classed
with them, who, as Shakspeare says, are *men of no mark or like-
lihood.*[22]

I inculcate as frequently as I can your forming yourselves
upon great principles and great models. Your time will be
much mis-spent in every other pursuit. Small excellencies
should be viewed, not studied; they ought to be viewed, be-
cause nothing ought to escape a Painter's observation: but for
no other reason.

There is another caution which I wish to give you. Be as
select in those whom you endeavour to please, as in those
whom you endeavour to imitate. Without the love of fame
you can never do any thing excellent; but by an excessive and
undistinguishing thirst after it, you will come to have vulgar
views; you will degrade your style; and your taste will be
entirely corrupted. It is certain that the lowest style will be
the most popular, as it falls within the compass of ignorance
itself; and the Vulgar will always be pleased with what is
natural, in the confined and misunderstood sense of the
word.

One would wish that such depravation of taste should be
counteracted with that manly pride which actuated Euripides
when he said to the Athenians who criticised his works, 'I do
not compose my works in order to be corrected by you, but
to instruct you.'[23] It is true, to have a right to speak thus, a
man must be an Euripides. However, thus much may be

allowed, that when an Artist is sure that he is upon firm ground, supported by the authority and practice of his predecessors of the greatest reputation, he may then assume the boldness and intrepidity of genius; at any rate he must not be tempted out of the right path by any allurement of popularity, which always accompanies the lower styles of painting.

I mention this, because our Exhibitions,[24] while they produce such admirable effects by nourishing emulation, and calling out genius, have also a mischievous tendency, by seducing the Painter to an ambition of pleasing indiscriminately the mixed multitude of people who resort to them.

DISCOURSE VI

IMITATION.—GENIUS BEGINS WHERE RULES END.— INVENTION;
ACQUIRED BY BEING CONVERSANT WITH THE INVENTIONS
OF OTHERS.—THE TRUE METHOD OF IMITATING.—BORROWING,
HOW FAR ALLOWABLE.—SOMETHING TO BE GATHERED FROM
EVERY SCHOOL.

GENTLEMEN,

WHEN I have taken the liberty of addressing you on the
course and order of your studies, I never proposed to enter
into a minute detail of the art. This I have always left to the
several Professors, who pursue the end of our institution with
the highest honour to themselves, and with the greatest ad-
vantage to the Students.[1]

My purpose in the discourses I have held in the Academy
has been to lay down certain general positions, which seem to
me proper for the formation of a sound taste: principles neces-
sary to guard the pupils against those errors, into which the
sanguine temper common to their time of life has a tendency
to lead them; and which have rendered abortive the hopes of
so many successions of promising young men in all parts of
Europe. I wished also, to intercept and suppress those preju-
dices which particularly prevail when the mechanism of paint-
ing is come to its perfection; and which, when they do prevail,
are certain utterly to destroy the higher and more valuable
parts of this literate and liberal profession.

These two have been my principal purposes; they are still as much my concern as ever; and if I repeat my own notions on the subject, you who know how fast mistake and prejudice, when neglected, gain ground upon truth and reason, will easily excuse me. I only attempt to set the same thing in the greatest variety of lights.

The subject of this discourse will be IMITATION,[2] as far as a painter is concerned in it. By imitation, I do not mean imitation in its largest sense, but simply the following of other masters, and the advantage to be drawn from the study of their works.

Those who have undertaken to write on our art, and have represented it as a kind of *inspiration*, as a *gift* bestowed upon peculiar favourites at their birth, seem to insure a much more favourable disposition from their readers,[3] and have a much more captivating and liberal air, than he who attempts to examine, coldly, whether there are any means by which this art may be acquired; how the mind may be strengthened and expanded, and what guides will show the way to eminence.

It is very natural for those who are unacquainted with the *cause* of any thing extraordinary, to be astonished at the *effect*, and to consider it as a kind of magick.[4] They, who have never observed the gradation by which art is acquired; who see only what is the full result of long labour and application of an infinite number and infinite variety of acts, are apt to conclude, from their entire inability to do the same at once, that it is not only inaccessible to themselves, but can be done by those only who have some gift of the nature of inspiration bestowed upon them.

The travellers into the East tell us, that when the ignorant inhabitants of those countries are asked concerning the ruins of stately edifices yet remaining amongst them, the melancholy monuments of their former grandeur and long-lost

science, they always answer, that they were built by magicians.[5] The untaught mind finds a vast gulph between its own powers, and those works of complicated art, which it is utterly unable to fathom; and it supposes that such a void can be passed only by supernatural powers.

And, as for artists themselves, it is by no means their interest to undeceive such judges, however conscious they may be of the very natural means by which their extraordinary powers were acquired; though our art, being intrinsically imitative, rejects this idea of inspiration, more perhaps than any other.

It is to avoid this plain confession of truth, as it should seem, that this imitation of masters, indeed almost all imitation, which implies a more regular and progressive method of attaining the ends of painting, has ever been particularly inveighed against with great keenness, both by ancient and modern writers.

To derive all from native power, to owe nothing to another, is the praise which men, who do not much think on what they are saying, bestow sometimes upon others, and sometimes on themselves; and their imaginary dignity is naturally heightened by a supercilious censure of the low, the barren, the groveling, the servile imitator.[6] It would be no wonder if a student, frightened by these terrifick and disgraceful epithets, with which the poor imitators are so often loaded, should let fall his pencil in mere despair; (conscious as he must be, how much he has been indebted to the labours of others, how little, how very little of his art was born with him;) and consider it as hopeless, to set about acquiring by the imitation of any human master, what he is taught to suppose is matter of inspiration from heaven.

Some allowance must be made for what is said in the gaiety of rhetorick. We cannot suppose that any one can really mean

to exclude all imitation of others. A position so wild would scarce deserve a serious answer; for it is apparent, if we were forbid to make use of the advantages which our predecessors afford us, the art would be always to begin, and consequently remain always in its infant state; and it is a common observation, that no art was ever invented and carried to perfection at the same time.

But to bring us entirely to reason and sobriety, let it be observed, that a painter must not only be of necessity an imitator of the works of nature, which alone is sufficient to dispel this phantom of inspiration, but he must be as necessarily an imitator of the works of other painters: this appears more humiliating, but is equally true; and no man can be an artist, whatever he may suppose, upon any other terms.

However, those who appear more moderate and reasonable, allow, that our study is to begin by imitation; but maintain that we should no longer use the thoughts of our predecessors, when we are become able to think for ourselves. They hold that imitation is as hurtful to the more advanced student, as it was advantageous to the beginner.

For my own part, I confess, I am not only very much disposed to maintain the absolute necessity of imitation in the first stages of the art; but am of opinion, that the study of other masters, which I here call imitation, may be extended throughout our whole lives, without any danger of the inconveniences with which it is charged, of enfeebling the mind, or preventing us from giving that original air which every work undoubtedly ought always to have.[7]

I am on the contrary persuaded that by imitation only, variety, and even originality of invention, is produced. I will go further; even genius, at least what generally is so called, is the child of imitation. But as this appears to be contrary to the general opinion, I must explain my position before I enforce it.

Genius is supposed to be a power of producing excellencies, which are out of the reach of the rules of art; a power which no precepts can teach, and which no industry can acquire.[8]

This opinion of the impossibility of acquiring those beauties, which stamp the work with the character of genius, supposes that it is something more fixed, than in reality it is; and that we always do, and ever did agree in opinion, with respect to what should be considered as the characteristick of genius. But the truth is, that the *degree* of excellence which proclaims *Genius* is different, in different times and different places; and what shows it to be so is, that mankind have often changed their opinion upon this matter.

When the Arts were in their infancy, the power of merely drawing the likeness of any object, was considered as one of its greatest efforts. The common people, ignorant of the principles of art, talk the same language even to this day. But when it was found that every man could be taught to do this, and a great deal more, merely by the observance of certain precepts; the name of Genius then shifted its application, and was given only to him who added the peculiar character of the object he represented; to him who had invention, expression, grace, or dignity; in short, those qualities, or excellencies, the power of producing which, could not *then* be taught by any known and promulgated rules.

We are very sure that the beauty of form, the expression of the passions, the art of composition, even the power of giving a general air of grandeur to a work, is at present very much under the dominion of rules. These excellencies were, heretofore, considered merely as the effects of genius; and justly, if genius is not taken for inspiration, but as the effect of close observation and experience.

He who first made any of these observations, and digested them, so as to form an invariable principle for him to work

by, had that merit, but probably no one went very far at once; and generally, the first who gave the hint, did not know how to pursue it steadily and methodically; at least not in the beginning. He himself worked on it, and improved it; others worked more, and improved further; until the secret was discovered, and the practice made as general, as refined practice can be made. How many more principles may be fixed and ascertained, we cannot tell; but as criticism is likely to go hand in hand with the art which is its subject, we may venture to say, that as that art shall advance, its powers will be still more and more fixed by rules.

But by whatever strides criticism may gain ground, we need be under no apprehension, that invention will ever be annihilated, or subdued; or intellectual energy be brought entirely within the restraint of written law. Genius will still have room enough to expatiate, and keep always at the same distance from narrow comprehension and mechanical performance.

What we now call Genius, begins, not where rules, abstractedly taken, end; but where known vulgar and trite rules have no longer any place. It must of necessity be, that even works of Genius, like every other effect, as they must have their cause, must likewise have their rules;[9] it cannot be by chance, that excellencies are produced with any constancy or any certainty, for this is not the nature of chance; but the rules by which men of extraordinary parts, and such as are called men of Genius, work, are either such as they discover by their own peculiar observations, or of such a nice texture as not easily to admit being expressed in words; especially as artists are not very frequently skilful in that mode of communicating ideas. Unsubstantial, however, as these rules may seem, and difficult as it may be to convey them in writing, they are still seen and felt in the mind of the artist; and he

works from them with as much certainty, as if they were embodied, as I may say, upon paper. It is true, these refined principles cannot be always made palpable, like the more gross rules of art;[10] yet it does not follow, but that the mind may be put in such a train, that it shall perceive, by a kind of scientifick sense, that propriety, which words, particularly words of unpractised writers, such as we are, can but very feebly suggest.

Invention is one of the great marks of genius; but if we consult experience, we shall find, that it is by being conversant with the inventions of others, that we learn to invent; as by reading the thoughts of others we learn to think.

Whoever has so far formed his taste, as to be able to relish and feel the beauties of the great masters, has gone a great way in his study; for, merely from a consciousness of this relish of the right, the mind swells with an inward pride, and is almost as powerfully affected, as if it had itself produced what it admires. Our hearts, frequently warmed in this manner by the contact of those whom we wish to resemble, will undoubtedly catch something of their way of thinking; and we shall receive in our own bosoms some radiation at least of their fire and splendour. That disposition, which is so strong in children, still continues with us, of catching involuntarily the general air and manner of those with whom we are most conversant; with this difference only, that a young mind is naturally pliable and imitative; but in a more advanced state it grows rigid, and must be warmed and softened, before it will receive a deep impression.

From these considerations, which a little of your own reflection will carry a great way further, it appears, of what great consequence it is, that our minds should be habituated to the contemplation of excellence; and that, far from being contented to make such habits the discipline of our youth only,

we should, to the last moment of our lives, continue a settled intercourse with all the true examples of grandeur. Their inventions are not only the food of our infancy, but the substance which supplies the fullest maturity of our vigour.

The mind is but a barren soil;[11] a soil which is soon exhausted, and will produce no crop, or only one, unless it be continually fertilized and enriched with foreign matter.[12]

When we have had continually before us the great works of Art to impregnate our minds with kindred ideas, we are then, and not till then, fit to produce something of the same species. We behold all about us with the eyes of those penetrating observers whose works we contemplate; and our minds, accustomed to think the thoughts of the noblest and brightest intellects, are prepared for the discovery and selection of all that is great and noble in nature. The greatest natural genius cannot subsist on its own stock: he who resolves never to ransack any mind but his own, will be soon reduced, from mere barrenness, to the poorest of all imitations; he will be obliged to imitate himself, and to repeat what he has before often repeated. When we know the subject designed by such men, it will never be difficult to guess what kind of work is to be produced.

It is vain for painters or poets to endeavour to invent without materials on which the mind may work, and from which invention must originate. Nothing can come of nothing.[13]

Homer is supposed to be possessed of all the learning of his time; and we are certain that Michael Angelo, and Raffaelle, were equally possessed of all the knowledge in the art which had been discovered in the works of their predecessors.

A mind enriched by an assemblage of all the treasures of ancient and modern art, will be more elevated and fruitful in resources, in proportion to the number of ideas which have

been carefully collected and thoroughly digested. There can be no doubt but that he who has the most materials has the greatest means of invention; and if he has not the power of using them, it must proceed from a feebleness of intellect; or from the confused manner in which those collections have been laid up in his mind.

The addition of other men's judgement is so far from weakening our own, as is the opinion of many, that it will fashion and consolidate those ideas of excellence which lay in embryo, feeble, ill-shaped, and confused, but which are finished and put in order by the authority and practice of those whose works may be said to have been consecrated by having stood the test of ages.[14]

The mind, or genius, has been compared to a spark of fire, which is smothered by a heap of fuel, and prevented from blazing into a flame: This simile, which is made use of by the younger Pliny, may be easily mistaken for argument or proof.[15] But there is no danger of the mind's being over-burthened with knowledge, or the genius extinguished by any addition of images; on the contrary, these acquisitions may as well, perhaps better, be compared, if comparisons signified any thing in reasoning, to the supply of living embers, which will contribute to strengthen the spark, that without the association of more fuel would have died away. The truth is, he whose feebleness is such, as to make other men's thoughts an incumbrance to him, can have no very great strength of mind or genius of his own to be destroyed; so that not much harm will be done at worst.

We may oppose to Pliny the greater authority of Cicero, who is continually enforcing the necessity of this method of study. In his dialogue on Oratory, he makes Crassus say, that one of the first and most important precepts is, to choose a proper model for our imitation. *Hoc sit primum in præceptis meis, ut demonstremus quem imitemur.*[16]

When I speak of the habitual imitation and continued study of masters, it is not to be understood, that I advise any endeavour to copy the exact peculiar colour and complexion of another man's mind; the success of such an attempt must always be like his, who imitates exactly the air, manner, and gestures, of him whom he admires. His model may be excellent, but the copy will be ridiculous: this ridicule does not arise from his having imitated, but from his not having chosen the right mode of imitation.

It is a necessary and warrantable pride to disdain to walk servilely behind any individual, however elevated his rank. The true and liberal ground of imitation is an open field; where, though he who precedes has had the advantage of starting before you, you may always propose to overtake him: it is enough however to pursue his course; you need not tread in his footsteps; and you certainly have a right to outstrip him if you can.

Nor whilst I recommend studying the art from artists, can I be supposed to mean, that nature is to be neglected: I take this study in aid, and not in exclusion, of the other. Nature is, and must be the fountain which alone is inexhaustible; and from which all excellencies must originally flow.

The great use of studying our predecessors is, to open the mind to shorten our labour, and to give us the result of the selection made by those great minds of what is grand or beautiful in nature; her rich stores are all spread out before us; but it is an art, and no easy art to know how or what to choose, and how to attain and secure the object of our choice. Thus the highest beauty of form must be taken from nature; but it is an art of long deduction and great experience, to know how to find it. We must not content ourselves with merely admiring and relishing; we must enter into the principles on which the work is wrought: these do not swim on the

superficies, and consequently are not open to superficial observers.

Art in its perfection is not ostentatious; it lies hid, and works its effect, itself unseen. It is the proper study[17] and labour of an artist to uncover and find out the latent cause of conspicuous beauties, and from thence form principles of his own conduct: such an examination is a continual exertion of the mind; as great, perhaps, as that of the artist whose works he is thus studying.

The sagacious imitator does not content himself with merely remarking what distinguishes the different manner or genius of each master; he enters into the contrivance in the composition how the masses of lights are disposed, the means by which the effect is produced, how artfully some parts are lost in the ground, others boldly relieved, and how all these are mutually altered and interchanged according to the reason and scheme of the work. He admires not the harmony of colouring alone, but examines by what artifice one colour is a foil to its neighbour. He looks close into the tints, examines of what colours they are composed, till he has formed clear and distinct ideas, and has learnt to see in what harmony and good colouring consists. What is learnt in this manner from the works of others becomes really our own, sinks deep, and is never forgotten: nay, it is by seizing on this clue that we proceed forward, and get further and further in enlarging the principles and improving the practice of our art.

There can be no doubt, but the art is better learnt from the works themselves, than from the precepts which are formed upon those works; but if it is difficult to choose proper models for imitation, it requires no less circumspection to separate and distinguish what in those models we ought to imitate.

I cannot avoid mentioning here, though it is not my intention at present to enter into the art and method of study, an

error which students are too apt to fall into. He that is forming himself, must look with great caution and wariness on those peculiarities, or prominent parts, which at first force themselves upon view; and are the marks, or what is commonly called the manner, by which that individual artist is distinguished.

Peculiar marks, I hold to be, generally, if not always, defects; however difficult it may be wholly to escape them.

Peculiarities in the works of art, are like those in the human figure: it is by them that we are cognizable, and distinguished one from another, but they are always so many blemishes: which, however, both in real life and in painting, cease to appear deformities, to those who have them continually before their eyes. In the works of art, even the most enlightened mind, when warmed by beauties of the highest kind, will by degrees find a repugnance within him to acknowledge any defects; nay, his enthusiasm will carry him so far, as to transform them into beauties, and objects of imitation.

It must be acknowledged, that a peculiarity of style, either from its novelty, or by seeming to proceed from a peculiar turn of mind, often escapes blame; on the contrary, it is sometimes striking and pleasing: but this it is a vain labour to endeavour to imitate; because novelty and peculiarity being its only merit, when it ceases to be new, it ceases to have value.

A manner therefore being a defect, and every painter, however excellent, having a manner, it seems to follow, that all kinds of faults, as well as beauties, may be learned under the sanction of the greatest authorities. Even the great name of Michael Angelo may be used, to keep in countenance a deficiency or rather neglect of colouring, and every other ornamental part of the art. If the young student is dry and hard, Poussin is the same. If his work has a careless and unfinished

air, he has most of the Venetian school to support him. If he makes no selection of objects, but takes individual nature just as he finds it, he is like Rembrandt. If he is incorrect in the proportions of his figures, Correggio was likewise incorrect. If his colours are not blended and united, Rubens was equally crude. In short, there is no defect that may not be excused, if it is a sufficient excuse that it can be imputed to considerable artists; but it must be remembered, that it was not by these defects they acquired their reputation; they have a right to our pardon, but not to our admiration.[18]

However, to imitate peculiarities or mistake defects for beauties, that man will be most liable, who confines his imitation to one favourite master; and even though he chooses the best, and is capable of distinguishing the real excellencies of his model, it is not by such narrow practice, that a genius or mastery in the art is acquired. A man is as little likely to form a true idea of the perfection of the art, by studying a single artist, as he would be to produce a perfectly beautiful figure, by an exact imitation of any individual living model. And as the painter by bringing together in one piece, those beauties which are dispersed among a great variety of individuals, produces a figure more beautiful than can be found in nature, so that artist who can unite in himself the excellencies of the various great painters, will approach nearer to perfection than any one of his masters. He who confines himself to the imitation of an individual, as he never proposes to surpass, so he is not likely to equal, the object of his imitation.[19] He professes only to follow; and he that follows must necessarily be behind.

We should imitate the conduct of the great artists in the course of their studies, as well as the works which they produced, when they were perfectly formed. Raffaelle began by imitating implicitly the manner of Pietro Perugino, under

whom he studied; hence his first works are scarce to be distinguished from his master's; but soon forming higher and more extensive views, he imitated the grand outline of Michael Angelo; he learned the manner of using colours from the works of Leonardo da Vinci, and Fratre Bartolomeo: to all this he added the contemplation of all the remains of antiquity that were within his reach; and employed others to draw for him what was in Greece and distant places. And it is from his having taken so many models, that he became himself a model for all succeeding painters; always imitating, and always original.

If your ambition, therefore, be to equal Raffaelle, you must do as Raffaelle did, take many models, and not even *him* for your guide alone, to the exclusion of others.*[20] And yet the number is infinite of those who seem, if one may judge by their style, to have seen no other works but those of their master, or of some favourite, whose *manner* is their first wish, and their last.

I will mention a few that occur to me of this narrow, confined, illiberal, unscientifick, and servile kind of imitators. Guido was thus meanly copied by Elizabetta Sirani, and Simone Cantarini; Poussin, by Verdier, and Cheron; Parmeggiano, by Jeronimo Mazzuoli. Paolo Veronese, and Iacomo Bassan, had for their imitators their brothers and sons. Pietro da Cortona was followed by Ciro Ferri, and Romanelli; Rubens, by Jacques Jordaens, and Diepenbeke; Guercino, by his own family, the Gennari. Carlo Maratti was imitated by Giuseppe Chiari, and Pietro de Pietri; and Rembrandt, by Bramer, Eeckhout, and Flink. All these, to whom may be added a much longer list of painters, whose works among the

* Sed non qui maxime imitandus, etiam solus imitandus est. Quintilian.

ignorant pass for those of their masters, are justly to be censured for barrenness and servility.

To oppose to this list a few that have adopted a more liberal style of imitation; – Pellegrino Tibaldi, Rosso, and Primaticcio, did not coldly imitate, but caught something of the fire that animates the works of Michael Angelo. The Caraccis formed their style from Pellegrino Tibaldi, Correggio, and the Venetian School. Domenichino, Guido, Lanfranco, Albano, Guercino, Cavidone, Schidone, Tiarini, though it is sufficiently apparent that they came from the school of the Caraccis, have yet the appearance of men who extended their views beyond the model that lay before them, and have shown that they had opinions of their own, and thought for themselves, after they had made themselves masters of the general principles of their schools.

Le Suer's first manner resembles very much that of his master Voüet: but as he soon excelled him, so he differed from him in every part of the art. Carlo Maratti succeeded better than those I have first named, and I think owes his superiority to the extension of his views; beside his master Andrea Sacchi, he imitated Raffaelle, Guido, and the Caraccis. It is true, there is nothing very captivating in Carlo Maratti; but this proceeded from a want which cannot be completely supplied; that is, want of strength of parts. In this certainly, men are not equal; and a man can bring home wares only in proportion to the capital with which he goes to market. Carlo, by diligence, made the most of what he had; but there was undoubtedly a heaviness about him, which extended itself, uniformly, to his invention, expression, his drawing, colouring, and the general effect of his pictures. The truth is, he never equalled any of his patterns in any one thing, and he added little of his own.

But we must not rest contented even in this general study

of the moderns; we must trace back the art to its fountain-head; to that source from whence they drew their principal excellencies, the monuments of pure antiquity. All the inventions and thoughts of the Antients, whether conveyed to us in statues, bas-reliefs, intaglios, cameos, or coins, are to be sought after and carefully studied; the genius that hovers over these venerable relicks, may be called the father of modern art.

From the remains of the works of the antients the modern arts were revived, and it is by their means that they must be restored a second time.[21] However it may mortify our vanity, we must be forced to allow them our masters; and we may venture to prophesy, that when they shall cease to be studied, arts will no longer flourish, and we shall again relapse into barbarism.

The fire of the artist's own genius operating upon these materials which have been thus diligently collected, will enable him to make new combinations, perhaps, superior to what had ever before been in the possession of the art: as in the mixture of the variety of metals, which are said to have been melted and run together at the burning of Corinth, a new and till then unknown metal was produced, equal in value to any of those that had contributed to its composition.[22] And though a curious refiner should come with his crucibles, analyse and separate its various component parts, yet Corthinian brass would still hold its rank amongst the most beautiful and valuable of metals.

We have hitherto considered the advantages of imitation as it tends to form the taste, and as a practice by which a spark of that genius may be caught, which illumines those noble works that ought always to be present to our thoughts.

We come now to speak of another kind of imitation;[23] the borrowing a particular thought, an action, attitude or figure,

and transplanting it into your own work, this will either come under the charge of plagiarism, or be warrantable, and deserve commendation, according to the address with which it is performed. There is some difference, likewise, whether it is upon the antients or moderns that these depredations are made. It is generally allowed, that no man need be ashamed of copying the antients: their works are considered as a magazine[24] of common property, always open to the public, whence every man has a right to take what materials he pleases; and if he has the art of using them, they are supposed to become to all intents and purposes his own property. The collection of the thoughts of the Antients which Raffaelle made with so much trouble, is a proof of his opinion on this subject. Such collections may be made with much more ease, by means of an art scarce known in this time; I mean that of engraving; by which, at an easy rate, every man may now avail himself of the inventions of antiquity.

It must be acknowledged that the works of the moderns are more the property of their authors. He, who borrows an idea from an antient, or even from a modern artist not his contemporary, and so accommodates it to his own work, that it makes a part of it, with no seam or joining appearing, can hardly be charged with plagiarism; poets practise this kind of borrowing, without reserve. But an artist should not be contented with this only; he should enter into a competition with his original, and endeavour to improve what he is appropriating to his own work. Such imitation is so far from having any thing in it of the servility of plagiarism, that it is a perpetual exercise of the mind, a continual invention. Borrowing or stealing with such art and caution, will have a right to the same lenity as was used by the Lacedemonians; who did not punish theft, but the want of artifice to conceal it.[25]

In order to encourage you to imitation, to the utmost

extent, let me add, that very finished artists in the inferior branches of the art, will contribute to furnish the mind and give hints, of which a skilful painter, who is sensible of what he wants, and is in no danger of being infected by the contract of vicious models, will know how to avail himself. He will pick up from dunghills what by a nice chemistry,[26] passing through his own mind, shall be converted into pure gold; and under the rudeness of Gothic essays, he will find original, rational, and even sublime inventions.

The works of Albert Durer, Lucas Van Leyden, the numerous inventions of Tobias Stimmer, and Jost Ammon, afford a rich mass of genuine materials, which wrought up and polished to elegance, will add copiousness[27] to what, perhaps, without such aid, could have aspired only to justness and propriety.

In the luxuriant style of Paul Veronese, in the capricious compositions of Tintoret, he will find something, that will assist his invention, and give points, from which his own imagination shall rise and take flight, when the subject which he treats will with propriety admit of splendid effects.

In every school, whether Venetian, French, or Dutch, he will find either ingenious compositions, extraordinary effects, some peculiar expressions, or some mechanical excellence, well worthy of his attention, and, in some measure, of his imitation. Even in the lower class of the French painters, great beauties are often found, united with great defects. Though Coypel wanted a simplicity of taste, and mistook a presumptuous and assuming air for what is grand and majestick; yet he frequently has good sense and judgement in his manner of telling his stories, great skill in his compositions, and is not without a considerable power of expressing the passions. The modern affectation of grace in his works, as well as in those of Bosch and Watteau, may be said to be

separated by a very thin partition, from the more simple and pure grace of Correggio and Parmegiano.

Among the Dutch painters, the correct, firm, and determined pencil, which was employed by Bamboccio and Jean Miel, on vulgar and mean subjects, might, without any change, be employed on the highest; to which, indeed, it seems more properly to belong. The greatest style, if that style is confined to small figures, such as Poussin generally painted, would receive an additional grace by the elegance and precision of pencil so admirable in the works of Teniers;[28] and though the school to which he belonged more particularly excelled in the mechanism of painting; yet it produced many, who have shown great abilities in expressing what must be ranked above mechanical excellencies. In the works of Frank Hals, the portrait-painter may observe the composition of a face, the features well put together, as the painter express it; from whence proceeds that strong-marked character of individual nature, which is so remarkable in his portraits, and is not found in an equal degree in any other painter. If he had joined to this most difficult part of the art, a patience in finishing what he had so correctly planned, he might justly have claimed the place which Vandyck, all things considered, so justly holds as the first of portrait-painters.

Others of the same school have shown great power in expressing the character and passions of those vulgar people which were the subjects of their study and attention. Among those, Jan Steen seems to be one of the most diligent and accurate observers of what passed in those scenes which he frequented, and which were to him an academy.[29] I can easily imagine, that if this extraordinary man had had the good fortune to have been born in Italy, instead of Holland, had he lived in Rome, instead of Leyden, and been blessed with Michael Angelo and Raffaelle, for his masters, instead of Brouwer and

Van Goyen; the same sagacity and penetration which distinguished so accurately the different characters and expression in his vulgar figures, would, when exerted in the selection and imitation of what was great and elevated in nature, have been equally successful; and he now would have ranged with the great pillars and supporters of our Art.

Men who, although thus bound down by the almost invincible powers of early habits, have still exerted extraordinary abilities within their narrow and confined circle; and have, from the natural vigour of their mind, given a very interesting expression and great force and energy to their works; though they cannot be recommended to be exactly imitated, may yet invite an artist to endeavour to transfer, by a kind of parody, their excellencies to his own performances. Whoever has acquired the power of making this use of the Flemish, Venetian, and French schools, is a real genius, and has sources of knowledge open to him which were wanting to the great artists who lived in the great age of painting.

To find excellencies, however dispersed; to discover beauties, however concealed by the multitude of defects with which they are surrounded, can be the work only of him, who having a mind always alive to his art, has extended his views to all ages and to all schools; and has acquired from that comprehensive mass which he has thus gathered to himself, a well-digested and perfect idea of his art, to which every thing is referred. Like a sovereign judge and arbiter of art, he is possessed of that presiding power which separates and attracts every excellence from every school; selects both from what is great, and what is little; brings home knowledge from the East and from the West; making the universe tributary towards furnishing his mind and enriching his works with originality, and variety of inventions.

Thus I have ventured to give my opinion of what appears

to me the true and only method by which an artist makes himself master of his profession; which I hold ought to be one continued course of imitation, that is not to cease but with his life.

Those, who either from their own engagements and hurry of business, or from indolence, or from conceit and vanity, have neglected looking out of themselves, as far as my experience and observation reaches, have from that time, not only ceased to advance, and improve in their performances, but have gone backward. They may be compared to men who have lived upon their principal, till they are reduced to beggary, and left without resources.

I can recommend nothing better therefore, than that you endeavour to infuse into your works what you learn from the contemplation of the works of others. To recommend this has the appearance of needless and superfluous advice; but it has fallen within my own knowledge, that artists, though they were not wanting in a sincere love for their art, though they had great pleasure in seeing good pictures, and were well skilled to distinguish what was excellent or defective in them, yet have gone on in their own manner, without any endeavour to give a little of those beauties, which they admired in others, to their own works. It is difficult to conceive how the present Italian painters, who live in the midst of the treasures of art, should be contented with their own style. They proceed in their common-place inventions, and never think it worth while to visit the works of those great artists with which they are surrounded.

I remember, several years ago, to have conversed at Rome with an artist of great fame throughout Europe;[30] he was not without a considerable degree of abilities, but those abilities were by no means equal to his own opinion of them. From the reputation he had acquired, he too fondly concluded that

he stood in the same rank when compared with his pre-
decessors, as he held with regard to his miserable con-
temporary rivals. In conversation about some particulars of
the works of Raffaelle, he seemed to have, or to affect to
have, a very obscure memory of them. He told me that he
had not set his foot in the Vatican for fifteen years together;
that he had been in treaty to copy a capital picture of Raffaelle,
but that the business had gone off; however, if the agreement
had held, his copy would have greatly exceeded the original.
The merit of this artist, however great we may suppose it, I
am sure would have been far greater, and his presumption
would have been far less, if he had visited the Vatican as in
reason he ought to have done, at least once every month of
his life.

I address myself, Gentlemen, to you who have made some
progress in the art, and are to be, for the future, under the
guidance of your own judgement and discretion. I consider
you as arrived to that period, when you have a right to think
for yourselves, and to presume that every man is fallible; to
study the masters with a suspicion, that great men are not
always exempt from great faults; to criticise, compare, and
rank their works in your own estimation, as they approach to,
or recede from that standard of perfection which you have
formed in your own minds, but which those masters them-
selves, it must be remembered, have taught you to make, and
which you will cease to make with correctness, when you
cease to study them. It is their excellencies which have taught
you their defects.

I would wish you to forget where you are, and who it is
that speaks to you, I only direct you to higher models and
better advisers. We can teach you here but very little; you are
henceforth to be your own teachers. Do this justice, however,
to the English Academy; to bear in mind, that in this place

you contracted no narrow habits, no false ideas, nothing that could lead you to the imitation of any living master, who may be the fashionable darling of the day. As you have not been taught to flatter us, do not learn to flatter yourselves. We have endeavoured to lead you to the admiration of nothing but what is truly admirable. If you choose inferior patterns, or if you make your own *former* works your patterns for your *latter*, it is your own fault.

The purport of this discourse, and, indeed, of most of my other discourses, is, to caution you against that false opinion, but too prevalent among artists, of the imaginary powers of native genius, and its sufficiency in great works. This opinion, according to the temper of mind it meets with, almost always produces, either a vain confidence, or a sluggish despair, both equally fatal to all proficiency.

Study therefore the great works of the great masters, for ever. Study as nearly as you can, in the order, in the manner, and on the principles, on which they studied. Study nature attentively, but always with those masters in your company; consider them as models which you are to imitate, and at the same time as rivals with whom you are to contend.

DISCOURSE VII[1]

THE REALITY OF A STANDARD OF TASTE, AS WELL AS OF CORPORAL
BEAUTY. BESIDE THIS IMMUTABLE TRUTH, THERE ARE SEC-
ONDARY TRUTHS, WHICH ARE VARIABLE; BOTH REQUIRING THE
ATTENTION OF THE ARTIST, IN PROPORTION TO THEIR STAB-
ILITY OR THEIR INFLUENCE.

GENTLEMEN,

IT has been my uniform endeavour, since I first addressed
you from this place, to impress you strongly with one ruling
idea. I wished you to be persuaded, that success in your art
depends almost entirely on your own industry; but the in-
dustry which I principally recommended, is not the industry
of the *hands*, but of the *mind*.

As our art is not a divine *gift*, so neither is it a mechanical
trade. Its foundations are laid in solid science: and practice,
though essential to perfection, can never attain that to which
it aims, unless it works under the direction of principle.

Some writers upon art carry this point too far, and suppose
that such a body of universal and profound learning is requis-
ite, that the very enumeration of its kinds is enough to frighten
a beginner. Vitruvius, after going through the many ac-
complishments of nature, and the many acquirements of learn-
ing, necessary to architect, proceeds with great gravity to
assert that he ought to be well skilled in the civil law; that he
may not be cheated in the title of the ground he builds on.[2]

But without such exaggeration, we may go so far as to assert, that a painter stands in need of more knowledge than is to be picked off his pallet, or collected by looking on his model, whether it be in life or in picture. He can never be a great artist, who is grossly illiterate.[3]

Every man whose business is description, ought to be tolerably conversant with the poets, in some language or other; that he may imbibe a poetical spirit, and enlarge his stock of ideas. He ought to acquire an habit of comparing and digesting his notions. He ought not to be wholly unacquainted with that part of philosophy which gives an insight into human nature, and relates to the manners, characters, passions, and affections. He ought to know *something* concerning the mind, as well as *a great deal* concerning the body of man. For this purpose, it is not necessary that he should go into such a compass of reading, as must, by distracting his attentions, disqualify him for the practical part of his profession, and make him sink the performer in the critick. Reading, if it can be made the favourite recreation of his leisure hours, will improve and enlarge his mind, without retarding his actual industry.[4] What such partial and desultory reading cannot afford, may be supplied by the conversation of learned and ingenious men, which is the best of all substitutes for those who have not the means or opportunities of deep study.[5] There are many such men in this age; and they will be pleased with communicating their ideas to artists, when they see them curious and docile, if they are treated with that respect and deference which is so justly their due. Into such society, young artists, if they make it the point of their ambition, will by degrees be admitted. There, without formal teaching, they will insensibly come to feel and reason like those they live with, and find a rational and systematick taste imperceptibly formed in their minds, which they will know how

to reduce to a standard, by applying general truth to their own purposes, better perhaps than those to whom they owned the original sentiment.

Of these studies, and this conversation, the desire and legitimate offspring is a power of distinguishing right from wrong; which power applied to works of art, is denominated TASTE.[6] Let me then, without further introduction, enter upon an examination, whether taste be so far beyond our reach, as to be unattainable by care; or be so very vague and capricious, that no care ought to be employed about it.

It has been the fate of arts to be enveloped in mysterious and incomprehensible language, as if it was thought necessary that even the terms should correspond to the idea entertained of the instability and uncertainty of the rules which they expressed.

To speak of genius and taste, as in any way connected with reason or common sense, would be, in the opinion of some towering talkers, to speak like a man who possessed neither; who had never felt that enthusiasm, or, to use their own inflated language, was never warmed by that Promethean fire, which animates the canvass and vivifies the marble.[7]

If, in order to be intelligible, I appear to degrade art by bringing her down from her visionary situation in the clouds, it is only to give her a more solid mansion upon the earth. It is necessary that at some time or other we should see things as they really are, and not impose on ourselves by that false magnitude with which objects appear when viewed indistinctly as through a mist.[8]

We will allow a poet to express his meaning, when his meaning is not well known to himself, with a certain degree of obscurity, as it is one source of the sublime.[9] But when, in plain prose, we gravely talk of courting the Muse in shady bowers; waiting the call and inspiration of Genius, finding

out where he inhabits, and where he is to be invoked with the greatest success; of attending to times and seasons when the imagination shoots with the greatest vigour, whether at the summer solstice or the vernal equinox;[10] sagaciously observing how much the wild freedom and liberty of imagination is cramped by attention to established rules;[11] and how this same imagination begins to grow dim in advanced age, smothered and deadened by too much judgement; when we talk such language, or entertain such sentiments as these, we generally rest contented with mere words, or at best entertain notions not only groundless but pernicious.

If all this means, what it is very possible was originally intended only to be meant, that in order to cultivate an art, a man secludes himself from the commerce of the world, and retires into the country at particular seasons: or that at one time of the year his body is in better health, and consequently his mind fitter for the business of hard thinking than at another time; or that the mind may be fatigued and grow confused by long and unremitted application; this I can understand. I can likewise believe, that a man eminent when young for possessing poetical imagination, may, from having taken another road, so neglect its cultivation, as to show less of its powers in his latter life. But I am persuaded, that scarce a poet is to be found, from Homer down to Dryden, who preserved a sound mind in a sound body,[12] and continued practising his profession to the very last, whose latter works are not as replete with the fire of imagination, as those which were produced in his more youthful days.

To understand literally these metaphors, or ideas expressed in poetical language, seems to be equally absurd as to conclude, that because painters sometimes represent poets writing from the dictates of a little winged boy or genius, that this same genius did really inform him in a whisper what he was

to write; and that he is himself but a mere machine, unconscious of the operations of his own mind.

Opinions generally received and floating in the world, whether true or false, we naturally adopt and make our own;[13] they may be considered as a kind of inheritance to which we succeed and are tenants for life, and which we leave to our posterity very nearly in the condition in which we received it; it not being much in any one man's power either to impair or improve it. The greatest part of these opinions, like current coin in its circulation, we are used to take without weighing or examining; but by this inevitable inattention many adulterated pieces are received, which, when we seriously estimate our wealth, we must throw away. So the collector of popular opinions, when he embodies his knowledge, and forms a system, must separate those which are true from those which are only plausible. But it becomes more peculiarly a duty to the professors of art not to let any opinions relating to *that* art pass unexamined. The caution and circumspection required in such examination we shall presently have an opportunity of explaining.

Genius and taste, in their common acceptation, appear to be very nearly related; the difference lies only in this, that genius has superadded to it a habit or power of execution; or we may say, that taste, when this power is added, changes its name, and is called genius. They both, in the popular opinion, pretend to an entire exemption from the restraint of rules. It is supposed that their powers are intuitive; that under the name of genius great works are produced, and under the name of taste an exact judgement is given, without our knowing why, and without our being under the least obligation to reason, precept, or experience.

One can scarce state these opinions without exposing their absurdity; yet they are constantly in the mouths of men, and

particularly of artists. They who have thought seriously on this subject, do not carry the point so far; yet I am persuaded, that even among those few who may be called thinkers, the prevalent opinion allows less than it ought to the powers of reason; and considers the principles of taste, which give all their authority to the rules of art, as more fluctuating, and as having less solid foundations, than we shall find, upon examination, they really have.

The common saying, that *tastes are not to be disputed*,[14] owes its influence, and its general reception, to the same error which leads us to imagine this faculty of too high an original to submit to the authority of an earthly tribunal. It likewise corresponds with the notions of those who consider it as a mere phantom of the imagination, so devoid of substance as to elude all criticism.

We often appear to differ in sentiments from each other, merely from the inaccuracy of terms, as we are not obliged to speak always with critical exactness. Something of this too may arise from want of words in the language in which we speak, to express the more nice discriminations which a deep investigation discovers. A great deal however of this difference vanishes, when each opinion is tolerably explained and understood by constancy and precision in the use of terms.

We apply the term TASTE to that act of the mind by which we like or dislike, whatever be the subject. Our judgement upon an airy nothing,[15] a fancy which has no foundation, is called by the same name which we give to our determination concerning those truths which refer to the most general and most unalterable principles of human nature; to the works which are only to be produced by the greatest efforts of the human understanding. However inconvenient this may be, we are obliged to take words as we find them; all we can do is to distinguish the THINGS to which they are applied.

We may let pass those things which are at once subjects of
taste and sense, and which having as much certainty as the
senses themselves, give no occasion to inquiry or dispute.
The natural appetite or taste of the human mind is for
TRUTH;[16] whether that truth results from the real agreement
or equality of original ideas among themselves; from the agree-
ment of the representation of any object with the thing repre-
sented; or from the correspondence of the several parts of any
arrangement with each other. It is the very same taste which
relishes a demonstration in geometry, that is pleased with the
resemblance of a picture to an original, and touched with the
harmony of musick.

All these have unalterable and fixed foundations in nature,
and are therefore equally investigated by reason, and known
by study; some with more, some with less clearness, but all
exactly in the same way. A picture that is unlike, is false.
Disproportionate ordonnance of parts is not right; because it
cannot be true, until it ceases to be a contradiction to assert,
that the parts have no relation to the whole. Colouring is
true, when it is naturally adapted to the eye, from brightness,
from softness, from harmony, from resemblance; because
these agree with their object, NATURE, and therefore are true;
as true as mathematical demonstration; but known to be true
only to those who study these things.

But beside real, there is also apparent truth, or opinion, or
prejudice. With regard to real truth, when it is known, the taste
which conforms to it is, and must be, uniform. With regard to
the second sort of truth, which may be called truth upon
sufferance, or truth by courtesy, it is not fixed, but variable.
However, whilst these opinions and prejudices, on which it is
founded, continue, they operate as truth; and the art, whose
office it is to please the mind, as well as instruct it, must direct
itself according to opinion, or it will not attain its end.

In proportion as these prejudices are known to be generally diffused, or long received, the taste which conforms to them approaches nearer to certainty, and to a sort of resemblance to real science, even where opinions are found to be no better than prejudices. And since they deserve, on account of their duration and extent, to be considered as really true, they become capable of no small degree of stability and determination, by their permanent and uniform nature.

As these prejudices become more narrow, more local, more transitory, this secondary taste becomes more and more fantastical; recedes from real science; is less to be approved by reason, and less followed in practice; though in no case perhaps to be wholly neglected, where it does not stand, as it sometimes does, in direct defiance of the most respectable opinions received amongst mankind.[17]

Having laid down these positions, I shall proceed with less method, because less will serve to explain and apply them.

We will take it for granted, that reason is something invariable, and fixed in the nature of things; and without endeavouring to go back to an account of first principles, which for ever will elude our search, we will conclude, that whatever goes under the name of taste, which we can fairly bring under the dominion of reason, must be considered as equally exempt from change. If therefore, in the course of this inquiry, we can show that there are rules for the conduct of the artist which are fixed and invariable, it follows of course, that the art of the connoisseur, or, in other words, taste, has likewise invariable principles.

Of the judgement which we make on the works of art, and the preference that we give to one class of art over another, if a reason be demanded, the question is perhaps evaded by answering, I judge from my taste; but it does not follow that a better answer cannot be given, though, for common gazers,

this may be sufficient. Every man is not obliged to investigate the cause of his approbation or dislike.

The arts would lie open for ever to caprice and casualty, if those who are to judge of their excellencies had no settled principles by which they are to regulate their decisions, and the merit or defect of performances were to be determined by unguided fancy. And indeed we may venture to assert, that whatever speculative knowledge is necessary to the artist, is equally and indispensably necessary to the connoisseur.

The first idea that occurs in the consideration of what is fixed in art, or in taste, is that presiding principle of which I have so frequently spoken in former discourses, – the general idea of nature. The beginning, the middle, and the end of every thing that is valuable in taste, is comprised in the knowledge of what is truly nature; for whatever notions are not conformable to those of nature, or universal opinion, must be considered as more or less capricious.

My notion of nature comprehends not only the forms which nature produces, but also the nature and internal fabrick and organization, as I may call it, of the human mind and imagination. The terms beauty, or nature, which are general ideas, are but different modes of expressing the same thing, whether we apply these terms to statues, poetry, or pictures. Deformity is not nature, but an accidental deviation from her accustomed practice.[18] This general idea therefore ought to be called Nature; and nothing else, correctly speaking, has a right to that name. But we are so far from speaking, in common conversation, with any such accuracy, that, on the contrary, when we criticise Rembrandt and other Dutch painters, who introduced into their historical pictures exact representations of individual objects with all their imperfections, we say, – though it is not in a good taste, yet it is nature.

This misapplication of terms must be very often perplexing to the young student. Is not art, he may say, an imitation of nature? Must he not therefore who imitates her with the greatest fidelity be the best artist? By this mode of reasoning Rembrandt has a higher place than Raffaelle. But a very little reflection will serve to show us that these particularities cannot be nature: for how can that be the nature of man, in which no two individuals are the same?

It plainly appears, that as a work is conducted under the influence of general ideas, or partial, it is principally to be considered as the effect of a good or a bad taste.

As beauty therefore does not consist in taking what lies immediately before you, so neither, in our pursuit of taste, are those opinions which we first received and adopted, the best choice, or the most natural to the mind and imagination. In the infancy of our knowledge we seize with greediness the good that is within our reach; it is by after-consideration, and in consequence of discipline, that we refuse the present for a greater good at a distance. The nobility or elevation of all arts, like the excellency of virtue itself, consists in adopting this enlarged and comprehensive idea; and all criticism built upon the more confined view of what is natural, may properly be called *shallow* criticism, rather than false: its defect is, that the truth is not sufficiently extensive.

It has sometimes happened, that some of the greatest men in our art have been betrayed into errors by this confined mode of reasoning. Poussin, who, upon the whole may be produced as an artist strictly attentive to the most enlarged and extensive ideas of nature, from not having settled principles on this point, has, in one instance at least, I think, deserted truth for prejudice. He is said to have vindicated the conduct of Julio Romano for his inattention to the masses of light and shade, or grouping the figures in THE BATTLE OF

CONSTANTINE,[19] as if designedly neglected, the better to cor-
respond with the hurry and confusion of a battle. Poussin's
own conduct in many of his pictures, makes us more easily
give credit to this report,[20] That it was too much his own
practice, THE SACRIFICE TO SILENUS, and THE TRIUMPH
OF BACCHUS AND ARIADNE,*[21] may be produced as in-
stances; but this principle is still more apparent, and may
be said to be even more ostentatiously displayed in his
PERSEUS and MEDUSA'S HEAD.†[22]

This is undoubtedly a subject of great bustle and tumult,
and that the first effect of the picture may correspond to the
subject, every principle of composition is violated; there is no
principal figure, no principal light, no groups; every thing is
dispersed, and in such a state of confusion, that the eye finds
no repose any where. In consequence of the forbidding appear-
ance, I remember turning from it with disgust, and should
not have looked a second time, if I had not been called back
to a closer inspection. I then indeed found, what we may
expect always to find in the works of Poussin, correct drawing,
forcible expression, and just character; in short all the ex-
cellencies which so much distinguish the works of this learned
painter.

This conduct of Poussin I hold to be entirely improper to
imitate. A picture should please at first sight, and appear to
invite the spectator's attention: if on the contrary the general
effect offends the eye, a second view is not always sought,
whatever more substantial and intrinsic merit it may possess.

Perhaps no apology ought to be received for offences com-
mitted against the vehicle (whether it be the organ of seeing,

* In the Cabinet of the Earl of Ashburnham.
† In the Cabinet of Sir Peter Burrel.

or of hearing,) by which our pleasures are conveyed to the mind. We must take care that the eye be not perplexed and distracted by a confusion of equal parts, or equal lights, or offended by an unharmonious mixture of colours, as we should guard against offending the ear by unharmonious sounds. We may venture to be more confident of the truth of this observation, since we find that Shakspeare, on a parallel occasion, has made Hamlet recommend to the players a precept of the same kind, – never to offend the ear by harsh sounds: *In the very torrent, tempest, and whirlwind of your passion*, says he, *you must acquire and beget a temperance that may give it smoothness.* And yet, at the same time, he very justly observes, *The end of playing, both at the first, and now, was and is, to hold, as 't were, the mirrour up to nature.*[23] No one can deny, that violent passions will naturally emit harsh and disagreeable tones: yet this great poet and critick thought that this imitation of nature would cost too much, if purchased at the expence of disagreeable sensations, or, as he expresses it, of *splitting the ear*.[24] The poet and actor, as well as the painter of genius who is well acquainted with all the variety and sources of pleasure in the mind and imagination, has little regard or attention to common nature, or creeping after common sense. By overleaping those narrow bounds, he more effectually seizes the whole mind, and more powerfully accomplishes his purpose. This success is ignorantly imagined to proceed from inattention to all rules, and a defiance of reason and judgement: whereas it is in truth acting according to the best rules in the justest reason.

He also thinks nature, in the narrow sense of the word, is alone to be followed, will produce but a scanty entertainment for the imagination: every thing is to be done with which it is natural for the mind to be pleased, whether it proceeds from

simplicity or variety, uniformity or irregularity; whether the scenes are familiar or exotic; rude and wild, or enriched and cultivated; for it is natural for the mind to be pleased with all these in their turn. In short, whatever pleases has in it what is analogous to the mind, and is, therefore, in the highest and best sense of the word, natural.

It is the sense of nature or truth, which ought more particularly to be cultivated by the professors of art: and it may be observed, that many wise and learned men, who have accustomed their minds to admit nothing for truth but what can be proved by mathematical demonstration, have seldom any relish for those arts which address themselves to the fancy, the rectitude and truth of which is known by another kind of proof: and we may add, that the acquisition of this knowledge requires as much circumspection and sagacity, as is necessary to attain those truths which are more capable of demonstration. Reason must ultimately determine our choice on every occasion; but this reason may still be exerted ineffectually by applying to taste principles which though right as far as they go, yet do not reach the object. No man, for instance, can deny, that it seems at first view very reasonable, that a statue which is to carry down to posterity the resemblance of an individual, should be dressed in the fashion of the times, in the dress which he himself wore: this would certainly be true, if the dress were part of the man: but after a time, the dress is only an amusement for an antiquarian; and if it obstructs the general design of the piece, it is to be disregarded by the artist. Common sense must here give way to a higher sense. In the naked form, and in the disposition of the drapery, the difference between one artist and another is principally seen. But if he is compelled to exhibit the modern dress, the naked form is entirely hid, and the drapery is already disposed by the skill of the tailor. Were a Phidias to

obey such absurd commands, he would please no more than an ordinary sculptor; since, in the inferior parts of every art, the learned and the ignorant are nearly upon a level.

These were probably among the reasons that induced the sculptor of that wonderful figure of Laocoon[25] to exhibit him naked, notwithstanding he was surprised in the act of sacrificing to Apollo, and consequently ought to have been shown in his sacerdotal habits, if those greater reasons had not preponderated. Art is not yet in so high estimation with us, as to obtain so great a sacrifice as the antients made, especially the Grecians; who suffered themselves to be represented naked, whether they were generals, law-givers, or kings.

Under this head of balancing and choosing the greater reason, or of two evils taking the least, we may consider the conduct of Rubens in the Luxembourg gallery,[26] where he has mixed allegorical figures with the representations of real personages, which must be acknowledged to be a fault; yet, if the artist considered himself as engaged to furnish this gallery with a rich, various, and splendid ornament, this could not be done, at least in an equal degree, without peopling the air and water with these allegorical figures: he therefore accomplished all that he purposed. In this case all lesser considerations, which tend to obstruct the great end of the work, must yield and give way.

The variety which portraits and modern dresses, mixed with allegorical figures, produce, is not to be slightly given up upon a punctilio of reason, when that reason deprives the art in a manner of its very existence. It must always be remembered that the business of a great painter is to produce a great picture; he must therefore take special care not to be cajoled by specious arguments out of his materials.

What has been so often said to the disadvantage of allegorical poetry, – that it is tedious, and uninteresting,[27] – cannot

with the same propriety be applied to painting, where the interest is of a different kind. If allegorical painting produces a greater variety of ideal beauty, a richer, a more various and delightful composition, and gives to the artist a greater opportunity of exhibiting his skill, all the interest he wishes for is accomplished, such a picture not only attracts, but fixes the attention.

If it be objected that Rubens judged ill at first in thinking it necessary to make his work so very ornamental, this puts the question upon new ground. It was his peculiar style; he could paint in no other; and he was selected for that work, probably because it was his style. Nobody will dispute but some of the best of the Roman or Bolognian schools would have produced a more learned and more noble work.

This leads us to another important province of taste, that of weighing the value of the different classes of the art, and of estimating them accordingly.

All arts have means within them of applying themselves with success both to the intellectual and sensitive part of our natures. It cannot be disputed, supposing both these means put in practice with equal abilities, to which we ought to give the preference; to him who represents the heroick arts and more dignified passions of man, or to him who, by the help of meretricious ornaments, however elegant and graceful, captivates the sensuality, as it may be called, of our taste. Thus the Roman and Bolognian schools are reasonably preferred to the Venetian, Flemish, or Dutch schools, as they address themselves to our best and noblest faculties.

Well-turned periods in eloquence, or harmony of numbers in poetry, which are in those arts what colouring is in painting, however highly we may esteem them, can never be considered as of equal importance with the art of unfolding truths that are useful to mankind, and which make us better or

wiser. Nor can those works which remind us of the poverty
and meanness of our nature, be considered as of equal rank
with what excites ideas of grandeur, or raises and dignifies
humanity; or, in the words of a late poet, which makes the
beholder *learn to venerate himself as a man.**[28]

It is reason and good sense, therefore, which ranks and
estimates every art, and every part of that art, according to its
importance, from the painter of animated, down to inani-
mated nature. We will not allow a man, who shall prefer the
inferior style, to say it is his taste; taste here has nothing, or
at least ought to have nothing, to do with the question. He
wants not taste, but sense and soundness of judgement.

Indeed perfection in an inferior style may be reasonably
preferred to mediocrity in the highest walks of art. A land-
scape of Claude Lorrain may be preferred to a history by
Luca Giordano; but hence appears the necessity of the con-
noisseur's knowing in what consists the excellency of each
class, in order to judge how near it approaches to perfection.

Even in works of the same kind, as in history-painting,
which is composed of various parts, excellence of an inferior
species, carried to a very high degree, will make a work very
valuable, and in some measure compensate for the absence of
the higher kinds of merit. It is the duty of the connoisseur to
know and esteem, as much as it may deserve, every part of
painting: he will not then think even Bassano unworthy of his
notice; who, though totally devoid of expression, sense, grace,
or elegance, may be esteemed on account of his admirable
taste of colours, which, in his best works, are little inferior to
those of Titian.

Since I have mentioned Bassano, we must do him likewise

*Dr Goldsmith.

the justice to acknowledge, that though he did not aspire to
the dignity of expressing the characters and passions of men,
yet, with respect to facility and truth in his manner of touch-
ing animals of all kinds, and giving them what painters call
their character, few have excelled him.

To Bassano we may add Paul Veronese and Tintoret, for
their entire inattention to what is justly thought the most
essential part of our art, the expression of the passions. Not-
withstanding these glaring deficiencies, we justly esteem their
works; but it must be remembered, that they do not please
from those defects, but from their great excellencies of an-
other kind, and in spite of such transgressions. These ex-
cellencies, too, as far as they go, are founded in the truth of
general nature; they tell the *truth*, though not *the whole truth*.

By these considerations, which can never be too frequently
impressed, may be obviated two errors, which I observed to
have been, formerly at least, the most prevalent, and to be
most injurious to artists; that of thinking taste and genius to
have nothing to do with reason, and that of taking particular
living objects for nature.

I shall now say something on that part of *taste*, which, as I
have hinted to you before, does not belong so much to the
external form of things, but is addressed to the mind, and
depends on its original frame, or, to use the expression,
the organization of the soul; I mean the imagination and the
passions. The principles of these are as invariable as the
former, and are to be known and reasoned upon in the same
manner, by an appeal to common sense deciding upon the
common feelings of mankind. This sense, and these feelings,
appear to me of equal authority, and equally conclusive. Now
this appeal implies a general uniformity and agreement in the
minds of men. It would be else an idle and vain endeavour to
establish rules of art; it would be pursuing a phantom, to

attempt to move affections with which we were entirely un-
acquainted. We have no reason to suspect there is a greater
difference between our minds than between our forms; of
which, though there are no two alike, yet there is a general
similitude that goes through the whole race of mankind; and
those who have cultivated their taste, can distinguish what is
beautiful or deformed, or, in other words, what agrees with
or deviates from the general idea of nature, in one case, as
well as in the other.

The internal fabrick of our minds,[29] as well as the external
form of our bodies, being nearly uniform; it seems then to
follow of course, that as the imagination is incapable of pro-
ducing any thing originally of itself, and can only vary and
combine those ideas with which it is furnished by means
of the senses, there will be necessarily an agreement in the im-
aginations, as in the senses of men. There being this agree-
ment, it follows, that in all cases, in our lightest amusements,
as well as in our most serious actions and engagements of life,
we must regulate our affections of every kind by that of others.
The well-disciplined mind acknowledges this authority, and
submits its own opinion to the publick voice. It is from
knowing what are the general feelings and passions of man-
kind, that we acquire a true idea of what imagination is;
though it appears as if we had nothing to do but to consult
our own particular sensations, and these were sufficient to
ensure us from all error and mistake.

A knowledge of the disposition and character of the human
mind can be acquired only by experience:[30] a great deal will
be learned, I admit, by a habit of examining what passes in
our bosoms, what are our own motives of action, and of what
kind of sentiments we are conscious on any occasion. We may
suppose an uniformity, and conclude that the same effect will
be produced by the same cause in the minds of others. This

examination will contribute to suggest to us matters of in-
quiry; but we can never be sure that our own sentiments are
true and right, till they are confirmed by more extensive
observation. One man opposing another determines nothing;
but a general union of minds, like a general combination of
the forces of all mankind, makes a strength that is irresistible.
In fact, as he who does not know himself, does not know
others, so it may be said with equal truth, that he who does
not know others, knows himself but very imperfectly.

A man who thinks he is guarding himself against prejudices
by resisting the authority of others, leaves open every avenue
to singularity, vanity, self-conceit, obstinancy, and many
other vices, all tending to warp the judgement, and prevent
the natural operation of his faculties. This submission to
others is a deference which we owe, and indeed are forced
involuntarily to pay. In fact, we never are satisfied with our
opinions, whatever we may pretend, till they are ratified and
confirmed by the suffrages of the rest of mankind. We dispute
and wrangle for ever; we endeavour to get men to come to us,
when we do not go to them.

He therefore who is acquainted with the works which have
pleased different ages and different countries, and has formed
his opinion on them, has more materials, and more means of
knowing what is analogous to the mind of man, than he who
is conversant only with the works of his own age or country.
What has pleased, and continues to please, is likely to please
again: hence are derived the rules of art, and on this immove-
able foundation they must ever stand.[31]

This search and study of the history of the mind ought not
to be confined to one art only. It is by the analogy that one
art bears to another, that many things are ascertained, which
either were but faintly seen, or, perhaps, would not have been
discovered at all, if the inventor had not received the first

hints from the practices of a sister art on a similar occasion.*[32] The frequent allusions which every man who treats of any art is obliged to make to others, in order to illustrate and confirm his principles, sufficiently show their near connection and inseparable relation.

All arts having the same general end, which is to please; and addressing themselves to the same faculties through the medium of the senses; it follows that their rules and principles must have a great affinity, as the different materials and the different organs or vehicles by which they pass to the mind, will permit them to retain.†

We may therefore conclude, that the real substance, as it may be called, of what goes under the name of taste, is fixed and established in the nature of things; that there are certain and regular causes by which the imagination and passions of men are affected; and that the knowledge of these causes is acquired by a laborious and diligent investigation of nature, and by the same slow progress as wisdom or knowledge of every kind, however instantaneous its operations may appear when thus acquired.[33]

It has been often observed, that the good and virtuous man alone can acquire this true or just relish even of works of art. This opinion will not appear entirely without foundation, when we consider that the same habit of mind, which is acquired by our search after truth in the more serious duties of life, is only transferred to the pursuit of lighter amusements. The same disposition, the same desire to find something steady, substantial, and durable, on which the mind can

* Nulla ars, non alterius artis, aut mater, aut propinqua est. TERTULL. as cited by JUNIUS.

† Omnes artes quæ ad humanitatem pertinent, habent quoddam commune vinculum, et quasi cognatione inter se continentur. CICERO.

lean as it were, and rest with safety, actuates us in both cases. The subject only is changed. We pursue the same method in our search after the idea of beauty and perfection of each; of virtue, by looking forwards beyond ourselves to society, and to the whole; of arts, by extending our views in the same manner to all ages and all times.

Every art, like our own, has in its composition fluctuating as well as fixed principles. It is an attentive inquiry into their difference that will enable us to determine how far we are influenced by custom and habit, and what is fixed in the nature of things.

To distinguish how much has solid foundation, we may have recourse to the same proof by which some hold that wit ought to be tried; whether it preserves itself when translated. That wit is false, which can subsist only in one language;[34] and that picture which pleases only one age or one nation, owes its reception to some local or accidental association of ideas.

We may apply this to every custom and habit of life. Thus the general principles of urbanity, politeness, or civility, have been the same in all nations; but the mode in which they are dressed, is continually varying. The general idea of showing respect is by making yourself less; but the manner, whether by bowing the body, kneeling, prostration, pulling off the upper part of our dress, or taking away the lower,* is a matter of custom.

Thus, in regard to ornaments, – it would be unjust to conclude that because they were at first arbitrarily contrived, they are therefore undeserving of our attention: on the contrary, he who neglects the cultivation of those ornaments,

*Put off thy shoes from off thy feet, for the place whereon thou standest is holy ground. Exodus, iii.5.

acts contrary to nature and reason. As life would be imperfect without its highest ornaments, the Arts, so these arts themselves would be imperfect without *their* ornaments. Though we by no means ought to rank these with positive and substantial beauties, yet it must be allowed, that knowledge of both is essentially requisite towards forming a complete, whole, and perfect taste. It is in reality from the ornaments, that arts receive their peculiar character and complexion; we may add, that in them we find the characteristical mark of a national taste; as by throwing up a feather in the air, we know which way the wind blows, better than by a more heavy matter.

The striking distinction between the works of the Roman, Bolognian, and Venetian schools, consists more in that general effect which is produced by colours, than in the more profound excellencies of the art; at least it is from thence that each is distinguished and known at first sight. Thus it is the ornaments, rather than the proportions of architecture, which at the first glance distinguish the different orders from each other; the Dorick is known by its triglyphs, the Ionick by its volutes, and the Corinthian by its acanthus.[35]

What distinguishes oratory from a cold narration, is a more liberal, though chaste, use of those ornaments which go under the name of figurative and metaphorical expressions; and poetry distinguishes itself from oratory, by words and expressions still more ardent and glowing. What separates and distinguishes poetry, is more particularly the ornament of *verse*: it is this which gives it its character, and is an essential without which it cannot exist. Custom has appropriated different metre to different kinds of composition, in which the world is not perfectly agreed. In England the dispute is not yet settled, which is to be preferred, rhyme or blank verse.[36] But however we disagree about what these metrical ornaments

shall be, that some metre is essentially necessary, is universally acknowledged.

In poetry or eloquence, to determine how far figurative or metaphorical language may proceed, and when it begins to be affectation or beside the truth, must be determined by taste; though this taste, we must never forget, is regulated and formed by presiding feeling of mankind, − by those works which have approved themselves to all times and all persons. Thus, though eloquence has undoubtedly an essential and intrinsic excellence, and immoveable principles common to all languages, founded in the nature of our passions and affections; yet it has its ornaments and modes of addresses, which are merely arbitrary. What is approved in the eastern nations as grand and majestic, would be considered by the Greeks and Romans as turgid and inflated; and they, in return, would be thought by the Orientals to express themselves in a cold and insipid manner.

We may add likewise to the credit of ornaments, that it is by their means that Art itself accomplishes its purpose. Fresnoy calls colouring, which is one of the chief ornaments of painting, *lena sororis*,[37] that which procures lovers and admirers to the more valuable excellencies of the art.

It appears to be the same right turn of mind which enables a man to acquire the *truth*, or the just idea of what is right, in the ornaments, as in the more stable principles of art. It has still the same centre of perfection, though it is the centre of a smaller circle.

To illustrate this by the fashion of dress, in which there is allowed to be a good or bad taste. The component parts of dress are continually changing from great to little, from short to long; but the general form still remains; it is still the same general dress, which is comparatively fixed, though on a very slender foundation; but it is on this which fashion must rest.

He who invents with the most success, or dresses in the best taste, would probably, from the same sagacity employed to greater purposes, have discovered equal skill, or have formed the same correct taste, in the highest labours of art.

I have mentioned taste in dress, which is certainly one of the lowest subjects to which this word is applied; yet, as I have before observed, there is a right even here, however narrow its foundation, respecting the fashion of any particular nation. But we have still more slender means of determining, to which of the different customs of different ages or countries we ought to give the preference, since they seem to be all equally removed from nature. If an European, when he has cut off his beard, and put false hair on his head, or bound up his own natural hair in regular hard knots, as unlike nature as he can possibly make it; and after having rendered them immoveable by the help of the fat of hogs, has covered the whole with flour, laid on by a machine with the utmost regularity; if, when thus attired, he issues forth, and meets a Cherokee Indian,[38] who has bestowed as much time at his toilet, and laid on with equal care and attention his yellow and red oker on particular parts of his forehead or cheeks, as he judges most becoming; whoever of these two despises the other for this attention to the fashion of his country, which ever first feels himself provoked to laugh, is the barbarian.

All these fashions are very innocent; neither worth disquisition, nor any endeavour to alter them; as the charge would, in all probability, be equally distant from nature. The only circumstance against which indignation may reasonably be moved, is, where the operation is painful or destructive of health; such as some of the practices at Otaheite,[39] and the straight lacing of the English ladies; of the last of which practices, how destructive it must be to health and long life,

the professor of anatomy took an opportunity of proving a few days since in this Academy.

It is in dress as in things of greater consequence. Fashions originate from those only who have the high and powerful advantages of rank, birth, and fortune. Many of the ornaments of art, those at least for which no reason can be given, are transmitted to us, are adopted, and acquire their consequence from the company in which we have been used to see them. As Greece and Rome are the fountains from whence have flowed all kinds of excellence, to that veneration which they have a right to claim for the pleasure and knowledge which they have afforded us, we voluntarily add our approbation of every ornament and every custom that belonged to them, even to the fashion of their dress. For it may be observed that, not satisfied with them in their own place, we make no difficulty of dressing statues of modern heroes or senators in the fashion of the Roman armour or peaceful robe; we go so far as hardly to bear a statue in any other drapery.

The figures of the great men of those nations have come down to us in sculpture. In sculpture remain almost all the excellent specimens of ancient art. We have so far associated personal dignity to the persons thus represented, and the truth of art to their manner of representation, that it is not in our power any longer to separate them. This is not so in painting; because having no excellent ancient portraits, that connection was never formed. Indeed we could no more venture to paint a general officer in a Roman military habit, than we could make a statue in the present uniform.[40] But since we have no ancient portraits, – to show how ready we are to adopt those kind of prejudices, we make the best authority among the moderns serve the same purpose. The great variety of excellent portraits with which Vandyck has enriched this nation, we are not content to admire for their real excellence,

but extend our approbation even to the dress, which happened
to be the fashion of that age. We all very well remember how
common it was a few years ago for portraits to be drawn in
this fantastick dress; and this custom is not yet entirely laid
aside. By this means it must be acknowledged very ordinary
pictures acquired something of the air and effect of the works
of Vandyck, and appeared therefore at first sight to be better
pictures than they really were; they appeared so, however, to
those only who had the means of making this association; and
when made, it was irresistible. But this association[41] is nature,
and refers to that secondary truth that comes from conformity
to general prejudice and opinion; it is therefore not merely
fantastical. Besides the prejudice which we have in favour of
ancient dresses, there may be likewise other reasons for the
effect which they produce; among which we may justly rank
the simplicity of them, consisting of little more than one
single piece of drapery, without those whimsical capricious
forms by which all other dresses are embarrassed.

Thus, though it is from the prejudice we have in favour of
the ancients, who have taught us architecture, that we have
adopted likewise their ornaments; and though we are satisfied
that neither nature nor reason are the foundation of those
beauties which we imagine we see in that art, yet if any one,
persuaded of this truth, should therefore invent new orders
of equal beauty, which we will suppose to be possible, they
would not please; nor ought he to complain, since the old has
that great advantage of having custom and prejudice on its
side. In this case we leave what has every prejudice in its
favour, to take that which will have no advantage over what
we have left, but novelty: which soon destroys itself, and at
any rate is but a weak antagonist against custom.

Ancient ornaments, having the right of possession, ought
not to be removed, unless to make room for that which not

only has higher pretensions, but such pretensions as will bal-
ance the evil and confusion which innovation always brings
with it.[42]

To this we may add, that even the durability of the ma-
terials will often contribute to give a superiority to one object
over another. Ornaments in buildings, with which taste is
principally concerned, are composed of materials which last
longer than those of which dress is composed; the former
therefore make higher pretensions to our favour and preju-
dice.

Some attention is surely due to what we can no more get
rid of, than we can go out of ourselves. We are creatures of
prejudice; we neither can nor ought to eradicate it; we must
only regulate it by reason; which kind of regulation is indeed
little more than obliging the lesser, the local and temporary
prejudices, to give way to those which are more durable and
lasting.[43]

He, therefore, who in his practice of portrait-painting,
wishes to dignify his subject, which we will suppose to be a
lady, will not paint her in the modern dress, the familiarity of
which alone is sufficient to destroy all dignity. He takes care
that his work shall correspond to those ideas and that imagin-
ation which he knows will regulate the judgement of others;
and therefore dresses his figure something with the general
air of the antique for the sake of dignity, and preserves some-
thing of the modern for the sake of likeness. By this conduct
his works correspond with those prejudices which we have in
favour of what we continually see; and the relish of the antique
simplicity corresponds with what we may call the more
learned and scientific prejudice.

There was a statue made not long since of Voltaire, which
the sculptor, not having that respect for the prejudices of
mankind which he ought to have had, made entirely naked,

and as meagre and emaciated as the original is said to be.[44] The consequence was what might have been expected: it remained in the sculptor's shop, though it was intended as a publick ornament and a publick honour to Voltaire, for it was procured at the expence of his contemporary wits and admirers.

Whoever would reform a nation, supposing a bad taste to prevail in it, will not accomplish his purpose by going directly against the stream of their prejudices. Men's minds must be prepared to receive what is new to them. Reformation is a work of time.[45] A national taste, however wrong it may be, cannot be totally changed at once; we must yield a little to the prepossession which has taken hold on the mind, and we may then bring people to adopt what would offend them, if endeavoured to be introduced by violence. When Battista Franco was employed, in conjunction with Titian, Paul Veronese and Tintoret, to adorn the library of St Mark, his work, Vasari says,[46] gave less satisfaction than any of the others: the dry manner of the Roman school was very ill calculated to please eyes that had been accustomed to the luxuriancy, splendour, and richness of Venetian colouring. Had the Romans been the judges of this work, probably the determination would have been just contrary; for in the more noble parts of the art Battista Franco was perhaps not inferior to any of his rivals.

GENTLEMEN,

It has been the main scope and principal end of this discourse to demonstrate the reality of a standard in taste, as well as in corporeal beauty; that a false or depraved taste is a thing as well known, as easily discovered, as any thing that is deformed, mis-shapen, or wrong, in our form or outward

make; and that this knowledge is derived from the uniformity or sentiments among mankind, from whence proceeds the knowledge of what are the general habits of nature; the result of which is an idea of perfect beauty.

If what has been advanced be true, – that beside this beauty or truth, which is formed on the uniform, eternal, and immutable laws of nature, and which of necessity can be but *one*; that beside this one immutable verity there are likewise what we have called apparent or secondary truths, proceeding from local and temporary prejudices, fancies, fashions or accidental connection of ideas; if it appears that these last have still their foundation, however slender, in the original fabrick of our minds; it follows that all these truths or beauties deserve and require the attention of the artist, in proportion to their stability or duration, or as their influence is more or less extensive. And let me add, that as they ought not to pass their just bounds, so neither do they, in a well-regulated taste, at all prevent or weaken the influence of those general principles, which alone can give to art its true and permanent dignity.

To form this just taste is undoubtedly in your own power, but it is to reason and philosophy that you must have recourse; from them you must borrow the balance, by which is to be weighed and estimated the value of every pretension that intrudes itself on your notice.

The general objection which is made to the introduction of Philosophy into the regions of taste, is, that it checks and restrains the flights of the imagination and gives that timidity, which an over-carefulness not to err or act contrary to reason is likely to produce. It is not so. Fear is neither reason nor philosophy. The true spirit of philosophy, by giving knowledge, gives a manly[47] confidence, and substitutes rational firmness in the place of vain presumption. A man of real taste is always a man of judgement in other respects; and those

inventions which either disdain or shrink from reason, are generally, I fear, more like the dreams of a distempered brain, than the exalted enthusiasm of a sound and true genius. In the midst of the highest flights of fancy or imagination, reason ought to preside from first to last, though I admit her more powerful operation is upon reflection.[48]

Let me add, that some of the greatest names of antiquity, and those who have most distinguished themselves in works of genius and imagination, were equally eminent for their critical skill. Plato, Artistotle, Cicero, and Horace; and among the moderns, Boileau, Corneille,[49] Pope, and Dryden, are at least instances of genius not being destroyed by attention or subjection to rules and science. I should hope therefore that the natural consequence of what has been said, would be, to excite in you a desire of knowing the principles and conduct of the great masters, of our art, and respect and veneration for them when known.

DISCOURSE VIII

THE PRINCIPLES OF ART, WHETHER POETRY OR PAINTING, HAVE THEIR FOUNDATION IN THE MIND; SUCH AS NOVELTY, VARIETY, AND CONTRAST; THESE IN THEIR EXCESS BECOME DEFECTS.— SIMPLICITY. ITS EXCESS DISAGREEABLE.—RULES NOT TO BE ALWAYS OBSERVED IN THEIR LITERAL SENSE: SUFFICIENT TO PRESERVE THE SPIRIT OF THE LAW.—OBSERVATIONS ON THE PRIZE PICTURES.

GENTLEMEN,

I HAVE recommended in former* discourses, that Artists should learn their profession by endeavouring to form an idea of perfection from the different excellencies which lie dispersed in the various schools of painting.[1] Some difficulty will still occur, to know what is beauty, and where it may be found; one would wish not to be obliged to take it entirely on the credit of fame; though to this, I acknowledge, the younger Students must unavoidably submit. Any suspicion in them of the chance of their being deceived, will have more tendency to obstruct their advancement, than even an enthusiastick[2] confidence in the perfection of their models. But to the more advanced in the art, who wish to stand on more stable and firmer ground, and to establish principles on a stronger foun-

* DISCOURSE II and VI.

dation than authority, however venerable or powerful, it may be safely told that there is still a higher tribunal, to which those great masters themselves must submit, and to which indeed every excellence in art must be ultimately referred. He who is ambitious to enlarge the boundaries of his art, must extend his views, beyond the precepts which are found in books or may be drawn from the practice of his predecessors, to a knowledge of those precepts in the mind, those operations of intellectual nature, – to which every thing that aspires to please, must be proportioned and accommodated.

Poetry having a more extensive power than our art, exerts its influence over almost all the passions; among those may be reckoned one of our most prevalent dispositions, anxiety for the future.[3] Poetry operates by raising our curiosity, engaging the mind by degrees to take an interest in the event, keeping that event suspended, and surprising at last with an unexpected catastrophe.

The Painter's art is more confined, and has nothing that corresponds with, or perhaps is equivalent to, this power and advantage of leading the mind on, till attention is totally engaged. What is done by Painting, must be done at one blow; curiosity has received at once all the satisfaction it can ever have.✗ There are, however, other intellectual qualities and dispositions which the Painter can satisfy and affect as powerfully as the poet: among those we may reckon our love of novelty, variety, and contrast: these qualities on examination, will be found to refer to a certain activity and restlessness which has a pleasure and delight in being exercised and put in motion: Art therefore only administers to those wants and desires of the mind.[4]

It requires no long disquisition to show, that the dispositions which I have stated actually subsist in the human mind.

✗ or unresolved suspense

Variety re-animates the attention, which is apt to languish under a continual sameness. Novelty makes a more forcible impression on the mind, than can be made by the representation of what we have often seen before; and contrasts rouse the power of comparison by opposition. All this is obvious; but, on the other hand, it must be remembered, that the mind, though an active principle, has likewise a disposition to indolence; and though it loves exercise, loves it only to a certain degree, beyond which it is very unwilling to be led, or driven; the pursuit therefore of novelty and variety may be carried to excess. When variety entirely destroys the pleasure proceeding from uniformity and repetition, and when novelty counteracts and shuts out the pleasure arising from old habits and customs, they oppose too much the indolence of our disposition: the mind therefore can bear with pleasure but a small portion of novelty at a time. The main part of the work must be in the mode to which we have been used. An affection to old habits and customs I take to be the predominant disposition of the mind, and novelty comes as an exception: where all is novelty, the attention, the exercise of the mind is too violent. Contrast, in the same manner, when it exceeds certain limits, is as disagreeable as a violent and perpetual opposition; it gives to the senses, in their progress, a more sudden change than they can bear with pleasure.

It is then apparent, that those qualities, however they contribute to the perfection of Art, when kept within certain bounds, if they are carried to excess, become defects, and require correction: a work consequently will not proceed better and better as it is more varied; variety can never be the ground-work and principle of the performance – it must be only employed to recreate and relieve.

To apply these general observations which belong equally to all arts, to ours in particular. In a composition, when the

objects are scattered and divided into many equal parts, the eye is perplexed and fatigued, from not knowing where to find the principal action, or which is the principal figure; for where all are making equal pretensions to notice, all are in equal danger of neglect.

The expression which is used very often, on these occasions is, the piece wants repose; a word which perfectly expresses a relief of the mind from that state of hurry and anxiety which it suffers, when looking at a work of this character.

On the other hand, absolute unity, that is, a large work, consisting of one group or mass of light only, would be as defective as an heroick poem without episode,[5] or any collateral incidents to recreate the mind with that variety which it always requires.

An instance occurs to me of two painters, (Rembrandt and Poussin,) of characters totally opposite to each other in every respect, but in nothing more than in their mode of composition, and management of light and shadow. Rembrandt's manner is absolute unity; he often has but one group, and exhibits little more than one spot of light in the midst of a large quantity of shadow: if he has a second mass, that second bears no proportion to the principal. Poussin, on the contrary, has scarce any principal mass of light at all, and his figures are often too much dispersed, without sufficient attention to place them in groups.

The conduct of these two painters is entirely the reverse of what might be expected from their general style and character; the works of Poussin being as much distinguished for simplicity, as those of Rembrandt for combination. Even this conduct of Poussin might proceed from too great an affection to simplicity of *another kind*; too great a desire to avoid that ostentation of art, with regard to light and shadow, on which Rembrandt so much wished to draw the attention: however,

each of them ran into contrary extremes, and it is difficult to determine which is the most reprehensible, both being equally distant from the demands of nature, and the purposes of art.[6]

The same just moderation must be observed in regard to ornaments; nothing will contribute more to destroy repose[7] than profusion, of whatever kind, whether it consists in the multiplicity of objects, or the variety and brightness of colours. On the other hand, a work without ornament, instead of simplicity, to which it makes pretensions, has rather the appearance of poverty. The degree to which ornaments are admissible, must be regulated by the professed style of the work; but we may be sure of this truth, — that the most ornamental style requires repose to set off even its ornaments to advantage. I cannot avoid mentioning here an instance of repose, in that faithful and accurate painter of nature, Shakspeare; the short dialogue between Duncan and Banquo, whilst they are approaching the gates of Macbeth's castle.[8] Their conversation very naturally turns upon the beauty of its situation, and the pleasantness of the air: and Banquo observing the martlets' nests in every recess of the cornice, remarks, that where those birds most breed and haunt, the air is delicate. The subject of this quiet and easy conversation gives that repose so necessary to the mind, after the tumultuous bustle of the preceding scenes, and perfectly contrasts the scene of horrour that immediately succeeds. It seems as if Shakspeare asked himself, What is a Prince likely to say to his attendants on such an occasion? The modern writers seem, on the contrary, to be always searching for new thoughts, such as never could occur to men in the situation represented.[9] This is also frequently the practice of Homer; who, from the midst of battles and horrours, relieves and refreshes the mind of the reader, by introducing some quiet rural image, or picture of familiar domestic life. The writers of every age

and country, where taste has begun to decline, paint and adorn every object they touch; are always on the stretch; never deviate or sink a moment from the pompous and the brilliant. Lucan, Statius, and Claudian, (as a learned critick has observed,)[10] are examples of this bad taste and want of judgement; they never soften their tones, or condescend to be natural; all is exaggeration and perpetual splendour, without affording repose of any kind.

As we are speaking of excesses, it will not be remote from our purpose to say a few words upon simplicity; which, in one of the senses in which it is used, is considered as the general corrector of excess. We shall at present forbear to consider it as implying that exact conduct which proceeds from an intimate knowledge of simple unadulterated nature, as it is then only another word for perfection, which neither stops short of, nor oversteps, reality and truth.

In our inquiry after simplicity, as in many other inquiries of this nature, we can best explain what is right, by showing what is wrong; and indeed, in this case it seems to be absolutely necessary: simplicity, being only a negative virtue, cannot be described or defined. We must therefore explain its nature, and show the advantage and beauty which is derived from it, by showing the deformity which proceeds from its neglect.

Though instances of this neglect might be expected to be found in practice, we should not expect to find in the works of criticks, precepts that bid defiance to simplicity and every thing that relates to it. Du Piles recommends to us portrait-painters, to add Grace and Dignity to the characters of those, whose pictures we draw: so far he is undoubtedly right; but, unluckily, he descends to particulars, and gives his own idea of Grace and Dignity, '*If*, says he, *you draw persons of high character and dignity, they ought to be drawn in such an attitude,*

that the Portraits must seem to speak to us of themselves, and, as
it were, to say to us, "Stop, take notice of me, I am that invincible
King, surrounded by Majesty:" "I am that valiant commander,
who struck terrour everywhere:" "I am that great minister, who
knew all the springs of politicks." "I am that magistrate of
consummate wisdom and probity."[11] He goes on in this
manner, with all the characters he can think on. We may
contrast the tumour of this presumptuous loftiness with the
natural unaffected air of the portraits of Titian, where dignity,
seeming to be natural and inherent, draws spontaneous rever-
ence, and instead of being thus vainly assumed, has the appear-
ance of an unalienable adjunct; whereas such pompous and
laboured insolence of grandeur is so far from creating respect,
that it betrays vulgarity and meanness, and new-acquired con-
sequence.

The painters, many of them at least, have not been back-
ward in adopting the notions contained in these precepts.
The portraits of Rigaud are perfect examples of an implicit
observance of these rules of Du Piles; so that though he was a
painter of great merit in many respects, yet that merit is
entirely overpowered by a total absence of simplicity in every
sense.

Not to multiply instances, which might be produced for
this purpose, from the works of History-painters, I shall men-
tion only one, – a picture which I have seen, of the Supreme
Being by Coypell.[12]

This subject the Roman Catholick painters have taken the
liberty to represent, however indecent the attempt, and how-
ever obvious the impossibility of any approach to an adequate
representation; but here the air and character, which the
Painter has given, and he has doubtless given the highest he
could conceive, are so degraded by an attempt at such dignity
as De Piles has recommended, that we are enraged at the

folly and presumption of the artist, and consider it as little less than profanation.

As we have passed to a neighbouring nation for instances of want of this quality, we must acknowledge, at the same time, that they have produced great examples of simplicity, in Poussin and Le Sueur. But as we are speaking of the most refined and subtle notion of perfection, may we not inquire, whether a curious eye cannot discern some faults, even in those great men? I can fancy, that even Poussin, by abhorring that affectation and that want of simplicity, which he observed in his countrymen, has, in certain particulars, fallen into the contrary extreme, so far as to approach to a kind of affectation: – to what, in writing, would be called pedantry.[13]

When Simplicity, instead of being a corrector, seems to set up for herself; that is, when an artist seems to value himself solely upon this quality; such an ostentatious display of simplicity becomes then as disagreeable and nauseous as any other kind of affectation. He is, however, in this case, likely enough to sit down contented with his work, for though he finds the world look at it with indifference or dislike, as being destitute of every quality that can recreate or give pleasure to the mind, yet he consoles himself that it has simplicity, a beauty of too pure and chaste a nature to be relished by vulgar minds.

It is in art as in morals; no character would inspire us with an enthusiastick admiration of his virtue, if that virtue consisted only in an absence of vice; something more is required; a man must do more than merely his duty, to be a hero.

Those works of the ancients, which are in the highest esteem, have something beside mere simplicity to recommend them. The Apollo, the Venus,[14] the Laocoon, the Gladiator, have a certain Composition of Action, have contrasts sufficient to give grace and energy in a high degree; but it must be

confessed of the many thousand antique statues which we have, that their general characteristick is bordering at least on inanimate insipidity.

Simplicity, when so very inartificial[15] as to seem to evade the difficulties of art, is a very suspicious virtue.

I do not, however, wish to degrade simplicity from the high estimation in which it has been every justly held. It is our barrier against that great enemy to truth and nature, Affectation, which is ever clinging to the pencil, and ready to drop in and poison every thing it touches.

Our love and affection to simplicity proceeds in a great measure from our aversion to every kind of affectation. There is likewise another reason why so much stress is laid upon this virtue; the propensity which artists have to fall into the contrary extreme; we therefore set a guard on that side which is most assailable. When a young artist is first told, that his composition and his attitudes must be contrasted, that he must turn the head contrary to the position of the body, in order to produce grace and animation; that his outline must be undulating, and swelling, to give grandeur; and that the eye must be gratified with a variety of colours:[16] When he is told this, with certain animating words of Spirit, Dignity, Energy, Grace, greatness of Style, and brilliancy of Tints, he becomes suddenly vain of his newly acquired knowledge, and never thinks he can carry those rules too far. It is then that the aid of simplicity ought to be called in to correct the exuberance of youthful ardour.

The same may be said in regard to Colouring, which in its pre-eminence is particularly applied to flesh. An artist in his first essay of imitating nature, would make the whole mass of one colour, as the oldest painters did; till he is taught to observe not only the variety of tints, which are in the object itself, but the differences produced by the gradual decline of

light to shadow: he then immediately puts his instruction in practice, and introduces a variety of distinct colours. He must then be again corrected and told, that though there is this variety, yet the effect of the whole upon the eye must have the union and simplicity of the colouring of nature.

And here we may observe, that the progress of an individual Student bears a great resemblance to the progress and advancement of the Art itself. Want of simplicity would probably be not one of the defects of an artist who had studied nature only, as it was not of the old masters, who lived in the time preceding the great Art of Painting; on the contrary, their works are too simple and too inartificial.

The Art in its infancy, like the first work of a Student, was dry, hard, and simple. But this kind of barbarous simplicity would be better named Penury, as it proceeds from mere want; from want of knowledge, want of resources, want of abilities to be otherwise: their simplicity was the offspring, not of choice, but necessity.

In the second stage they were sensible of this poverty; and those who were the most sensible of the want, were the best judges of the measure of the supply. There were painters who emerged from poverty without falling into luxury. Their success induced others, who probably never would of themselves have had strength of mind to discover the original defect, to endeavour at the remedy by an abuse; and they ran into the contrary extreme.[17] But however they may have strayed, we cannot recommend to them to return to that simplicity which they have justly quitted; but to deal out their abundance with a more sparing hand, with the dignity which makes no parade, either of its riches, or of its art. It is not easy to give a rule which may serve to fix this just and correct medium; because when we may have fixed, or nearly fixed the middle point, taken as a general principle, circumstances may oblige us to

depart from it, either on the side of Simplicity, or on that of
Variety and Decoration.

I thought it necessary in a former discourse,[18] speaking of
the difference of the sublime and ornamental style of painting,
– in order to excite your attention to the more manly, noble,
and dignified manner, – to leave perhaps an impression too
contemptuous of those ornamental parts of our Art, for which
many have valued themselves, and many works are much
valued and esteemed.

I said then, what I thought it was right at that time to say:
I supposed the disposition of young men more inclinable to
splendid negligence, than perseverance in laborious appli-
cation to acquire correctness; and therefore did as we do in
making what is crooked straight, by bending it the contrary
way, in order that it may remain straight at last.

For this purpose, then, and to correct excess or neglect of
any kind, we may here add, that it is not enough that a work
be learned; it must be pleasing: the painter must add grace to
strength, if he desires to secure the first impression in his
favour. Our taste has a kind of sensuality about it, as well as a
love of the sublime; both these qualities of the mind are to
have their proper consequence, as far as they do not counter-
act each other; for that is the grand error which much care
ought to be taken to avoid.

There are some rules, whose absolute authority, like that of
our nurses, continues no longer than while we are in a state of
childhood. One of the first rules, for instance, that I believe
every master would give to a young pupil, respecting his
conduct and management of light and shadow, would be what
Lionardo da Vinci has actually given;[19] that you must oppose
a light ground to the shadowed side of your figure, and a dark
ground to the light side. If Lionardo had lived to see the
superior splendour and effect which has been since produced

by the exactly contrary conduct, – by joining light to light
and shadow to shadow, – though without doubt he would
have admired it, yet, as it ought not, so probably it would not
be the first rule with which he would have begun his instruc-
tions.

Again; in the artificial management of the figures, it is
directed that they shall contrast each other according to the
rules generally given; that if one figure opposes his front to
the spectator, the next figure is to have his back turned, and
that the limbs of each individual figure be contrasted, that is,
if the right leg be put forward, the right arm is to be drawn
back.

It is very proper that those rules should be given in the
Academy; it is proper the young students should be informed
that some research is to be made, and that they should be
habituated to consider every excellence as reduceable to prin-
ciples. Besides, it is the natural progress of instruction to teach
first what is obvious and perceptible to the senses, and from
hence proceed gradually to notions large, liberal, and com-
plete, such as comprise the more refined and higher ex-
cellencies in Art. But when students are more advanced, they
will find that the greatest beauties of character and expression
are produced without contrast; nay more, that this contrast
would ruin and destroy that natural energy of men engaged
in real action, unsolicitous of grace. St Paul preaching at
Athens in one of the Cartoons, far from any affected academ-
ical contrast of limbs, stands equally on both legs, and both
hands are in the same attitude: add contrast, and the whole
energy and unaffected grace of the figure is destroyed. Elymas
the sorcerer[20] stretches both hands forward in the same direc-
tion, which gives perfectly the expression intended. Indeed
you never will find in the works of Raffaelle any of those
school-boy affected contrasts. Whatever contrast there is,

appears without, any seeming agency of art, by the natural chance of things.

What has been said of the evil of excesses of all kinds, whether of simplicity, variety, or contrast, naturally suggests to the painter the necessity of a general inquiry into the true meaning and cause of rules, and how they operate on those faculties to which they are addressed: by knowing their general purpose and meaning, he will often find that he need not confine himself to the literal sense, it will be sufficient if he preserve the spirit of the law.

Critical remarks are not always understood without examples:[21] it may not be improper therefore to give instances where the rule itself though generally received, is false, or where a narrow conception of it may lead the artists into great errors.

It is given as a rule by Fresnoy, That *the principal figure of a subject must appear in the midst of the picture, under the principal light, to distinguish it from the rest.*[22] A painter who should think himself obliged strictly to follow this rule, would encumber himself with needless difficulties; he would be confined to great uniformity of composition, and be deprived of many beauties which are incompatible with its observance. The meaning of this rule extends or ought to extend, no further than this: – That the principal figure should be immediately distinguished at the first glance of the eye; but there is no necessity that the principal light should fall on the principal figure, or that the principal figure should be in the middle of the picture. It is sufficient that it be distinguished by its place, or by the attention of other figures pointing it out to the spectator. So far is this rule from being indispensable, that it is very seldom practised, other considerations of greater consequence often standing in the way. Examples in opposition to this rule, are found in the Cartoons, in Christ's

Charge to Peter, the Preaching of St Paul, and Elymas the Sorcerer, who is undoubtedly the principal object in that picture. In none of those compositions is the principal figure in the midst of the picture. In the very admirable composition of the Tent of Darius,[23] by Le Brun, Alexander is not in the middle of the picture, nor does the principal light fall on him; but the attention of all the other figures immediately distinguishes him, and distinguishes him more properly; the greatest light falls on the daughter of Darius, who is in the middle of the picture, where it is more necessary the principal light should be placed.

It is very extraordinary that Felibien, who has given a very minute description of this picture, but indeed such a description as may be rather called panegyrick than criticism, thinking it necessary (according to the precept of Fresnoy) that Alexander should possess the principal light, has accordingly given it to him; he might with equal truth have said that he was placed in the middle of the picture, as he seemed resolved to give this piece every kind of excellence which he conceived to be necessary to perfection. His generosity is here unluckily misapplied, as it would have destroyed, in a great measure, the beauty of the composition.

Another instance occurs to me, where equal liberty may be taken in regard to the management of light. Though the general practice is, to make a large mass about the middle of the picture surrounded by shadow, the reverse may be practised, and the spirit of the rule may still be preserved. Examples of this principle reversed may be found very frequently in the works of the Venetian School. In the great composition of Paul Veronese, THE MARRIAGE AT CANA,[24] the figures are for the most part in half shadow; the great light is in the sky; and indeed the general effect of this picture, which is so striking, is no more than what we often see in landscapes,

in small pictures of fairs and country feasts; but those prin-
ciples of light and shadow, being transferred to a large scale, to
a space containing near a hundred figures as large as life, and
conducted to all appearance with as much facility, and with
an attention as steadily fixed upon *the whole together*; as if it
were a small picture immediately under the eye, the work
justly excites our admiration; the difficulty being encreased
as the extent is enlarged.

The various modes of composition are infinite; sometimes
it shall consist of one large group in the middle of the picture,
and the smaller groups on each side; or a plain space in the
middle, and the groups of figures ranked round this vacuity.

Whether this principal broad light be in the middle space
of ground, as in THE SCHOOL OF ATHENS;[25] or in the sky, as
in THE MARRIAGE AT CANA, in THE ANDROMEDA, and in
most of the pictures of Paul Veronese; or whether the light be
on the groups; whatever mode of composition is adopted,
every variety and licence is allowable: this only is indisputably
necessary, that to prevent the eye from being distracted and
confused by a multiplicity of objects of equal magnitude,
those objects, whether they consist of lights, shadows, or
figures, must be disposed in large masses and groups properly
varied and contrasted; that to a certain quantity of action a
proportioned space of plain ground is required; that light is
to be supported by sufficient shadow; and we may add, that a
certain quantity of cold colours is necessary to give value and
lustre to the warm colours: what those proportions are cannot
be so well learnt by precept as by observation on pictures,
and in this knowledge bad pictures will instruct as well as
good. Our inquiry why pictures have a bad effect, may be as
advantageous as the inquiry why they have a good effect;
each will corroborate the principles that are suggested by the
other.

Though it is not my *business* to enter into the detail of our Art, yet I must take this opportunity of mentioning one of the means of producing that great effect which we observe in the works of the Venetian painters, as I think it is not generally known or observed. It ought, in my opinion, to be indispensably observed, that the masses of light in a picture be always of a warm mellow colour, yellow, red, or a yellowish-white; and that the blue, the grey, or the green colours be kept almost entirely out of these masses, and be used only to support and set off these warm colours; and for this purpose, a small proportion of cold colours will be sufficient.[26]

Let this conduct be reversed; let the light be cold, and the surrounding colours warm, as we often see in the works of the Roman and Florentine painters, and it will be out of the power of art, even in the hands of Rubens or Titian, to make a picture splendid and harmonious.

Le Brun and Carlo Maratti were two painters of great merit, and particularly what may be called Academical Merit, but were both deficient in this management of colours: the want of observing this rule is one of the causes of that heaviness of effect which is so observable in their works. The principal light in the Picture of Le Brun, which I just now mentioned, falls on Statira, who is dressed very injudiciously in a pale blue drapery; it is true, he has heightened this blue with gold, but that is not enough, the whole picture has a heavy air, and by no means answers the expectation raised by the Print. Poussin often made a spot of blue drapery, when the general hue of the picture was inclinable to brown or yellow; which shows sufficiently, that harmony of colouring was not a part of the art that had much engaged the attention of that great painter.

The conduct of Titian in the picture of BACCHUS AND ARIADNE,[27] has been much celebrated, and justly, for the

harmony of colouring. To Ariadne is given (say the criticks) a red scarf, to relieve the figure from the sea, which is behind her. It is not for that reason, alone, but for another of much greater consequence; for the sake of the general harmony and effect of the picture. The figure of Ariadne is separated from the great group, and is dressed in blue, which added to the colour of the sea, makes that quantity of cold colour which Titian thought necessary for the support and brilliancy of the great group; which group is composed, with very little exception, entirely of mellow colours. But as the picture in this case would be divided into two distinct parts, one half cold, and the other warm, it was necessary to carry some of the mellow colours of the great group into the cold part of the picture, and a part of the cold into the great group; accordingly Titian gave Ariadne a red scarf, and to one of the Bacchante a little blue drapery.

The light of the picture, as I observed, ought to be of a warm colour; for though white may be used for the principal light, as was the practice of many of the Dutch and Flemish painters, yet it is better to suppose *that white* illumined by the yellow rays of the setting sun, as was the manner of Titian. The superiority of which manner is never more striking, than when in a collection of pictures we chance to see a portrait of Titian's hanging by the side of a Flemish picture, (even though that should be of the hand of Vandyck), which, however admirable in other respects, becomes cold and grey in the comparison.

The illuminated parts of objects are in nature of a warmer tint than those that are in the shade: what I have recommended, therefore, is no more, than that the same conduct be observed in the whole, which is acknowledged to be necessary in every individual part. It is presenting to the eye the same effect as that which it has been *accustomed* to feel, which in

this case, as in every other, will always produce beauty; no principle therefore in our art can be more certain, or is derived from a higher source.

What I just now mentioned of the supposed reason why Ariadne has part of her drapery red, gives me occasion here to observe, that this favourite quality of giving objects relief, and which De Piles and all the Criticks have considered as a requisite of the utmost importance,[28] was not one of those objects which much engaged the attention of Titian; painters of an inferior rank have far exceeded him in producing this effect. This was a great object of attention, when art was in its infant state; as it is at present with the vulgar and ignorant, who feel the highest satisfaction in seeing a figure, which, as they say, looks as if they could walk round it. But however low I may rate this pleasure of deception, I should not oppose it, did it not oppose itself to a quality of a much higher kind, by counteracting entirely that fulness of manner which is so difficult to express in words, but which is found in perfection in the best works of Corregio, and we may add, of Rembrandt. This effect is produced by melting and losing the shadows in a ground still darker than those shadows; whereas that relief is produced by opposing and separating the ground from the figure, either by light, or shadow, or colour. This conduct of in-laying, as it may be called, figures on their ground, in order to produce relief, was the practice of the old Painters, such as Andrea Mantegna, Pietro Perugino, and Albert Durer; and to these we may add the first manner of Lionardo da Vinci, Giorgione, and even Corregio; but these three were among the first who began to correct themselves in dryness of style, by no longer considering relief as a principal object. As those two qualities, relief, and fulness of effect, can hardly exist together, it is not very difficult to determine to which we ought to give the preference. An Artist

is obliged for ever to hold a balance in his hand, by which he must determine the value of different qualities; that, when *some* fault must be committed, he may choose the least. Those painters who have best understood the art of producing a good effect, have adopted one principle that seems perfectly conformable to reason; that a part may be sacrificed for the good of the whole. Thus, whether the masses consist of light or shadow, it is necessary that they should be compact and of a pleasing shape: to this end some parts may be made darker and some lighter, and reflections stronger than nature would warrant. Paul Veronese took great liberties of this kind. It is said, that being once asked why certain figures were painted in shade, as no cause was seen in the picture itself, he turned off the inquiry by answering, '*una nuevola che passa,*' a cloud is passing, which has overshadowed them.

But I cannot give a better instance of this practice than a picture which I have of Rubens; it is a representation of a Moonlight.[29] Rubens has not only diffused more light over the picture than is in nature, but has bestowed on it those warm glowing colours by which his works are so much distinguished. It is so unlike what any other painters have given us of Moonlight, that it might be easily mistaken, if he had not likewise added stars, for a fainter setting sun. – Rubens thought the eye ought to be satisfied in this case, above all other considerations: he might, indeed, have made it more natural, but it would have been at the expence of what he thought of much greater consequence, – the harmony proceeding from the contrast and variety of colours.

This same picture will furnish us with another instance, where we must depart from nature for a greater advantage. The Moon in this picture does not preserve so great a superiority in regard to its lightness over the object which it illumines, as it does in nature; this is likewise an intended deviation, and

for the same reason. If Rubens had preserved the same scale
of gradation of light between the Moon and the objects, which
is found in nature, the picture must have consisted of one
small spot of light only, and at a little distance from the
picture nothing but this spot would have been seen. It may
be said, indeed, that this being the case, it is a subject that
ought not to be painted: but then, for the same reason, neither
armour, nor any thing shining ought ever to be painted; for
though pure white is used in order to represent the greatest
light of shining objects, it will not in the picture preserve the
same superiority over flesh, as it has in nature, without keep-
ing that flesh-colour of a very low tint. Rembrandt, who
thought it of more consequence to paint light than the objects
that are seen by it, has done this in a picture of Achilles
which I have.[30] The head is kept down to a very low tint, in
order to preserve this due gradation and distinction between
the armour and the face; the consequence of which is, that
upon the whole, the picture is too black. Surely too much is
sacrificed here to this narrow conception of nature: allowing
the contrary conduct a fault, yet it must be acknowledged a
less fault than making a picture so dark that it cannot be seen
without a peculiar light, and then with difficulty. The merit
or demerit of the different conduct of Rubens and Rembrandt
in those instances which I have given, is not to be determined
by the narrow principles of nature, separated from its effect
on the human mind. Reason and common sense tell us, that
before, and above all other considerations, it is necessary that
the work should be seen, not only without difficulty or in-
convenience, but with pleasure and satisfaction; and every
obstacle which stands in the way of this pleasure and conveni-
ence must be removed.

The tendency of this Discourse, with the instances which
have been given, is not so much to place the Artist above

rules, as to teach him their reason; to prevent him from entertaining a narrow confined conception of Art; to clear his mind from a perplexed variety of rules and their exceptions, by directing his attention to an intimate acquaintance with the passions and affections of the mind, from which all rules arise, and to which they are all referable. Art effects its purpose by their means; an accurate knowledge, therefore, of those passions and dispositions of the mind is necessary to him who desires to affect them upon sure and solid principles.

A complete essay or inquiry into the connection between the rules of Art, and the eternal and immutable dispositions of our passions, would be indeed going at once to the foundation of criticism;*[31] but I am too well convinced what extensive knowledge, what subtle and penetrating judgment would be required to engage in such an undertaking: it is enough for me, if in the language of painters, I have produced a slight sketch of a part of this vast composition, but that sufficiently distinct to show the usefulness of such a theory, and its practicability.

Before I conclude, I cannot avoid making one observation on the pictures now before us.[32] I have observed, that every candidate has copied the celebrated invention of Timanthes in hiding the face of Agamemnon in his mantle; indeed such lavish encomiums have been bestowed on this thought, and that too by men of the highest character in critical knowledge, – Cicero, Quintilian, Valerius, Maximus, and Pliny, –[33] and have been since re-echoed by almost every modern that has written on the Arts, that your adopting it can neither be wondered at, nor blamed. It appears now to be so much

*This was inadvertently said. I did not recollect the admirable treatise *On the Sublime and Beautiful.*

connected with the subject, that the spectator would perhaps
be disappointed in not finding united in the picture what he
always united in his mind, and considered as indispensably
belonging to the subject. But it may be observed, that those
who praise this circumstance were not painters. They use it
as an illustration only of their own art; it served their purpose,
and it was certainly not their business to enter into the objec-
tions that lie against it in another Art. I fear *we* have but very
scanty means of exciting those powers over the imagination
which make so very considerable and refined a part of poetry.
It is a doubt with me, whether we should even make the
attempt. The chief, if not the only occasion which the painter
has for this artifice, is, when the subject is improper to be
more fully represented, either for the sake of decency, or to
avoid what would be disagreeable to be seen: and this is not
to raise or increase the passions, which is the reason that is
given for this practice, but on the contrary to diminish their
effect.

It is true, sketches, or such drawings as painters generally
make for their works, give this pleasure of imagination to a
high degree. From a slight, undetermined drawing, where the
ideas of the composition and character are, as I may say, only
just touched upon, the imagination supplies more than the
painter himself, probably, could produce; and we accordingly
often find that the finished work disappoints the expectation
that was raised from the sketch; and this power of the imagina-
tion is one of the causes of the great pleasure we have in
viewing a collection of drawings by great painters. These
general ideas, which are expressed in sketches, correspond
very well to the art often used in Poetry. A great part of the
beauty of the celebrated description of Eve in Milton's PARA-
DISE LOST,[34] consists in using only general indistinct ex-
pressions, every reader making out the detail according to his

own particular imagination, – his own idea of beauty, grace, expression, dignity, or loveliness: but a painter, when he represents Eve on a canvass, is obliged to give a determined form, and his own idea of beauty distinctly expressed.

We cannot on this occasion, nor indeed on any other, recommend an undeterminate manner or vague ideas of any kind, in a complete and finished picture. This notion, therefore, of leaving any thing to the imagination, opposes a very fixed and indispensable rule in our art, – that every thing shall be carefully and distinctly expressed, as if the painter knew, with correctness and precision, the exact form and character of whatever is introduced into the picture. This is what with us is called Science, and Learning: which must not be sacrificed and given up for an uncertain and doubtful beauty, which, not naturally belonging to our Art, will probably be sought for without success.

Mr Falconet has observed, in a note on this passage in his translation of Pliny, that the circumstance of covering the face of Agamemnon was probably not in consequence of any fine imagination of the painter,[35] which he considers as a discovery of the criticks, – but merely copied from the description of the sacrifice, as it is found in Euripides.

The words from which the picture is supposed to be taken, are these: *Agamemnon saw Iphigenia advance towards the fatal altar; he groaned, he turned aside his head, he shed tears, and covered his face with his robe.*[36]

Falconet does not at all acquiesce in the praise that is bestowed on Timanthes; not only because it is not his invention, but because he thinks meanly of this trick of concealing, except in instances of blood, where the objects would be too horrible to be seen; but, says he, 'in an afflicted Father, in a King, in Agamemnon, you, who are a painter, conceal from me the most interesting circumstance, and then put me off

with sophistry and a veil. You are (he adds) a feeble Painter, without resource: you do not know even those of your Art: I care not what veil it is, whether closed hands, arms raised, or any other action that conceals from me the countenance of the Hero. You think of veiling Agamemnon; you have unveiled your own ignorance. A Painter who represents Agamemnon veiled, is as ridiculous as a Poet would be, who in a pathetic situation, in order to satisfy my expectations, and rid himself of the business, should say, that the sentiments of his hero are so far above whatever can be said on this occasion, that he shall say nothing.'

To what Falconet has said, we may add, that supposing this method of leaving the expression of grief to the imagination, to be, as it was thought to be, the invention of the painter, and that it deserves all the praise that has been given it, still it is a trick that will serve but once; whoever does it a second time, will not only want novelty, but be justly suspected of using artifice to evade difficulties. If difficulties overcome make a great part of the merit of Art, difficulties evaded can deserve but little commendation.

DISCOURSE IX

GENTLEMEN,

THE honour which the Arts acquire by being permitted to take possession of this noble habitation,[1] is one of the most considerable of the many instances we have received of His Majesty's protection; and the strongest proof of his desire to make the Academy respectable.

Nothing has been left undone, that might contribute to excite our pursuit, or to reward our attainments. We have already the happiness of seeing the Arts in a state to which they have never before arrived in this nation. This Building, in which we are now assembled, will remain to many future ages an illustrious specimen of the Architect's* abilities.[2] It is our duty to endeavour that those who gaze with wonder at the structure, may not be disappointed when they visit the apartments. It will be no small addition to the glory which this nation has already acquired from having given birth to eminent men in every part of science, if it should be enabled to produce, in consequence of this institution, a School of

* Sir William Chambers.

English Artists. The estimation in which we stand in respect to our neighbours, will be in proportion to the degree in which we excel or are inferior to them in the acquisition of intellectual excellence, of which Trade and its consequential riches must be acknowledged to give the means; but a people whose whole attention is absorbed in those means, and who forget the end, can aspire but little above the rank of a barbarous nation. Every establishment that tends to the cultivation of the pleasures of the mind, as distinct from those of sense, may be considered as an inferior school of morality, where the mind is polished and prepared for higher attainments.[3]

Let us for a moment take a short survey of the progress of the mind towards what is, or ought to be, its true object of attention. Man, in his lowest state, has no pleasures but those of sense, and no wants but those of appetite; afterwards, when society is divided into different ranks, and some are appointed to labour for the support of others, those whom their superiority sets free from labour, begin to look for intellectual entertainments. Thus, whilst the shepherds were attending their flocks, their masters made the first astronomical observations;[4] so musick is said to have had its origin from a man at leisure listening to the strokes of a hammer.

As the senses, in the lowest state of nature, are necessary to direct us to our support, when that support is once secure there is danger in following them further; to him who has no rule of action but the gratification of the senses, plenty is always dangerous: it is therefore necessary to the happiness of individuals, and still more necessary to the security of society, that the mind should be elevated to the idea of general beauty, and the contemplation of general truth; by this pursuit the mind is always carried forward in search of something more excellent than it finds, and obtains its proper superiority over

the common senses of life, by learning to feel itself capable of
higher aims and nobler enjoyments. In this gradual exaltation
of human nature, every art contributes its contingent towards
the general supply of mental pleasure. Whatever abstracts the
thoughts from sensual gratifications, whatever teaches us to
look for happiness within ourselves, must advance in some
measure the dignity of our nature.[5]

Perhaps there is no higher proof of the excellency of man
than this, – that to a mind properly cultivated whatever is
bounded is little.[6] The mind is continually labouring to ad-
vance, step by step, through successive gradations of excel-
lence, towards perfection, which is dimly seen, at a great
though not hopeless distance, and which we must always
follow because we never can attain;[7] but the pursuit rewards
itself: one truth teaches another, and our store is always in-
creasing, though nature can never be exhausted. Our art, like
all arts which address the imagination, is applied to somewhat
a lower faculty of the mind, which approaches nearer to sen-
suality; but through sense and fancy it must make its way to
reason; for such is the progress of thought, that we perceive
by sense, we combine by fancy, and distinguish by reason:
and without carrying our art out of its natural and true
character, the more we purify it from every thing that is gross
in sense, in that proportion we advance its use and dignity;
and in proportion as we lower it to mere sensuality, we pervert
its nature, and degrade it from the rank of liberal art; and this
is what every artist ought well to remember. Let him re-
member also, that he deserves just so much encouragement
in the state as he makes himself a member of it virtuously
useful, and contributes in his sphere to the general purpose
and perfection of society.

The Art which we profess has beauty for its object; this it
is our business to discover and to express; the beauty of

which we are in quest is general and intellectual; it is an idea
that subsists only in the mind; the sight never beheld it, nor
has the hand expressed it: it is an idea residing in the breast
of the artist, which he is always labouring to impart, and
which he dies at last without imparting; but which he is yet
so far able to communicate as to raise the thoughts, and
extend the views of the spectator; and which, by a succession
of art, may be so far diffused, that its effects may extend
themselves imperceptibly into publick benefits, and be among
the means of bestowing on whole nations refinement of taste:
which, if it does not lead directly to purity of manners,
obviates at least their greatest depravation, by disentangling
the mind from appetite, and conducting the thoughts through
successive stages of excellence, till that contemplation of uni-
versal rectitude and harmony which began by Taste, may, as
it is exalted and refined, conclude in Virtue.[8]

DISCOURSE X

GENTLEMEN,

I SHALL now, as it has been customary on this day, and on
this occasion, communicate to you such observations as have
occurred to me on the Theory of Art.[1]

If these observations have hitherto referred principally to
Painting, let it be remembered that this Art is much more
extensive and complicated than Sculpture, and affords there-
fore a more ample field for criticism; and as the greater
includes the less, the leading principles of Sculpture are com-
prised in those of Painting.

However, I wish now to make some remarks with par-
ticular relation to Sculpture; to consider wherein, or in what
manner, its principles and those of Painting agree or differ;
what is within its power of performing, and what it is vain
or improper to attempt; that it may be clearly and distinctly
known what ought to be the great purpose of the Sculptor's
labours.

Sculpture is an art of much more simplicity and uniformity
than painting; it cannot with propriety, and the best effect, be
applied to many subjects. The object of its pursuit may be

comprised in two words, Form and Character; and those qualities are presented to us in one manner, or in one style only; whereas the powers of Painting, as they are more various and extensive, so they are exhibited in as great a variety of manners. The Roman, Lombard, Florentine, Venetian, and Flemish Schools, all pursue the same end by different means. But Sculpture having but one style, can only to one style of Painting have any relation; and to this (which is indeed the highest and most dignified that Painting can boast), it has a relation so close, that it may be said to be almost the same art operating upon different materials. The Sculptors of the last age, from not attending sufficiently to this discrimination of the different styles of Painting, have been led into many errors. Though they well knew that they were allowed to imitate, or take ideas for the improvement of their own Art from the grand style of Painting, they were not aware that it was not permitted to borrow in the same manner from the ornamental. When they endeavour to copy the picturesque[2] effects, contrasts, or petty excellencies of whatever kind, which not improperly find a place in the inferior branches of Painting, they doubtless imagine themselves improving and extending the boundaries of their art by this imitation; but they are in reality violating its essential character, by giving a different direction to its operations, and proposing to themselves either what is unattainable, or at best a meaner object of pursuit.[3] The grave and austere character of Sculpture requires the utmost degree of formality in composition; picturesque contrasts have here no place; every thing is carefully weighed and measured, one side making almost an exact equipoise to the other: a child is not a proper balance to a full grown figure, nor is a figure sitting or stooping a companion to an upright figure.

The excellence of every art must consist in the complete

accomplishment of its purpose; and if by a false imitation of nature, or mean ambition of producing a picturesque effect or illusion of any kind, all the grandeur of ideas which this art endeavours to excite, be degraded or destroyed, we may boldly oppose ourselves to any such innovation. If the producing of a deception is the summit of this art, let us at once give to statues the addition of colour; which will contribute more towards accomplishing this end, than all those artifices which have been introduced and professedly defended, on no other principle but that of rendering the work more natural. But as colour is universally rejected, every practice liable to the same objection must fall with it. If the business of Sculpture were to administer pleasure to ignorance, or a mere entertainment to the senses, the Venus of Medicis might certainly receive improvement by colour; but the character of Sculpture makes it her duty to afford delight of a different, and, perhaps, of a higher kind; the delight resulting from the contemplation of perfect beauty: and this, which is in truth an intellectual pleasure, is in many respects incompatible with what is merely addressed to the senses, such as that with which ignorance and levity contemplate elegance of form.

The Sculptor may be safely allowed to practise every means within the power of his art to produce a deception, provided this practice does not interfere with or destroy higher excellencies; on these conditions he will be forced, however loth, to acknowledge that the boundaries of his art have long been fixed, and that all endeavours will be vain that hope to pass beyond the best works which remain of ancient Sculpture.

Imitation is the means, and not the end, of art; it is employed by the Sculptor as the language by which his ideas are presented to the mind of the spectator. Poetry and elocution of every sort make use of signs, but those signs are

arbitrary and conventional. The sculptor employs the representation of the thing itself; but still as a means to a higher end, – as a gradual ascent always advancing towards faultless form and perfect beauty. It may be thought at the first view, that even this form, however perfectly presented, is to be valued and take its rank only for the sake of a still higher object, that of conveying sentiment and character, as they are exhibited by attitude, and expression of the passions. But we are sure from experience, that the beauty of form alone, without the assistance of any other quality, makes of itself a great work, and justly claims our esteem and admiration. As a proof of the high value we set on the mere excellence of form, we may produce the greatest part of the works of Michael Angelo, both in painting and sculpture; as well as most of the antique statues, which are justly esteemed in a very high degree, though no very marked or striking character or expression of any kind is represented.

But, as a stronger instance that this excellence alone inspires sentiment, what artist ever looked at the Torso[4] without feeling a warmth of enthusiasm, as from the highest efforts of poetry? From whence does this proceed? What is there in this fragment that produces this effect, but the perfection of this science of abstract form?

A mind elevated to the contemplation of excellence, perceives in this defaced and shattered fragment, *disjecta membra poetæ*,[5] the traces of superlative genius, the reliques of a work on which succeeding ages can only gaze with inadequate admiration.

It may be said that this pleasure is reserved only to those who have spent their whole life in the study and contemplation of this art; but the truth is, that all would feel its effects, if they could divest themselves of the expectation of *deception*, and look only for what it really is, a *partial* representation of

nature. The only impediment of their judgment must then proceed from their being uncertain to what rank, or rather kind of excellence, it aspires; and to what sort of approbation it has a right. This state of darkness is, without doubt, irksome to every mind; but by attention to works of this kind the knowledge of what is aimed at comes of itself, without being taught, and almost without being perceived.

The Sculptor's art is limited in comparison of others, but it has its variety and intricacy within its proper bounds. Its essence is correctness: and when to correct and perfect form is added the ornament of grace, dignity of character, and appropriated expression, as in the Apollo, the Venus, the Laocoon, the Moses of Michael Angelo,[6] and many others, this art may be said to have accomplished its purpose.

What Grace is, how it is to be acquired or conceived, are in speculation difficult questions; but *causa latet, res est notissima*:[7] without any perplexing inquiry, the effect is hourly perceived. I shall only observe, that its natural foundation is correctness of design; and though grace may be sometimes united with incorrectness, it cannot proceed from it.

But to come nearer to our present subject. It has been said that the grace of the Apollo depends on a certain degree of incorrectness; that the head is not anatomically placed between the shoulders; and that the lower half of the figure is longer than just proportion allows.[8]

I know that Corregio and Parmegiano are often produced as authorities to support this opinion; but very little attention will convince us, that the incorrectness of some parts which we find in their works, does not contribute to grace, but rather tends to destroy it. The Madonna, with the sleeping Infant, and beautiful group of Angels, by Parmegiano, in the Palazzo Piti,[9] would not have lost any of its excellence, if the neck, fingers, and indeed the whole figure of the Virgin,

instead of being so very long and incorrect, had preserved their due proportion.

In opposition to the first of these remarks, I have the authority of a very able Sculptor of this Academy,[10] who has copied that figure, consequently measured and carefully examined it, to declare, that the criticism is not true. In regard to the last, it must be remembered that Apollo is here in the exertion of one of his peculiar powers, which is swiftness; he has therefore that proportion which is best adapted to that character. This is no more incorrectness, than when there is given to an Hercules an extraordinary swelling and strength of muscles.

The art of discovering and expressing grace is difficult enough of itself, without perplexing ourselves with what is incomprehensible. A supposition of such a monster as Grace, begot by Deformity, is poison to the mind of a young Artist, and may make him neglect what is essential to his art, correctness of Design, in order to pursue a phantom, which has no existence but in the imagination of affected and refined speculators.

I cannot quit the Apollo, without making one observation on the character of this figure. He is supposed to have just discharged his arrow at the Python; and, by the head retreating a little towards the right shoulder, he appears attentive to its effect. What I would remark is the difference of this attention from that of the Discobolus, who is engaged in the same purpose, watching the effect of his Discus.[11] The graceful, negligent, though animated, air of the one, and the vulgar eagerness of the other, furnish a signal instance of the judgment of the ancient sculptors in their nice discrimination of character. They are both equally true to nature, and equally admirable.

It may be remarked, that Grace, Character, and Expression,

though words of different sense and meaning, and so under-
stood when applied to the works of Painters, are indiscrimi-
nately used when we speak of Sculpture. This indecision
we may suspect to proceed from the undetermined effects of
the Art itself; those qualities are exhibited in Sculpture
rather by form and attitude than by the features, and can
therefore be expressed but in a very general manner.

Though the Laocoon and his two sons have more ex-
pression in the countenance than perhaps any other antique
statues, yet it is only the general expression of pain; and this
passion is still more strongly expressed by the writhing and
contortion of the body than by the features.

It has been observed in a late publication,[12] that if the
attention of the Father in this group had been occupied more
by the distress of his children, than by his own sufferings, it
would have raised a much greater interest in the spectator.
Though this observation comes from a person whose opinion,
in every thing relating to the Arts, carries with it the highest
authority, yet I cannot but suspect that such refined ex-
pression is scarce within the province of this Art; and in
attempting it, the Artist will run the great risk of enfeebling
expression, and making it less intelligible to the spectator.

As a general figure presents itself in a more conspicuous
manner than the features, it is there we must principally look
for expression or character; *patuit in corpore vultus*;[13] and, in
this respect, the Sculptor's art is not unlike that of Dancing,
where the attention of the spectator is principally engaged by
the attitude and action of the performer, and it is there he
must look for whatever expression that art is capable of ex-
hibiting. The Dancers themselves acknowledge this, by often
wearing masks, with little diminution in the expression. The
face bears so very inconsiderable a proportion to the effect
of the whole figure, that the ancient Sculptors neglected to

animate the features, even with the general expression of the passions. Of this the group of the Boxers is a remarkable instance;[14] they are engaged in the most animated action with the greatest serenity of countenance. This is not recommended for imitation, (for there can be no reason why the countenance should not correspond with the attitude and expression of the figure,) but is mentioned in order to infer from hence, that this frequent deficiency in ancient Sculpture could proceed from nothing but a habit of inattention to what was considered as comparatively immaterial.

Those who think Sculpture can express more than we have allowed, may ask, by what means we discover, at the first glance, the character that is represented in a Bust, Cameo, or Intaglio? I suspect it will be found, on close examination, by him who is resolved not to see more than he really does see, that the figures are distinguished by their *insignia* more than by any variety of form or beauty. Take from Apollo his Lyre, from Bacchus his Thirsus[15] and Vineleaves, and Meleager the Boar's Head,[16] and there will remain little or no difference in their characters. In a Juno, Minerva, or Flora, the idea of the artist seems to have gone no further than representing perfect beauty, and afterwards adding the proper attributes,[17] with a total indifference to which they gave them. Thus John de Bologna, after he had finished a group of a young man holding a young woman in his arms, with an old man at his feet, called his friends together, to tell him what name he should give it, and it was agreed to call it The Rape of the Sabines;*[18] and this is the celebrated group which now stands before the old Palace at Florence. The figures have the same general expression which is to be found in most of the antique

* See *Il Reposo di Raffaelle Borghini.*

Sculpture; and yet it would be no wonder if future cricticks should find out delicacy of expression which was never intended; and go so far as to see, in the old man's countenance, the exact relation which he bore to the woman who appears to be taken from him.

Though Painting and Sculpture are, like many other arts, governed by the same general principles, yet in the detail, or what may be called the by-laws of each art, there seems to be no longer any connection between them. The different materials upon which those two arts exert their powers, must infallibly create a proportional difference in their practice. There are many petty excellencies which the Painter attains with ease, but which are impracticable in Sculpture; and which, even if it could accomplish them, would add nothing to the true value and dignity of the work.

Of the ineffectual attempts which the modern Sculptors have made by way of improvement, these seem to be the principal;[19] the practice of detaching drapery from the figure, in order to give the appearance of flying in the air; —

Of making different plans in the same bas-relievos; —

Of attempting to represent the effects of perspective: —

To those we may add the ill effect of figures cloathed in a modern dress.

The folly of attempting to make stone sport and flutter in the air, is so apparent, that it carries with it its own reprehension; and yet to accomplish this, seemed to be the great ambition of many modern Sculptors, particularly Bernini: his art was so much set on overcoming this difficulty, that he was for ever attempting it, though by that attempt he risked every thing that was valuable in the art.

Bernini stands in the first class of modern Sculptors, and therefore it is the business of criticism to prevent the ill effects of so powerful an example.

From his very early work of Apollo and Daphne,[20] the world justly expected he would rival the best productions of ancient Greece; but he soon strayed from the right path. And though there is in his works something which always distinguishes him from the common herd, yet he appears in his latter performances to have lost his way. Instead of pursuing the study of that ideal beauty with which he had so successfully begun, he turned his mind to an injudicious quest of novelty, attempted what was not within the province of the art, and endeavoured to overcome the hardness and obstinacy of his materials; which even supposing he had accomplished, so far as to make this species of drapery appear natural, the ill effect and confusion occasioned by its being detached from the figure to which it belongs, ought to have been alone a sufficient reason to have deterred him from that practice.

We have not, I think, in our Academy, any of Bernini's works, except a cast of the head of his Neptune;[21] this will be sufficient to serve us for an example of the mischief produced by this attempt of representing the effects of the wind. The locks of the hair are flying abroad in all directions, insomuch that it is not a superficial view that can discover what the object is which is represented, or distinguish those flying locks from the features, as they are all of the same colour, of equal solidity, and consequently project with equal force.

The same entangled confusion which is here occasioned by the hair, is produced by drapery flying off; which the eye must, for the same reason, inevitably mingle and confound with the principle parts of the figure.

It is a general rule, equally true in both Arts, that the form and attitude of the figure should be seen clearly, and without any ambiguity, at the first glance of the eye. This the painter can easily do by colour, by losing parts in the ground, or

keeping them so obscure as to prevent them from interfering with the more principal objects. The sculptor has no other means of preventing this confusion than by attaching the drapery for the greater part close to the figure; the folds of which, following the order of the limbs, whenever the drapery is seen, the eye is led to trace the form and attitude of the figure at the same time.

The drapery of the Apollo,[22] though it makes a large mass, and is separated from the figure, does not affect the present question, from the very circumstance of its being so completely separated; and from the regularity and simplicity of its form, it does not in the least interfere with a distinct view of the figure. In reality, it is no more a part of it than a pedestal, a trunk of a tree, or an animal, which we often see joined to statues.

The principal use of those appendages is to strengthen and preserve the statue from accidents; and many are of the opinion, that the mantle which falls from the Apollo's arm is for the same end; but surely it answers a much greater purpose, by preventing that dryness of effect which would inevitably attend a naked arm, extended almost at full length, to which we may add, the disagreeable effect which would proceed from the body and arm making a right angle.

The Apostles, in the church of St John Lateran,[23] appear to me to fall under the censure of an injudicious imitation of the manner of the painters. The drapery of those figures, from being disposed of large masses, gives undoubtedly that air of grandeur which magnitude or quantity is sure to produce. But though it should be acknowledged, that it is managed with great skill and intelligence, and contrived to appear as light as the materials will allow, yet the weight and solidity of stone was not to be overcome.

Those figures are much in the style of Carlo Maratti, and

such as we may imagine he would have made, if he had attempted Sculpture; and when we know he had the super-intendance of that work, and was an intimate friend of one of the principal Sculptors, we may suspect that his taste had some influence, if he did not even give the designs. No man can look at those figures without recognizing the manner of Carlo Maratti. They have the same defect which his works so often have, of being overlaid with drapery, and that too arti-ficially disposed. I cannot but believe, that if Ruscono, Le Gros, Monot, and the rest of the Sculptors employed in that work, had taken for their guide the simple dress, such as we see in the antique statues of the philosophers, it would have given more real grandeur to their figures, and would certainly have been more suitable to the characters of the Apostles.

Though there is no remedy for the ill effect of those solid projections, which flying drapery in stone must always pro-duce in statues, yet in bas-relievos it is totally different; those detached parts of drapery the Sculptor has here as much power over as the Painter, by uniting and losing it in the ground, so that it shall not in the least entangle and confuse the figure.

But here again the Sculptor, not content with this successful imitation, if it may be so called, proceeds to represent figures, or groups of figures on different plans; that is some on the fore-ground, and some at a greater distance, in the manner of Painters in historical compositions. To do this he has no other means than by making the distant figures of less dimen-sions, and relieving them in a less degree from the surface; but this is not adequate to the end; they will still appear only as figures on a less scale, but equally near the eye with those in the front of the piece.

Nor does the mischief of this attempt, which never ac-complishes its intention, rest here: by this division of the

work into many minute parts, the grandeur of its general effect is inevitably destroyed.

Perhaps the only circumstance in which the Modern have excelled the Ancient Sculptors, in the management of a single group in basso-relievo; the art of gradually raising the group from the flat surface, till it imperceptibly emerges into alto-relievo. Of this there is no ancient example remaining that discovers any approach to the skill which Le Gros has shown in an Altar in the Jesuits' Church at Rome.[24] Different plans or degrees of relief in the same group have, as we see in this instance, a good effect, though the contrary happens when the groups are separated, and are at some distance behind each other.

This improvement in the art of composing a group in basso-relievo was probably first suggested by the practice of the modern Painters, who relieve their figures, or groups of figures, from their ground, by the same gentle gradation; and it is accomplished in every respect by the same general principles; but as the marble has no colour, it is the composition itself that must give it its light and shadow. The ancient Sculptors could not borrow this advantage from their Painters, for this was an art with which they appear to have been entirely unacquainted; and in the bas-relievos of Lorenzo Ghiberti, the casts of which we have in the Academy, this art is no more attempted than it was by the Painters of his age.[25]

The next imaginary improvement of the moderns, is the representing the effects of Perspective in bas-relief. Of this little need be said; all must recollect how ineffectual has been the attempt of modern Sculptors to turn their buildings which they have introduced as seen from their angle, with a view to make them appear to recede from the eye in perspective. This, though it may show indeed their eager desire to en-

counter difficulties, shows at the same time how inadequate their materials are even to this their humble ambition.

The Ancients, with great judgment, represented only the elevation of whatever architecture they introduced into their bas-reliefs, which is composed of little more than horizontal or perpendicular lines; whereas the interruption of crossed lines, or whatever causes a multiplicity of subordinate parts, destroys that regularity and firmness of effect on which grandeur of style so much depends.

We came now to the last consideration; in what manner Statues are to be dressed, which are made in honour of men, either now living, or lately departed.

This is a question which might employ a long discourse of itself: I shall at present only observe, that he who wishes not to obstruct the Artist, and prevent his exhibiting his abilities to their greatest advantage, will certainly not desire a modern dress.

The desire of transmitting to posterity the shape of modern dress must be acknowledged to be purchased at a prodigious price, even the price of every thing that is valuable in art.

Working in stone is a very serious business; and it seems to be scarce worth while to employ such durable materials in conveying to posterity a fashion of which the longest existence scarce exceeds a year.

However agreeable it may be to the Antiquary's principles of equity and gratitude, that as he has received great pleasure from the contemplation of the fashions of dress of former ages, he wishes to give the same satisfaction to future Antiquaries: yet, methinks, pictures of an inferior style, or prints, may be considered as quite sufficient, without prostituting this great art to such mean purposes.

In this town may be seen an Equestrian Statue in a modern dress,[26] which may be sufficient to deter future artists from

any such attempt: even supposing no other objection, the familiarity of the modern dress by no means agrees with the dignity and gravity of Sculpture.

Sculpture is formal, regular, and austere; disdains all familiar objects, as incompatible with its dignity; and is an enemy to every species of affectation, or appearance of academical art. All contrast, therefore, of one figure to another, or of the limbs of a single figure, or even in the folds of the drapery, must be sparingly employed. In short, whatever partakes of fancy or caprice, or goes under the denomination of Picturesque, (however to be admired in its proper place,) is incompatible with that sobriety and gravity which is peculiarly the characteristick of this art.

There is no circumstance which more distinguishes a well-regulated and sound taste, then a settled uniformity of design, where all the parts are compact, and fitted to each other, every thing being of a piece. This principle extends itself to all habits of life, as well as to all works of art. Upon this general ground therefore we may safely venture to pronounce, that the uniformity and simplicity of the materials on which the Sculptor labours, (which are only white marble,) prescribes bounds to his art, and teaches him to confine himself to a proportionable simplicity of design.

DISCOURSE XI[1]

GENIUS.—CONSISTS PRINCIPALLY IN THE COMPREHENSION OF A
WHOLE; IN TAKING GENERAL IDEAS ONLY.

GENTLEMEN,

THE highest ambition of every Artist is to be thought a man
of Genius. As long as this flattering quality is joined to his
name, he can bear with patience the imputation of care-
lessness, incorrectness, or defects of whatever kind.

So far indeed is the presence of Genius from implying an
absence of faults, that they are considered by many as its
inseparable companions. Some go such lengths as to take
indication from them, and not only excuse faults on account
of Genius, but presume Genius from the existence of certain
faults.[2]

It is certainly true, that a work may justly claim the charac-
ter of Genius, though full of errors; and it is equally true,
that it may be faultless, and yet not exhibit the least spark of
Genius. This naturally suggests an inquiry, a desire at least
of inquiring, what qualities of a work and of a workman may
justly entitle a Painter to that character.

I have in a former discourse* endeavoured to impress you
with a fixed opinion, that a comprehensive and critical

*Discourse III.

knowledge of the works of nature is the only source of beauty
and grandeur. But when we speak to Painters, we must always
consider this rule, and all rules, with a reference to the mech-
anical practice of their own particular Art. It is not properly
in the learning, the taste, and the dignity of the ideas, that
Genius appears as belonging to a Painter. There is a Genius
particular and appropriated to his own trade, (as I may call
it,) distinguished from all others. For that power, which
enables the Artist to conceive his subject with dignity, may
be said to belong to general education; and is as much the
Genius of a Poet, or the professor of any other liberal Art, or
even a good critick in any of those arts, as of a Painter.
Whatever sublime ideas may fill his mind, he is a Painter
only as he can put in practice what he knows, and communi-
cate those ideas by visible representation.

If my expression can convey my idea, I wish to distinguish
excellence of this kind by calling it the Genius of mechanical
performance. This Genius consists, I conceive, in the power
of expressing that which employs your pencil, whatever it
may be, *as a whole*; so that the general effect and power of the
whole may take possession of the mind, and for a while sus-
pend the consideration of the subordinate and particular
beauties or defects.

The advantage of this method of considering objects, is
what I wish now more particularly to enforce. At the same
time I do not forget, that a Painter must have the power of
contracting as well as dilating his sight; because, he that does
not at all express particulars, expresses nothing; yet it is cer-
tain, that a nice discrimination of minute circumstances, and
a punctilious delineation of them, whatever excellence it may
have, (and I do not mean to detract from it,) never did confer
on the Artist the character of Genius.[3]

Beside those minute differences in things which are fre-

quently not observed at all, and when they are, make little impression, there are in all considerable objects great characteristick distinctions, which press strongly on the senses, and therefore fix the imagination. These are by no means, as some persons think, an aggregate of all the small discriminating particulars: nor will such an accumulation of particulars ever express them. These answer to what I have heard great lawyers[4] call the leading points in a case, or the leading cases relative to those points.

The detail of particulars, which does not assist the expression of the main characteristick, is worse than useless, it is mischievous, as it dissipates the attention, and draws it from the principal point. It may be remarked, that the impression which is left on our mind even of things which are familiar to us, is seldom more than their general effect; beyond which we do not look in recognising such objects. To express this in Painting, is to express what is congenial and natural to the mind of man, and what gives him by reflection his own mode of conceiving. The other pre-supposes *nicety* and *research*, which are only the business of the curious and attentive, and therefore does not speak to the general sense of the whole species; in which common, and, as I may so call it, mother tongue, every thing grand and comprehensive must be uttered.

I do not mean to prescribe what degree of attention ought to be paid to the minute parts; this it is hard to settle. We are sure that it is expressing the general effect of the whole, which alone can give to objects their true and touching character; and wherever this is observed, whatever else may be neglected, we acknowledge the hand of a Master. We may even go further, and observe, that when the general effect only is presented to us by a skilful hand, it appears to express the object represented in a more lively manner than the minutest resemblance would do.

These observations may lead to very deep questions, which I do not mean here to discuss; among others, it may lead to an inquiry, Why we are not always pleased with the most absolute possible resemblance of an imitation to its original object. Cases may exist in which such a resemblance may be even disagreeable. I shall only observe that the effect of figures in Wax-work, though certainly a more exact representation than can be given by Painting or Sculpture, is a sufficient proof that the pleasure we receive from imitation is not increased merely in proportion as it approaches to minute and detailed reality; we are pleased, on the contrary, by seeing ends accomplished by seemingly inadequate means.

To express protuberance by actual relief, to express the softness of flesh by the softness of wax, seems rude and inartificial,[5] and creates no grateful surprise. But to express distances on a plain surface, softness by hard bodies, and particular colouring by materials which are not singly of that colour, produces that magic which is the prize and triumph of art.

Carry this principle a step further. Suppose the effect of imitation to be fully compassed by means still more inadequate; let the power of a few well-chosen strokes, which supersede labour by judgment and direction, produce a complete impression of all that the mind demands in an object; we are charmed with such an unexpected happiness of execution, and begin to be tired with the superfluous diligence, which in vain solicits an appetite already satiated.

The properties of all objects, as far as a Painter is concerned with them, are, the outline or drawing, the colour, and the light and shade. The drawing gives the form, the colour its visible quality, and the light and shade its solidity.

Excellence in any one of these parts of art will never be acquired by an artist, unless he has the habit of looking upon

objects at large, and observing the effect which they have on the eye when it is dilated, and employed upon the whole, without seeing any one of the parts distinctly. It is by this that we obtain the ruling characteristick, and that we learn to imitate it by short and dexterous methods. I do not mean by dexterity a trick or mechanical habit, formed by guess, and established by custom; but that science, which, by a profound knowledge of ends and means, discovers the shortest and surest way to its own purpose.

If we examine with a critical view the manner of those painters whom we consider as patterns, we shall find that their great fame does not proceed from their works being more highly finished than those of other artists, or from a more minute attention to details, but from that enlarged comprehension which sees the whole object at once, and that energy of art which gives its characteristick effect by adequate expression.

Raffaelle and Titian are two names which stand the highest in our art; one for Drawing, the other for Painting. The most considerable and the most esteemed works of Raffaelle are the Cartoons, and his Fresco works in the Vatican; those, as we all know, are far from being minutely finished: his principal care and attention seems to have been fixed upon the adjustment of the whole, whether it was the general composition, or the composition of each individual figure; for every figure may be said to be a lesser whole, though in regard to the general work to which it belongs, it is but a part; the same may be said of the head, of the hands, and feet. Though he possessed this art of seeing and comprehending the whole, as far as form is concerned, he did not exert the same faculty in regard to the general effect, which is presented to the eye by colour, and light and shade. Of this the deficiency of his oil pictures, where this excellence is more expected than in Fresco, is a sufficient proof.

It is to Titian we must turn our eyes to find excellence with regard to colour, and light and shade, in the highest degree. He was both the first and the greatest master of this art. By a few strokes he knew how to mark the general image and character of whatever object he attempted; and produced, by this alone, a truer representation than his master Giovanni Bellino, or any of his predecessors, who finished every hair. His great care was to express the general colour, to preserve the masses of light and shade, and to give by opposition the idea of that solidity which is inseparable from natural objects. When those are preserved, though the work should possess no other merit, it will have in a proper place its complete effect; but where any of these are wanting, however minutely laboured the picture may be in the detail, the whole will have a false and even an unfinished appearance, at whatever distance, or in whatever light, it can be shown.[6]

It is vain to attend to the variation of tints, if, in that attention, the general hue of flesh is lost; or to finish ever so minutely the parts, if the masses are not observed, or the whole not well put together.

Vasari seems to have had no great disposition to favour the Venetian Painters, yet he every where justly commends *il modo di fare, la maniera, la bella pratica*; that is, the admirable manner and practice of that school. On Titian, in particular, he bestows the epithets of *giudicioso, bello, e stupendo*.[7]

This manner was then new to the world, but that unshaken truth on which it is founded, has fixed it as a model to all succeeding Painters: and those who will examine into the artifice, will find it to consist in the power of generalising, and in the shortness and simplicity of the means employed.

Many artists, as Vasari likewise observes, have ignorantly imagined they are imitating the manner of Titian,[8] when they leave their colours rough, and neglect the detail; but, not

possessing the principles on which he wrought, they have produced what he calls *goffe pitture*, absurd foolish pictures; for such will always be the consequence of affecting dexterity without science, without selection, and without fixed principles.

Raffaelle and Titian seem to have looked at nature for different purposes; they both had the power of extending their view to the whole; but one looked only for the general effect as produced by form, the other as produced by colour.

We cannot entirely refuse to Titian the merit of attending to the general *form* of his object, as well as colour; but his deficiency lay, a deficiency at least when he is compared with Raffaelle, in not possessing the power like him, of correcting the form of his model by any general idea of beauty in his own mind. Of this his St Sebastian is a particular instance.[9] This figure appears to be a most exact representation both of the form and the colour of the model, which he then happened to have before him; it has all the force of nature, and the colouring is flesh itself; but, unluckily, the model was of a bad form, especially the legs. Titian has with as much care preserved these defects, as he has imitated the beauty and brilliancy of the colouring. In his colouring he was large and general, as in his design he was minute and partial: in the one he was a Genius, in the other not much above a copier. I do not, however, speak now of all his pictures: instances enough may be produced in his works, where those observations on his defects could not with any propriety be applied: but it is in the manner or language, as it may be called, in which Titian and others of that school express themselves, that their chief excellence lies. This manner is in reality, in painting, what language is in poetry; we are all sensible how differently the imagination is affected by the same sentiment expressed in different words, and how mean or how grand the same

object appears when presented to us by different Painters. Whether it is the human figure, an animal, or even inanimate objects, there is nothing, however unpromising in appearance, but may be raised into dignity, convey sentiment, and produce emotion, in the hands of a Painter of genius. What was said of Virgil, that he threw even the dung about the ground with an air of dignity,[10] may be applied to Titian: whatever he touched, however naturally mean, and habitually familiar, by a kind of magick he invested with grandeur and importance.

I must here observe, that I am not recommending a neglect of the detail; indeed it would be difficult, if not impossible, to prescribe *certain* bounds, and tell how far, or when it is to be observed or neglected; much must, at last, be left to the taste and judgment of the artist. I am well aware that a judicious detail will sometimes give the force of truth to the work, and consequently interest the spectator. I only wish to impress on your minds the true distinction between essential and subordinate powers; and to show what qualities in the art claim your *chief* attention, and what may, with the least injury to your reputation, be neglected. Something, perhaps, always must be neglected; the lesser ought then to give way to the greater; and since every work can have but a limited time allotted to it, (for even supposing a whole life to be employed about one picture, it is still limited,) it appears more reasonable to employ that time to the best advantage, in contriving various methods of composing the work, – in trying different effect of light and shadow, – and employing the labour of correction in heightening by a judicious adjustment of the parts the effects of the whole, – than that the time should be taken up in minutely finishing those parts.[11]

But there is another kind of high finishing, which may safely be condemned, as it seems to counteract its own purpose; that is, when the artist, to avoid that hardness which

proceeds from the outline cutting against the ground, softens and blends the colours to excess: this is what the ignorant call high finishing, but which tends to destroy the brilliancy of colour, and the true effect of representation; which consists very much in preserving the same proportion of sharpness and bluntness that is found in natural objects. This extreme softening, instead of producing the effect of softness, gives the appearance of ivory, or some other hard substance, highly polished.

The portraits of Cornelius Jansen appear to have this defect, and consequently want that suppleness which is the characteristick of flesh; whereas, in the works of Vandyck we find that true mixture of softness and hardness perfectly observed. The same defect may be found in the manner of Vanderwerf, in opposition to that of Teniers; and such also, we may add, is the manner of Raffaelle in his oil pictures, in comparison with that of Titian.

The name which Raffaelle has so justly maintained as the first of Painters, we may venture to say was not acquired by this laborious attention. His apology may be made by saying that it was the manner of his country; but if he had expressed his ideas with the facility and eloquence, as it may be called, of Titian, his works would certainly not have been less excellent; and that praise, which ages and nations have poured out upon him, for possessing Genius in the higher attainments of art, would have been extended to them all.

Those who are not conversant in works of art, are often surprised at the high value set by connoisseurs on drawings which appear careless, and in every respect unfinished; but they are truly valuable; and their value arises from this, that they give the idea of an whole; and this whole is often expressed by a dexterous facility which indicates the true power of a Painter, even though roughly exerted: whether it consists

in the general composition, or the general form of each figure, or the turn of the attitude which bestows grace and elegance. All this we may see fully exemplified in the very skilful drawings of Parmegiano and Correggio. On whatever account we value these drawings, it is certainly not for high finishing, or a minute attention to particulars.

Excellence in every part, and in every province of our art, from the highest style of history down to the resemblances of still-life, will depend on this power of extending the attention at once to the whole, without which the greatest diligence is vain.

I wish you to bear in mind, that when I speak of an whole, I do not mean simply an *whole* as belonging to composition, but an *whole* with respect to the general style of colouring; an *whole* with regard to the light and shade; an *whole* of every thing which may separately become the main object of a Painter.

I remember a Landscape-painter in Rome, who was known by the name of STUDIO from his patience in high finishing, in which he thought the whole excellence of art consisted;[12] so that he once endeavoured, as he said, to represent every individual leaf on a tree. This picture I never saw; but I am very sure that an artist, who looked only at the general character of the species, the order of the branches, and the masses of the foliage, would in a few minutes produce a more true resemblance of trees, than this Painter in as many months.

A Landscape-painter certainly ought to study anatomically (if I may use the expression) all the objects which he paints; but when he is to turn his studies to use, his skill, as a man of genius, will be displayed in showing the general effect, preserving the same degree of hardness and softness which the objects have in nature; for he applies himself to the imagination, not to the curiosity,[13] and works not for the Virtuoso or the

Naturalist, but for the common observer of life and nature.[14] When he knows his subject, he will know not only what to describe, but what to omit: and this skill in leaving out, is, in all things, a great part of knowledge and wisdom.

The same excellence of manner which Titian displayed in History or Portrait-painting, is equally conspicuous in his Landscapes, whether they are professedly such, or serve only as back-grounds. One of the most eminent of this latter kind is to be found in the picture of St Pietro Martire.[15] The large trees, which are here introduced, are plainly distinguished from each other by the different manner with which the branches shoot from their trunks, as well as by their different foliage; and the weeds in the foreground are varied in the same manner, just as much as variety requires, and no more. When Algarotti, speaking of this picture, praises it for the minute discriminations of the leaves and plants, even, as he says, to excite the admiration of a Botanist,[16] his intention was undoubtedly to give praise even at the expence of truth; for he must have known, that this is not the character of the picture; but connoisseurs will always find in pictures what they think they ought to find: he was not aware that he was giving a description injurious to the reputation of Titian.

Such accounts may be very hurtful to young artists, who never have had an opportunity of seeing the work described; and they may possibly conclude, that this great Artist acquired the name of the Divine Titian from his eminent attention to such trifling circumstances, which in reality would not raise him above the level of the most ordinary Painter.

We may extend these observations even to what seems to have but a single, and that an individual object. The excellence of Portrait-painting, and we may add, even the likeness, the character, and countenance, as I have observed in another place, depend more upon the general effect produced by the

Painter, than on the exact expression of the peculiarities, or minute discrimination of the parts. The chief attention of the artist is therefore employed in planting the features in their proper places, which so much contributes to giving the effect and true impression of the whole. The very peculiarities may be reduced to classes and general descriptions; and there are therefore large ideas to be found even in this contracted subject. He may afterwards labour single features to what degree he thinks proper, but let him not forget continually to examine, whether in finishing the parts he is not destroying the general effect.

It is certainly a thing to be wished, that all excellence were applied to illustrate subjects that are interesting and worthy of being commemorated; whereas, of half the pictures that are in the world, the subject can be valued only as an occasion which set the artist to work: and yet, our high estimation of such pictures, without considering or perhaps without knowing the subject, shows how much our attention is engaged by the art alone.

Perhaps nothing that we can say will so clearly show the advantage and excellence of this faculty, as that it confers the character of Genius on works that pretend to no other merit; in which is neither expression, character, or dignity, and where none are interested in the subject. We cannot refuse the character of Genius to the marriage of Paolo Veronese,[17] without opposing the general sense of mankind, (great authorities have called it the triumph of Painting,) or to the altar of St Augustine at Antwerp, by Rubens, which equally deserves that title, and for the same reason.[18] Neither of those pictures have any interesting story to support them. That of Paolo Veronese is only a representation of a great concourse of people at a dinner; and the subject of Rubens, if it may be called a subject where nothing is doing, is an assembly of various Saints that lived in different ages. The

whole excellence of those pictures consists in mechanical dex-
terity, working however under the influence of that com-
prehensive faculty which I have so often mentioned.

It is by this, and this alone, that the mechanical power is
ennobled, and raised much above its natural rank. And it
appears to me, that with propriety it acquires this character,
as an instance of that superiority with which mind predomi-
nates over matter,[19] by contracting into one whole what
nature had made multifarious.

The great advantage of this idea of a whole is, that a greater
quantity of truth may be said to be contained and expressed
in a few lines or touches, than in the most laborious finishing
of the parts where this is not regarded. It is upon this foun-
dation that it stands; and the justness of the observation would
be confirmed by the ignorant in art, if it were possible to take
their opinions unseduced by some false notion of what they
imagine they ought to see in a Picture. As it is an art, they
think they ought to be pleased in proportion as they see that
art ostentatiously displayed; they will, from this supposition,
prefer neatness, high-finishing, and gaudy colouring, to the
truth, simplicity, and unity of nature. Perhaps, too, the totally
ignorant beholder, like the ignorant artist, cannot comprehend
an whole, nor even what it means. But if false notions do not
anticipate their perceptions, they who are capable of obser-
vation, and who, pretending to no skill, look only straight
forward, will praise and condemn in proportion as the Painter
has succeeded in the effect of the whole. Here, general, satis-
faction, or general dislike, though perhaps despised by the
Painter, as proceeding from the ignorance of the principles of
art, may yet help to regulate his conduct, and bring back his
attention to that which ought to be his principal object, and
from which he has deviated for the sake of minuter beauties.

An instance of this right judgment I once saw in a child, in

going through a gallery where there were many portraits of the last ages, which, though neatly put out of hand, were very ill put together. The child paid no attention to the neat finishing or naturalness of any bit of drapery, but appeared to observe only the ungracefulness of the persons represented, and put herself in the posture of every figure which she saw in a forced and awkward attitude. The censure of nature, uninformed, fastened upon the greatest fault that could be in a picture, because it related to the character and management of the whole.

I should be sorry, if what has been said should be understood to have any tendency to encourage that carelessness which leaves work in an unfinished state. I commend nothing for the want of exactness; I mean to point out that kind of exactness which is the best, and which is alone truly to be so esteemed.

So far is my disquisition from giving countenance to idleness, that there is nothing in our art which enforces such continual exertion and circumspection, as an attention to the general effect of the whole. It requires much study and much practice; it requires the Painter's entire mind; whereas the parts may be finishing by nice touches, while his mind is engaged on other matters; he may even hear a play or a novel read without much disturbance. The artist who flatters his own indolence, will continually find himself evading this active exertion, and applying his thoughts to the general effect, even when it has been the ease and laziness of highly finishing the parts; producing at last what Cowley calls 'laborious effects of idleness.'[20]

No work can be too much finished, provided the diligence employed be directed to its proper object; but I have observed that an excessive labour in the detail has, nine times in ten, been pernicious to the general effect, even when it has been the labour of great masters. It indicates a bad choice, which is an ill setting out in any undertaking.

To give a right direction to your industry has been my principal purpose in this discourse. It is this, which I am confident often makes the difference between two Students of equal capacities, and of equal industry. While the one is employing his labour on minute objects of little consequence, the other is acquiring the art, and perfecting the habit, of seeing nature in an extensive view, in its proper proportions, and its due subordination of parts.

Before I conclude, I must make one observation sufficiently connected with the present subject.

The same extension of mind which gives the excellence of Genius to the theory and mechanical practice of the art, will direct him likewise in the method of study, and give him the superiority over those who narrowly follow a more confined track of partial imitation. Whoever, in order to finish his education, should travel to Italy, and spend his whole time there only in copying pictures, and measuring statues or buildings, (though these things are not to be neglected,) would return with little improvement.[21] He that imitates the Iliad, says Dr Young, is not imitating Homer.[22] It is not by laying up in the memory the particular details of any of the great works of art, that any man becomes a great artist, if he stops without making himself master of the general principles on which these works are conducted. If he even hopes to rival those whom he admires, he must consider their works as the means of teaching him the true art of seeing nature. When this is acquired, he then may be said to have appropriated their powers, or at least the foundation of their powers, to himself; the rest must depend upon his own industry and application.[23] The great business of study is, to form a *mind*,[24] adapted and adequate to all times and all occasions; to which all nature is then laid open, and which may be said to possess the key of her inexhaustible riches.

DISCOURSE XII[1]

PARTICULAR METHODS OF STUDY OF LITTLE CONSEQUENCE.—
LITTLE OF THE ART CAN BE TAUGHT.—LOVE OF METHOD OFTEN
A LOVE OF IDLENESS.—PITTORI IMPROVVISATORI APT TO BE
CARELESS AND INCORRECT; SELDOM ORIGINAL AND
STRIKING.—THIS PROCEEDS FROM THEIR NOT STUDYING THE
WORKS OF OTHER MASTERS.

GENTLEMEN,

IN consequence of the situation in which I have the honour
to be placed in this Academy, it has often happened, that I
have been consulted by the young Students who intend to
spend some years in Italy, concerning the method of regulat-
ing their studies. I am, as I ought to be, solicitously desirous
to communicate the entire result of my experience and obser-
vation; and though my openness and facility in giving my
opinions might make some amends for whatever was defective
in them, yet I fear my answers have not often given satisfac-
tion. Indeed I have never been sure, that I understood per-
fectly what they meant, and was not without some suspicion
that they had not themselves very distinct ideas of the object
of their inquiry.

If the information required was, by what means the path
that leads to excellence could be discovered; if they wished to
know whom they were to take for their guides; what to adhere
to, and what to avoid; where they were to bait, and where

they were to take up their rest; what was to be tasted only, and what should be their diet; such general directions are certainly proper for a Student to ask, and for me, to the best of my capacity, to give; but these rules have been already given: they have, in reality, been the subject of almost all my Discourses from this place. But I am rather inclined to think, that by *method of study*, it was meant, (as several do mean), that the times and the seasons should be prescribed, and the order settled, in which every thing was to be done: that it might be useful to point out to what degree of excellence one part of the Art was to be carried, before the Student proceeded to the next; how long he was to continue to draw from the ancient statues, when to begin to compose, and when to apply to the study of colouring.

Such a detail of instruction might be extended with a great deal of plausible and ostentatious amplification. But it would at best be useless. Our studies will be for ever, in a very great degree, under the direction of chance; like travellers, we must take what we can get, and when we can get it; whether it is or is not administered to us in the most commodious manner, in the most proper place, or at the exact minute when we would wish to have it.

Treatises on education, and method of study, have always appeared to me to have one general fault.[2] They proceed upon a false supposition of life; as if we possessed not only a power over events and circumstances, but had a greater power over ourselves than I believe any of us will be found to possess. Instead of supposing ourselves to be perfect patterns of wisdom and virtue, it seems to me more reasonable to treat ourselves (as I am sure we must now and then treat others) like humoursome children, whose fancies are often to be indulged, in order to keep them in good humour with themselves and their pursuits. It is necessary to use some artifice

of this kind in all processes which by their very nature are long, tedious, and complex, in order to prevent our taking that aversion to our studies, which the continual shackles of methodical restraint are sure to produce.

I would rather wish a student, as soon as he goes abroad, to employ himself upon whatever he has been incited to by any immediate impulse, than to go sluggishly about a prescribed task, whatever he does in such a state of mind, little advantage accrues from it, as nothing sinks deep enough to leave any lasting impression; and it is impossible that any thing should be well understood, or well done, that is taken into a reluctant understanding, and executed with a servile hand.

It is desirable, and indeed is necessary to intellectual health, that the mind should be recreated and refreshed with a variety in our studies; that in the irksomeness of uniform pursuit we should be relieved, and, if I may so say, deceived, as much as possible. Besides, the minds of men are so very differently constituted, that it is impossible to find one method which shall be suitable to all. It is of no use to prescribe to those who have no talents; and those who have talents will find methods for themselves – methods dictated to them by their own particular dispositions, and by the experience of their own particular necessities.

However, I would not be understood to extend this doctrine to the younger students. The first part of the life of a student, like that of other school-boys, must necessarily be a life of restraint. The grammar, the rudiments, however unpalatable, must at all events be mastered. After a habit is acquired of drawing correctly from the model (whatever it may be) which he has before him, the rest, I think, may be safely left to chance; always supposing that the student is *employed*, and that his studies are directed to the proper object.

A passion for his art, and an eager desire to excel, will

more than supply the place of method. By leaving a student to himself, he may possibly indeed be led to undertake matters above his strength: but the trial will at least have this advantage, it will discover to himself his own deficiencies; and this discovery alone, is a very considerable acquisition. One inconvenience, I acknowledge, may attend bold and arduous attempts; frequent failure may discourage. This evil, however, is not more pernicious than the slow proficiency which is the natural consequence of too easy tasks.[3]

Whatever advantages method may have in dispatch of business, (and there it certainly has many,) I have but little confidence of its efficacy in acquiring excellence in any art whatever. Indeed, I have always strongly suspected, that this love of method, on which some persons appear to place so great dependence, is, in reality, at the bottom, a love of idleness, a want of sufficient energy to put themselves into immediate action: it is a sort of an apology to themselves for doing nothing. I have known artists who may truly be said to have spent their whole lives, or at least the most precious part of their lives, in planning methods of study, without ever beginning; resolving, however, to put it all in practice at some time or other, – when a certain period arrives, – when proper conveniences are procured, – or when they remove to a certain place better calculated for study. It is not uncommon for such persons to go abroad with the most honest and sincere resolution of studying hard, when they shall arrive at the end of their journey. The same want of exertion, arising from the same cause which made them at home put off the day of labour until they had found a proper scheme for it, still continues in Italy, and they consequently return home with little, if any, improvement.

In the practice of art, as well as in morals, it is necessary to keep a watchful and jealous eye over ourselves; idleness,

assuming the specious disguise of industry, will lull to sleep all suspicion of our want of an active exertion of strength. A provision of endless apparatus, a bustle of infinite inquiry and research, or even the mere mechanical labour of copying, may be employed, to evade and shuffle off real labour, — the real labour of thinking.

I have declined for these reasons to point out any particular method and course of study to young Artists on their arrival in Italy. I have left it to their own prudence, a prudence which will grow and improve upon them in the course of unremitted, ardent industry, directed by a real love of their profession, and an unfeigned admiration of those who have been universally admitted as patterns of excellence in the art.

In the exercise of that general prudence, I shall here submit to their consideration such miscellaneous observations as have occurred to me on considering the mistaken notions or evil habits, which have prevented that progress towards excellence, which the natural abilities of several Artists might otherwise have enabled them to make.

False opinions and vicious habits have done far more mischief to students, and to Professors too, than any wrong methods of study.

Under the influence of sloth, or of some mistaken notion, is that disposition which always wants to lean on other men. Such Students are always talking of the prodigious progress they should make, if they could but have the advantage of being taught by some particular eminent Master. To him they would wish to transfer that care, which they ought and must take of themselves. Such are to be told, that after the rudiments are past, very little of our Art can be taught by others. The most skilful Master can do little more than put the end of the clue into the hands of his Scholar, by which he must conduct himself.

It is true, the beauties and defects of the works of our predecessors may be pointed out; the principles on which their works are conducted may be explained; the great examples of Ancient Art may be spread out before them; but the most sumptuous entertainment is prepared in vain, if the guests will not take the trouble of helping themselves.

Even the Academy itself, where every convenience for study is procured, and laid before them, may, from that very circumstance, from leaving no difficulties to be encountered in the pursuit, cause a remission of their industry. It is not uncommon to see young artists, whilst they are struggling with every obstacle in their way, exert themselves with such success as to outstrip competitors possessed of every means of improvement. The promising expectation which was formed, on so much being done with so little means, has recommended them to a Patron, who has supplied them with every convenience of study; from that time their industry and eagerness of pursuit has forsaken them; they stand still, and see others rush on before them.

Such men are like certain animals, who will feed only when there is but little provender, and that got at with difficulty through the bars of a rack, but refuse to touch it when there is an abundance before them.

Perhaps, such a falling off may proceed from the faculties being overpowered by the immensity of the materials; as the traveller despairs ever to arrive at the end of his journey, when the whole extent of the road which he is to pass is at once displayed to his view.

Among the first moral qualities, therefore, which a Student ought to cultivate, is a just and manly confidence in himself, or rather in the effects of that persevering industry which he is resolved to possess.

When Raffaelle, by means of his connection with Bramante,

the Pope's Architect, was fixed upon to adorn the Vatican with his works,[4] he had done nothing that marked in him any great superiority over his contemporaries; though he was then but young, he had under his direction the most considerable Artists of his age; and we know what kind of men those were: a lesser mind would have sunk under such a weight; and if we should judge from the meek and gentle disposition which we are told was the character of Raffaelle, we might expect this would have happened to him; but his strength appeared to increase in proportion as exertion was required; and it is not improbable that we are indebted to the good fortune which first placed him in that conspicuous situation, for those great examples of excellence which he has left us.

The observations to which I formerly wished, and now desire, to point your attention, relate not to errors which are committed by those who have no claim to merit, but to those inadvertencies into which men of parts only can fall by the over-rating or the abuse of some real, though perhaps subordinate, excellence. The errors last alluded to are those of backward, timid characters; what I shall now speak of, belong to another class; to those Artists who are distinguished for the readiness and facility of their invention. It is undoubtedly a splendid and desirable accomplishment to be able to design instantaneously any given subject. It is an excellence that I believe every Artist would wish to possess; but unluckily, the manner in which this dexterity is acquired, habituates the mind to be contented with first thoughts without choice or selection. The judgement, after it has been long passive, by degrees loses its power of becoming active when exertion is necessary.

Whoever, therefore, has this talent, must in some measure undo what he has had the habit of doing, or at least give a new turn to his mind: great works, which are to live and

stand the criticism of posterity, are not performed at a heat. A proportionable time is required for deliberation and circumspection. I remember when I was at Rome looking at the fighting Gladiator,[5] in company with an eminent Sculptor,[6] and I expressed my admiration of the skill with which the whole is composed, and the minute attention of the Artist to the change of every muscle in that momentary exertion of strength, he was of opinion that a work so perfect required nearly the whole life of man to perform.

I believe, if we look around us, we shall find, that in the sister art of Poetry, what has been soon done, has been as soon forgotten. The judgement and practice of a great Poet on this occasion is worthy attention. Metastasio,[7] who has so much and justly distinguished himself throughout Europe, at his outset was an *Improvvisatore*, or extempore Poet, a description of men not uncommon in Italy: it is not long since he was asked by a friend, if he did not think the custom of inventing and reciting *extempore*, which he practised when a boy in his character of an *Improvvisatore*, might not be considered as a happy beginning of his education; he thought it, on the contrary, a disadvantage to him: he said that he had acquired by that habit a carelessness and incorrectness, which it cost him much trouble to overcome, and to substitute in the place of it a totally different habit, that of thinking with selection, and of expressing himself with correctness and precision.

However extraordinary it may appear, it is certainly true, that the inventions of the *Pittori improvvisatori*, as they may be called, have, – notwithstanding the common boast of their authors that all is spun from their own brain, – very rarely any thing that has in the least the air of originality: – their compositions are generally common-place, uninteresting, without character or expression; like those flowery speeches that we sometimes hear, which impress no new ideas on the mind.

I would not be thought, however, by what has been said, to oppose the use, the advantage, the necessity there is, of a Painter's being readily able to express his ideas by sketching. The further he can carry such designs, the better. The evil to be apprehended is, his resting there, and not correcting them afterwards from nature, or taking the trouble to look about him for whatever assistance the works of others will afford him.

We are not to suppose, that when a Painter sits down to deliberate on any work, he has all his knowledge to seek; he must not only be able to draw *extempore* the human figure in every variety of action, but he must be acquainted likewise with the general principles of composition, and possess a habit of foreseeing, while he is composing, the effect of the masses of light and shadow, that will attend such a disposition. His mind is entirely occupied by his attention to the whole. It is a subsequent consideration to determine the attitude and expression of individual figures. It is in this period of his work that I would recommend to every artist to look over his port-folio, or pocket-book, in which he has treasured up all the happy inventions, all the extraordinary and expressive attitudes, that he has met with in the course of his studies; not only for the sake of borrowing from those studies whatever may be applicable to his own work, but likewise on account of the great advantage he will receive by bringing the ideas of great Artists more distinctly before his mind, which will teach him to invent other figures in a similar style.[8]

Sir Francis Bacon speaks with approbation of the provisionary methods Demosthenes and Cicero employed to assist their invention: and illustrates their use by a quaint comparison after his manner.[9] These particular *Studios* being not immediately connected with our art, I need not cite the passage I allude to, and shall only observe that such preparation

totally opposes the general received opinions that are floating in the world, concerning genius and inspiration. The same great man in another place, speaking of his own essays, remarks, that they treat of 'those things, wherein both men's lives and persons are most conversant, whereof a man shall find much in experience, but little in books:'[10] they are then what an artist would naturally call invention; and yet we may suspect that even the genius of Bacon, great as it was, would never have been enabled to have made those observations, if his mind had not been trained and disciplined by reading the observations of others. Nor could he without such reading have known that those opinions were not to be found in other books.

I know there are many Artists of great fame who appear never to have looked out of themselves, and who probably would think it derogatory to their character, to be supposed to borrow from any other Painter. But when we recollect, and compare the works of such men with those who took to their assistance the inventions of others, we shall be convinced of the great advantage of this latter practice.

The two men most eminent for readiness of invention, that occur to me, are Luca Giordano and La Fage; one in painting, and the other in drawing.

To such extraordinary powers as were possessed by both of those Artists, we cannot refuse the character of Genius; at the same time, it must be acknowledged, that it was that kind of mechanick Genius which operates without much assistance of the head. In all their works, which are (as might be expected) very numerous, we may look in vain for any thing that can be said to be original and striking; and yet, according to the ordinary ideas of originality, they have as good pretensions as most Painters; for they borrowed very little from others, and still less will any Artist, that can distinguish between excellence and insipidity, ever borrow from them.

To those men, and all such, let us oppose the practice of the first of Painters. I suppose we shall all agree, that no man ever possessed a greater power of invention, and stood less in need of foreign assistance, than Raffaelle; and yet, when he was designing one of his greatest as well as latest works, the Cartoons, it is very apparent that he had the studies which he had made from Masaccio before him.[11] Two noble figures of St Paul, which he found there, he adopted in his own work: one of them he took for St Paul preaching at Athens; and the other for the same Saint, when chastising the sorcerer Elymas. Another figure in the same work, whose head is sunk in his breast, with his eyes shut, appearing deeply wrapt up in thought, was introduced amongst the listeners to the preaching of St Paul. The most material alteration that is made in those two figures of St Paul, is the addition of the left hands, which are not seen in the original. It is a rule that Raffaelle observed, (and indeed ought never to be dispensed with,) in a principal figure, to show both hands; that it should never be a question, what is become of the other hand. For the Sacrifice at Listra, he took the whole ceremony much as it stands in an ancient Basso-relievo, since published in the ADMIRANDA.[12]

I have given examples from those pictures only of Raffaelle which we have among us, though many other instances might be produced of this great Painter's not disdaining assistance: indeed his known wealth was so great, that he might borrow where he pleased without loss of credit.[13]

It may be remarked, that this work of Masaccio, from which he has borrowed so freely, was a publick work, and at no farther distance from Rome, than Florence; so that if he had considered it a disgraceful theft, he was sure to be detected; but he was well satisfied that his character for Invention would be little affected by such a discovery; nor is it, except in the opinion of those who are ignorant of the manner in which great works are built.

Those who steal from mere poverty; who, having nothing of their own, cannot exist a minute without making such depredations; who are so poor that they have no place in which they can even deposit what they have taken; to men of this description nothing can be said: but such Artists as those to whom I suppose myself now speaking, men whom I consider as competently provided with all the necessaries and conveniences of art, and who do not desire to steal baubles and common trash, but wish only to possess peculiar rarities which they select to ornament their cabinets, and take care to enrich the general store with materials of equal or of greater value than what they have taken; such men surely need not be ashamed of that friendly intercourse which ought to exist among Artists, of receiving from the dead and giving to the living, and perhaps to those who are yet unborn.[14]

The daily food and nourishment of the mind of an Artist is found in the great works of his predecessors. There is no other way for him to become great himself. *Serpens, nisi serpentem comederit, non fit draco,*[15] is a remark of a whimsical Natural History, which I have read, though I do not recollect its title; however false as to dragons, it is applicable enough to Artists.

Raffaelle, as appears from what has been said, had carefully studied the works of Masaccio; and indeed there was no other, if we except Michael Angelo, (whom he likewise imitated,) so worthy of his attention; and though his manner was dry and hard, his compositions formal, and not enough diversified, according to the custom of Painters in that early period, yet his works possess that grandeur and simplicity which accompany, and even sometimes proceed from, regularity and hardness of manner. We must consider the barbarous[16] state of the Arts before his time, when skill in drawing was so little understood, that the best of the painters could not even

foreshorten the foot, but every figure appeared to stand upon his toes; and what served for drapery, had, from the hardness and smallness of the folds, too much the appearance of cords clinging round the body. He first introduced large drapery, flowing in an easy and natural manner: indeed he appears to be the first who discovered the path that leads to every excellence to which the Art afterwards arrived, and may therefore be justly considered as one of the Great Fathers of modern Art.

Though I have been led on to a longer digression respecting this great Painter than I intended, yet I cannot avoid mentioning another excellence which he possessed in a very eminent degree; he was as much distinguished among his contemporaries for his diligence and industry, as he was for the natural faculties of his mind. We are told that his whole attention was absorbed in the pursuit of his art, and that he acquired the name of Masaccio,* from his total disregard to his dress, his person, and all the common concerns of life. He is indeed a signal instance of what well-directed diligence will do in a short time; he lived but twenty-seven years; yet in that short space carried the art so far beyond what it had before reached, that he appears to stand alone as a model for his successors. Vasari gives a long catalogue of Painters and Sculptors,[17] who formed their taste, and learned their Art, by studying his works; among those, he names Michael Angelo, Lionardo da Vinci, Pietro Perugino, Raffaelle, Bartolomeo, Andrea del Sarto, Il Rosso, and Pierino del Vaga.

The habit of contemplating and brooding over the ideas of great geniuses, till you find yourself warmed by the contact, is the true method of forming an artist-like mind; it is im-

* The addition of *accio* denotes some deformity or imperfection attending that person to whom it is applied. R.

possible, in the presence of those great men, to think, or invent in a mean manner; a state of mind is acquired that receives those ideas only which relish of grandeur and simplicity.

Beside the general advantage of forming the taste by such an intercourse, there is another of a particular kind, which was suggested to me by the practice of Raffaelle, when imitating the work of which I have been speaking. The figure of the Proconsul, Sergius Paulus, is taken from the Felix of Masaccio,[18] though one is a front figure, and the other seen in profile; the action is likewise somewhat changed; but it is plain Raffaelle had that figure in his mind. There is a circumstance indeed, which I mention by the bye, which marks it very particularly; Sergius Paulus wears a crown of laurel; this is hardly reconcileable to strict propriety, and the *costume*,[19] of which Raffaelle was in general a good observer; but he found it so in Masaccio, and he did not bestow so much pains in disguise as to change it. It appears to me to be an excellent practice, thus to suppose the figures which you wish to adopt in the works of those great Painters to be statues; and to give, as Raffaelle has here given, another view, taking care to preserve all the spirit and grace you find in the original.

I should hope, from what has been lately said, that it is not necessary to guard myself against any supposition of recommending an entire dependence upon former masters. I do not desire that you shall get other people to do your business, or to think for you; I only wish you to consult with, to call in, as Counsellors, men the most distinguished for their knowledge and experience, the result of which counsel must ultimately depend upon yourself. Such conduct in the commerce of life has never been considered as disgraceful, or in any respect to imply intellectual imbecility; it is a sign rather of that true wisdom, which feels individual imperfection; and is conscious

to itself how much collective observation is necessary to fill the immense extent, and to comprehend the infinite variety of nature. I recommend neither self-dependence nor plagiarism. I advise you only to take that assistance which every human being wants, and which, as appears from the examples that have been given, the greatest Painters have not disdained to accept. Let me add, that the diligence required in the search, and the exertion subsequent in accommodating those ideas to your own purpose, is a business which idleness will not, and ignorance cannot, perform. But in order more distinctly to explain what kind of borrowing I mean, when I recommend so anxiously the study of the works of great Masters, let us for a minute return again to Raffaelle, consider his method of practice, and endeavour to imitate him, in his manner of imitating others.

The two figures of St Paul which I lately mentioned, are so nobly conceived by Masaccio, that perhaps it was not in the power even of Raffaelle himself to raise and improve them, nor has he attempted it; but he has had the address to change in some measure without diminishing the grandeur of their character; he has substituted, in the place of a serene composed dignity, that animated expression which was necessary to the more active employment he has assigned them.

In the same manner he has given more animation to the figure of Sergius Paulus, and to that which is introduced in the picture of St Paul preaching, of which little more than hints are given by Masaccio, which Raffaelle has finished. The closing the eyes of this figure, which in Masaccio might be easily mistaken for sleeping, is not in the least ambiguous in the Cartoon: his eyes indeed are closed, but they are closed with such vehemence, that the agitation of a mind *perplexed in the extreme*[20] is seen at the first glance; but what is most extraordinary, and I think particularly to be admired, is, that

the same idea is continued through the whole figure, even to the drapery, which is so closely muffled about him, that even his hands are not seen; by this happy correspondence between the expression of the countenance, and the disposition of the parts, the figure appears to think from head to foot. Men of superior talents alone are capable of thus using and adapting other men's minds to their own purposes, or are able to make out and finish what was only in the original a hint or imperfect conception. A readiness in taking such hints, which escape the dull and ignorant, makes in my opinion no inconsiderable part of that faculty of the mind which is called Genius.[21]

It often happens that hints may be taken and employed in a situation totally different from that in which they were originally employed. There is a figure of a Bacchante leaning backward, her head thrown quite behind her, which seems to be a favourite invention, as it is so frequently repeated in basso-relievos, cameos, and intaglios; it is intended to express an enthusiastick frantick kind of joy. This figure Baccio Bandinelli, in a drawing that I have of that Master, of the Descent from the Cross, has adopted, (and he knew very well what was worth borrowing,) for one of the Marys, to express frantick agony of grief. It is curious to observe, and it is certainly true, that the extremes of contrary passions are with very little variation expressed by the same action.

If I were to recommend method in any part of the study of a Painter, it would be in regard to invention; that young Students should not presume to think themselves qualified to invent, till they were acquainted with those stores of invention the world already possesses, and had by that means accumulated sufficient materials for the mind to work with. It would certainly be no improper method of forming the mind of a young Artist, to begin with such exercises as the Italians call a *Pasticcio*[22] composition of the different excellencies which

are dispersed in all other works of the same kind. It is not supposed that he is to stop here, but that he is to acquire by this means the art of selecting, first what is truly excellent in Art, and then what is still more excellent in Nature; a task which, without this previous study, he will be but ill qualified to perform.

The doctrine which is here advanced, is acknowledged to be new, and to many may appear strange. But I only demand for it the reception of a stranger; a favourable and attentive consideration, without that entire confidence which might be claimed under authoritative recommendation.[23]

After you have taken a figure, or any idea of a figure, from any of those great Painters, there is another operation still remaining, which I hold to be indispensably necessary, that is, never to neglect finishing from nature every part of the work. What is taken from a model, though the first idea may have been suggested by another, you have a just right to consider as your own property. And here I cannot avoid mentioning a circumstance in placing the model, though to some it may appear trifling. It is better to possess the model with the attitude you require, than to place him with your own hands: by this means it happens often that the model puts himself in an action superior to your own imagination. It is a great matter to be in the way of accident, and to be watchful and ready to take advantage of it: besides, when you fix the position of a model, there is danger of putting him in an attitude into which no man would naturally fall. This extends even to drapery. We must be cautious in touching and altering a fold of the stuff, which serves as a model, for fear of giving it inadvertently a forced form; and it is perhaps better to take the chance of another casual throw, than to alter the position in which it was at first accidentally cast.

Rembrandt, in order to take the advantage of accident,

appears often to have used the pallet-knife to lay his colours on the canvass, instead of the pencil. Whether it is the knife or any other instrument, it suffices if it is something that does not follow exactly the will. Accident in the hands of an Artist who knows how to take the advantage of its hints, will often produce bold and capricious beauties of handling and facility, such as he would not have thought of, or ventured, with his pencil, under the regular restraint of his hand. However, this is fit only on occasions where no correctness of form is required, such as clouds, stumps of trees, rocks, or broken ground. Works produced in an accidental manner will have the same free unrestrained air as the works of nature, whose particular combinations seem to depend upon accident.[24]

I again repeat, you are never to lose sight of nature; the instant you do, you are all abroad, at the mercy of every gust of fashion, without knowing or seeing the point to which you ought to steer. Whatever trips you make, you must still have nature in your eye. Such deviations as art necessarily requires, I hope in a future Discourse to be able to explain.[25] In the mean time, let me recommend to you, not to have too great dependance on your practice or memory, however strong those impressions may have been which are there deposited. They are for ever wearing out, and will be at last obliterated, unless they are continually refreshed and repaired.

It is not uncommon to meet with artists who, from a long neglect of cultivating this necessary intimacy with Nature, do not even know her when they see her; she appearing a stranger to them, from their being so long habituated to their own representation of her. I have heard Painters acknowledge, though in that acknowledgment no degradation of themselves was intended, that they could do better without Nature than with her; or, as they expressed it themselves, *that it only put them out*.[26] A Painter with such ideas and such habits, is

indeed in a most hopeless state. *The art of seeing Nature*, or, in other words, the art of using Models, is in reality the great object, the point to which all our studies are directed. As for the power of being able to do tolerably well, from practice alone, let it be valued according to its worth. But I do not see in what manner it can be sufficient for the production of correct, excellent, and finished Pictures. Works deserving this character never were produced, nor ever will arise, from memory alone; and I will venture to say, that an Artist who brings to his work a mind tolerably furnished with the general principles of Art, and a taste formed upon the works of good Artists, in short, who knows in what excellence consists, will, with the assistance of Models, which we will likewise suppose he has learnt the art of using, be an over-match for the greatest painter that ever lived who should be debarred such advantages.

Our neighbours, the French, are much in this practice of *extempore* invention, and their dexterity is such as even to excite admiration, if not envy; but how rarely can this praise be given to their finished pictures!

The late Director of their Academy, *Boucher*,[27] was eminent in this way. When I visited him some years since in France, I found him at work on a very large Picture, without drawings or models of any kind. On my remarking this particular circumstance, he said, when he was young, studying his art, he found it necessary to use models; but he had left them off for many years.

Such Pictures as this was, and such as I fear always will be produced by those who work solely from practice or memory, may be a convincing proof of the necessity of the conduct which I have recommended. However, in justice I cannot quit this Painter without adding, that in the former part of his life, when he was in the habit of having recourse to

nature,[28] he was not without a considerable degree of merit, – enough to make half the Painters of his country his imitators; he had often grace and beauty, and good skill in composition; but I think, all under the influence of a bad taste: his imitators are indeed abominable.

Those Artists who have quitted the service of nature, (whose service, when well understood, is *perfect freedom*,)[29] and have put themselves under the direction of I know not what capricious fantastical mistress, who fascinates and over-powers their whole mind, and from whose dominion there are no hopes of their being ever reclaimed, (since they appear perfectly satisfied, and not at all conscious of their forlorn situation,) like the transformed followers of Comus, –

> Not once perceive their foul disfigurement;
> But boast themselves more comely than before.[30]

Methinks, such men, who have found out so short a path, have no reason to complain of the shortness of life, and the extent of art; since life is so much longer than is wanted for their improvement, or indeed is necessary for the accomplish-ment of their idea of perfection. On the contrary, he who recurs to nature, at every recurrence renews his strength. The rules of art he is never likely to forget; they are few and simple; but nature is refined, subtle, and infinitely various, beyond the power and retention of memory; it is necessary, therefore, to have continual recourse to her. In this inter-course, there is no end of his improvement; the longer he lives, the nearer he approaches to the true and perfect idea of art.

DISCOURSE XIII[1]

GENTLEMEN,

To discover beauties, or to point out faults, in the works of celebrated Masters, and to compare the conduct of one Artist with another, is certainly no mean or inconsiderable part of criticism; but this is still no more than to know the art through the Artist. This test of investigation must have two capital defects; it must be narrow, and it must be uncertain. To enlarge the boundaries of the Art of Painting, as well as to fix its principles, it will be necessary, that, *that* art, and *those* principles, should be considered in their correspondence with the principles of the other arts, which, like this, address themselves primarily and principally to the imagination. When those connected and kindred principles are brought together to be compared, another comparison will grow out of this; that is, the comparison of them all with those of human nature, from whence arts derive the materials upon which they are to produce their effects.

When this comparison of art with art, and of all arts with the nature of man, is once made with success, our guiding lines are as well ascertained and established, as they can be in matters of this description.

This, as it is the highest style of criticism, is at the same time the soundest; for it refers to the eternal and immutable nature of things.

You are not to imagine that I mean to open to you at large, or to recommend to your research, the whole of this vast field of science. It is certainly much above my faculties to reach it; and though it may not be above yours to comprehend it fully, if it were fully and properly brought before you, yet perhaps the most perfect criticism requires habits of speculation and abstraction, not very consistent with the employment which ought to occupy, and the habits of mind which ought to prevail in a practical Artist. I only point out to you these things, that when you do criticise, (as all who work on a plan will criticise more or less,) your criticism may be built on the foundation of true principles; and that though you may not always travel a great way, the way that you do travel may be the right road.

I observe, as a fundamental ground, common to all the Arts with which we have any concern in this discourse, that they address themselves only to two faculties of the mind, its imagination and its sensibility.

All theories which attempt to direct or to control the Art, upon any principles falsely called rational, which we form to ourselves upon a supposition of what ought in reason to be the end or means of Art, independent of the known first effect produced by objects on the imagination, must be false and delusive. For though it may appear bold to say it, the imagination is here the residence of truth. If the imagination be affected, the conclusion is fairly drawn; if it be not affected, the reasoning is erroneous, because the end is not obtained; the effect itself being the test, and the only test, of the truth and efficacy of the means.[2]

There is in the commerce of life, as in Art, a sagacity which

is far from being contradictory to right reason, and is superior to any occasional exercise of that faculty; which supersedes it; and does not wait for the slow progress of deduction, but goes at once, by what appears a kind of intuition, to the conclusion. A man endowed with this faculty, feels and acknowledges the truth, though it is not always in his power, perhaps, to give a reason for it; because he cannot recollect and bring before him all the materials that gave birth to his opinion; for very many and very intricate considerations may unite to form the principle, even of small and minute parts, involved in, or dependent on a great system of things: though these in process of time are forgotten, the right impression still remains fixed in his mind.

This impression is the result of the accumulated experience of our whole life, and has been collected, we do not always know how or when. But this mass of collective observation, however acquired, ought to prevail over that reason, which however powerfully exerted on any particular occasion, will probably comprehend but a partial view of the subject; and our conduct in life, as well as in the Arts, is, or ought to be, generally governed by this habitual reason: it is our happiness that we are enabled to draw on such funds. If we were obliged to enter into a theoretical deliberation on every occasion, before we act, life would be at a stand, and Art would be impracticable.

It appears to me therefore, that our first thoughts, that is, the effect which any thing produces on our minds, on its first appearance, is never to be forgotten; and it demands for that reason, because it is the first, to be laid up with care. If this be not done, the Artist may happen to impose on himself by partial reasoning; by a cold consideration of those animated thoughts which proceed, not perhaps from caprice or rashness, (as he may afterwards conceit,)[3] but from the fulness of

his mind, enriched with the copious stores of all the various inventions which he had ever seen, or had ever passed in his mind. These ideas are infused into his design, without any conscious effort; but if he be not on his guard, he may reconsider and correct them, till the whole matter is reduced to a common-place invention.

This is sometimes the effect of what I mean to caution you against; that is to say, an unfounded distrust of the imagination and feeling, in favour of narrow, partial, confined, argumentative theories; and of principles that seem to apply to the design in hand; without considering those general impressions on the fancy in which real principles of *sound reason*, and of much more weight and importance, are involved, and, as it were, lie hid, under the appearance of a sort of vulgar sentiment.

Reason, without doubt, must ultimately determine every thing; at this minute it is required to inform us when that very reason is to give way to feeling.

Though I have often spoke of that mean conception of our art which confines it to mere imitation, I must add, that it may be narrowed to such a mere matter of experiment, as to exclude from it the application of science, which alone gives dignity and compass to any art. But to find proper foundations for science is neither to narrow or to vulgarise it; and this is sufficiently exemplified in the success of experimental philosophy. It is the false system of reasoning, grounded on a partial view of things, against which I would most earnestly guard you. And I do it the rather, because those narrow theories, so coincident with the poorest and most miserable practice, and which are adopted to give it countenance, have not had their origin in the poorest minds, but in the mistakes, or possibly in the mistaken interpretations, of great and commanding authorities. We are not therefore in this case misled by feeling, but by false speculation.

When such a man as Plato speaks of Painting as only an imitative art, and that our pleasure proceeds from observing and acknowledging the truth of the imitation,[4] I think he misleads us by a partial theory. It is in this poor, partial, and so far, false, view of the art, that Cardinal Bembo has chosen to distinguish even Raffaelle himself, whom our enthusiasm honours with the name of Divine. The same sentiment is adopted by Pope in his epitaph on Sir Godfrey Kneller; and he turns the panegyrick solely on imitation, as it is a sort of deception.[5]

I shall not think my time misemployed, if by any means I may contribute to confirm your opinion of what ought to be the object of your pursuit; because, though the best criticks must always have exploded this strange idea, yet I know that there is a disposition towards a perpetual recurrence to it, on account of its simplicity and superficial plausibility. For this reason I shall beg leave to lay before you a few thoughts on this subject; to throw out some hints that may lead your minds to an opinion, (which I take to be the truth,) that Painting is not only to be considered as an imitation, operating by deception, but that it is, and ought to be, in many points of view, and strictly speaking, no imitation at all of external nature. Perhaps it ought to be as far removed from the vulgar idea of imitation, as the refined civilized state in which we live, is removed from a gross state of nature; and those who have not cultivated their imaginations, which the majority of mankind certainly have not, may be said, in regard to arts, to continue in this state of nature. Such men will always prefer imitation to that excellence which is addressed to another faculty that they do not possess; but these are not the persons to whom a Painter is to look, any more than a judge of morals and manners ought to refer controverted points upon those subjects to the opinions of people taken from the banks of the Ohio, or from New Holland.[6]

It is the lowest style only of arts, whether of Painting, Poetry, or Musick, that may be said, in the vulgar sense, to be naturally pleasing. The higher efforts of those arts we know by experience, do not affect minds wholly uncultivated. This refined taste is the consequence of education and habit; we are born only with a capacity of entertaining this refinement, as we are born with a disposition to receive and obey all the rules and regulations of society; and so far it may be said to be natural to us, and no further.

What has been said, may show the Artist how necessary it is, when he looks about him for the advice and criticism of his friends, to make some distinction of the character, taste, experience, and observation in this Art, of those, from whom it is received. An ignorant uneducated man may, like Apelles's critick, be a competent judge of the truth of the representation of a sandal;[7] or to go somewhat higher, like Moliere's old woman, may decide upon what is nature, in regard to comick humour;[8] but a critick in the higher style of art, ought to possess the same refined taste, which directed the Artist in his work.

To illustrate this principle by a comparison with other Arts, I shall now produce some instances to show, that they, as well as our own Art, renounce the narrow idea of nature, and the narrow theories derived from that mistaken principle, and apply to that reason only which informs us not what imitation is, – a natural representation of a given object, – but what it is natural for the imagination to be delighted with. And perhaps there is no better way of acquiring this knowledge, than by this kind of analogy: each art will corroborate and mutually reflect the truth on the other. Such a kind of juxtaposition may likewise have this use, that whilst the Artist is amusing himself in the contemplation of other Arts, he may habitually transfer the principles of those Arts to that

which he professes; which ought to be always present to his mind, and to which every thing is to be referred.

So far is Art from being derived from, or having any immediate intercourse with, particular nature as its model, that there are many Arts that set out with a professed deviation from it.

This is certainly not so exactly true in regard to Painting and Sculpture. Our elements are laid in gross common nature, – an exact imitation of what is before us: but when we advance to the higher state, we consider this power of imitation, though first in the order of acquisition, as by no means the highest in the scale of perfection.

Poetry addresses itself to the same faculties and the same dispositions as Painting, though by different means.[9] The object of both is to accommodate itself to all the natural propensities and inclinations of the mind. The very existence of Poetry depends on the licence it assumes of deviating from actual nature, in order to gratify natural propensities by other means, which are found by experience full as capable of affording such gratification. It sets out with a language in the highest degree artificial, a construction of measured words, such as never is, nor ever was used by man. Let this measure be what it may, whether hexameter or any other metre used in Latin or Greek, – or Rhyme, or blank Verse varied with pauses and accents, in modern languages, – they are all equally removed from nature, and equally a violation of common speech. When this artificial mode has been established as the vehicle of sentiment, there is another principle in the human mind, to which the work must be referred, which still renders it more artificial, carries it still further from common nature, and deviates only to render it more perfect. That principle is the sense of congruity, coherence, and consistency, which is a real existing principle in man; and it must be gratified. There-

fore having once adopted a style and a measure not found in common discourse, it is required that the sentiments also should be in the same proportion elevated above common nature, from the necessity of there being an agreement of the parts among themselves, that one uniform whole may be produced.

To correspond therefore with this general system of deviation from nature, the manner in which poetry is offered to the ear, the tone in which it is recited, should be as far removed from the tone of conversation, as the words of which that Poetry is composed. This naturally suggests the idea of modulating the voice by art, which I suppose may be considered as accomplished to the highest degree of excellence in the recitative of the Italian Opera; as we may conjecture it was in the Chorus that attended the ancient drama. And though the most violent passions, the highest distress, even death itself, are expressed in singing or recitative, I would not admit as sound criticism the condemnation of such exhibitions on account of their being unnatural.[10]

If it is natural for our senses, and our imaginations, to be delighted with singing, with instrumental musick, with poetry, and with graceful action, taken separately; (none of them being in the vulgar sense natural, even in that separate state;) it is conformable to experience, and therefore agreeable to reason as connected with and referred to experience, that we should also be delighted with this union of musick, poetry, and graceful action joined to every circumstance of pomp and magnificence calculated to strike the senses of the spectator. Shall reason stand in the way, and tell us that we ought not to like what we know we do like, and prevent us from feeling the full effect of this complicated exertion of art? This is what I would understand by poets and painters being allowed to dare every thing; for what can be more daring, than

accomplishing the purpose and end of art, by a complication of means, none of which have their archetypes in actual nature?

So far therefore is servile imitation from being necessary, that whatever is familiar, or in any way reminds us of what we see and hear every day, perhaps does not belong to the higher provinces of art, either in poetry or painting. The mind is to be transported, as Shakspeare expresses it, *beyond the ignorant present*,[11] to ages past. Another and a higher order of beings is supposed; and to those beings every thing which is introduced into the work must correspond. Of this conduct, under these circumstances, the Roman and Florentine schools afford sufficient examples. Their style by this means is raised and elevated above all others; and by the same means the compass of art itself is enlarged.

We often see grave and great subjects attempted by artists of another school; who, though excellent in the lower class of art, proceeding on the principles which regulate that class, and not recollecting, or not knowing, that they were to address themselves to another faculty of the mind, have become perfectly ridiculous.

The picture which I have at present in my thoughts is a sacrifice of Iphigenia, painted by Jan Steen, a painter of whom I have formerly had occasion to speak with the highest approbation;[12] and even in this picture, the subject of which is by no means adapted to his genius, there is nature and expression; but it is such expression, and the countenances are so familiar, and consequently so vulgar, and the whole accompanied with such finery of silks and velvets, that one would be almost tempted to doubt, whether the artist did not purposely intend to burlesque his subject.[13]

Instances of the same kind we frequently see in poetry. Parts of Hobbes's translation of Homer[14] are remembered and repeated merely for the familiarity and meanness of their

phraseology, so ill corresponding with the ideas which ought to have been expressed, and, as I conceive, with the style of the original.

We may proceed in the same manner through the comparatively inferior branches of art. There are in works of that class, the same distinction of a higher and a lower style; and they take their rank and degree in proportion as the artist departs more, or less, from common nature, and makes it an object of his attention to strike the imagination of the spectator by ways belonging specially to art, – unobserved and untaught out of the school of its practice.

If our judgements are to be directed by narrow, vulgar, untaught or rather ill-taught reason, we must prefer a portrait by Denner, or any other high finisher, to those of Titian or Vandyck; and a landscape of Vanderheyden to those of Titian or Rubens; for they are certainly more exact representations of nature.

If we suppose a view of nature represented with all the truth of the *camera obscura*,[15] and the same scene represented by a great artist, how little and mean will the one appear in comparison of the other, where no superiority is supposed from the choice of the subject. The scene shall be the same, the difference only will be in the manner in which it is presented to the eye. With what additional superiority then will the same Artist appear when he has the power of selecting his materials, as well as elevating his style? Like Nicolas Poussin, he transports us to the environs of ancient Rome, with all the objects which a literary education makes so precious and interesting to man: or, like Sebastian Bourdon, he leads us to the dark antiquity of the Pyramids of Egypt;[16] or, like Claude Lorrain, he conducts us to the tranquillity of Arcadian scenes and fairy land.

Like the history-painter, a painter of landscapes in this

style and with this conduct, sends the imagination back into antiquity; and, like the poet, he makes the elements sympathise with his subject: whether the clouds roll in volumes like those of Titian or Salvator Rosa, – or, like those of Claude, are gilded with the setting sun; whether the mountains have sudden and bold projections, or are gently sloped; whether the branches of his trees shoot out abruptly in right angles from their trunks, or follow each other with only a gentle inclination. All these circumstances contribute to the general character of the work, whether it be of the elegant, or of the more sublime kind. If we add to this the powerful materials of lightness and darkness, over which the Artist has complete dominion, to vary and dispose them as he pleases; to diminish, or increase them, as will best suit his purpose, and correspond to the general idea of his work; a landscape thus conducted, under the influence of a poetical mind, will have the same superiority over the more ordinary and common views, as Milton's *Allegro* and *Pensoroso*[17] have over a cold prosaick narration or description; and such a picture would make a more forcible impression on the mind than the real scenes, were they presented before us.

If we look abroad to other Arts, we may observe the same distinction, the same division into two classes; each of them acting under the influence of two different principles, in which the one follows nature, the other varies it, and sometimes departs from it.

The Theatre, which is said *to hold the mirrour up to nature*,[18] comprehends both those ideas. The lower kind of Comedy, or Farce, like the inferior style of Painting, the more naturally it is represented, the better; but the higher appears to me to aim no more at imitation, so far as it belongs to any thing like deception, or to expect that the spectators should think that the events there represented are really pass-

ing before them, than Raffaelle in his Cartoons, or Poussin in his Sacraments, expected it to be believed, even for a moment, that what they exhibited were real figures.[19]

For want of this distinction, the world is filled with false criticism. Rafaelle is praised for naturalness and deception, which he certainly has not accomplished, and as certainly never intended; and our late great actor, Garrick, has been as ignorantly praised by his friend Fielding;[20] who doubtless imagined he had hit upon an ingenious device, by introducing in one of his novels, (otherwise a work of the highest merit,) an ignorant man, mistaking Garrick's representation of a scene in Hamlet, for reality. A very little reflection will convince us, that there is not one circumstance in the whole scene that is of the nature of deception. The merit and excellence of Shakspeare, and of Garrick, when they were engaged in such scenes, is of a different and much higher kind. But what adds to the falsity of this intended compliment, is, that the best stage-representation appears even more unnatural to a person of such a character, who is supposed never to have seen a play before, than it does to those who have had a habit of allowing for those necessary deviations from nature which the Art requires.

In theatrick representation, great allowances must always be made for the place in which the exhibition is represented; for the surrounding company, the lighted candles, the scenes visibly shifted in your sight, and the language of blank verse, so different from common English; which merely as English must appear surprising in the mouths of Hamlet, and all the court and natives of Denmark. These allowances are made; but their being made puts an end to all manner of deception: and further; we know that the more low, illiterate, and vulgar any person is, the less he will be disposed to make these allowances, and of course to be deceived by any imitation; the

things in which the trespass against the nature and common probability is made in favour of the theatre, being quite within the sphere of such uninformed men.[21]

Though I have no intention of entering into all the circumstances of unnaturalness in theatrical representations,[22] I must observe that even the expression of violent passion is not always the most excellent in proportion as it is the most natural; so, great terror and such disagreeable sensations may be communicated to the audience, that the balance may be destroyed by which pleasure is preserved, and holds its predominancy in the mind: violent distortion of action, harsh screamings of the voice, however great the occasion, or however natural on such occasion, are therefore not admissible in the theatrick art. Many of these allowed deviations from nature arise from the necessity which there is, that every thing should be raised and enlarged beyond its natural state; that the full effect may come home to the spectator, which otherwise would be lost in the comparatively extensive space of the Theatre. Hence the deliberate and stately step, the studied grace of action, which seems to enlarge the dimensions of the Actor, and alone to fill the stage. All this unnaturalness, though right and proper in its place, would appear affected and ridiculous in a private room; *quid enim deformius, quàm scenam in vitam transferre?*[23]

And here I must observe, and I believe it may be considered as a general rule, that no Art can be grafted with success on another art. For though they all profess the same origin, and to proceed from the same stock, yet each has its own peculiar modes both of imitating nature, and of deviating from it, each for the accomplishment of its own particular purpose. These deviations, more especially, will not bear transplantation to another soil.

If a Painter should endeavour to copy the theatrical pomp

and parade of dress and attitude, instead of that simplicity, which is not a greater beauty in life than it is in Painting, we should condemn such Pictures, as painted in the meanest style.[24]

So also Gardening, as far as Gardening is an Art, or entitled to that appellation, is a deviation from nature; for if the true taste consists, as many hold, in banishing every appearance of Art, or any traces of the footsteps of man, it would then be no longer a Garden. Even though we define it, 'Nature to advantage dress'd,'[25] and in some sense is such, and much more beautiful and commodious for the recreation of man; it is however, when so dressed, no longer a subject for the pencil of a Landscape-Painter, as all Landscape-Painters know, who love to have recourse to Nature herself, and to dress her according to the principles of their own Art; which are far different from those of Gardening, even when conducted according to the most approved principles; and such as a Landscape-Painter himself would adopt in the disposition of his own grounds, for his own private satisfaction.[26]

I have brought together as many instances as appear necessary to make out the several points which I wished to suggest to your consideration in this Discourse; that your own thoughts may lead you further in the use that may be made of the analogy of the Arts; and of the restraint which a full understanding of the diversity of many of their principles ought to impose on the employment of that analogy.

The great end of all those arts is, to make an impression on the imagination and the feeling. The imitation of nature frequently does this. Sometimes it fails, and something else succeeds. I think therefore the true test of all the arts is not solely whether the production is a true copy of nature, but whether it answers the end of art, which is to produce a pleasing effect upon the mind.

It remains only to speak a few words of Architecture, which does not come under the denomination of an imitative art. It applies itself, like Musick, (and I believe we may add Poetry,) directly to the imagination, without the invention of any kind of imitation.

There is in Architecture, as in Painting, an inferior branch of art, in which the imagination appears to have no concern. It does not, however, acquire the name of a polite and liberal art, from its usefulness, or administering to our wants or necessities, but from some higher principle: we are sure that in the hands of a man of genius it is capable of inspiring sentiment, and of filling the mind with great and sublime ideas.

It may be worth the attention of Artists to consider what materials are in their hands, that may contribute to this end; and whether this art has it not in its power to address itself to the imagination with effect, by more ways than are generally employed by Architects.

To pass over the effect produced by that general symmetry and proportion, by which the eye is delighted, as the ear is with musick, Architecture certainly possesses many principles in common with Poetry and Painting. Among those which may be reckoned as the first, is, that of affecting the imagination by means of association of ideas.[27] Thus, for instance, as we have naturally a veneration for antiquity, whatever building brings to our remembrance ancient customs and manners, such as the castles of the Barons of ancient Chivalry, is sure to give this delight.[28] Hence it is that *towers and battlements*[29] are so often selected by the Painter and the Poet, to make a part of the composition of their ideal Landscape; and it is from hence in a great degree, that in the buildings of Vanbrugh, who was a Poet as well as an Architect, there is a greater display of imagination, than we shall find perhaps in any

other, and this is the ground of the effect we feel in many of his works, notwithstanding the faults with which many of them are justly charged. For this purpose, Vanbrugh appears to have had recourse to some of the principles of the Gothick Architecture; which, though not so ancient as the Grecian, is more so to our imagination, with which the Artist is more concerned than with absolute truth.[30]

The Barbarick splendour of those Asiatick Buildings, which are now publishing by a member of this Academy,*[31] may possibly, in the same manner, furnish an Architect, not with models to copy, but with hints of composition and general effect, which would not otherwise have occurred.

It is, I know, a delicate and hazardous thing, (and as such I have already pointed it out,) to carry the principles of one art to another, or even to reconcile in one object the various modes of the same Art, when they proceed on different principles. The sound rules of the Grecian Architecture are not to be lightly sacrificed. A deviation from them, or even an addition to them, is like a deviation or addition to, or from, the rules of other Arts, – fit only for a great master, who is thoroughly conversant in the nature of man, as well as all combinations in his own Art.

It may not be amiss for the Architect to take advantage *sometimes* of that to which I am sure the Painter ought always to have his eyes open, I mean the use of accidents: to follow when they lead, and to improve them, rather than always to trust to a regular plan. It often happens that additions have been made to houses, at various times, for use or pleasure. As such buildings depart from regularity, they now and then acquire something of scenery by this accident, which I should think might not unsuccessfully be adopted by an Architect, in

*Mr Hodges.

an original plan, if it does not too much interfere with convenience. Variety and intricacy is a beauty and excellence in every other of the arts which address the imagination: and why not in Architecture?

The forms and turnings of the streets of London, and other old towns, are produced by accident, without any original plan or design: but they are not always the less pleasant to the walker or spectator, on that account. On the contrary, if the city had been built on the regular plan of Sir Christopher Wren, the effect might have been, as we know it is in some new parts of the town, rather unpleasing; the uniformity might have produced weariness, and a slight degree of disgust.[32]

I can pretend to no skill in the detail of Architecture. I judge now of the art, merely as a Painter. When I speak of Vanbrugh, I mean to speak of him in the language of our art. To speak then of Vanbrugh in the language of a Painter, he had originality of invention, he understood light and shadow, and had great skill in composition. To support his principal object, he produced his second and third groups or masses; he perfectly understood in his Art what is the most difficult in ours, the conduct of the back-ground; by which the design and invention is set off to the greatest advantage. What the back-ground is in Painting, in Architecture is the real ground on which the building is erected; and no Architect took greater care than he that his work should not appear crude and hard: that is, it did not abruptly start out of the ground without expectation or preparation.

This is a tribute which a Painter owes to an Architect who composed like a Painter; and was defrauded of the due reward of his merit by the Wits of his time, who did not understand the principles of composition in poetry better than he; and who knew little, or nothing, of what he understood perfectly,

the general ruling principles of Architecture and Painting. His fate was that of the great Perrault; both were the objects of the petulant sarcasms of factious men of letters; and both have left some of the fairest ornaments which to this day decorate their several countries; the façade of the Louvre, Blenheim, and Castle-Howard.[33]

Upon the whole, it seems to me, that the object and intention of all the Arts is to supply the natural imperfection of things, and often to gratify the mind by realizing and embodying what never existed but in the imagination.

It is allowed on all hands, that facts, and events, however they may bind the Historian, have no dominion over the Poet or the Painter. With us, History is made to bend and conform to this great idea of Art. And why? Because these Arts, in their highest province, are not addressed to the gross senses; but to the desires of the mind, to that spark of divinity which we have within, impatient of being circumscribed and pent up by the world which is about us. Just so much as our Art has of this, just so much of dignity, I had almost said of divinity, it exhibits; and those of our Artists who possessed this mark of distinction in the highest degree, acquired from thence the glorious appellation of DIVINE.

DISCOURSE XIV[1]

———

GENTLEMEN,

IN the study of our Art, as in the study of all Arts, something is the result of *our own* observation of Nature; something, and that not little, the effect of the example of those who have studied the same nature before us, and who have cultivated before us the same Art, with diligence and success. The less we confine ourselves in the choice of those examples, the more advantage we shall derive from them; and the nearer we shall bring our performances to a correspondence with nature and the great general rules of Art. When we draw our examples from remote and revered antiquity, – with some advantage undoubtedly in that selection, – we subject ourselves to some inconveniences. We may suffer ourselves to be too much led away by great names, and to be too much subdued by overbearing authority. Our learning, in that case, is not so much an exercise of our judgement, as a proof of our docility. We find ourselves, perhaps, too much overshadowed; and the character of our pursuits is rather distinguished by the tameness of the follower, than animated by the spirit of emulation. It is sometimes of service, that our examples should be *near* us; and such as raise a reverence, sufficient to induce us carefully to observe them, yet not so great as to

prevent us from engaging with them in something like a generous contention.

We have lately lost Mr Gainsborough,[2] one of the greatest ornaments of our Academy. It is not our business here, to make panegyricks on the living, or even on the dead who were of our body. The praise of the former might bear appearance of adulation; and the latter, of untimely justice; perhaps of envy to those whom we have still the happiness to enjoy, by an oblique suggestion of invidious comparisons. In discoursing therefore on the talents of the late Mr Gainsborough, my object is, not so much to praise or to blame him, as to draw from his excellencies and defects, matter of instruction to the Students in our Academy. If ever this nation should produce genius sufficient to acquire to us the honourable distinction of an English School, the name of Gainsborough will be transmitted to posterity, in the history of the Art, among the very first of that rising name. That our reputation in the Arts is now only rising, must be acknowledged; and we must expect our advances to be attended with old prejudices, as adversaries, and not as supporters; standing in this respect in a very different situation from the late artists of the Roman School, to whose reputation ancient prejudices have certainly contributed: the way was prepared for them, and they may be said rather to have lived in the reputation of their country, than to have contributed to it; whilst whatever celebrity is obtained by English Artists, can arise only from the operation of a fair and true comparison. And when they communicate to their country a share of their reputation, it is a portion of fame not borrowed from others, but solely acquired by their own labour and talents. As Italy has undoubtedly a prescriptive right to an administration bordering on prejudice, as a soil peculiarly adapted, congenial, and, we may add, destined to the production of men of great genius in our Art,

we may not unreasonably suspect that a portion of the great fame of some of their late artists has been owing to the general readiness and disposition of mankind, to acquiesce in their original prepossessions in favour of the productions of the Roman School.

On this ground, however unsafe, I will venture to prophesy, that two of the last distinguished painters of that country, I mean Pompeio Battoni and Raffaelle Mengs,[3] however great their names may at present sound in our ears, will very soon fall into the rank of Imperiale, Sebastian Concha, Placido Constanza, Masuccio, and the rest of their immediate predecessors; whose names, though equally renowned in their life-time, are now fallen into what is little short of total oblivion. I do not say that those painters were not superior to the artist I allude to, and whose loss we lament, in a certain routine of practice, which, to the eyes of common observers, has the air of a learned composition, and bears a sort of superficial resemblance to the manner of the great men who went before them. I know this perfectly well; but I know likewise, that a man, looking for real and lasting reputation, must unlearn much of the common-place method so observable in the works of the artists whom I have named. For my own part, I confess, I take more interest in, and am more captivated with the powerful impression of nature, which Gainsborough exhibited in his portraits and in his landscapes, and the interesting simplicity and elegance of his little ordinary beggar-children, than with any of the works of that School, since the time of Andrea Sacchi, or perhaps we may say Carlo Maratti; two painters who may truly be said to be ULTIMI ROMANORUM.[4]

I am well aware how much I lay myself open to the censure and ridicule of the academical professors of other nations, in preferring the humble attempts of Gainsborough to the works

of those regular graduates in the great historical style. But we have the sanction of all mankind in preferring genius in a lower rank of art, to feebleness and insipidity in the highest.

It would not be to the present purpose, even if I had the means and materials, which I have not, to enter into the private life of Mr Gainsborough. The history of his gradual advancement,[5] and the means by which he acquired such excellence in his art, would come nearer to our purposes and wishes, if it were by any means attainable; but the slow progress of advancement is in general imperceptible to the man himself who makes it; it is the consequence of an accumulation of various ideas which his mind had received, he does not perhaps know how or when. Sometimes indeed it happens, that he may be able to mark the time when from the sight of a picture, a passage in an author, or a hint in conversation, he has received, as it were, some new and guiding light, something like inspiration, by which his mind had been expanded; and is morally sure that his whole life and conduct has been affected by that accidental circumstance. Such interesting accounts, we may however sometimes obtain from a man who has acquired an uncommon habit of self-examination, and has attended to the progress of his own improvement.

It may not be improper to make mention of some of the customs and habits of this extraordinary man; points which come more within the reach of an observer; I however mean such only as are connected with his art, and indeed were, as I apprehend, the causes of his arriving to that high degree of excellence, which we see and acknowledge in his works. Of these causes we must state, as the fundamental, the love which he had to his art; to which, indeed, his whole mind appears to have been devoted, and to which every thing was referred; and this we may fairly conclude from various circumstances of his life, which were known to his intimate friends. Among

others he had a habit of continually remarking to those who happened to be about him whatever peculiarity of countenance, whatever accidental combination of figure, or happy effects of light and shadow, occurred in prospects, in the sky, in walking the streets, or in company. If, in his walks, he found a character that he liked, and whose attendance was to be obtained, he ordered him to his house: and from the fields he brought into his painting-room, stumps of trees, weeds, and animals of various kinds; and designed them, not from memory, but immediately from the objects. He even framed a kind of model of landscapes on his table; composed of broken stones, dried herbs, and pieces of looking glass, which he magnified and improved into rocks, trees and water.[6] How far this latter practice may be useful in giving hints, the professors of landscape can best determine. Like every other technical practice, it seems to me wholly to depend on the general talent of him who uses it. Such methods may be nothing better than contemptible and mischievous trifling; or they may be aids. I think upon the whole, unless we constantly refer to real nature, that practice may be more likely to do harm than good. I mention it only, as it shows the solicitude and extreme activity which he had about every thing that related to his art; that he wished to have his objects embodied as it were, and distinctly before him; that he neglected nothing which could keep his faculties in exercise, and derived hints from every sort of combination.

We must not forget whilst we are on this subject, to make some remarks on his custom of painting by night,[7] which confirms what I have already mentioned, – his great affection to his art; since he could not amuse himself in the evening by any other means so agreeable to himself. I am indeed much inclined to believe that it is a practice very advantageous and improving to an artist; for by this means he will acquire a

new and a higher perception of what is great and beautiful in Nature. By candle-light, not only objects appear more beautiful, but from their being in a great breadth of light and shadow, as well as having a greater breadth and uniformity of colour, nature appears in a higher style; and even the flesh seems to take a higher and richer tone of colour. Judgement is to direct us in the use to be made of this method of study; but the method itself is, I am very sure, advantageous. I have often imagined that the two great colourists, Titian and Correggio, though I do not know that they painted by night, formed their high ideas of colouring from the effects of objects by this artificial light: but I am more assured, that whoever attentively studies the first and best manner of Guercino, will be convinced that he either painted by this light, or formed his manner on this conception.

Another practice Gainsborough had, which is worth mentioning, as it is certainly worthy of imitation; I mean his manner of forming all the parts of his picture together; the whole going on at the same time, in the same manner as nature creates her works. Though this method is not uncommon to those who have been regularly educated, yet probably it was suggested to him by his own natural sagacity. That this custom is not universal appears from the practice of a painter whom I have just mentioned, Pompeio Battoni, who finished his historical pictures part after part, and in his portraits completely finished one feature before he proceeded to another. The consequence was, as might be expected; the countenance was never well expressed; and, as the painters say, the whole was not well put together.

The first thing required to excel in our art, or I believe in any art, is not only a love for it, but even an enthusiastick ambition to excel in it. This never fails of success proportioned to the natural abilities with which the artist has been

endowed by Providence. Of Gainsborough, we certainly know, that his passion was not the acquirement of riches, but excellence in his art; and to enjoy that honourable fame which is sure to attend it. — That *he felt this ruling passion*[8] *strong in death*, I am myself a witness. A few days before he died, he wrote me a letter, to express his acknowledgements for the good opinion I entertained of his abilities, and the manner in which (he had been informed) I always spoke of him; and desired he might see me once more before he died.[9] I am aware how flattering it is to myself to be thus connected with the dying testimony which this excellent painter bore to his art. But I cannot prevail on myself to suppress, that I was not connected with him, by any habits of familiarity: if any little jealousies had subsisted between us, they were forgotten, in those moments of sincerity; and he turned towards me as one, who was engrossed by the same pursuits, and who deserved his good opinion, by being sensible of his excellence. Without entering into a detail of what passed at this last interview, the impression of it upon my mind was, that his regret at losing life, was principally the regret of leaving his art; and more especially as he now began, he said, to see what his deficiencies were; which, he said, he flattered himself in his last works were in some measure supplied.

When such a man as Gainsborough arrives to great fame, without the assistance of an academical education, without travelling to Italy, or any of those preparatory studies which have been so often recommended, he is produced as an instance, how little such studies are necessary; since so great excellence may be acquired without them. This is an inference not warranted by the success of any individual; and I trust it will not be thought that I wish to make this use of it.

It must be remembered that the style and department of art which Gainsborough chose, and in which he so much

excelled, did not require that he should go out of his own country for the objects of his study; they were every where about him; he found them in the streets, and in the fields; and from the models thus accidentally found, he selected with great judgement such as suited his purpose. As his studies were directed to the living world principally, he did not pay a general attention to the works of the various masters, though they are, in my opinion, always of great use, even when the character of our subject requires us to depart from some of their principles. It cannot be denied, that excellence in the department of the art which he professed may exist without them; that in such subjects, and in the manner that belongs to them, the want of them is supplied, and more than supplied, by natural sagacity, and a minute observation of particular nature. If Gainsborough did not look at nature with a poet's eye, it must be acknowledged that he saw her with the eye of a painter; and gave a faithful, if not a poetical, representation of what he had before him.

Though he did not much attend to the works of the great historical painters of former ages, yet he was well aware that the language of the art – the art of imitation – must be learned somewhere; and as he knew that he could not learn it in an equal degree from his contemporaries, he very judiciously applied himself to the Flemish School, who are undoubtedly the greatest masters of one necessary branch of art; and he did not need to go out of his own country for examples of that school: from that he learnt the harmony of colouring, the management and disposition of light and shadow, and every means which the masters of it practised, to ornament and give splendour to their works. And to satisfy himself as well as others, how well he knew the mechanism and artifice which they employed to bring out that tone of colour which we so much admired in their works, he occasionally made

copies from Rubens, Teniers, and Vandyck, which it would be no disgrace to the most accurate connoisseur to mistake, at the first sight, for the works of those masters. What he thus learned, he applied to the originals of nature, which he saw with his own eyes; and imitated, not in the manner of those masters, but in his own.

Whether he most excelled in portraits, landscapes, or fancy-pictures,[10] it is difficult to determine: whether his portraits were most admirable for exact truth of resemblance, or his landscapes for a portrait-like representation of nature, such as we see in the works of Rubens, Ruysdaal, and others of those schools. In his fancy-pictures, when he had fixed on his object of imitation, whether it was the mean and vulgar form of a wood-cutter, or a child of an interesting character, as he did not attempt to raise the one, so neither did he lose any of the natural grace and elegance of the other; such a grace, and such an elegance, as are more frequently found in cottages than in courts. This excellence was his own, the result of his particular observation and taste; for this he was certainly not indebted to the Flemish School, nor indeed to any School; for his grace was not academical or antique, but selected by himself from the great school of nature; and there are yet a thousand modes of grace, which are neither theirs, nor his, but lie open in the multiplied scenes and figures of life, to be brought out by skilful and faithful observers.

Upon the whole, we may justly say, that whatever he attempted he carried to a high degree of excellence. It is to the credit of his good sense and judgement, that he never did attempt that style of historical painting, for which his previous studies had made no preparation.

And here it naturally occurs to oppose the sensible conduct of Gainsborough, in this respect, to that of our late excellent Hogarth, who, with all his extraordinary talents, was not

blessed with this knowledge of his own deficiency; or of the bounds which were set to the extent of his own powers. After this admirable artist had spent the greater part of his life in an active, busy, and, we may add, successful attention to the ridicule of life; after he had invented a new species of dramatic painting, in which probably he will never be equalled, and had stored his mind with infinite materials to explain and illustrate the domestic and familiar scenes of common life, which were generally, and ought to have been always, the subject of his pencil; he very imprudently, or rather presumptuously, attempted the great historical style, for which his previous habits had by no means prepared him:[11] he was indeed so entirely unacquainted with the principles of this style, that he was not even aware that any artificial preparation was at all necessary. It is to be regretted, that any part of the life of such a genius should be fruitlessly employed. Let his failure teach us not to indulge ourselves in the vain imagination, that by a momentary resolution we can give either dexterity to the hand, or a new habit to the mind.

I have, however, little doubt, but that the same sagacity, which enabled those two extraordinary men to discover their true object, and the peculiar excellence of that branch of art which they cultivated, would have been equally effectual in discovering the principles of the higher style; if they had investigated those principles with the same eager industry which they exerted in their own department. As Gainsborough never attempted the heroick style, so neither did he destroy the character and uniformity of his own style, by the idle affectation of introducing mythological learning in any of his pictures. Of this boyish folly we see instances enough, even in the works of great painters. When the Dutch School attempt this poetry of our art in their landscapes, their performances are beneath criticism; they become only an object of

laughter. This practice is hardly excusable, even in Claude Lorrain, who had shown more discretion, if he had never meddled with such subjects.

Our late ingenious Academician, Wilson,[12] has, I fear, been guilty, like many of his predecessors, of introducing gods and goddesses, ideal beings, into scenes which were by no means prepared to receive such personages. His landscapes were in reality too near common nature to admit supernatural objects. In consequence of this mistake, in a very admirable picture of a storm, which I have seen of his hand, many figures are introduced in the fore ground, some in apparent distress, and some struck dead, as a spectator would naturally suppose, by the lightning; had not the painter injudiciously (as I think) rather chosen that their death should be imputed to a little Apollo, who appears in the sky, with his bent bow, and that those figures should be considered as the children of Niobe.[13]

To manage a subject of this kind, a peculiar style of art is required; and it can only be done without impropriety, or even without ridicule, when we adapt the character of the landscape, and that too, in all its parts, to the historical or poetical representation. This is a very difficult adventure, and it requires a mind thrown back two thousand years, and as it were naturalized in antiquity, like that of Nicolo Poussin, to atchieve it. In the picture alluded to, the first idea that presents itself is that of wonder, at seeing a figure in so uncommon a situation as that in which the Apollo is placed; for the clouds on which he kneels have not the appearance of being able to support him; they have neither the substance nor the form fit for the receptacle of a human figure; and they do not possess in any respect that romantic character which is appropriated to such an object, and which alone can harmonize with poetical stories.

It appears to me, that such conduct is no less absurd, than if a plain man, giving a relation of a real distress, occasioned by an inundation accompanied with thunder and lightning, should, instead of simply relating the event, take it into his head, in order to give a grace to his narration, to talk of Jupiter Pluvius, or Jupiter and his thunder-bolts, or any other figurative idea; an intermixture which, though in poetry, with its proper preparations and accompaniments, it might be managed with effect, yet in the instance before us would counteract the purpose of the narrator, and instead of being interesting, would be only ridiculous.

The Dutch and Flemish style of landscape, not even excepting those of Rubens, is unfit for poetical subjects; but to explain in what this ineptitude consists, or to point out all the circumstances that give nobleness, grandeur, and the poetick character, to style, in landscape, would require a long discourse of itself; and the end would be then perhaps but imperfectly attained. The painter who is ambitious of this perilous excellence, must catch his inspiration from those who have cultivated with success the poetry, as it may be called, of the art; and they are few indeed.

I cannot quit this subject without mentioning two examples which occur to me at present, in which the poetical style of landscape may be seen happily executed; the one is Jacob's Dream by Salvator Rosa, and the other the Return of the Ark from captivity, by Sebastian Bourdon.[14] With whatever dignity those histories are presented to us in the language of Scripture, this style of painting possesses the same power of inspiring sentiments of grandeur and sublimity, and is able to communicate them to subjects which appear by no means adapted to receive them. A ladder against the sky has no very promising appearance of possessing a capacity to excite any heroick ideas; and the Arc, in the hands of a second-rate

master, would have little more effect than a common waggon on the highway; yet those subjects are so poetically treated throughout, the parts have such a correspondence with each other, and the whole and every part of the scene is so visionary, that it is impossible to look at them, without feeling, in some measure, the enthusiasm which seems to have inspired the painters.

By continual contemplation of such works, a sense of the higher excellencies of art will by degrees dawn on the imagination; at every review that sense will become more and more assured, until we come to enjoy a sober certainty of the real existence (if I may so express myself) of those almost ideal beauties; and the artist will then find no difficulty in fixing in his mind the principles by which the impression is produced; which he will feel and practise, though they are perhaps too delicate and refined, and too peculiar to the imitative art, to be conveyed to the mind by any other means.

To return to Gainsborough: the peculiarity of his manner, or style, or we may call it – the language in which he expressed his ideas, has been considered by many as his greatest defect. But without altogether wishing to enter into the discussion – whether this peculiarity was a defect or not, intermixed, as it was, with great beauties, of some of which it was probably the cause, it becomes a proper subject of criticism and enquiry to a painter.

A novelty and peculiarity of manner, as it is often a cause of our approbation, so likewise it is often a ground of censure; as being contrary to the practice of other painters, in whose manner we have been initiated, and in whose favour we have perhaps been prepossessed from our infancy, for, fond as we are of novelty, we are upon the whole creatures of habit. However, it is certain, that all those odd scratches and marks, which on a close examination, are so observable in Gains-

borough's pictures, and which even to experienced painters appear rather the effect of accident than design; this chaos, this uncouth and shapeless appearance, by a kind of magick, at a certain distance assumes form, and all the parts seem to drop into their proper places, so that we can hardly refuse acknowledging the full effect of diligence, under the appearance of chance and hasty negligence. That Gainsborough himself considered this peculiarity in his manner, and the power it possesses of exciting surprise, as a beauty in his works, I think may be inferred from the eager desire which we know he always expressed, that his pictures, at the Exhibition, should be seen near, as well as at a distance.[15]

The slightness which we see in his best works cannot always be imputed to negligence. However they may appear to superficial observers, painters know very well that a steady attention to the general effect takes up more time, and is much more laborious to the mind, than any mode of high finishing, or smoothness, without such attention. His *handling, the manner of leaving the colours*, or, in other words, the methods he used for producing the effect, had very much the appearance of the work of an artist who had never learned from others the usual and regular practice belonging to the art; but still, like a man of strong intuitive perception of what was required, he found out a way of his own to accomplish his purpose.

It is no disgrace to the genius of Gainsborough, to compare him to such men as we sometimes meet with, whose natural eloquence appears even in speaking a language which they can scarce be said to understand; and who, without knowing the appropriate expression of almost any one idea, contrive to communicate the lively and forcible impressions of an energetick mind.

I think some apology may reasonably be made for his

manner without violating truth, or running any risk of poison-
ing the minds of the younger students, by propagating false
criticism, for the sake of raising the character of a favourite
artist. It must be allowed, that this hatching manner of Gains-
borough did very much contribute to the lightness of effect
which is so eminent a beauty in his pictures; as on the con-
trary, much smoothness, and uniting the colours, is apt to
produce heaviness. Every artist must have remarked, how
often that lightness of hand which was in his dead-colour,[16]
or first painting, escaped in the finishing, when he had de-
termined the parts with more precision; and another loss he
often experiences, which is of greater consequence; whilst he
is employed in the detail, the effect of the whole together is
either forgotten or neglected. The likeness of a portrait, as I
have formerly observed, consists more in preserving the
general effect of the countenance, than in the most minute
finishing of the features, or any of the particular parts. Now
Gainsborough's portraits were often little more, in regard to
finishing, or determining the form of the features, than what
generally attends a dead colour; but as he was always atten-
tive to the general effect, or whole together, I have often im-
agined that this unfinished manner contributed even to that
striking resemblance for which his portraits are so remarkable.
Though this opinion may be considered as fanciful, yet I
think a plausible reason may be given, why such a mode of
painting should have such an effect. It is pre-supposed that
in this undetermined manner there is the general effect;
enough to remind the spectator of the original; the imagin-
ation supplies the rest, and perhaps more satisfactory to him-
self, if not more exactly, than the artist, with all his care,
could possibly have done. At the same time it must be acknow-
ledged there is one evil attending this mode; that if the portrait
were seen; previous to any knowledge of the original, different

persons would form different ideas, and all would be disappointed at not finding the original correspond with their own conceptions; under the great latitude which indistinctness gives to the imagination to assume almost what character or form it pleases.

Every artist has some favourite part, on which he fixes his attention, and which he pursues with such eagerness, that it absorbs every other consideration; and he often falls into the opposite error of that which he would avoid, which is always ready to receive him. Now Gainsborough having truly a painter's eye for colouring, cultivated those effects of the art which proceed from colours; and sometimes appears to be indifferent to or to neglect other excellencies. Whatever defects are acknowledged, let him still experience from us the same candour[17] that we so freely give upon similar occasions to the ancient masters; let us not encourage that fastidious disposition, which is discontented with every thing short of perfection, and unreasonably require, as we sometimes do, a union of excellencies, not perhaps quite compatible with each other. – We may, on this ground, say even of the divine Raffaelle, that he might have finished his picture as highly and as correctly as was his custom, without heaviness of manner; and that Poussin might have preserved all his precision without hardness or dryness.

To show the difficulty of uniting solidity with lightness of manner, we may produce a picture of Rubens in the church of St Judule, at Brussels, as an example; the subject is, *Christ's charge to Peter*;[18] which, as it is the highest, and smoothest, finished picture I remember to have seen of that master, so it is by far the heaviest; and if I had found it in any other place, I should have suspected it to be a copy; for painters know very well, that it is principally by this air of facility, or the want of it, that originals are distinguished from copies. – A

lightness of effect produced by colour, and that produced by facility of handling, are generally united; a copy may preserve something of the one, it is true, but hardly ever of the other; a connoisseur therefore finds it often necessary to look carefully into the picture before he determines on its originality. Gainsborough possessed this quality of lightness of manner and effect, I think, to an unexampled degree of excellence; but it must be acknowledged, at the same time, that the sacrifice which he made to this ornament of our art, was too great; it was, in reality, preferring the lesser excellencies to the greater.

To conclude. However we may apologize for the deficiencies of Gainsborough, (I mean particularly his want of precision and finishing,) who so ingeniously contrived to cover his defects by his beauties; and who cultivated that department of art, where such defects are more easily excused; you are to remember, that no apology can be made for this deficiency, in that style which this Academy teaches, and which ought to be the object of your pursuit. It will be necessary for you, in the first place, never to lose sight of the great rules and principles of the art, as they are collected from the full body of the best general practice, and the most constant and uniform experience; this must be the groundwork of all your studies: afterwards you may profit, as in this case I wish you to profit, by the peculiar experience and personal talents of artists living and dead; you may derive lights, and catch hints, from their practice; but the moment you turn them into models, you fall infinitely below them; you may be corrupted by excellencies, not so much belonging to the art, as personal and appropriated to the artist; and become bad copies of good painters, instead of excellent imitators of the great universal truth of things.

DISCOURSE XV

GENTLEMEN,

THE intimate connection which I have had with the ROYAL ACADEMY ever since its establishment, the social duties in which we have all mutually engaged for so many years, make any profession of attachment to this Institution, on my part, altogether superfluous; the influence of habit alone in such a connection would naturally have produced it.

Among men united in the same body, and engaged in the same pursuit, along with permanent friendship occasional differences will arise.[1] In these disputes men are naturally too favourable to themselves, and think perhaps too hardly of their antagonists. But composed and constituted as we are, those little contentions will be lost to others, and they ought certainly to be lost amongst ourselves in mutual esteem for talents and acquirements: every controversy ought to be, and I am persuaded, will be, sunk in our zeal for the perfection of our common Art.

In parting with the Academy, I shall remember with pride, affection, and gratitude, the support with which I have almost uniformly been honoured from the commencement of our intercourse. I shall leave you Gentlemen, with unaffected

cordial wishes for your future concord, and with a well-
founded hope that in that concord the auspicious and not
obscure origin of our Academy may be forgotten in the splen-
dour of your succeeding prospects.

My age, and my infirmities still more than my age,[2] make
it probable that this will be the last time I shall have the
honour of addressing you from this place. Excluded as I am,
spatiis iniquis,[3] from indulging my imagination with a distant
and forward perspective of life, I may be excused if I turn my
eyes back on the way which I have passed.

We may assume to ourselves, I should hope, the credit of
having endeavoured, at least, to fill with propriety that middle
station which we hold in the general connection of things.
Our predecessors have laboured for our advantage, we labour
for our successors; and though we have done no more in this
mutual intercourse and reciprocation of benefits, than has
been effected by other societies formed in this nation for the
advancement of useful and ornamental knowledge,[4] yet there
is one circumstance which appears to give us an higher claim
than the credit of merely doing our duty. What I at present
allude to, is the honour of having been, some of us, the first
contrivers, and all of us the promoters and supporters, of the
annual Exhibition. This scheme could only have originated
from Artists already in possession of the favour of the publick;
as it would not have been so much in the power of others to
have excited curiosity. It must be remembered, that for the
sake of bringing forward into notice concealed merit, they
incurred the risk of producing rivals to themselves; they vol-
untarily entered the lists, and ran the race a second time for
the prize which they had already won.[5]

When we take a review of the several departments of the
Institution, I think we may safely congratulate ourselves on
our good fortune in having hitherto seen the chairs of our

Professors filled with men of distinguished abilities, and who have so well acquitted themselves of their duty in their several departments. I look upon it to be of importance, that none of them should be ever left unfilled:[6] a neglect to provide for qualified persons, is to produce a neglect of qualifications.

In this honourable rank of Professors, I have not presumed to class myself; though in the Discourses which I have had the honour of delivering from this place, while in one respect I may be considered as a volunteer, in another view it seems as if I was involuntarily pressed into this service. If prizes were to be given, it appeared not only proper, but almost indispensably necessary, that something should be said by the President on the delivery of those prizes: and the President for his own credit would wish to say something more than mere words of compliment, which, by being frequently repeated, would soon become flat and uninteresting, and by being uttered to many, would at last become a distinction to none: I thought, therefore, if I were to preface this compliment with some instructive observations on the Art, when we crowned merit in the Artists whom we rewarded, I might do something to animate and guide them in their future attempts.[7]

I am truly sensible how unequal I have been to the expression of my own ideas. To develope the latent excellencies, and draw out the interior principles, of our art, requires more skill and practice in writing, than is likely to be possessed by a man perpetually occupied in the use of the pencil and the pallet. It is for that reason, perhaps, that the sister Art has had the advantage of better criticism. Poets are naturally writers of prose. They may be said to be practising only an inferior department of their own art, when they are explaining and expatiating upon its most refined principles. But still such difficulties ought not to deter Artists who are not

prevented by other engagements, from putting their thoughts in order as well as they can, and from giving to the publick the result of their experience. The knowledge which an Artist has of his subject will more than compensate for any want of elegance in the manner of treating it, or even of perspicuity, which is still more essential; and I am convinced that one short essay written by a Painter, will contribute more to advance the theory of our art, than a thousand volumes such as we sometimes see; the purpose of which appears to be rather to display the refinement of the Author's own conceptions of impossible practice, than to convey useful knowledge or instruction of any kind whatever. An Artist knows what is, and what is not, within the province of his art to perform; and is not likely to be for ever teazing the poor Student with the beauties of mixed passions, or to perplex him with an imaginary union of excellencies incompatible with each other.[8]

To this work, however, I could not be said to come totally unprovided with materials. I had seen much, and I had thought much upon what I had seen; I had something of an habit of investigation, and a disposition to reduce all that I observed and felt in my own mind, to method and system; but never having seen what I myself knew, distinctly placed before me on paper, I knew nothing correctly. To put those ideas into something like order was, to my inexperience, no easy task. The composition, the *ponere totum*[9] even of a single Discourse, as well as of a single statue, was the most difficult part, as perhaps it is of every other art, and most requires the hand of a master.

For the manner, whatever deficiency there was, I might reasonably expect indulgence; but I thought it indispensably necessary well to consider the opinions which were to be given out from this place, and under the sanction of a Royal

Academy; I therefore examined not only my own opinions, but likewise the opinions of others.[10] I found in the course of this research, many precepts and rules established in our art, which did not seem to me altogether reconcileable with each other, yet each seemed in itself to have the same claim of being supported by truth and nature; and this claim, irreconcileable as they may be thought, they do in reality alike possess.

To clear away those difficulties, and reconcile those contrary opinions, it became necessary to distinguish the greater truth, as it may be called, from the lesser truth; the larger and more liberal idea of nature from the more narrow and confined; that which addresses itself to the imagination,[11] from that which is solely addressed to the eye. In consequence of this discrimination, the different branches of our art, to which those different truths were referred, were perceived to make so wide a separation, and put on so new an appearance, that they seemed scarcely to have proceeded from the same general stock. The different rules and regulations, which presided over each department of art, followed of course: every mode of excellence, from the grand style of the Roman and Florentine Schools down to the lowest rank of still life, had its due weight and value, – fitted some class or other; and nothing was thrown away. By this disposition of our art into classes, that perplexity and confusion, which I apprehend every Artist has at some time experienced from the variety of styles, and the variety of excellence with which he is surrounded, is, I should hope, in some measure removed, and the Student better enabled to judge for himself, what peculiarly belongs to his own particular pursuit.

In reviewing my Discourses, it is no small satisfaction to be assured that I have, in no part of them, lent my assistance to foster *newly-hatched unfledged* opinions, or endeavoured to support paradoxes, however tempting may have been their

novelty, or however ingenious I might, for the minute, fancy them to be; nor shall I, I hope, any where be found to have imposed on the minds of young Students declamation for argument, a smooth period for a sound precept. I have pursued a plain and *honest method*;[12] I have taken up the art simply as I found it exemplified in the practice of the most approved Painters. That approbation which the world has uniformly given, I have endeavoured to justify by such proofs as questions of this kind will admit; by the analogy which Painting holds with the sister Arts,[13] and consequently by the common congeniality which they all bear to our nature. And though in what has been done no new discovery is pretended I may still flatter myself, that from the discoveries which others have made by their own intuitive good sense and native rectitude of judgement, I have succeeded in establishing the rules and principles of our art on a more firm and lasting foundation than that on which they had formerly been placed.[14]

Without wishing to divert the Student from the practice of his Art to speculative theory, to make him a mere Connoisseur instead of a Painter, I cannot but remark, that he will certainly find an account in considering once for all, on what ground the fabrick of our art is built. Uncertain, confused, or erroneous opinions are not only detrimental to an Artist in their immediate operation, but may possibly have very serious consequences; affect his conduct, and give a peculiar character (as it may be called) to his taste, and to his pursuits, through his whole life.

I was acquainted at Rome in the early part of my life, with a Student of the French Academy,[15] who appeared to me to possess all the qualities requisite to make a great Artist, if he had suffered his taste and feelings, and I may add even his prejudices, to have fair play. He saw and felt the excellencies

of the great works of Art with which we were surrounded, but lamented that there was not to be found that Nature which is so admirable in the inferior schools; and he supposed with Felibien, Du Piles, and other Theorists, that such an union of different excellencies would be the perfection of Art. He was not aware, that the narrow idea of nature, of which he lamented the absence in the works of those great Artists, would have destroyed the grandeur of the general ideas which he admired, and which was indeed the cause of his admiration. My opinions being then confused and unsettled, I was in danger of being borne down by this kind of plausible reasoning, though I remember I then had a dawning of suspicion that it was not sound doctrine; and at the same time I was unwilling obstinately to refuse assent to what I was unable to confute.

That the young Artist may not be seduced from the right path, by following, what, at first view, he may think the light of Reason, and which is indeed Reason in part, but not in the whole, has been much the object of these Discourses.

I have taken every opportunity of recommending a rational method of study, as of the last importance. The great, I may say the sole use of an Academy is, to put, and for some time to keep, Students in that course, that too much indulgence may not be given to peculiarity, and that a young man may not be taught to believe, that what is generally good for others is not good for him.

I have strongly inculcated in my former Discourses, as I do in this my last, the wisdom and necessity of previously obtaining the appropriated instruments of the Art, in a first correct design, and a plain manly colouring before any thing more is attempted. But by this I would not wish to cramp and fetter the mind, or discourage those who follow (as most of us may at one time have followed) the suggestion of a strong

inclination: something must be conceded to great and irresist-
ible impulses: perhaps every Student must not be strictly
bound to general methods, if they strongly thwart the peculiar
turn of his own mind. I must confess that it is not absolutely
of much consequence, whether he proceeds in the general
method of seeking first to acquire mechanical accuracy, before
he attempts poetical flights, provided he diligently studies to
attain the full perfection of the style he pursues; whether like
Parmegiano, he endeavours at grace and grandeur of manner
before he has learned correctness of drawing, if like him he
feels his own wants, and will labour, as that eminent artist
did, to supply those wants; whether he starts from the East or
from the West, if he relaxes in no exertion to arrive ultimately
at the same goal. The first publick work of Parmegiano is the
St Eustachius, in the church of St Petronius in Bologna,[16]
and was done when he was a boy; and one of the last of his
works is the Moses breaking the tables, in Parma.[17] In the
former there is certainly something of grandeur in the outline,
or in the conception of the figure, which discovers the draw-
ings of future greatness; of a young mind impregnated with
the sublimity of Michael Angelo, whose style he here at-
tempts to imitate, though he could not then draw the human
figure with any common degree of correctness. But this same
Parmegiano, when in his more mature age he painted the
Moses, had so completely supplied his first defects, that we
are here at a loss which to admire most, the correctness of
drawing, or the grandeur of the conception. As a confirmation
of its great excellence, and of the impression which it leaves
on the minds of elegant spectators, I may observe, that our
great Lyrick Poet, when he conceived his sublime idea of the
indignant Welch bard, acknowledged, that though many years
had intervened, he had warmed his imagination with the re-
membrance of this noble figure of Parmegiano.[18]

When we consider that Michael Angelo was the great archetype to whom Parmegiano was indebted for that grandeur which we find in his works, and from whom all his contemporaries and successors have derived whatever they have possessed of the dignified and the majestick; that he was the bright luminary, from whom Painting has borrowed a new lustre; that under his hands it assumed a new appearance, and is become another and superior art; I may be excused if I take this opportunity, as I have hitherto taken every occasion, to turn your attention to this exalted Founder and Father of Modern Art, of which he was not only the inventor, but which, by the divine energy of his own mind, he carried at once to its highest point of possible perfection.

The sudden maturity to which Michael Angelo brought out Art, and the comparative feebleness of his followers, and imitators, might perhaps be reasonably, at least plausibly explained, if we had time for such an examination. At present I shall only observe, that the subordinate parts of our Art, and perhaps of other Arts, expand themselves by a slow and progressive growth; but those which depend on a native vigour of imagination generally burst forth at once in fulness of beauty. Of this Homer probably, and Shakspeare more assuredly, are signal examples.[19] Michael Angelo possessed the poetical part of our art in a most eminent degree: and the same daring spirit, which urged him first to explore the unknown regions of the imagination, delighted with the novelty, and animated by the success of his discoveries, could not have failed to stimulate and impel him forward in his career beyond those limits, which his followers, destitute of the same incentives, had not strength to pass.

To distinguish between correctness of drawing, and that part which respects the imagination, we may say the one approaches to the mechanical, (which in its way too may

make just pretensions to genius,) and the other to the poetical. To encourage a solid and vigorous course of study, it may not be amiss to suggest, that perhaps a confidence in the mechanick produces a boldness in the poetick. He that is sure of the goodness of his ship and tackle puts out fearlessly from the shore; and he who knows that his hand can execute whatever his fancy can suggest, sports with more freedom in embodying the visionary forms of his own creation. I will not say Michael Angelo was eminently poetical, only because he was greatly mechanical; but I am sure that mechanick excellence invigorated and emboldened his mind to carry painting into the regions of poetry, and to emulate that art in its most adventurous flights. Michael Angelo equally possessed both qualifications. Yet of mechanick excellence there were certainly great examples to be found in Ancient Sculpture, and particularly in the fragment known by the name of the Torso of Michael Angelo; but of that grandeur of character, air, and attitude, which he threw into all his figures, and which so well corresponds with the grandeur of his outline, there was no example; it could therefore proceed only from the most poetical and sublime imagination.

It is impossible not to express some surprise, that the race of Painters who preceded Michael Angelo, men of acknowledged great abilities, should never have thought of transferring a little of that grandeur of outline which they could not but see and admire in Ancient Sculpture, into their own works; but they appear to have considered Sculpture as the later Schools of Artists look at the inventions of Michael Angelo, – as something to be admired, but with which they have nothing to do: *quod super nos, nihil ad nos.*[20] The Artists of that age, even Raffaelle himself, seemed to be going on very contentedly in the dry manner of Pietro Perugino; and if Michael Angelo had never appeared, the Art might still have continued in the same style.

Beside Rome and Florence, where the grandeur of this style was first displayed, it was on this Foundation that the Caracci built the truly great Academical Bolognian school, of which the first stone was laid by Pellegrino Tibaldi. He first introduced this style amongst them; and many instances might be given in which he appears to have possessed as by inheritance, the true, genuine, noble and elevated mind of Michael Angelo. Though we cannot venture to speak of him with the same fondness as his countrymen, and call him, as the Caracci did, *Nostro Michael Angelo riformato*,[21] yet he has a right to be considered amongst the first and greatest of his followers: there are certainly many drawings and inventions of his, of which Michael Angelo himself might not disdain to be supposed the author, or that they should be, as in fact they often are, mistaken for his. I will mention one particular instance, because it is found in a book which is in every young Artist's hand; – Bishop's Ancient Statues.[22] He there has introduced a print, representing Polyphemus, from a drawing of Tibaldi, and has inscribed it with the name of Michael Angelo, to whom he has also in the same book attributed a Sybil of Raffaelle. Both these figures, it is true, are professedly in Michael Angelo's style and spirit, and even worthy of his hand. But we know that the former is painted in the *Institute a Bologna* by Tibaldi,[23] and the other in the *Pace* by Raffaelle.[24]

The Caracci, it is acknowledged, adopted the mechanical part with sufficient success. But the divine part which addresses itself to the imagination, as possessed by Michael Angelo or Tibaldi, was beyond their grasp: they formed however, a most respectable school, a style more on the level, and calculated to please a great number; and if excellence of this kind is to be valued according to the number, rather than the weight and quality of admirers, it would assume even a higher

rank in Art. The same, in some sort, may be said of Tintoret, Paolo Veronese, and others of the Venetian Painters. They certainly much advanced the dignity of their style by adding to their fascinating powers of colouring something of the strength of Michael Angelo; at the same time it may still be a doubt, how far their ornamental elegance would be an advantageous addition to his grandeur. But if there is any manner of Painting which may be said to unite kindly with his style, it is that of Titian. His handling, the manner in which his colours are left on the canvass, appears to proceed (as far as that goes) from a congenial mind, equally disdainful of vulgar criticism.

MICHAEL ANGELO's strength thus qualified, and made more palatable to the general taste, reminds me of an observation which I heard a learned critick* make, when it was incidentally remarked, that our translation of Homer, however excellent, did not convey the character, nor had the grand air of the original. He replied, that if Pope had not cloathed the naked Majesty of Homer with the graces and elegancies of modern fashions, – though the real dignity of Homer was degraded by such a dress, his translation would not have met with such a favourable reception, and he must have been contented with fewer readers.[25]

Many of the Flemish painters, who studied at Rome in that great era of our art, such as Francis Rloris, Hemskerk, Michael Coxis, Jerom Cock,[26] and others, returned to their own country with as much of this grandeur as they could carry. But like seeds falling on a soil not prepared or adapted to their nature, the manner of Michael Angelo thrived but little with them; perhaps, however, they contributed to prepare the

* Dr Johnson.

way for that free, unconstrained, and liberal outline, which was afterwards introduced by Rubens, through the medium of the Venetian Painters.

The grandeur of style has been in different degrees disseminated over all Europe. Some caught it by living at the time, and coming into contact with the original author, whilst others received it at second hand; and being every where adopted, it has totally changed the whole taste and style of design, if there could be said to be any style before his time. Our art, in consequence, now assumes a rank to which it could never have dared to aspire, if Michael Angelo had not discovered to the world the hidden powers which it possessed. Without his assistance we never could have been convinced, that Painting was capable of producing an adequate representation of the persons and actions of the heroes of the Iliad.

I would ask any man qualified to judge of such works, whether he can look with indifference at the personification of the Supreme Being in the centre of the Capella Sestina,[27] or the figures of the Sybils which surround that chapel, to which we may add the statue of Moses; and whether the same sensations are not excited by those works, as what he may remember to have felt from the most sublime passages of Homer? I mention those figures more particularly, as they come nearer to a comparison with his Jupiter, his demi-gods, and heroes; those Sybils and Prophets being a kind of intermediate beings between men and angels. Though instances may be produced in the works of other Painters, which may justly stand in competition with those I have mentioned, such as the Isaiah and the vision of Ezekiel, by Raffaelle,[28] the St Mark of Frate Bartolomeo,[29] and many others; yet these, it must be allowed, are inventions so much in Michael Angelo's manner of thinking, that they may be truly considered as so many rays, which discover manifestly the centre from whence they emanated.

The sublime in Painting, as in Poetry, so overpowers, and takes such a possession of the whole mind, that no room is left for attention to minute criticism. The little elegancies of art in the presence of these great ideas thus greatly expressed, lose all their value, and are, for the instant at least, felt to be unworthy of our notice. The correct judgment, the purity of taste, which characterise Raffaelle, the exquisite grace of Correggio and Parmegiano, all disappear before them.[30]

That Michael Angelo was capricious in his inventions, cannot be denied; and this may make some circumspection necessary in studying his works; for though they appear to become him, an imitation of them is always dangerous, and will prove sometimes ridiculous. 'Within that circle none durst walk but he.'[31] To me, I confess his caprice does not lower the estimation of his genius, even though it is sometimes, I acknowledge, carried to the extreme: and however those eccentrick excursions are considered, we must at the same time recollect that those faults, if they are faults, are such as never could occur to a mean and vulgar mind; that they flowed from the same source which produced his greatest beauties, and were therefore such as none but himself was capable of committing: they were the powerful impulses of a mind unused to subjection of any kind, and too high to be controlled by cold criticism.

Many see his daring extravagance, who can see nothing else. A young Artist finds the works of Michael Angelo so totally different from those of his own master, or of those with whom he is surrounded, that he may be easily persuaded to abandon and neglect studying a style, which appears to him wild, mysterious, and above his comprehension, and which he therefore feels no disposition to admire; a good disposition, which he concludes that he should naturally have, if the style deserved it. It is necessary therefore, that students

should be prepared for the disappointment which they may experience at their first setting out; and they must be cautioned, that probably they will not, at first sight, approve.

It must be remembered, that this great style itself is artificial in the highest degree, it presupposes in the spectator, a cultivated and prepared artificial state of mind. It is an absurdity therefore, to suppose that we are born with this taste, though we are with the seeds of it, which, by the heat and kindly influence of his genius, may be ripened in us.

A late Philosopher and Critick* has observed, speaking of taste, that *we are on no account to expect that fine things should descend to us* – our taste, if possible, must be made to ascend to them. The same learned writer recommends to us *even to feign a relish, till we find a relish come; and feel, that what began in fiction, terminates in reality.*[32] If there be in our Art any thing of that agreement or compact, such as I apprehend there is in musick, with which the Critick is necessarily required previously to be acquainted, in order to form a correct judgment: the comparison with this art will illustrate what I have said on these points, and tend to show the probability, we may say the certainty, that men are not born with a relish for those arts in their most refined state, which as they cannot understand, they cannot be impressed with their effects. This great style of Michael Angelo is as far removed from the simple representation of the common objects of nature, as the most refined Italian musick is from the inartificial notes of nature, from whence they both profess to originate. But without such a supposed compact, we may be very confident that the highest state of refinement in either of those arts will not be relished without a long and industrious attention.

In pursuing this great Art, it must be acknowledged that

*James Harris, Esq. R.

we labour under greater difficulties than those who were born in the age of its discovery, and whose minds from their infancy were habituated to this style; who learned it as a language, as their mother tongue. They had no mean taste to unlearn; they needed no persuasive discourse to allure them to a favourable reception of it, no abstruse investigation of its principles to convince them of the great latent truths on which it is founded. We are constrained, in these latter days, to have recourse to a sort of Grammar and Dictionary, as the only means of recovering a dead language. It was by them learned by rote, and perhaps better learned that way than by precept.

The style of Michael Angelo, which I have compared to language, and which may, poetically speaking, be called the language of the Gods, now no longer exists, as it did in the fifteenth century;[33] yet, with the aid of diligence, we may in a great measure supply the deficiency which I mentioned, – of not having his works so perpetually before our eyes, – by having recourse to casts from his models and designs in Sculpture; to drawings, or even copies of those drawings; to prints, which, however ill executed, still convey something by which this taste may be formed, and a relish may be fixed and established in our minds for this grand style of invention. Some examples of this kind we have in the Academy; and I sincerely wish there were more, that the younger students might in their first nourishment imbibe this taste; whilst others, though settled in the practice of the common-place style of Painters, might infuse, by this means, a grandeur into their works.

I shall now make some remarks on the course which I think most proper to be pursued in such a study. I wish you not to go so much to the derivative streams, as to the fountain-head; though the copies are not to be neglected; be-cause they may give you hints in what manner you may copy,

and how the genius of one man may be made to fit the peculiar manner of another.

To recover this lost taste, I would recommend young Artists to study the works of Michael Angelo, as he himself did the works of the ancient Sculptors; he began when a child, a copy of a mutilated Satyr's head, and finished in his model what was wanting in the original.[34] In the same manner, the first exercise that I would recommend to the young artist when he first attempts invention, is, to select every figure, if possible, from the inventions of Michael Angelo. If such borrowed figures will not bend to his purpose, and he is constrained to make a change to supply a figure himself, that figure will necessarily be in the same style with the rest; and his taste will by this means be naturally initiated, and nursed in the lap of grandeur. He will sooner perceive what constitutes this grand style by one practical trial than by a thousand speculations, and he will in some sort procure to himself that advantage which in these later ages has been denied him; the advantage of having the greatest of Artists for his master and instructor.

The next lesson should be, to change the purpose of the figures without changing the attitude, as Tintoret has done with the Sampson of Michael Angelo.[35] Instead of the figure which Sampson bestrides, he has placed an eagle under him; and instead of the jaw-bone, thunder and lightning in his right hand; and thus it becomes a Jupiter. Titian, in the same manner, has taken the figure which represents God dividing the light from the darkness in the vault of the Capella Sestina, and has introduced it in the famous battle of Cadore,[36] so much celebrated by Vasari; and extraordinary as it may seem, it is here converted to a general, falling from his horse. A real judge who should look at this picture, would immediately pronounce the attitude of that figure to be in a greater style

than any other figure of the composition. These two instances may be sufficient, though many more might be given in their works, as well as in those of other great Artists.

When the Student has been habituated to this grand conception of the Art, when the relish for this style is established, makes a part of himself, and is woven into his mind, he will, by this time, have got a power of selecting from whatever occurs in nature that is grand, and corresponds with that taste which he has now acquired; and will pass over whatever is common-place, and insipid. He may then bring to the mart such works of his own proper invention as may enrich and increase the general stock of invention in our Art.

I am confident of the truth and propriety of the advice which I have recommended; at the same time I am aware, how much by this advice I have laid myself open to the sarcasms of those criticks who imagine our Art to be a matter of inspiration. But I should be sorry it should appear even to myself that I wanted that courage which I have recommended to the Students in another way: equal courage perhaps is required in the adviser and the advised; they both must equally dare and bid defiance to narrow criticism and vulgar opinion.

That the Art has been in a gradual state of decline, from the age of Michael Angelo to the present, must be acknowledged; and we may reasonably impute this declension to the same cause to which the ancient Criticks and Philosophers have imputed the corruption of eloquence. Indeed the same causes are likely at all times and in all ages to produce the same effects: indolence, – not taking the same pains as our great predecessors took, – desiring to find a shorter way, – are the general imputed causes. The words of Petronius*

*Pictura quoque non alium exitum fecit, postquam 'gyptiorum audacia tam magnæ artis compendiariam invenit. R.

are very remarkable. After opposing the natural chaste beauty of the eloquence of former ages to the strained inflated style then in fashion, 'neither,' says he, 'has the Art in Painting had a better fate, after the boldness of the Egyptians had found out a compendious way to execute so great an art.'[37]

By *compendious*, I understand him to mean a mode of Painting, such as has infected the style of the later Painters of Italy and France; common-place, without thought, and with as little trouble, working as by a receipt; in contra-distinction to that style for which even a relish cannot be acquired without care and long attention, and most certainly the power of executing cannot be obtained without the most laborious application.

I have endeavoured to stimulate the ambition of Artists to tread in this great path of glory, and, as well as I can, have pointed out the track which leads to it, and have at the same time told them the price at which it may be obtained. It is an ancient saying, that labour is the price which the Gods have set upon every thing valuable.[38]

The great Artist who has been so much the subject of the present Discourse, was distinguished even from his infancy for his indefatigable diligence; and this was continued through his whole life, till prevented by extreme old age. The poorest of men, as he observed himself, did not labour from necessity, more than he did from choice. Indeed, from all the circumstances related of his life, he appears not to have had the least conception that his art was to be acquired by any other means than great labour; and yet he, of all men that ever lived, might make the greater pretensions to the efficacy of native genius and inspiration. I have no doubt that he would have thought it no disgrace, that it should be said of him, as he himself said of Raffaelle, that he did not possess his art from

nature, but by long study.*[39] He was conscious that the great excellence to which he arrived was gained by dint of labour, and was unwilling to have it thought that any transcendent skill, however natural its effects might seem, could be purchased at a cheaper price than he had paid for it. This seems to have been the true drift of his observation. We cannot suppose it made with any intention of depreciating the genius of Raffaelle, of whom he always spoke, as Condivi says, with the greatest respect: though they were rivals, no such illiberality existed between them; and Raffaelle on his part entertained the greatest veneration for Michael Angelo, as appears from the speech which is recorded of him, that he congratulated himself, and thanked God, that he was born in the same age with that painter.[40]

If the high esteem and veneration in which Michael Angelo has been held by all nations and in all ages, should be put to the account of prejudice, it must still be granted that those prejudices could not have been entertained without a cause: the ground of our prejudice then becomes the source of our admiration. But from whatever it proceeds, or whatever it is called, it will not, I hope, be thought presumptuous in me to appear in the train, I cannot say of his imitators, but of his admirers. I have taken another course, one more suited to my abilities, and to the taste of the times in which I live. Yet however unequal I feel myself to that attempt, were I now to begin the world again, I would tread in the steps of that great master: to kiss the hem of his garment, to catch the slightest of his perfections, would be glory and distinction enough for an ambitious man.

I feel a self-congratulation in knowing myself capable of

*Che Rafaelle non ebbe quest' arte da natura, ma per longo studio. R.

such sensations as he intended to excite. I reflect, not without vanity, that these Discourses bear testimony of my admiration of that truly divine man; and I should desire that the last words which I should pronounce in this Academy, and from this place, might be the name of – MICHAEL ANGELO.*

* Unfortunately for mankind, these *were* the last words pronounced by this great Painter from the Academical chair. He died about fourteen months after this Discourse was delivered.[41] M[alone].

APPENDIX A

THE IRONICAL DISCOURSE

(*See the list on p. 365 for any abbreviations used in the Appendices.*)

THE so-called 'Ironical' Discourse postdates the series proper. It seems to have been written in the summer of 1791, just before JR's residual eyesight declined further. Like many of his contemporaries (Horace Walpole, Edward Gibbon, Charles Burney and William Cowper spring to mind), JR was a former liberal who was horrified by the events of the French Revolution, even before the Terror set in. He applauded the sentiments of his friend Edmund Burke's *Reflections on the Revolution in France*, published in November 1790 (in fact JR had a preview or pre-hearing). The Discourse satirizes 'progressive' ideas of the time, initially from a political standpoint but ultimately in terms of artistic theory and attitudes. Hilles (*Portraits*, p. 125) suggests James Barry as a prime target.

Malone may have known of the manuscript but omitted it from the *Works*. It turned up among the Boswell papers in 1940. The new Discourse was printed for the first and only time in *Portraits*, pp. 127–46. For a valuable introduction by Hilles, see pp. 123–6.

SIR JOSHUA'S PREFACE

THE following ironical discourse owes its origin to a conversation on Burke's *Reflections on the Revolution of France*, of which book Sir Joshua Reynolds expressed the most

enthusiastic admiration, both in regard to the doctrine which it contained, and the eloquence in which that doctrine was conveyed.

The conversation turned on the power which is lodged in majorities. It was said that the French nation having almost unanimously adopted the revolution had in its favour this greatest criterion of truth. This inference was disputed. Sir Joshua was of opinion that if matters of taste are determined as he thinks they ought to be, by weight rather than by tale, much more political questions, which involved so much science, ought to be determined by the few learned in that art, and not by the ignorant majority.

That the majority were ignorant was denied, and much was said of the 'present enlightened age,' and on the general diffusion of knowledge amongst all ranks of people. They were therefore capable of judging for themselves. They had tasted of the tree of knowledge: they now knew good from evil, and would not take it as they had done. That [they had tasted] of the tree of knowledge was granted, but they had only tasted and, it appears, as much to their own loss as 'twas to our first parents. Our poet says, 'Drink deep, or taste not.'[1]

This tree of knowledge, on which they pretend to say that mankind now have battened, does not grow upon a new made, slender soil, but is fastened by strong roots to ancient rocks, and is the slow growth of ages. There are but few of strength sufficient to climb the summit of this rock, from whence indeed they may look down to us and clouds below.

It was acknowledged that more people could read and write and cast accounts[2] than in any former age, and that more people read newspapers, magazines, etc. But it was not to be inferred from thence that this smattering of knowledge capacitated them to set up for legislators, or to measure, separate, and balance exactly rational liberty against sound and

necessary restraint; or, in regard to taste and skill in arts, that we were a jot the nearer to see a Michael Angelo, Raphael, Titian, or Correggio, because there were at present a greater number of middling artists than at any other period; or, because we have more dabblers in poetry, that there is a greater probability of our seeing arise amongst us a Homer or a Milton.

It is now as it ever has been. Few people reach the summit from which they look down on the rest of mankind. However it may be in arithmetic, in such studies ever so many additions of units will not possess the efficacy of the compact number of twenty. A hundred thousand near-sighted men, that see only what is just before them, make no equivalent to one man whose view extends to the whole horizon round him, though we may safely acknowledge at the same time that like the real near-sighted men, they see and comprehend as distinctly what is within the focus of their sight as accurately (I will allow sometimes more accurately) than the others. Though a man may see his way in the management of his own affairs, within his own little circle, with the greatest acuteness and sagacity, such habits give him no pretensions to set up for a politician. So far is this diffusion of superficial knowledge from being an argument of our superiority in the deeper recesses of science, that on the contrary we hear it continually given as a reason why there are not at present such learned men as in former ages, from this very circumstance – that every man, having a mouthful (just enough to save himself from an intellectual famine), does not take the pains necessary to get a bellyful. If this be true, the diffusion of knowledge is against them, instead of an argument in their favour. It was asked likewise whether, from a little smattering in physic, a man would act wisely in discarding his physicians and prescribe to himself, whether by such quacking, sound constitutions have not been often destroyed.

Sir Joshua added, that to be a politician was, he apprehended, as much a trade or profession as his own: that the science of politics, as well as a true taste in works of art, was acquired by labour and study, and by other means; and that in both cases, we are sure that half-educated minds are in a worse state than total ignorance: the worst will appear the best, as being within their narrow comprehension. He instanced a certain painter now in England, an artist of great merit, though he paints in a different and a much inferior style to Vandyck; yet if the merit of each of them was to be determined by the majority, there would be 99 in 100 in favour of this artist.

He proceeded to observe [that] he would undertake to write a discourse on those obvious and vulgar principles, which should come home to the bosoms of the ignorant[3] (which are always the majority) and which should be thought to contain more sound doctrine than those which he had delivered in the Academy; and such doctrine, proceeding *ex cathedra*, would probably so poison the minds of the students as might eventually keep back the harvest of arts which we expect from the nation, perhaps for fifty years. A few days after was produced the following discourse, which, though a playful trifle, he is persuaded by his friends to let it bring up the rear of his last volume, as they think it may contribute towards banishing from the world the popular and vulgar notions about genius and inspiration, as well as those opinions which have been entertained both by the great vulgar and the small, of what ought to be the object of art.

THE DISCOURSE

GENTLEMEN:

It is with great regret that I see so many students labouring day after day in the Academy, as if they imagined that a liberal art, as ours is, was to be acquired like a mechanical trade, by dint of labour, or I may add the absurdity of supposing that it could be acquired by any means whatever. We know that if you are born with a genius, labour is unnecessary; if you have it not, labour is in vain; genius is all in all. It was wittily said by a bright genius, who observed another to labour in the composition of a discourse which he was to deliver in public, that such a painstaker was fitter to make a pulpit than to preach in it.

Genius, as it disdains all assistance, so it defies all obstacles. The student here may inform himself whether he has been favoured by heaven with this truly divine gift. If he finds it necessary to copy, to study the works of other painters, or any way to seek for help out of himself, he may be sure that he has received nothing of that inspiration. My advice is that he immediately quit the Academy, and apply to something to which his genius is adapted. Let the student consider with himself whether he is impelled forward by irresistible instinct. He himself is little more than a machine, unconscious of the power which impels him forward to the instant performance of what others learn by the slow method of rules and precepts. Who does not feel the highest disdain for all the *imitatores servum pecus*[4] as well as the most sovereign contempt for all rules, or rather receipts, which dullness have prescribed for the acquisition of this great and liberal art?

What is the use of rules, but to cramp and fetter genius?

The rules which dull men have introduced into liberal arts smother that flame which would otherwise blaze out in originality of invention. Shakespeare, as the great Ralph says, writ without rules. (Quote the note of the *Dunciad*. He made the following wise answer.)[5] The idea of making a work of genius by rule has been sufficiently laughed at. (Swift in his receipt to make an epic poem.)

One is at a loss, says the great Bacon, to determine which was the greatest trifler, [Apelles or Albert Dürer, 'whereof the one would make a personage by geometrical proportions; the other, by taking the best parts out of divers faces to make one excellent.'][6] It is but too true that this weak observation is found in Bacon's *Essays*, as if he thought that there was no rule for beauty or proportion. Cardinal Bembo had a true idea of what the highest excellence consists, and in his epitaph on Raphael has flattered him as supposing he possessed it, but alas![7]

Having given my idea of genius, before I proceed to explain how it shows itself and what are its operations, it is necessary that you should be aware that our art is in a corrupted state, and has been gradually departing from simple first principles ever since the time of Michael Angelo, the first grand corrupter of the natural taste of man. He first introduced and substituted this style founded on imagination, of which we may truly say there is not even the least gleam of common sense. The mere stating the question discovers its absurdity. What is cultivating the imagination, but to open a school to teach systematically madness and folly, and to renounce reason and even common sense?

It is not easy to account for the tame submission of mankind, either in first adopting this new style, or for its authority continuing to this present age. We can only put it to the account of a prejudice, which perhaps originated from his

being highly favoured by the popes and great men of his time and is handed down to our time. But shall we in these enlightened times tamely adopt and inherit their ignorant prejudices? No! Let us examine everything by the standard of our own reason, renounce all prejudices for the reputed wisdom of others. Let me ask any sensible artist who has seen the Cappella Sistina of Michael Angelo whether he found in the works of this great teacher of the nonsense of imagination that true nature which he had been taught to expect to find and which he knows he ought to find.

It has been often remarked by many of our learned connoisseurs, that painters are the worst judges of pictures; and the reason why they are so, is from their imbibing prejudices. A man who never saw a picture is therefore the best judge. He has no rule but his taste and feeling. . . . [We should remember Apelles's critic] and Molière's old woman;[8] and above all, what that excellent philosopher and connoisseur Pliny has recorded as the greatest effort of art of two of the greatest painters of antiquity, Zeuxis and Parrhasius, one painting a bunch of grapes that the birds pecked at and the other a curtain which deceived even the painter himself.[9] What a poor figure Michael Angelo would have made in this noble contention of superiority! We must not forget in more modern times Giotto's Circle.[10] These great masters knew what was the real object of art, and went directly to the point. Nature herself was always at their elbow, and they wanted no other instruction.

Let the works in the Cappella Sistina – or to refer to what we have in our own nation, the vaunted cartoons – let them be examined by the criterion of nature, and we shall be convinced how much the art has swerved from truth. Does any man, when he looks at those pictures, recognize his neighbour's face? Does anybody mistake the drapery, as it is called,

for real stuff such as they are intended to represent? Is it silk, satin, or velvet? What a falling off from the ancient simplicity of art! Let us imitate the great Mirabeau.[11] Set fire to all the pictures, prints, and drawings of Raphael and Michael Angelo; *non tali auxilio*.[12] Destroy every trace that remains of ancient taste. Let us pull the whole fabric down at once, root it up even to its foundation. Let us begin the art again upon this solid ground of nature and of reason. The world will then see what naked art is, in its uneducated, unprejudiced, unadulterated state.

The daring to give this advice, the glory of stepping forth in this great work of reformation, and endeavouring to rescue the world from the worse than barbarous tyranny of prejudice, and restore the sovereignty of reason, will be sufficient honour for me and my poor endeavours.

I have only a few words to add respecting sculpture. As monuments are now erecting in St Paul's,[13] I would recommend to the committee that the sculptor be obliged to dress his figures, whether one or many, in the very dress of the times – the dress which they themselves wore. If this obliges the sculptor to acquire an accurate observation of the fashions as they fluctuate, this additional trouble will be fully compensated by [his] being saved another trouble, the disposition of the drapery, that being already done to his hands by the tailor. And, by the way, the tailor will be found a necessary person to be consulted [as to] what the exact fashions were in that very year when the person died, that the monument may be correct in the 'costume' as the learned call it.[14] We know very well what a difference every year makes in the cut of our clothes.

When it shall be determined by the committee that no monumental figure shall be suffered in St Paul's but in the modern dress, it will be necessary to add to the committee a

certain number of the most ingenious tailors, who shall have
a voice in regard to fashion. After the people have been a
little accustomed to this naturalness, the Academy will, upon
the same principles, proceed a step further and add colour
to these statues, which will complete the deception [and]
complete the honour of the Royal Academy. This improve-
ment is reserved for this enlightened age, when knowledge is
so generally diffused – i.e., when we think for ourselves and
dare to reason without prejudices for the opinions of others.
We shall soon not leave one stone upon another in the fabric
of art. We then rear an edifice not founded on imagination,
castles in the air, but on common sense adapted to the meanest
capacity, equally comprehended by the ignorant as the
learned. My last words are: follow reason, follow nature.

THREE *IDLER* PAPERS

In 1759 JR supplied three *Idler* papers for the series of weekly periodical essays mainly written by Samuel Johnson. There were 104 of these essays printed in the *Universal Chronicle*, appearing each Saturday in the newspaper conducted by Goldsmith's friend John Newbery. Johnson wrote ninety-two of these essays; Thomas Warton contributed three; and Bennet Langton was the author of one. For a discussion of the circumstances, see *LC*, pp. 15–22. The three papers were collected in 1761 in a rare pamphlet; a copy was given by Johnson to JR, who in turn gave it to Malone.

THE IDLER

NUMB. 76 *Saturday, September* 29 1759

TO THE IDLER

SIR,

I was much pleased with your ridicule of those shallow Critics, whose judgement, though often right as far as it goes, yet reaches only to inferior beauties; and who, unable to comprehend the whole, judge only by parts, and from thence determine the merit of extensive works. But there is another

kind of Critick still worse, who judges by narrow rules, and those too often false, and which though they should be true, and founded on nature, will lead him but a very little way towards the just estimation of the sublime beauties in works of Genius; for whatever part of an art can be executed or criticised by rules, that part is no longer the work of Genius, which implies excellence out of the reach of rules. For my own part, I profess myself an Idler, and love to give my judgement, such as it is, from my immediate perceptions, without much fatigue of thinking; and I am of opinion, that if a man has not those perceptions right, it will be vain for him to endeavour to supply their place by rules; which may enable him to talk more learnedly, but not to distinguish more acutely. Another reason which has lessened my affection for the study of Criticism is, that Criticks, so far as I have observed, debar themselves from receiving any pleasure from the polite arts, at the same time that they profess to love and admire them: for these rules being always uppermost, give them such a propensity to criticise, that instead of giving up the reins of their imagination into their author's hands, their frigid minds are employed in examining whether the performance be according to the rules of art.

To those who are resolved to be Criticks in spite of nature, and at the same time have no great disposition to much reading and study, I would recommend to assume the character of Connoisseur, which may be purchased at a much cheaper rate than that of a Critick in poetry. The remembrance of a few names of Painters, with their general characters, and a few rules of the Academy, which they may pick up among the Painters, will go a great way towards making a very notable Connoisseur.

With a Gentleman of this cast, I visited last week the Cartoons at Hampton-Court; he was just returned from Italy,

a Connoisseur, of course, and of course his mouth full of
nothing but the Grace of Raffaelle, the Purity of Domenich-
ino, the Learning of Poussin, the Air of Guido, the greatness
of Taste of the Caraccis, and the Sublimity and grand Con-
torno of Michael Angelo; with all the rest of the cant of
Criticism, which he emitted with that volubility which gener-
ally those orators have, who annex no ideas to their words.

As we were passing through the rooms, in our way to the
Gallery, I made him observe a whole length of Charles the
First, by Vandyck, as a perfect representation of the character
as well as the figure of the man: He agreed it was very fine,
but it wanted spirit and contrast, and had not the flowing
line, without which a figure could not possibly be graceful.
When we entered the Gallery, I thought I could perceive him
recollecting his Rules by which he was to criticise Raffaelle. I
shall pass over his observation of the boats being too little,
and other criticisms of that kind, till we arrived at St *Paul
preaching*. 'This,' says he, 'is esteemed the most excellent of
all the Cartoons: what nobleness, what dignity there is in that
figure of St Paul! and yet what an addition to that nobleness
could Raffaelle have given, had the art of Contrast been
known in his time; but above all, the flowing line, which
constitutes Grace and Beauty. You would not then have seen
an upright figure standing equally on both legs, and both
hands stretched forward in the same direction, and his dra-
pery, to all appearance, without the least art of disposition.'
The following Picture is the *Charge to Peter*. 'Here,' says he,
'are twelve upright figures; what a pity it is that Raffaelle was
not acquainted with the pyramidal principle; he would then
have contrived the figures in the middle to have been on
higher ground, or the figures at the extremities stooping or
lying; which would not only have formed the group into the
shape of a pyramid, but likewise contrasted the standing

figures. Indeed,' added he, 'I have often lamented that so great a genius as Raffaelle had not lived in this enlightened age, since the art has been reduced to principles, and had his education in one of the modern Academies; what glorious works might we then have expected from his divine pencil!'

I shall trouble you no longer with my friend's observations, which, I suppose, you are now able to continue by yourself. It is curious to observe, that at the same time that great admiration is pretended for a name of fixed reputation, objections are raised against those very qualities by which that great name was acquired.

These Criticks are continually lamenting that Raffaelle had not the Colouring and Harmony of Rubens, or the Light and Shadow of Rembrandt, without considering how much the gay harmony of the former, and affectation of the latter, would take from the Dignity of Raffaelle; and yet Rubens had great Harmony, and Rembrandt understood Light and Shadow; but what may be an excellence in a lower class of Painting, becomes a blemish in a higher; as the quick, sprightly turn, which is the life and beauty of epigrammatick compositions, would but ill suit with the majesty of heroic Poetry.

To conclude; I would not be thought to infer from any thing that has been said, that Rules are absolutely unnecessary, but to censure scrupulosity, a servile attention to minute exactness, which is sometimes inconsistent with higher excellence, and is lost in the blaze of expanded genius.

I do not know whether you will think Painting a general subject. By inserting this letter, perhaps you will incur the censure a man would deserve, whose business being to entertain a whole room, should turn his back on the company, and talk to a particular person.

I am, Sir, &c.

NUMB. 79 *Saturday, October* 20 1759

TO THE IDLER

SIR,

YOUR acceptance of a former letter on Painting, gives me encouragement to offer a few more sketches on the same subject.

Amongst the Painters and the writers on Painting, there is one maxim universally admitted and continually inculcated. *Imitate Nature*, is the invariable rule; but I know none who have explained in what manner this rule is to be understood; the consequence of which is, that every one takes it in the most obvious sense, – that objects are represented naturally, when they have such relief that they seem real. It may appear strange, perhaps, to hear this sense of the rule disputed; but it must be considered, that if the excellency of a Painter consisted only in this kind of imitation, Painting must lose its rank, and be no longer considered as a liberal art, and sister to Poetry; this imitation being merely mechanical, in which the slowest intellect is always sure to succeed best; for the Painter of genius cannot stoop to drudgery, in which the understanding has no part; and what pretence has the art to claim kindred with Poetry, but by its power over the imagination? To this power the Painter of genius directs his aim; in this sense he studies Nature, and often arrives at his end, even by being unnatural, in the confined sense of the word.

The grand style of Painting requires this minute attention to be carefully avoided, and must be kept as separate from it as the style of Poetry from that of History. Poetical ornaments destroy that air of truth and plainness which ought to

characterise History; but the very being of Poetry consists in departing from this plain narration, and adopting every ornament that will warm the imagination. To desire to see the excellencies of each style united, to mingle the Dutch with the Italian School, is to join contrarieties which cannot subsist together, and which destroy the efficacy of each other. The Italian attends only to the invariable, the great and general ideas which are fixed and inherent in universal Nature; the Dutch, on the contrary, to literal truth and a minute exactness in the detail, as I may say, of Nature modified by accident. The attention to these petty peculiarities is the very cause of this naturalness so much admired in the Dutch pictures, which, if we suppose it to be a beauty, is certainly of a lower order, that ought to give place to a beauty of a superior kind, since one cannot be obtained but by departing from the other.

If my opinion were asked concerning the works of Michael Angelo, whether they would receive any advantage from possessing this mechanical merit, I should not scruple to say, they would lose, in a great measure, the effect which they now have on every mind susceptible of great and noble ideas. His works may be said to be all genius, and soul; and why should they be loaded with heavy matter, which can only counteract his purpose by retarding the progress of the imagination?

If this opinion should be thought one of the wild extravagances of enthusiasm, I shall only say, that those who censure it are not conversant in the works of the great Masters. It is very difficult to determine the exact degree of enthusiasm that the arts of Painting and Poetry may admit. There may perhaps be too great an indulgence, as well as too great a restraint of imagination; and if the one produces incoherent monsters, the other produces what is full as bad, lifeless

insipidity. An intimate knowledge of the passions and good sense, but not common sense, must at last determine its limits. It has been thought, and I believe with reason, that Michael Angelo sometimes transgressed those limits; and I think I have seen figures by him, of which it was very difficult to determine, whether they were in the highest degree sublime or extremely ridiculous. Such faults may be said to be the ebullition of Genius; but at least he had this merit, that he never was insipid; and whatever passion his works may excite, they will always escape contempt.

What I have had under consideration is the sublimest style, particularly that of Michael Angelo, the Homer of Painting. Other kinds may admit of this naturalness, which of the lowest kind is the chief merit; but in Painting, as in Poetry, the highest style has the least of common nature.

One may safely recommend a little more enthusiasm to the modern Painters; too much is certainly not the vice of the present age. The Italians seem to have been continually declining in this respect from the time of Michael Angelo to that of Carlo Maratti, and from thence to the very pathos of insipidity to which they are now sunk; so that there is no need of remarking, that where I mentioned the Italian Painters in opposition to the Dutch, I mean not the moderns, but the heads of the old Roman and Bolognian Schools; nor did I mean to include in my idea of an Italian Painter, the Venetian School, which may be said to be the Dutch part of the Italian Genius. I have only to add a word of advice to the Painters, – that however excellent they may be in Painting naturally, they would not flatter themselves very much upon it; and to the Connoisseurs, that when they see a cat or a fiddle painted so finely, that as the phrase is, *it looks as if you could take it up*, they would not for that reason immediately compare the Painter to Raffaelle and Michael Angelo.

NUMB. 82 *Saturday, November* 10 1759

To The Idler

SIR,

DISCOURSING in my last letter on the different practice of the Italian and Dutch Painters, I observed that 'the Italian Painter attends only to the invariable, the great, and general ideas, which are fixed and inherent in universal nature.'

I was led into the subject of this letter by endeavouring to fix the original cause of this conduct of the Italian Masters. If it can be proved that by this choice they selected the most beautiful part of the creation, it will show how much their principles are founded on reason, and, at the same time, discover the origin of our ideas of beauty.

I suppose it will be easily granted, that no man can judge whether any animal be beautiful in its kind, or deformed, who has seen only one of that species; this is as conclusive in regard to the human figure; so that if a man, born blind, were to recover his sight, and the most beautiful woman were brought before him, he could not determine whether she was handsome or not; nor if the most beautiful and most deformed were produced, could he any better determine to which he should give the preference, having seen only those two. To distinguish beauty, then, implies the having seen many individuals of that species. If it is asked, how is more skill acquired by the observation of greater numbers? I answer, that, in consequence of having seen many, the power is acquired, even without seeking after it, of distinguishing between accidental blemishes and excrescences which are continually varying the surface of Nature's works,

and the invariable general form which Nature most frequently produces, and always seems to intend in her productions.

Thus amongst the blades of grass or leaves of the same tree, though no two can be found exactly alike, the general form is invariable: a Naturalist, before he chose one as a sample, would examine many; since if he took the first that occurred, it might have, by accident or otherwise, such a form as that it would scarce be known to belong to that species; he selects as the Painter does, the most beautiful, that is, the most general form of nature.

Every species of the animal as well as the vegetable creation may be said to have a fixed or determinate form, towards which Nature is continually inclining, like various lines terminating in the centre; or it may be compared to pendulums vibrating in different directions over one central point: and as they all cross the centre, though only one passes through any other point, so it will be found that perfect beauty is oftener produced by nature than deformity; I do not mean than deformity in general, but than any one kind of deformity. To instance in a particular part of a feature; the line that forms a ridge of the nose is beautiful when it is straight; this then is the central form, which is oftener found than either concave, convex, or any other irregular form that shall be proposed. As we are then more accustomed to beauty than deformity, we may conclude that to be the reason why we approve and admire it, as we approve and admire customs and fashions of dress for no other reason than that we are used to them; so that though habit and custom cannot be said to be the cause of beauty, it is certainly the cause of our liking it; and I have no doubt but that if we were more used to deformity than beauty, deformity would then lose the idea now annexed to it, and take that of beauty: as if the whole world should agree,

that *yes* and *no* should change their meaning; *yes* would then deny, and *no* would affirm.

Whoever undertakes to proceed further in this argument, and endeavours to fix a general criterion of beauty respecting different species, or to show why one species is more beautiful than another, it will be required from him first to prove that one species is really more beautiful than another. That we prefer one to the other, and with very good reason, will be readily granted; but it does not follow from thence that we think it a more beautiful form; for we have no criterion of form by which to determine our judgement. He who says a swan is more beautiful than a dove, means little more than that he has more pleasure in seeing a swan than a dove, either from the stateliness of its motions, or its being a more rare bird; and he who gives the preference to the dove, does it from some association of ideas of innocence which he always annexes to the dove; but if he pretends to defend the preference he gives to one or the other by endeavouring to prove that this more beautiful form proceeds from a particular gradation of magnitude, undulation of a curve, or direction of a line, or whatever other conceit of his imagination he shall fix on, as a criterion of form, he will be continually contradicting himself, and find at last that the great Mother of Nature will not be subjected to such narrow rules. Among the various reasons why we prefer one part of her works to another, the most general, I believe, is habit and custom; custom makes, in a certain sense, white black, and black white; it is custom alone determines our preference of the colour of the Europeans to the Ethiopians, and they, for the same reason, prefer their own colour to ours. I suppose no body will doubt, if one of their Painters were to paint the Goddess of Beauty, but that he would represent her black, with thick lips, flat nose, and woolly hair; and, it seems to me, he would act very

unnaturally if he did not: for by what criterion will any one dispute the propriety of his idea! We indeed say, that the form and colour of the European is preferable to that of the Ethiopian; but I know of no other reason we have for it, but that we are more accustomed to it. It is absurd to say, that beauty is possessed of attractive powers, which irresistibly seize the corresponding mind with love and admiration, since that argument is equally conclusive in favour of the white and the black philosophers.

The black and white nations must, in respect of beauty, be considered as of different kinds, at least a different species of the same kind; from one of which to the other, as I observed, no inference can be drawn.

Novelty is said to be one of the causes of beauty. That novelty is a very sufficient reason why we should admire, is not denied; but because it is uncommon, it is therefore beautiful? The beauty that is produced by colour, as when we prefer one bird to another, though of the same form, on account of its colour, has nothing to do with the argument, which reaches only to form. I have here considered the word Beauty as being properly applied to form alone. There is a necessity of fixing this confined sense; for there can be no argument, if the sense of the word is extended to every thing that is approved. A rose may as well be said to be beautiful, because it has a fine smell, as a bird because of its colour. When we apply the word Beauty, we do not mean always by it a more beautiful form, but something valuable on account of its rarity, usefulness, colour, or any other property. A horse is said to be a beautiful animal; but had a horse as few good qualities as a tortoise, I do not imagine that he would then be deemed beautiful.

A fitness to the end proposed, is said to be another cause of beauty; but supposing we were proper judges of what form is

the most proper in an animal to constitute strength or swiftness, we always determine concerning its beauty, before we exert our understanding to judge of his fitness.

From what has been said, it may be inferred, that the works of Nature, if we compare one species with another, are all equally beautiful, and that preference is given from custom or some association of ideas; and that, in creatures of the same species, beauty is the medium or centre of all its various forms.

To conclude, then, by way of corollary: if it has been proved that the Painter, by attending to the invariable and general ideas of Nature, produce beauty, he must, by regarding minute particularities, and accidental discriminations, deviate from the universal rule, and pollute his canvass with deformity.

APPENDIX C

REYNOLDS AND THE CLUB

As stated in the Introduction (pp. 35–51), JR was profoundly influenced by the Club, which he helped to found in 1764. The aim of this appendix is to bring together relevant facts concerning those fellow members of the Club who provide an immediate context for the *Discourses* – either because they are cited in the text, or because their own works include parallel undertakings to that of JR. The list is thus selective and does not include prominent Club members such as R. B. Sheridan, C. J. Fox, William Windham, George Colman, Thomas Percy and many more.

The information supplied includes the following: date of election to the Club; first meeting with JR, if known; details of any portrait(s) by JR; works cited by JR; relevant productions (that is, with parallel aims to the *Discourses*).

Samuel Johnson (1709–84): Elected to Club 1764. Met JR *c.* 1755/6. Portraits by JR: 1756/7, 1769, 1775, 1778, 1784. Work cited by JR: *The Lives of the English Poets* (1779–81). See introduction, pp. 43–7.

Oliver Goldsmith (*c.* 1730–74): Elected to Club 1764. Met JR *c.* 1762. Portrait by JR: *c.* 1769. Work cited by JR: *The Traveller* (1764). Dedicated to JR: *The Deserted Village* (1770). Sketch by JR: see *Portraits*, pp. 40–54.

Edmund Burke (1729–97): Elected to Club 1764. Met JR *c.* 1756. Portraits by JR: *c.* 1768, *c.* 1770, third portrait (date

unknown). Work cited by JR: *Sublime and Beautiful* (1757).
Executor of JR. (See also Appendix D.)

David Garrick (1717–79): Elected to Club 1773. Met JR
 c. 1755/6. Portraits by JR: 1769–? (seven in all?). Instanced
 by JR in Discourse XIII. Sketch by JR: see *Portraits*,
 pp. 86–8.

James Boswell (1740–95): Elected to Club 1773. Met JR
 1769. Portrait by JR: 1785. Biographical notes on JR: see
 Portraits, pp. 20–23. Dedicated to JR: *The Life of Samuel
 Johnson* (1791). JR procured him honorary RA office
 (1791).

Edward Gibbon (1737–94): Elected to Club 1774. Met JR
 c. 1773. Portrait by JR: 1779. Appears in JR's dialogue: see
 Portraits, pp. 95–105. Proposed by JR as Professor of Anci-
 ent History at RA (1788).

Adam Smith (1723–90): Elected to Club 1775. Met JR
 c. 1764. Work drawn on by JR: *The Theory of Moral Senti-
 ments* (1759).

Joseph Warton (1722–1800): Elected to Club 1777. Met JR
 c. 1757/8. Proposed by JR for Club. Gave JR invitation for
 New College Chapel window. Portrait by JR: 1784? Work
 cited by JR: *An Essay on the Writings and Genius of Pope*
 (1756–82).

Joseph Banks (1743–1820): Elected to Club 1778. Met JR
 1771? Portraits by JR: 1772; group portrait of Dilettanti
 1777. Received presentation copies of *Discourses*. Chairman
 of committee for Johnson's monument; JR also a member.

Edmond Malone (1741–1812): Elected to Club 1782. Met
 JR (date unknown). Portrait by JR: 1778/9. JR's executor
 and editor of the posthumous *Works*; helped JR to revise
 the *Discourses*.

Thomas Warton (1728–90): Elected to Club 1782. Met JR
 (date unknown). Portrait by JR: 1784? Supported by JR

for post of poet laureate (appointed 1785). Wrote verses on JR's New College Chapel window (1782). Relevant work: *The History of English Poetry* (1774–81).

Charles Burney (1726–1814): Elected to Club 1784. Met JR (date unknown). Portrait by JR: 1781. Father of novelist Fanny Burney, much admired by JR. Work used by JR: musical tours (1771–3). Relevant work: *History of Music* (1776–89).

William Hamilton (1730–1803): Elected to Club 1784. Met JR by 1770. Fellow-member with JR of Society of Dilettanti: portrait in Dilettanti group (1777). JR admired Baron d'Hancarville's *Collection of Antiquities* (1766–7), describing Hamilton's earlier haul. JR may have painted Emma Hamilton.

See also references in the Notes to Thomas Percy, Lord Palmerston, Bennet Langton, John Dunning.

Sometimes JR acted, as it were, in concert with the Club. Thus he, Johnson, Burke, Garrick and Goldsmith all came to the defence of Giuseppe Baretti in 1769; whilst several members helped to ensure the success of *She Stoops to Conquer* in 1774 and *The School for Scandal* in 1777. JR painted Burke, Burney, Robert Chambers, Garrick, Goldsmith and Johnson (as well as non-members such as Baretti and Arthur Murphy) for the Thrales' house at Streatham. Finally, JR's complicity in the ethos of the Club may be gauged from the role allotted to him in Goldsmith's *Retaliation* (1774), alongside Johnson, Burke, Garrick and others.

BURKE'S TRIBUTE TO REYNOLDS

AFTER JR's death on 23 February 1792, Edmund Burke drafted an obituary which appeared in the *Morning Chronicle* on 25 February. The original draft, formerly in the possession of F. W. Hilles, was printed in *The Correspondence of Edmund Burke*, vol. VII, ed. P. J. Marshall and J. A. Woods (Cambridge, 1968), pp. 76–7. I have consulted this draft to establish the text here. Burke paid another warm tribute to JR in his letter to the king of Poland on 28 February (pp. 78–9), and as executor engaged in correspondence with Edmond Malone and Philip Metcalfe concerning other celebrations in JR's memory (pp. 79–80, 99–100).

February 24 1792

LAST Night, in the sixty-ninth year of his Age, died at his house in Leicester fields, Sir Joshua Reynolds. His illness was long, but borne with a mild and cheerful fortitude, without the least mixture of any thing irritable or querelous, agreeably to the placid and even Tenour of his whole Life. He had from the beginning of his Malady a distinct view of his Dissolution, which he contemplated with that entire composure, which nothing but the innocence, integrity, and usefulness of his Life, and an unaffected submission to the Will of Providence could bestow. In this situation he had every consolation from family tenderness, which his tenderness to his family had always merited.

Sir Joshua Reynolds was on very many accounts one of the most memorable men of his Time. He was the first Englishman who added the praise of the eligant Arts to the other Glories of his Country. In Taste, in grace, in facility, in happy invention, and in the Richness and Harmony of colouring, he was equal to the great masters of the renowned Ages. In Pourtrait he went beyond them; for he communicated to that description of the art, in which English artists are the most engaged a variety, a Fancy, and a dignity derived from the higher Branches, which even those who professed them a superior manner, did not always preserve when they delineated individual nature. His Pourtraits remind the Spectator of the Invention of History, and the amenity of Landscape. In painting pourtraits, he appeard not to be raised upon that platform; but to descend to it from an higher sphere. His paintings illustrate his Lessons – and his Lessons seem to be derived from his Paintings.

He possessed the Theory as perfectly as the Practice of his Art. To be such a painter, he was a profound and penetrating Philosopher.

In full affluence of foreign and domestick Fame, admired by the expert in art, and by the learned in Science, courted by the great, caressed by Sovereign powers, and celebrated by distinguishd Poets, his Native humility, modesty and Candour never forsook him, even on surprise or provocation, nor was the least degree of arrogance or assumption visible to the most scrutinizing eye, in any part of his Conduct or discourse.

His talents of every kind powerful from Nature, and not meanly cultivated by Letters, his social Virtues in all the relations, and all the habitudes of Life renderd him the center of a very great and unparalleled Variety of agreeable Societies, which will be dissipated by his Death. He had too much

merit not to excite some Jealousy; too much innocence to provoke any Enmity. The loss of no man of his Time can be felt with more sincere, general, and unmixed Sorrow.

HAIL! AND FAREWELL!

ABBREVIATIONS

THROUGHOUT this volume 'JR' refers to Joshua Reynolds, 'RA' to the Royal Academy, and 'Club' to the so-called Literary Club founded by Reynolds and Johnson. Except where otherwise stated, the place of publication of the works included here is London.

Barrell J. Barrell, *The Political Theory of Painting from Reynolds to Hazlitt* (New Haven, 1986).

Blake William Blake, *The Complete Poetry and Prose of William Blake*, ed. G. Keynes (1969).

Boswell, *Grand Tour* Boswell on the Grand Tour: Italy, Corsica and France, ed. F. Brady and F. A. Pottle (1955).

Burney *Dr Burney's Musical Tours in Europe: An Eighteenth-Century Musical Tour in France and Italy*, ed. P. A. Scholes (1959).

CHW *The Yale Edition of the Correspondence of Horace Walpole*, ed. W. S. Lewis (New Haven, 1937–83).

Fry Joshua Reynolds, *Discourses*, ed. R. Fry (1905).

Gibbon *Gibbon's Journey from Geneva to Rome*, ed. G. A. Bonnard (1961).

Hagstrum J. H. Hagstrum *The Sister Arts* (Chicago, 1958).

Hudson D. Hudson, *Sir Joshua Reynolds: A Personal Study* (1958).

LC	F. W. Hilles, *The Literary Career of Sir Joshua Reynolds* (Cambridge, 1936).
Letters	*Letters of Sir Joshua Reynolds*, ed. F. W. Hilles (Cambridge, 1929).
Lives of Poets	Samuel Johnson, *The Lives of the English Poets*, ed. G. B. Hill (Oxford, 1905).
LSJ	James Boswell, *The Life of Samuel Johnson*, ed. G. B. Hill and L. F. Powell (Oxford, 1934–64).
L/T	C. R. Leslie and T. Taylor, *Life and Times of Sir Joshua Reynolds*, 2 vols. (1865).
Monk	S. H. Monk, *The Sublime* (Ann Arbor, Mich., 1960).
Northcote	James Northcote, *The Life of Sir Joshua Reynolds*, 2 vols. (1818).
Penny	N. Penny, *Reynolds* (1986).
Piozzi	Hester Lynch Piozzi, *Observations and Reflections made in the Course of a Journey through France, Germany and Italy*, ed. H. Barrows (1967).
Portraits	*Portraits by Sir Joshua Reynolds*, ed. F. W. Hilles (1952).
Sublime and Beautiful (S&B)	Edmund Burke, *A Philosophical Enquiry into the Origins of our Ideas of the Sublime and Beautiful*, ed. J. T. Boulton (1958).
Smollett	Tobias Smollett, *Travels through France and Italy*, ed. F. Felsenstein (Oxford, 1979).
Spence	Joseph Spence, *Letters from the Grand Tour*, ed. S. Klima (Montreal, 1975).
Thraliana	Hester Thrale, *Thraliana: The Diary of Mrs Hester Lynch Thrale*, ed. K. C. Balderston, 2nd edn, 2 vols. (Oxford, 1951).

Tilley	M. P. Tilley, *A Dictionary of the Proverb in England in the Sixteenth and Seventeenth Centuries* (1950).
Vasari	Giorgio Vasari, *The Lives of the Painters, Sculptors and Architects*, tr. A. B. Hinds (1963).
Wark	Joshua Reynolds, *Discourses on Art*, ed. R. R. Wark (New Haven, 1975).
Whitley	W. T. Whitley, *Artists and their Friends in England 1700–1799* (1928).
Wimsatt	*Dr Johnson on Shakespeare*, ed. W. K. Wimsatt (Harmondsworth, 1969).
Wind	E. Wind, *Hume and the Heroic Portrait*, ed. J. Anderson (Oxford, 1986).
Works	*The Works of Sir Joshua Reynolds, Knt.*, ed. Edmond Malone, 2 vols. (1797), rev. edn, 3 vols. (1798). See Note on the Text, p. 70, for further details.
Young	Edward Young, 'Conjectures on Original Composition' in E. D. Jones (ed.), *English Critical Essays XVI–XVIII Centuries* (1947).

NOTES ON THE DISCOURSES

Where information is taken from standard sources such as *The Dictionary of National Biography*, *The New Cambridge Bibliography of English Literature*, *The Complete Peerage* or *The Oxford English Dictionary* (*OED*), these sources are not routinely specified. Those translations that are not otherwise credited are by the editor. For artists, architects and art historians, see the Biographical Index of Artists, p. 409. For abbreviations and short titles, see the list on p. 365. Except where otherwise stated, the place of publication for the works cited here is London.

TO THE KING

1. George III (1738–1820), who had been on the throne since 1760. For his relations with JR, see Hudson, pp. 91–3. Official portraits of the king and queen by JR were painted around 1778–9 for the Council Room of the Academy at Somerset House: 'That the monarch should agree to sit to him was requested by Reynolds as a condition of his acceptance of the Presidency of the Academy – or so it was reported' (Penny, p. 285).

This general dedication was first published at the head of the 1778 collection; Malone moved it to the head of the *Works* in 1797. Samuel Johnson wrote the dedication, with seeming reluctance, on 18 April 1778 (*LSJ*, III. 524), about a month before the collected *Discourses* appeared.

2. For the foundation of the Royal Academy in 1768, see Introduction, pp. 6–11.

3. The climate was widely believed to affect human character, society and politics: Montesquieu devotes four books (i.e. chapters)

at the centre of his hugely influential *Esprit des lois* (1748) to the topic. As Wark points out (p. 3), James Barry had attempted in 1775 to confute the view that the weather impeded English efforts to excel in the arts. Climatic effects are also discussed in Goldsmith's *Traveller* (1764); for JR's admiration of his friend's poem, see *LSJ*, III. 252.

DISCOURSE I

1. The first Discourse was delivered on 2 January 1769 at the official opening of the Academy; for a reproduction of JR's entry in his appointment book, see Hudson, p. 98. The dedication to the members of the RA was published, together with the first Discourse, in late January or February 1769.

2. For the background to the Academy and its foundation, see Introduction, pp. 4–13.

3. Recent students of George III have attempted to rehabilitate his reputation as an enlightened patron of the arts: see John Brooke, *King George III* (1972).

4. Although there were elaborate negotiations to set up the Academy, based around Sir William Chambers, JR is thought to have played only a small part: see Hudson, pp. 90–92.

5. In the *Works* JR omitted a paragraph which appeared in the original Discourse, concerning the so-called 'progress' of the arts from Greece; for the circumstances, see *LC*, p. 47.

6. As Fry points out (p. 429), 'This puts the change . . . too late. The first great change took place on [Raphael's] visit to Florence in 1504.' 'Gothic' here means primitive, unpolished or simply old-fashioned. See also Vasari, II. 231.

7. In 1769 JR wrote to James Barry, then in Rome, requesting his help: 'I suppose you have heard of the establishment of a royal academy here; the first opportunity I have I will send you the discourse I delivered at its opening . . . As I hope you will hereafter be one of our body, I wish you would, as opportunity offers, make memorandums of the regulations of the academies that you may visit in your travels, to be engrafted on our own, if they should be found useful' (*Letters*, p. 19).

8. JR wrote to the diplomat and archaeologist William Hamilton on 28 March 1769: 'We have four Professors Mr Penny of Painting Mr Chambers of Architecture Mr Wale of Geometry and Perspective and Dr Hunter of Anatomy each gives six Lectures every year – the

salary £30 per annum, we have nine Visitors who attend every evening for a month alternately, he must be in the Academy two hours whilst the young men make a drawing fore which he receives half a Guinea' (*Letters*, p. 23). Francis Hayman was one of the first visitors elected. JR was wrong about the Professor of Architecture, who was William Sandby.

9. See Appendix A, the 'Ironical Discourse', p. 342.

10. Pope, *Essay on Criticism*, 1. 155. See S. H. Monk, 'A Grace beyond the Reach of Art', *Journal of the History of Ideas*, v (1944), 131–50.

11. Proverbial (Tilley, S951).

12. JR has probably in mind chiefly the Académie Royale, founded in Paris in 1648 and housed in the Louvre. He had recently visited Paris and seems to have found the Académie lacking in real creative or dynamic force (see L/T, 1. 415–16).

13. *They wish to find . . . a good painter*: this passage was recast from a draft printed in *LC*, p. 217.

14. William Blake commented, 'The Lives of the Painters say that Rafael Died of Dissipation. Idleness is one Thing & Dissipation Another. He who has Nothing to Dissipate Cannot Dissipate; the Weak Man may be Virtuous Enough, but will Never be an Artist' (Blake, p. 454).

15. *Attitude*: technical term in art – the 'disposition' of a figure in a painting or sculpture; the modern sense (as in an attitude of mind) was only just evolving.

16. A drawing at Chantilly (not by Raphael), collected and engraved by the Comte de Caylus (see Biographical Index).

17. JR's letter to Hamilton (see note 8 above) continued by listing 'eight other members [who] are appointed to form the laws, and it is this body which is called the Council who govern the Academy' (*Letters*, p. 23). Though JR presided over the Council, Chambers as Treasurer exercised a major role in the running of the Academy. See John Harris, *Sir William Chambers: Knight of the Polar Star* (1970), pp. 163–9.

18. Francis Milner Newton (1720–94), portrait painter, had been Secretary of the Society of Artists and took this role in the Academy from its foundation until 1788. The 'instrument' setting up the Academy and outlining its constitution was signed by the king on 10 December 1768.

19. Giovanni de' Medici (1475–1521), son of Lorenzo the Magnificent, reigned as Pope Leo X from 1513 to his death. However, as Wark suggests (p. 21), JR may mean rather the outstanding artistic achievements under the papacy of Julius II (1503–13).

20. Pliny, *Natural History*, xxxv. 10; possibly borrowed by J R from Franciscus Junius or Francesco Algarotti, his regular sources (see Biographical Index).

DISCOURSE II

1. Delivered on 11 December 1769. This and the remaining Discourses (except no. IX) coincided with the annual distribution of prizes to the students of the Academy.

2. *Supplies*: makes good, makes up for, supplements.

3. Proverbial, from the Latin *ex nihilo nihil fit* (Tilley, N285).

4. *Originality*: this was a recent word and something of a vogue term, used by writers such as Thomas Gray and above all Edward Young, whose *Conjectures on Original Composition* (1759) gave wide currency to the term. JR's father was an early friend of Young, who was well known to Samuel Johnson. JR, like Johnson, harboured doubts as to the value of what was purely and simply 'original'.

5. Fry (p. 430) lists some painters actually working in Italy during 1769, including Canaletto, Guardi, Zuccharelli, Mengs, Batoni and, only 'just', Tiepolo (for he died in 1770). 'The dangerous people,' adds Fry, 'were, no doubt, Mengs and Batoni.' See Discourse XIV, note 3.

6. Again this seems to be in conscious reaction to Young's *Conjectures* (see note 4 above), as exemplified by a passage beginning, 'Let not great examples, or authorities, browbeat thy reason into too great a difference of thyself' (Young, p. 288). See also Barrell, pp. 127-8. For a draft version of JR's passage, see *LC*, p. 218; and for a source in JR's reading in Pope, *LC*, p. 212.

7. *Complication*: combination.

8. Reliant on Junius (see *LC*, p. 127). For JR's gradual recognition of the merits of Raphael, after a period of copying the master's works, see Malone's comments (quoted by Wind, p. 79).

9. Blake characteristically responds: 'Meer Enthusiasm is the All in ALL! Bacon's Philosophy has Ruin'd England' (Blake, p. 456).

10. Several passages in this Discourse are echoed in JR's letter to James Barry written in the same year. Specifically he warns against 'copying those ornamental pictures which the travelling gentlemen always bring home with them'; and counsels Barry to immerse himself whilst in Rome in Michelangelo and Raphael. 'If you should not relish them at first . . . never cease looking till you feel something like inspiration comes over you, till you think every other painter insipid in comparison' (*Letters*, pp. 17-19).

11. For Lodovico Carracci (previous sentence) see Biographical Index. The paintings JR mentions mostly remain in various collections at Bologna. He saw the *St Matthew* at the Mendicanti; the *St Jerome* in the Palazzo Ranuzzi; the *St John* in S. Giovanni Battista. JR's friend Charles Burney noticed 'several fine things by Lodovico Carach' in the Palazzo Zampiero when he visited Bologna a year later, in August 1770 (Burney, I. 149).

12. *Port-crayon*: an instrument used to hold a crayon for drawing, usually a metal tube split at one end.

13. *Pencil*: brush.

14. As elsewhere, JR plays around a number of proverbial forms (see Tilley, N305).

15. Philopoemen (*c*. 250–183 BC), general of the Achaean league, defeated Sparta (see Plutarch, *Philopoemen*, v; for Livy, see note 16.) The opening of this paragraph derives from Junius (*LC*, p. 126).

16. Livy, XXXV. 28. 1–7, first cited by Junius (see *LC*, p. 126). The translation is apparently JR's own.

17. An allusion to Leonardo's *Trattato della pittura* (first published in 1651), but most likely drawn by JR from a work he may have owned – de Piles's *Art of Painting*, the English translation (1706) – where Leonardo's remark is cited.

18. Blake annotated this passage, calling it 'A Stroke at Mortimer!'. He meant the historical painter John Hamilton Mortimer (1740–79); however, it has been pointed out that Mortimer had not attempted his 'monster' etchings in 1769, when this Discourse was delivered. See Blake, p. 457, and John Sunderland, *John Hamilton Mortimer: His Life and Works* (1988), p. 95.

19. *Juggler*: conjuror.

DISCOURSE III

1. The third Discourse was delivered on 14 December 1770, and was addressed to what might be called intermediate students.

2. A good short survey of 'general nature' in this period can be found in W. K. Wimsatt and C. Brooks, *Literary Criticism: A Short History*, the volume entitled *Neo-Classical Criticism* (1970), pp. 313–36, with extensive citation of JR and Samuel Johnson.

3. *Amuse*: divert, distract, with the added idea of deceive.

4. See the footnote: JR found the references in Junius (*LC*, pp. 19–20). They are to the commentaries on Plato's *Timaeus* by the fifth-century scholiast Proclus of Byzantium; and to Cicero, *Orator*, II. v.

5. Phidias made a statue of Zeus at Olympia and of the chryseleph-
antine Athena at the Parthenon.

6. The notion evolved in Italy in the seventeenth century as *lo stile
grande*, and became applied to a noble manner of historical painting,
matching the epic 'grand style' in literature.

7. 'Enthusiastic Admiration is the first Principle of Knowledge &
its last. Now he begins to Degrade, to Deny & to Mock' (Blake,
p. 458).

8. 'The Man who never in his mind & Thoughts travel'd to Heaven
is No Artist' (Blake, p. 458). For the divine inspiration of the artist,
compare Young, p. 279.

9. See *Idler*, 79 (p. 351 above), for a fuller discussion of the grand
style.

10. The terminology of the Longinian concept of the sublime: see
Monk, p. 185. (See also Discourse V, note 13.)

11. JR had adumbrated the idea of 'the most general form of nature'
in *Idler*, 82 (p. 355 above).

12. 'The Great Bacon – he is Call'd: I call him the little Bacon . . .
He is like Sr. Joshua, full of Self-contradiction & Knavery' (Blake,
p. 459).

13. In the *Ferrara Gazette*, during 1779, a tribute was paid to four
great men of modern England, with Burke cast as Cicero, Garrick as
Roscius, Johnson as Plato and JR as Apelles. See *Thraliana*, 1. 404.

14. The same passage from Bacon's essay 'Of Beauty' is used in the
'Ironical Discourse', in order to support the view that rules 'cramp
and fetter genius'. See Appendix A and *Portraits*, p. 134.

15. Alluding to Horace, *Ars poetica*, 11. 25–6: 'brevis esse laboro, /
obscurus fio' ('I strive to be brief, and grow obscure').

16. *This laborious investigation . . . care and sagacity*: these last two
paragraphs were added in JR's late revision around 1791 (*LC*,
pp. 190–94).

17. Respectively the Farnese *Hercules*, the *Gladiator*, then in the
Villa Borghese, and the *Apollo Belvedere*. Tobias Smollett, who
visited the Vatican in 1765, thought the *Apollo* 'the most beautiful
statue that ever was formed' (p. 286). Hester Piozzi (p. 217) found
'beauty and dignity beyond what human nature can now boast'.
Charles Burney in 1770 found 'the fighting Gladiator most amaz-
ingly fine – drawing, attitude and muscular force, with manly grace
are all united' (1. 297). Edward Gibbon had noted in 1764 that it
was 'esteemed the most correct, tho' not the most pleasing statue in
Rome' (Gibbon, p. 249).

18. Dr William Hunter (1718–83), Professor of Anatomy at the

Academy from its foundation, brother of the equally famous surgeon John Hunter. In 1787 JR was asked by members of Glasgow University whether he could paint a posthumous portrait of William Hunter, and is said to have replied with the single word 'possum' (see Whitley, II. 82–3). The picture is now at the Hunterian Museum in Glasgow.

19. The footnote cites Quintilian, II. v. 12, by Junius (*LC*, p. 287). Dancing-masters were standard targets of satire, usually symbolizing artificial manners and false breeding.

20. Close to a number of passages in Samuel Johnson (especially *Rasselas*, ch. 10), and seen by some as a 'creative misreading' of Johnson. See also Monk, p. 185.

21. A proverbial tag which had been used in the *Spectator*, 30 April 1711 (see *LC*, p. 108). The original source is Plutarch: 'I paint for eternity' (*Life of Pericles*, 159D). For Zeuxis, see Biographical Index.

22. JR has in mind the elaborate baroque set-pieces of such French decorative painters as Charles Lebrun and Louis Laguerre.

23. Following the maxim, 'custom (habit) is a second nature' (Tilley, C932).

24. JR recalls the famous passage of Johnson's *Rasselas*, ch. 10, in which Imlac instructs the prince that 'the business of a poet . . . is to examine not the individual but the species . . . he does not number the streaks of the tulip, or describe the different shades in the verdure of the forest . . . he . . . must neglect the minuter discriminations'.

25. JR derived from writers such as Jonathan Richardson (see Introduction, pp. 13–16) the idea that love of art would conduce to instil noble and genteel feelings in the public. The liberal arts were originally confined to the seven disciplines of the Trivium and the Quadrivium, which included music but excluded the visual arts; but by this time the claims of the fine arts to a part in gentlemanly education were widely accepted. For the civic role of taste, see Barrell, *passim*.

26. Vasari, III. 70, life of Marcantonio Bolognese.

27. *Boors*: specifically used of Dutch (or sometimes German) peasants.

28. *The club of Hercules*: proverbial for any 'stick of unusual size and formidable appearance' (*OED*, quoting *Brewer's Dictionary of Phrase and Fable*].

29. Edward Penny (1714–91), painter of portraits and historical subjects had been vice-president of the Incorporated Society of Artists and then served as first Professor of Painting at the Academy (1769–

83). According to a newspaper critic in 1770, Penny's *'prelections must be curious, as his head ... cannot be accused of containing anything'* (Whitley, II. 277). JR also comes in for criticism, along with the honorary professors 'Doctor Pendulum' (Johnson), Giuseppe Baretti and Oliver Goldsmith.

DISCOURSE IV

1. Delivered on 10 December 1771.

2. There were various traditional schemes setting out the component parts of artistic creation, mostly derived from the rhetoricians' breakdown of literary skills (invention, elocution, and so on). One scheme for the visual arts (cited by Fry, p. 431) comprised invention, disposition, attitude, members and colour. Junius in his *De pictura veterum* (1637) had classified these differently: invention, proportion, colour, motion and disposition. The key element was invention, meaning the ability to find the right subject and with it select an ordering principle for the entire work.

3. 'Sympathy' had become a vogue word in the previous two decades, through works such as Burke's *Sublime and Beautiful* (*S&B*, pp. 44–5) and Adam Smith's *Theory of Moral Sentiments* (see the edition of the latter by D. D. Raphael and A. L. MacFie, 1976, pp. 9–26). JR reflects a new awareness of the affective power of art.

4. *In request*: in fashion, in demand.

5. Here and at other points in this Discourse, JR seems to have in mind a controversy set off by Benjamin West's *Death of Wolfe*, shown at the Academy in 1771. This was an attempt to paint a large 'historical' subject in modern dress, and occasioned a considerable stir. According to West's biographer John Galt, JR was gradually converted to the merits of West's effort 'to exhibit heroes in coats, breeches, and cock'd hats'. For a full discussion, see Wind, pp. 100–104.

6. 'Sacrifice the Parts, What becomes of the Whole?' (Blake, p. 462).

7. *Group*: the word entered the English language as a technical term in art criticism, meaning an assemblage of figures combining to form a distinct part of the design. The first usage in *OED* is from John Dryden's translation (1695) of Charles-Alphonse Dufresnoy's *De arte graphica* (first published in 1668), a book JR almost certainly owned.

8. A submerged reference to the tag 'ars est celare artem' (Tilley, A335).

376

NOTES ON THE DISCOURSES

9. Compare J R's draft notes for an essay among the Boswell papers: 'Arts have little to do with reason. They address themselves to another faculty; their whole commerce is with the imagination' (cited in *Portraits*, p. 108).

10. *Discover*: reveal, make evident.

11. *Professors*: exponents.

12. Full-size designs by Raphael intended for tapestries to be hung in the Sistine Chapel; they were brought to England by Charles I and were in J R's time on view at Hampton Court. Later they were moved to Buckingham House (now the Palace).

13. 2 Corinthians 10:10: 'For his letters, they say, are weighty and strong; but his bodily presence is weak, and his speech of no account.'

14. Agesilaus (*c*. 444–361 BC), king of Sparta, a friend of Xenophon, who relates his successful campaigns against the Thebans. For Alexander the Great, see Plutarch's life of him.

15. Deriving from the doctrine of *ut pictura poesis*, which gave primacy to historical painting. On concealing defects, see Horace Warpole's comment on J R's picture of Soame Jenyns (16 September 1777): 'It is a proof of Sir Joshua's art, who could give a strong resemblance of so uncouth a countenance without leaving it disagreeable' (*CHW*, II. 58).

16. Bernini's *David* 'taking aim at Goliath, sling in hand, is said to be Bernini's own portrait, and is very ugly' (Burney, I. 297, on visiting the Villa Borghesi in Rome in 1770). One of Bernini's earliest sculptures for Cardinal Scipione Borghese (*c*. 1620).

17. *Monotony*: that is, monochrome , a sense not recorded in *OED*.

18. *Artificial*: contrived, unnatural. Compare this with the notes for an essay on Shakespeare in the Boswell papers: 'Poussin is too artificial in his draperies, perhaps in the whole. Carlo Maratti the same. Raphael's right taste makes him introduce accidental folds' (cited in *Portraits*, p. 109).

19. J R's friend Edmund Burke had to set out the classic opposition of the sublime with the merely pretty or elegant in his codification of these aesthetic categories, *A Philosophical Enquiry into the Origins of our Ideas of the Sublime and Beautiful* (1757). See Monk, *passim*.

20. This conference has not so far been traced: Wark (p. 63) notes that the episode is not reported in André Félibien's 'Conférences de l'Académie Royale'.

21. Then in the King's Cabinet, now in Rennes museum (Fry, p. 432).

22. *Pencil*: brush.

23. *Macbeth* v. v. 26–8.

24. De Piles alludes to the habit in Carracci of using only twelve figures in a composition; his remarks were attached to Dryden's translation (1695) of Dufresnoy's *De arte graphica* (first published in 1668).

25. Again close to the central doctrine of Burke's treatise, which aligned the sublime with the vast, and the beautiful with the small and domestic.

26. *However great the difference . . . give to a work*: on this passage Blake commented, 'Somebody Else wrote this page for Reynolds. I think that Barry or Fuseli wrote it, or dictated it' (Blake, p. 463). Probably not a serious comment, but in any case the suggestion is palpably wrong.

27. See Vasari, IV. 207.

28. Vasari, 'Battista Franco', IV. 23.

29. Again not traced in Félibien's report of the 'Conférences de l'Académie Royale' (cf. note 20 above).

30. For comments by Gainsborough, who had received a copy of this Discourse from the painter Prince Hoare, see his *Letters*, ed. M. Woodall (1963), p. 96. He wrote that it was 'amazingly clever, and cannot be too much admired . . . by every candid lover of the Art'.

31. For fuller comments by JR on the Dutch school, see his 'Journey to Flanders and Holland' in *Works*, II. 369–74.

32. According to Fry (p. 433), this 'must be' Joseph Cooper (1682–1743), mentioned by Horace Walpole as a follower of Caravaggio in *Anecdotes of Painting* (1786), IV. 110.

33. One of the few paragraphs in the *Discourses* which directly confronts JR's own situation as a fashionable portrait painter, aiming for high artistic effects, while equally conscious of the need to produce strongly identified likenesses. The 'more permanent' fashions JR employed include the timeless van Dyck costume, mythological guises (Mrs Sheridan as St Cecilia), 'fancy' pictures (Miss Meyer as Hebe), comic transformations (Master Crewe as Henry VIII) and allusive dress, such as Mrs Siddons as the Tragic Muse.

34. Pope, 'Epistle to a Lady', ll. 49–52, from his *Moral Essays*. For JR's extensive reading of Pope, see *LC*, p. 116, 212–13.

35. Philosophically close to Johnson's reflections when he reached Iona in 1773: 'Whatever makes the past, the distant, or the future predominate over the present, advances us in the dignity of thinking beings' (*A Journey to the Western Islands of Scotland*, ed. Mary Lascelles, New Haven, 1971, p. 148.) JR's aesthetic theory often echoes at one remove Johnson's wider moral thought.

DISCOURSE V

1. Delivered on 10 December 1772.

2. Not all the precise pictures can be identified with certainty, but one is probably *The Massacre of the Innocents* (Bologna, 1611); see JR's notes on paintings in Bologna, L/T, I. 474. The 'daughter of Herodias' is possibly the *Salome* in the Chicago Art Institute; Smollett (p. 292) was 'charmed with the Herodias, by Guido Rheni', in the Borghese, Rome – which may be what JR has in mind.

3. Pliny, *Natural History*, XXXIV. 77.

4. *Ductile*: flexible, versatile.

5. See Discourse II, p. 96 above.

6. Guilio Romano (see Biographical Index) was the architect of the Palazzo del Te, a pleasure house for the Gonzagas, at Mantua (from 1526). He supplied elaborate fresco decorations in an illusionist or early mannerist style.

7. Pietro Perugino (see Biographical Index) who, before his revaluation by the Pre-Raphaelites, was regarded as an insipid and shallow artist.

8. Probably only in part from the hand of Raphael, mostly executed by Giulio Romano, amongst others. Located in the church of S. Pietro in Montario, where it was seen by JR in 1752 (L/T, I. 471) and by Gibbon in 1764: 'esteemed the first picture in Rome and perhaps in the world' (Gibbon, p. 242). See also Burney, I. 203.

9. For a draft of this paragraph, see *LC*, pp. 223–4. See also Vasari, III. 119, 'Sebastiano Viniziano'.

10. See Discourse I, note 19.

11. Wark (p. 83) suggests that JR took this example from Francesco Algarotti's *Essay on Painting* (English translation, 1764).

12. There are similarities in this comparison to the differing estimates given by Smollett (pp. 284–5): 'Michael Angelo, with all his skill in anatomy, his correctness of design, his grand composition, his fire, and force of expression, seems to have had very little idea of grace ... [Whereas, of Raphael:] No man ever expressed the sentiments so happily, in visage, attitude, and gesture: but he seems to have had too much phlegm to strike off the grand passions, or reach the sublime parts of painting.' Monk (pp. 186–7) draws a highly instructive parallel with Johnson's famous comparison between Dryden and Pope (*Lives of Poets*, III. 220–23).

13. See Monk, p. 188. The treatise on the sublime from late antiquity, traditionally attributed to Dionysius Longinus, was trans-

lated in the sixteenth century but owed its widespread currency to the version by Boileau (1674). The best-known English version was that of Leonard Welsted (1712), though the main British advocate of Longinian rapture was John Dennis.

14. *Characteristical*: that is, performed in a way that characterizes, 'betokens character or special quality' (*OED*).

15. *Archetype*: a pre-Jungian usage, meaning simply 'prototype'.

16. *Savage*: the word above all others which had become associated with Rosa (see Biographical Index): witness the famous allusion by James Thomson to 'Whatever . . . savage Rosa dash'd, or learned Poussin drew' (*Castle of Indolence*, 1. xxxviii). The standard motifs of his work – crags, stormy landscapes, banditti – became synonymous with the sublime. Horace Walpole makes this explicit in a letter written in 1739 on crossing the Alps: 'Precipices, mountains, torrents, wolves, rumblings – Salvator Rosa' (*CHW*, XIII. 180). In a draft for this Discourse J R referred to 'the excentric stile of Salvator Rosa' (*LC*, p. 223).

17. Edmond Malone added a note in 1798, 'A more detailed character of Rubens may be found in the 'Journey to Flanders and Holland' (see *Works*, II. 413–27).

18. 'To my Eye Rubens's Colouring is most contemptible' (Blake, p. 469, with further strictures).

19. The *Aldobrandini Wedding*, a fresco discovered in 1605 on the Esquiline Hill in Rome, now in the Vatican Library.

20. The second series of the *Seven Sacraments* (Ellesmere collection, on loan from the Duke of Sutherland to the National Gallery of Scotland, Edinburgh), painted 1644–8, and in the famous collection of the Regent in Paris before being acquired by the Gower family for the Bridgewater House gallery at the end of the eighteenth century.

21. These lines perhaps reflect Johnson's often-expressed dislike of allegory, especially the intrusion of antique mythology into a modern subject. Compare, for example, the remark on John Gay's *Trivia*: 'An honest blacksmith might have done for Patty what is performed by Vulcan' (*Lives of Poets*, II. 284).

22. *1 Henry IV*, III. ii. 45 (slightly misquoted).

23. From an anecdote collected by the compiler Valerius Maximus, *Facta et dicta memorabilia*, III. 7; but probably drawn by J R from an intermediary source that I have not traced.

24. The Academy exhibitions had been held each April and May since its inception. They were attended by an interested public (as noted by Horace Walpole, for example, in the detailed comments he made on each show) and provoked intense discussion in the press.

DISCOURSE VI

1. Discourse VI was delivered on 10 December 1774. The four original professors (see Discourse I, note 8) were Edward Penny (1714–91), Painting; Samuel Wale (d. 1786), Perspective; William Hunter (1718–83), Anatomy; and Thomas Sandby (1721–98) – brother of the better-known Paul Sandby – Architecture. In addition, J R had used his influence to have honorary appointments made: Giuseppe Baretti as Secretary for Foreign Correspondence, Samuel Johnson as Professor of Ancient Literature, and Oliver Goldsmith as Professor of Ancient History. No duties devolved on these latter persons. Goldsmith was succeeded on his death in 1774 by Thomas Franklin, who had been named chaplain to the Academy at its foundation. Franklin (1721–84), a classical scholar and a writer of miscellaneous works, was another friend of J R. When Johnson and Franklin died in 1784, they were succeeded by other members of the Club: Bennet Langton and Edward Gibbon. A resolution was then passed by the Council of the Academy that the honorary professors should be 'recommended' to give a public lecture annually; but nothing came of this (see Whitley, II. 19). Finally, to complete the collaborative picture, it should be noted that in 1791 James Boswell became Secretary for Foreign Correspondence and his fellow-Clubman Thomas Bernard chaplain. See also Introduction, pp. 10–11.

2. The concept of imitation underlay criticism of all the arts in this period, especially that based on the model of Aristotle. In its primary sense it referred to the way in which a work of art copied nature; this is the 'larger' usage which J R has in mind, as opposed to the more limited notion of modelling works of art upon the practice of earlier masters.

3. Blake (p. 470) commented on this paragraph: 'Bacon's Philosophy has Destroy'd Art & Science. The Man who says that the Genius is not Born, but Taught – is a Knave.' Critics like John Dennis had stressed the divine nature of artistic inspiration, and Joseph Addison had written an important piece in the *Spectator* (No. 160, 3 September 1711) on 'these great natural Genius's that were never disciplined and broken by Rules of Art'. But almost certainly J R has in mind the fashionable views of Edward Young, who had maintained that 'genius is from heaven, learning from man' (Young, p. 283).

4. Again Young (p. 279) asserts that 'a genius differs from a good understanding, as a magician from a good architect'.

NOTES ON THE DISCOURSES 381

5. Wark (p. 94) quotes from Robert Wood, *The Ruins of Balbec* (1757), a work owned by JR. He almost certainly knew Wood as a fellow member of the Society of Dilettanti, but would have disliked the other's political activities as the under-secretary responsible for prosecuting JR's friend John Wilkes.

6. Recalling Horace, *Epistles*, 1. xix. 19: 'O imitatores, servum pecus!' ('You mimics, you servile herd!'). JR's own practice as a painter had always involved extensive borrowing and allusion, a practice which Horace Walpole was quick to recognize and defend: 'Sir J. Reynolds has been accused of plagiarism for having borrowed attitudes from ancient masters ... [But] when a single posture is imitated from an historic picture and applied to a portrait in a different dress and with new attributes, this is not plagiarism but quotation: and a quotation from a great author, with a novel application of the sense, has allowed to be an instance of parts and taste; and may have more merit than the original' (footnote to the Advertisement to *Anecdotes of Painting in England*, 3rd edn, 1786, IV. vii). See the classic discussion of JR's borrowings in Wind, pp. 69–73.

7. Young had argued in respect of literature, 'Who knows whether Shakespeare might not have thought less, if he had read more? Who knows, if he might not have laboured under the load of Jonson's learning?' (Young, p. 299). Again, 'Shakespeare mingled no water with his wine, lowered his genius by no vapid imitation' (p. 298).

8. Compare: 'Born originals, how comes it to pass that we die copies? That meddling ape Imitation, as soon as we come to years of indiscretion ... snatches the pen and blots out ... all mental individuality' (Young, p. 285).

9. In direct contradiction of Young's assertions: 'For unprescribed beauties, and unexampled excellence, which are characteristic of genius, lie without the pale of learning's authorities, and laws ... For rules, like crutches, are a needful aid to the lame, though an impediment to the strong' (Young, p. 279).

10. *Palpable ... gross*: the word-cluster shows, as often, how deeply JR's mind was impregnated with Shakespeare: 'this palpable-gross play' (*A Midsummer Night's Dream*, v. i .376).

11. Blake comments, 'Reynolds Thinks that Man Learns all that he knows. I say on the Contrary that Man Brings All that he has or can have into the World with him. Man is born like a Garden ready Planted & Sown' (p. 471).

12. For a draft of this paragraph, see *LC*, p. 224.

13. See Discourse II, note 3.

14. Compare Young: 'Too great awe for [the ancients] lays genius

under restraint, and denies it that free scope, that full elbow-room, which is requisite for striking its most masterly strikes' (p. 279). Or again: 'Thyself so reverence, as to prefer the native growth of thy own mind to the richest import from abroad; such borrowed riches make us poor' (pp. 278–9, 289).

15. Not discovered in Pliny: JR's draft has simply, 'Genius has been compared by somebody' (*LC*, p. 226).

16. *De oratore*, II. xxii. 90.

17. *Proper study*: see Pope, *Essay on Man*, II. 2.

18. For a draft version of this paragraph, see *LC*, p. 227.

19. Here for once there is some partial convergence with Young's views: 'Imitation is inferiority confessed; emulation is superiority contested, or denied . . . that fetters, this fires' (Young, pp. 293–4).

20. See footnote: Quintilian, *Institutio oratoria*, X. 24.

21. The central tenet of neoclassical doctrine: hence the common usage of 'the revival of learning' for what we now call the Renaissance.

22. Pliny, *Natural History*, XXXIV. 3, 6–8. Corinthian brass was thought to be an alloy of gold, silver and copper, used in costly ornaments; the city was burnt to the ground by the consul Mummius in 146 BC.

23. At one time JR planned an essay on the topic 'why imitation pleases', but he seems to have dropped this when he found in a conversation with Adam Smith that the latter had composed a short study of this topic: see JR to Bennet Langton, 12 September 1782, cited in *Portraits*, pp. 155–6.

24. *Magazine*: storehouse, repository.

25. Plutarch on the life of Lycurgus, xvii, in *Lives*.

26. *Chemistry*: alchemy.

27. *Copiousness*: fullness or richness of matter. There are some echoes of the passage in Johnson's discussion of the metaphysical poets 'in the mass of materials . . . wit and useful knowledge may sometimes be found . . . such as, when they are expanded to perspicuity and polished to elegance, may give lustre to works which have more propriety though less copiousness of sentiment' (*Lives of Poets*, I. 22).

28. JR noted in his 'Journey to Flanders and Holland' (*Works*, II. 372) that 'the works of David Teniers, jun. are worthy the closest attention of a painter, who desires to excel in the mechanical knowledge of his art. His manner of touching, or what we call handling, has perhaps never been equalled.' For Teniers, see also Biographical Index.

29. Similarly, after his visit to the low countries in 1781, JR observed, 'Jan Steen has a strong manly style of painting, which might become even the design of Raffaelle, and he has shown ... great truth in the expression and character of his figures' (*Works*, II. 373).

30. Fry (p. 435) cites Edmund Gosse's suggestions that JR has in mind principally A. R. Mengs; Wark (p. 111) suggests rather Pompeo Batoni. (See Biographical Index for both Mengs and Batoni.) There are some difficulties about the former identification, since Mengs was a great admirer of Raphael, but there is more evidence of hostility between JR and Mengs, who was in Rome throughout the period of JR's stay there. Outside Italy and England he was also better known than Batoni. A less likely but conceivable candidate is Francesco Zuccarelli (1702–88), who later settled in England and became a foundation member of the Academy, but who had returned to Italy by this date.

DISCOURSE VII

1. Delivered on 10 December 1776.

2. Vitruvius Pollio (see Biographical Index), *De architectura*, I. i. 10.

3. *Illiterate*: unlearned, esp. lacking in knowledge of humane letters.

4. For a full discussion of JR's own reading and its place in his thought about the practice of painting, see *LC*, pp. 112–27.

5. See Introduction, pp. 35–51. JR's immediate circle, as is well known, included Samuel Johnson, Oliver Goldsmith, Edmund Burke, James Boswell, Charles Burney, Edward Gibbon, Adam Smith, David Garrick, Edmond Malone, Bishop Percy and other members of the 'literary' Club. But it also included bluestockings and notable women writers such as Fanny Burney, Hester Thrale, Elizabeth Montagu and Hannah More; erudite politicians such as Charles James Fox and John Dunning; men of the world (in various senses) such as John Wilkes, Sir Joseph Banks, the second Viscount Palmerston, Sir William Hamilton and Warren Hastings; leading figures in the theatrical world such as Sarah Siddons, R. B. Sheridan and George Colman; as well as notable churchmen, soldiers, doctors and lawyers. (This list is confined to friends, excluding the glittering collection of men and women who sat for JR.)

6. *Taste*: the watchword in mid-century aesthetics, both in Britain

and on the Continent. Developed by (amongst others) the Warton brothers, fellow-members of the Club and friends of JR. See Joan Pittock, *The Ascendancy of Taste* (1973).

7. JR is perhaps thinking of Shaftesbury (*Characteristics of Men, Manners, Opinions, and Times*, rev. edn, 1714, I. 207); more pervasively of John Dennis; but certainly of the kind of art criticism influenced by Young, with his quotation of the tag from Cicero: 'No one was ever a great man, without some divine afflatus' (*De natura deorum*, II. 66).

8. A characteristically Johnsonian emphasis. For one example out of very many, see Johnson to Bennet Langton, 21 September 1758 (cited *LSJ*, I. 339): 'Let us endeavour to see things as they are.' And see also the passage on 'the stability of truth' in the *Preface to Shakespeare* (Wimsatt, p. 59), followed by the reference to one 'who has mazed his imagination in following the phantoms which other writers raise up before him' (p. 61). In some sense JR is here opposed to the aesthetics of Burke, where the absence of Cartesian clear and distinct ideas is seen not as a fatal confusion but an enabling and sublime blurring. See, for example, *S & B*, p. 60.

9. Burke had remarked that 'All *general* privations are great, because they are all terrible: *Vacuity, Darkness, Solitude*, and *Silence*' (*S & B*, p. 71), and had stressed the sublime potential of obscurity in particular: 'to make anything very terrible, *obscurity* seems in general to be necessary'.

10. A recurrent topic in Johnson: see, for example, his words on Milton (*Lives of Poets*, I. 136–7); on Gray (III. 433); as well as *LSJ* I. 332–3, II. 263, with further instances cited there.

11. Again directly flying in the face of Young, who states that 'Genius can set us right in composition, without the rules of the learned' (Young, p. 280).

12. Rendering the Juvenalian tag, 'Mens sana in corpore sano' (Tilley, M974).

13. For Johnson's ready acquiescence in public opinion (or so he liked to fancy), see *LSJ*, I. 200.

14. Here JR does appear to be momentarily at odds with Johnson, who quoted the same proverb (Tilley, D385) in a more positive spirit: 'These apologies are always useless, "de gustibus non est disputandum"; men may be convinced, but they cannot be pleased, against their will' (*Lives of Poets*, II. 217). Hume also cited the proverb approvingly in his essay 'Of the Standard of Taste' (1757).

15. A recollection from *A Midsummer Night's Dream*, v. i. 16–17.

16. Compare what Boswell reports: 'he [Johnson] inculcated upon

all his friends the importance of perpetual vigilance against the slightest degrees of falsehood; the effect of which, as Sir Joshua Reynolds observed to me, has been, that all who were of his *school* are distinguished for a love and truth and accuracy' (*LSJ*, III. 229–30).

17. There is some relation here to a fragmentary essay 'On Prejudice' which survives among the Boswell papers at Yale (printed in *Portraits*, pp. 157–8).

18. See the passage in *Idler*, 82 (p. 354 above) on the need to distinguish between 'accidental blemishes and excrescences which are continually varying the surface of Nature's works, and the invariable general form which Nature most frequently produces, and always seems to intend in her productions'.

19. JR refers to frescoes in the Sala di Constantino in the Vatican. See also Burney, I. 219, where he states that 'it is impossible to admire sufficiently' this picture: each figure should be studied first singly and then 'in composition'. Burney had probably encountered the work already from engravings by his friend Robert Strange, who was known to JR as a persistent critic of the Academy.

20. *It has sometimes happened . . . credit to this report*: JR revised parts of this section and made the sense more explicit by replacing a few sentences from the original.

21. See first footnote: John, second Earl of Ashburnham (1724–1812), described by Horace Walpole as 'a most decent, reserved and servile courtier'. See second footnote: Sir Peter Burrell (1754–1820), MP, created Baron Gwydir in 1796.

22. The first and third of these pictures are not thought to be by Poussin, according to Wark (p. 125). But the first appears to be *The Triumph of Silenus* (1635–6), of which there is a copy in the National Gallery, London; the second is certainly *The Triumph of Bacchus* (1635–6), of which there is a copy in the Nelson Gallery/Atkins Museum, Kansas City; whilst the third must be spurious. For a full discussion of the Bacchanals, see Anthony Blunt, *Nicolas Poussin* (Washington, DC, 1967), I. 134–47.

23. *Hamlet*, III. ii. 6–9, 24–6.

24. ibid., III. ii. 12.

25. Rediscovered in 1506, the famous Hellenistic marble group had been extensively discussed, by Jonathan Richardson and Winckelmann amongst others, before Lessing wrote his influential treatise in 1766. For Smollett (p. 286) it 'surpassed my expectation . . . Pliny has done it no more than justice in saying it is the most excellent piece that ever was cut in marble'. About a month later Boswell also

saw it in the Vatican museum and noted, 'Laocoon supreme; equal to all ideas.' Shortly afterwards he grew more critical: 'Laocoon's sons too much formed: men in miniature' (Boswell, *Grand Tour*, pp. 70, 89). Hester Piozzi (p. 216) observes, 'Laocoon's agonies torment one.'

26. A series on the life of Maria de' Medici (1622–5) for the Palais du Luxembourg (now in the Louvre). JR had probably most recently visited the gallery in August 1771.

27. A frequent Johnsonian topic: for instance, he calls the mythology of ancient poets 'tedious and oppressive' (*Lives of Poets*, I. 213); see also Waller (I. 295), Rowe (II. 68), Gay (II. 283), and Gray (III. 439); as well as *LSJ*, IV. 16–17 ('It is evident enough that no one who writes now can use the Pagan deities and mythology'). See also Discourse V, note 21.

28. Goldsmith, *The Traveller* (1764), I. 334. Goldsmith had died two years earlier. For JR's high estimate of the poem, see *Portraits* p. 53. The paragraph echoes numerous passages in Johnson (see, for example, the end of *Idler*, 4), which define the role of the artist as that of making the world better – more easy to enjoy or to endure.

29. Hume similarly writes of 'some particular forms or qualities, from the original structure of the internal fabric [of the mind], are calculated to please, and others to displease' ('Of the Standard of Taste'). The argument of the succeeding paragraph rests on a Lockian epistemology shared by most writers of the day, but vigorously opposed by Blake. See Johnson in Wimsatt, p. 59.

30. Again Hume stresses experience as the only guide to all the rules of composition, as opposed to *a priori* principles; what count are 'general observations, concerning what has universally been found to please in all countries and in all ages' ('Of the Standard of Taste').

31. Once more echoing what Hume says of the 'foundation' of the 'rules of composition' ('Of the Standard of Taste').

32. See footnote: Tertullian, source unlocated, and Cicero, *Pro Archia*, I. ii; both found in Junius – see *LC*, p. 125. ('All the arts relating to mankind have a certain common bond, and are forged into a sort of kinship with one another.')

33. Hume concludes that 'though the principles of taste be universal, and nearly, if not entirely the same in all men; yet few are qualified to give judgement on any work of art, or establish their own sentiment as the standard of beauty' ('Of the Standard of Taste').

34. This test had first been applied by Addison in the *Spectator*, 61 (10 May 1711). See also Barrell, p. 149.

35. The three Greek orders were commonly joined with their Roman additions, Tuscan and Composite, in writers such as the pattern-book compiler William Halfpenny; JR sticks to the traditional grammar of architecture. Triglyphs are vertical strips on the frieze portion of the entablature; volutes are the coiled decorations on the Ionic capital; the acanthus refers to rows of leaves on the capital of the Corinthian column.

36. Young (p. 291) had stated, 'what we mean, is, verse unfallen, uncurst; verse reclaimed, reinthroned in the true language of the gods'. Johnson's fullest discussion occurs in his life of Milton, where he argues that 'Poetry may subsist without rhyme, but English poetry will not often please' (*Lives of Poets*, 1. 191–4). JR hedged: 'If I judge of rhyme from reason, I think ill, if from feeling think I prefer it' (*Portraits*, p. 158).

37. Charles-Alphonse Dufresnoy (see Biographical Index), *De arte graphica* (1668), 1. 263.

38. JR almost certainly recalled the visit of three Cherokee chiefs from South Carolina, who came to London in June 1762 to conclude a peace. They were presented to the king and stayed until 20 August. Accounts of their visit have been left by Gibbon, Elizabeth Montagu and the Duchess of Northumberland, amongst others. According to a press report, JR was painting the chiefs for reproduction by copperplate engraving. This evidently fell through, but JR made them a number of visits in July (L/T, 1. 213–14).

39. *Othaheite*: Tahiti, which had come into prominence following visits by Bougainville in 1768 and by Cook in 1769 (with Banks) and 1773. The Tahitian Omai was brought to England in July 1774 and enjoyed a diverse social round until his departure in June 1776. At the time this Discourse was delivered, he was on board the *Resolution* with Cook in the southern Indian Ocean. JR had painted his famous picture of Omai (Castle Howard) in, probably, late 1775; it was shown at the Academy exhibition in 1776. For the islander and his environment, see E. H. McCormick, *Omai: Pacific Envoy* (Auckland, 1977).

40. See Wind, pp. 88–99, on the tension between heroic style and modern dress in the 1770s and 1780s. For the popular 'Vandyke' dress in portraiture, see Aileen Ribeiro, *The Dress Worn at Masquerades in England 1730–1790* (New York, 1984).

41. JR calls up the popular ideas of associationism, deriving chiefly from Locke and versified by Mark Akenside in *The Pleasures of Imagination* (1744). Irrelevant mental associations had been a major source of fun in Laurence Sterne's *Tristram Shandy* (1759–68). Sterne had sat for JR in 1760.

42. A comparison has been drawn with Johnson's remarks in the preface to his *Dictionary*: 'if the changes that we fear be thus irresistible, what remains but to acquiesce with silence, as in the other insurmountable distresses of humanity? It remains that we retard what we cannot repel, that we palliate what we cannot cure' (see Barrell, p. 153). There is also some relation to Burke's *Reflections on the Revolution in France*: 'Instead of casting away all our old prejudices, we cherish them to a very considerable degree, and, to take more shame to ourselves, we cherish them because they are prejudices; and the longer they have lasted, and the more generally they have prevailed, the more we cherish them.'

43. Again close to Burke's *Reflections* (see note 42 above): 'Many of our men of speculation, instead of exploding general prejudices, employ their sagacity to discover the latent wisdom which prevails in them. If they find what they seek ... they think it more wise to continue the prejudice, with the reason involved, than to cast away the cloak of prejudice, and to leave nothing but the naked reason; because prejudice, with its reason, has motive to give action to that reason, and an affection which will give it permanence.'

44. The statue of Voltaire (1776) by Jean-Baptiste Pigalle (1714–85), now in the Palais de l'Institut, Paris. JR had not visited Paris since 1771 and would not have seen the sculpture. Voltaire did not die until 30 May 1778.

45. Naturally Burke would have sympathized: in the *Reflections* (see note 42 above) he writes with heavy irony, 'Thanks to our sullen resistance to innovation, thanks to the cold sluggishness of our national character, we still bear the stamp of our forefathers. We have not (as I conceive) lost the generosity and dignity of thinking of the fourteenth century; nor as yet have we subtilized ourselves into savages.'

46. Vasari, IV. 22.

47. *Manly*: adult, independent.

48. *To form this just taste ... upon reflection*: for a draft version of these two paragraphs, see LC, p. 228.

49. Nicolas Boileau-Despréaux (1636–1711), whose *Art poétique* (1674) enshrined neoclassical standards of taste. Pierre Corneille (1606–84), the tragic dramatist; seen as representative of the decorum and regularity of French classicism.

DISCOURSE VIII

1. Discourse VIII was delivered on 10 December 1778. For a draft of the opening argument, see *LC*, p. 229.

2. *Enthusiastick*: irrational, unfounded.

3. The subject of Johnson's *Rambler*, 2 (24 March 1750): 'The quality of looking forward into futurity, seems the unavoidable condition of a being, whose motions are gradual, and whose life is progressive.' See also *Rambler*, 5 (3 April 1750).

4. The human desire for novelty is one of the most central concerns in all Johnson's work: 'We desire, we pursue, we obtain, we are satiated: we desire something else, and begin a new pursuit' – see *Rambler*, 6 (7 April 1750). For an excellent discussion of this theme, see W. J. Bate, *The Achievement of Samuel Johnson* (New York, 1955), pp. 65–74. See also *S & B*, p. 31.

5. *Episode*: the technical term in the criticism of epic poetry for a set digression or brief sub-plot.

6. *An instance occurs . . . purposes of art*: for a draft of these two paragraphs see *LC*, p. 230.

7. *Repose*: in this Discourse JR seems to extend the technical sense of 'repose' as used in art criticism, referring to that of an area of shadow in an otherwise brightly coloured painting (see quotations from Dryden and others, in *OED*, 'repose', 3c). In the relevant section of Dufresnoy's *De arte graphica*, William Mason in his translation of 1783 (with notes by JR) has 'a calm reposing gloom' (l. 387).

8. *Macbeth*, I. vi. 1–10. Johnson had briefly discussed the scene in his *Observations on the Tragedy of Macbeth* (1745).

9. This is a paraphrase of Johnson's argument in the early paragraphs of the *Preface to Shakespeare* (Wimsatt, pp. 59–61).

10. JR's friend Joseph Warton laments the 'short duration of a true taste in poetry among the Romans', and criticizes Statius, Lucan, Claudian and Seneca for their 'distorted and unnatural' writing, in their quest for 'remote and artificial decorations'. See *An Essay on the Writings and Genius of Pope* (1756–82), II. 21–3. Publication of the second volume of this work was delayed until 1782, but the text was written and set up in type many years earlier. JR was at this time engaged on the design for a window in New College Chapel, which had been proposed to him by Warton. A dual portrait from this same year shows two young men examining a print of JR's portrait of Warton.

11. JR quotes from the English translation of Roger de Piles's *Cours*

de peintures par principes (1708), which appeared as *The Principles of Painting* (1743). JR owned the original French edition (*LC*, p. 119).

12. A baroque ceiling for the chapel at Versailles (1708), using *trompe l'oeil* effects. For Coypel, see Biographical Index.

13. *I can fancy . . . called pedantry*: for a draft version of the sentence, see *LC*, p. 230.

14. The *Venus de' Medici*, in the Uffizi, Florence. Gibbon admired the statue in 1764, preferring it to Titian's painting of Venus (Gibbon, pp. 122–3); Smollett on the other hand confessed his inability to feel 'that enthusiastic admiration with which others are inspired . . . I cannot help thinking that there is no beauty in the features of Venus; and that the attitude is awkward and out of character' (Smollett. p. 236). See also Burney, 1. 178–9, and Piozzi, p. 134, admiring both the sculpture and the painting.

15. *Inartificial*: artless, unsophisticated.

16. Standard advice, as represented by Dufresnoy, *De arte graphica*, ll. 193–211.

17. It is impossible to be certain exactly what JR has in mind when describing these 'primitive' stages of art history. The first stage might be the era of Giotto, the second that of Massaccio or possibly even that of Botticelli (who was still little known). But this is speculative.

18. See Discourse IV, pp. 124–5. A passage of four short paragraphs in the original text was omitted here in the *Works*.

19. Leonardo da Vinci, *Trattato della pittura* (first published in 1651).

20. For Elymas, see Acts 13: 8–12. For Raphael's cartoons (previous sentence), see Discourse IV, note 12.

21. A formula lifted bodily from Johnson (*Lives of Poets*, 1. 22–3). The first instalment of the *Lives*, containing this portion taken from the life of Cowley, was published around June 1779. Johnson sent JR a copy, and in any case JR may have read the work in manuscript. He copied out this passage when rereading the *Lives*.

22. Dufresnoy, *De arte graphica*, ll. 129–31. In the note JR appended to these lines in Mason's translation (1783), he expressed similar views to those set out in this paragraph.

23. Now in the Louvre; Félibien's *Tent of Darius Explained* (English translation, 1703; a copy was passed on to JR from his father) makes similar points. For a marginal note by JR, see *LC*, p. 232.

24. On the *Marriage at Cana* (now in the Louvre), see Spence, p. 90: 'Tis in his usual way, magnificent instead of proper.' Like Spence, JR saw the picture at S. Giorgio Maggiore, Venice, and

made notes in 1752 which underlie this present passage (L/T, I. 68–9).

25. A fresco in the Stanza della Segnatura, Vatican (*c.* 1509). Burney admired the fresco in 1770, though deploring its bad condition (Burney, I. 219). See also Smollett, p. 284; for JR's parody in the form of a scene depicting English visitors to Rome, painted in 1751, see Wind, pp. 77–80, as well as L/T, I. 46.

26. As Fry points out (p. 436), this passage gave rise to the legend that Gainsborough painted his *Blue Boy* as a deliberate refutation of JR's assertions. It cannot be true for the simple reason that Gainsborough's portrait of Master Buttall was painted *c.* 1770. But, as Jack Lindsay says, 'the work none the less plays an important part in the wordless polemic between the two artists' – see *Gainsborough* (1982), p. 96.

27. Now in the National Gallery, London (painted *c.* 1520).

28. De Piles, in his 'Observations', which were attached to the Dryden translation (1695) of Dufresnoy's *De arte graphica* (first published in 1668).

29. *Landscape by Moonlight*, sold with JR's collection after his death in March 1705; for the sale, see Whitley, II. 195–6.

30. Otherwise the *Man in Armour*. For other evidence of JR's interest in Rembrandt, see his 'Journey to Flanders and Holland', *Works*, II. 344–6, 356–8.

31. See footnote: at some stage (probably in the 1780s or early 1790s) JR attempted to get Burke to revise the *Sublime and Beautiful*, but he never did this (see *LC*, p. 118). Though some passages in the *Discourses* reflect marked differences in aesthetic outlook from that of Burke, JR always expressed strong admiration for 'the admirable treatise'. This is much the same as with Johnson, who called it 'an example of true criticism' (*LSJ*, II. 90) but did not adopt its tenets in any thoroughgoing way.

32. That is, the pictures by the students which were being awarded prizes on this occasion.

33. Cicero, *Orator*, XXII. 74; Quintilian, *Institutio oratoria*, II. 13; Valerius Maximus, *Facta et dicta memorabilia*, VIII; Pliny, *Natural History*, XXXV. xxxvi. 73.

34. Referring to *Paradise Lost*, IV. 304–24. JR's early mentor, Jonathan Richardson, together with his son, had discussed the passage in *Explanatory Notes and Remarks on Paradise Lost* (1734).

35. The sculptor Falconet (see Biographical Index) translated Books XXXIV–VI of Pliny's *Natural History* in 1772. JR termed him 'my friend' in a notebook entry (*LC*, p. 77).

36. Euripedes, *Iphigenia at Aulis*, ll. 1547–50.

DISCOURSE IX

1. Discourse IX was delivered on 16 October 1780. Uniquely, the occasion was the opening of the new permanent accommodation for the Academy in Somerset House, in the Strand. Although the Academy had enjoyed the use of seven rooms in Inigo Jones's portion of Somerset House, with some teaching space as well as the council room and library, there had been no gallery and the annual exhibition had taken place in Lambe's auction rooms, Pall Mall. Sir William Chambers had presented plans for the new school and exhibition rooms to the Council in 1776; and they were ready in time for the exhibition in April 1780, when JR showed the king around them. JR had also painted his only ceiling design, an allegorical treatment of 'Theory' as 'an elegant and majestick female', as Giuseppe Baretti's official guide put it. Furthermore, he made a portrait of Chambers for the assembly room in the new building. See Penny, pp. 284–5.

2. For Chambers, see Biographical Index and Introduction, pp. 9–10. For his work at Somerset House, see J. Harris, *Sir William Chambers: Knight of the Polar Star* (1970), pp. 96–106.

3. Orthodox eighteenth-century doctrine: a considerable sense of inferiority was felt when Britain's standing in the fine arts lagged behind its increasing wealth, industrial and commercial growth, and expansion as a world power following the Seven Years' War. Although JR's desire to see the establishment of an 'English school' is linked to his own ambitions for international recognition, it is fair to say that he consistently sought to advance the cause of other English artists. See also Discourse XIV.

4. Influenced by the idea of social development from primitive to advanced societies, central to the work of the Scottish Enlightenment, and above all in the masterpiece of JR's friend, Adam Smith: that is, *The Wealth of Nations*, published four years before this Discourse.

5. In cadence, as well as in sentiment, JR is here remarkably close to a famous sentence in Johnson's *Journey to the Western Islands of Scotland* (1775): 'Whatever withdraws us from the power of our senses; whatever make the past, the distant, or the future predominate over the present, advances us in the dignity of thinking beings.' See also Discourse IV, note 35.

6. Directly prompted by the arguments of Burke's *Sublime and Beautiful*, as in the famous statement that 'a clear idea is . . . another name for a little idea' (*S & B*, p. 63).

7. Compare Johnson on the gradual progress towards intellectual goals: 'The widest excursions of the mind are made by short flights frequently repeated; the most lofty fabricks of science are formed by the continued accumulation of single propositions' (*Rambler*, 137, 9 July 1751).

8. This eloquent paragraph mixes Platonic aesthetics, the language of civic humanism, and the Johnsonian final emphasis on virtue. The means of 'disentangling the mind from appetite' are the subject of *Rambler*, 7 (10 April 1750), where a prime motive of virtue is 'contemplation of its excellence'.

DISCOURSE X

1. Discourse X was delivered on 11 December 1780, returning to the regular series of prize-giving ceremonies.

2. *Picturesque*: 'possessing pleasing and interesting qualities of form and colour (but not implying the highest beauty or sublimity)' (*OED*). The term was to become a vogue word largely owing to William Gilpin, written accounts of whose tours, with observations on 'picturesque beauty', started to appear in 1782. JR later wrote 'Considerations on Gilpin's Essay on the Picturesque' (L/T, II. 606–8), together with a letter to Gilpin (*Letters*, pp. 217–19). In both of these he opposes the separation of the picturesque from the category of the beautiful, suggests that the picturesque is 'incompatible with the grand style', and relates its use to the ornamental manner of Rubens and the Venetian painters rather than to Michelangelo and Raphael.

3. J. G. Herder in his *Plastik* (1778) had drawn a distinction between painting (the art of the eye), sculpture (the art of touch) and music (the art of the ear), but most theorists had tended to lump sculpture together with painting in distinction from the literary or musical arts.

4. A late-Hellenistic marble carving of a male torso, much admired in the Renaissance and succeeding centuries, exhibited in the Cortile del Belvedere at the Vatican, now becoming more of an open-air gallery than its former state as a garden of antiquities.

5. Horace, *Satires*, I. iv. 62 ('the remains of the dismembered poet').

6. Part of the tomb for Pope Julius II (1513). Like other visitors, Boswell was disconcerted by the horns (a traditional attribute): 'Beard too long; horns, though sacred, yet ludicrous as like satyr; rest of the figure superb' (*Grand Tour*, pp. 66–7).

7. Ovid, *Metamorphoses*, IV. 287 ('the source [of the fountain] is not to be seen, but its force is fully apparent').

8. JR probably refers to Francesco Algarotti, who made this point in his *Essay on Painting* (English translation, 1764), p. 42.

9. The *Madonna da collo lungo*, now in the Uffizi, dating from the early 1530s. JR visited the Pitti Palace to study its collection whilst in Florence, during May and June 1752 (L/T, I. 59).

10. Perhaps Joseph Wilton (1722–1803), sculptor to the king, who had been chiefly active with his friend Chambers in creating the steps leading to the fountain of the Academy; he was Keeper of the Academy 1786–90. Wilton was in Rome throughout JR's time there, a period which might have provided his opportunity to measure the *Apollo Belvedere*. Wilton was painted by JR at Florence in 1752 (see previous note for JR's visit).

11. 'Modern research has succeeded in turning the head of the Discobulus round the other way, so that he looks back at the disc' (Fry, p. 437) This is the famous statue of a discus-thrower, a bronze attributed to Myron (*c*. 450 BC)

12. The author of these views is unclear. Hazlitt suggested William Lock (1731–1810), virtuoso and collector of Norbury Park, the friend of Fanny Burney; he owned a copy of the *Discobolus*, and seems plausible, but I have not traced the reference. Hazlitt may simply be reminding himself that Lock possessed such a copy.

13. Statius, *Thebaid*, VI. 573 ('the face lay open in the body'). The received text is 'latuit' ('was hidden').

14. JR probably means *The Wrestlers* (now in the Uffizi). Strongly expressive countenances only appear regularly in Greek sculpture of the fourth century BC, created by masters such as Scopas.

15. *Thirsus*: a rod encircled with vines and ivy, commonly allotted to Bacchus in art.

16. Meleager gave to Atlanta the head of a boar which she had helped to kill. There was a well-known treatment of this subject by Lebrun.

17. *Attributes*: conventional symbols to show identity, such as the arrows of Cupid.

18. *The Rape of the Sabines* (1583) by Giovanni Bologna (see Biographical Index), in the Loggia dei Lanzi, Florence. For JR's admiring comments on Giovanni in 1752, see L/T, I. 60.

19. A broad attack on baroque and rococo sculpture, which makes it difficult to suggest particular targets.

20. Charles Burney saw this in the Villa Borghese in 1770 and found it 'exquisite – it has all the beauty of perfect preservation, added to infinite grace and expression' (Burney, I. 297).

21. Wark (p. 183) suggests that this is *Neptune and Triton* (now in the Victoria and Albert Museum), which JR bought on speculation for 700 guineas, but which he failed to sell at the public show of his collection in 1791 (Hudson, p. 224).

22. That is, the *Apollo Belvedere* (see Discourse III, note 17).

23. Francesco Borromini had transformed the interior of St John Lateran, Rome, in 1646–50; additions were subsequently made and these included the sculptures of the *Apostles*, some of which were contributed by Pierre Legros (see Biographical Index). Burney (I. 214) admired them more than JR.

24. Probably an altar in S. Ignazio, Rome, by Legros.

25. The sculptures were engraved by Thomas Patch (whom JR had known in Rome) and published in 1774; they were part of bronze doors made by Ghiberti (see Biographical Index) for the Baptistery at Florence (early fifteenth century). According to Smollett (p. 239), 'Buonaroti [Michelangelo] used to say [these doors] deserved to be made the gates of Paradise.'

26. A statue by Sir Henry Cheere of the Duke of Cumberland, the 'butcher' of Culloden, who had died in 1765. It was set up at the expense of Lieutenant-General William Strode in 1770, on a prominent site in Cavendish Square; taken down in 1868. The duke was not an easy subject for an equestrian statue, as he weighed twenty stone. JR made his own full-length portrait of the duke in flowing Garter robes (*c.* 1760).

DISCOURSE XI

1. Delivered on 10 December 1782. This was the last occasion on which Johnson attended: 'Then I went to the Painters distribution of prizes. Sir Joshua made his Speech. The king is not heard with more attention' (Johnson to Hester Thrale, 11 December 1782, *The Letters of Samuel Johnson*, ed. R. W. Chapman, Oxford, 1952, II. 522).

2. For this permissive version of criticism, see S. H. Monk, 'A Grace beyond the Reach of Art', *Journal of the History of Ideas*, III (1944), 131–50.

3. Compare Johnson: 'A poet overlooks the casual distinction of country and condition, as a painter, satisfied with the figure, neglects the drapery' (Wimsatt, p. 62).

4. JR was well acquainted with a number of distinguished lawyers, including John Dunning, Lord Ashburton (1731–85); Sir William Jones (1746–94), Sir Robert Chambers (1737–1803), and William Scott, Lord Stowell (1745–1836). All were members of the Club.

5. *Inartificial*: lacking in artistry, crude.

6. Johnson made small revisions to this section of JR's draft of the Discourse: see *LC*, pp. 135, 233–4.

7. See Vasari, IV. 199–215, especially 199, 201, 209.

8. Vasari, IV. 209.

9. JR refers to a picture above the high altar at S. Niccolo dei Frari, Venice: see JR's comments on his visit in 1752 (L/T, I. 75–6). Compare Burney (I. 133): 'In the Chiesa de' Frari there are two pictures by Titian much admired; but the largest at the great Altar, an Assumption on wood, appears so dark that none of that great painter's beautiful colouring appears.'

10. Quoting Addison, 'An Essay on Virgil's Georgics', attached to Dryden's translation of Virgil (1697).

11. *In his colouring . . . finishing those parts*: drafts of portions of these last two paragraphs survive: see *LC*, pp. 234–6.

12. Hendrik Frans van Lint (see Biographical Index), who sometimes signed his work 'Studio'. He became a member of the congregation of virtuosi in Rome in 1744, and their regent in 1752, at the time of JR's residence there.

13. *Curiosity*: 'Scientific or artistic interest; the quality of a curioso or virtuoso; connoisseurship. *Obs.*' (*OED*, citing an example from Johnson's life of Addison, 1781.)

14. Compare Johnson on Shakespeare as 'the poet of nature' (Wimsatt, pp. 59–60).

15. Now destroyed; however JR was able to see the original in SS. Giovanni e Paolo, Venice, in 1752 (L/T, I. 67–8). See also Hazlitt, *Conversations with Northcote*, ed. E. Gosse (1894), p. 30. Spence had commented in 1731, 'Vasari calls [St Pietro Martire] the best of all Titian's works, but so ill kept that we –, who are no connoisseurs, should take it for a wretched piece of daubing' (p. 90).

16. JR quotes from the eighth chapter of Francesco Algarotti's *Essay on Painting* (1764).

17. The *Marriage at Cana*: see Discourse VIII, note 24. For further comments, stressing the musicians among the 'great concourse of people', see Burney, I. 113. The phrase 'the Triumph of Painting'

comes from de Piles's *Art of Painting*, the English translation (1706).

18. Recent impressions, for JR had seen the altar-piece in Antwerp during his visit of August 1781; see *Works*, II. 308–14, as well as Barrell, p. 349. JR's journal contains exactly the same comments on the picture as those presented here.

19. I have not been able to find any earlier example of the usage 'mind . . . over matter', though in philosophic contexts 'mind' and 'matter' were often opposed, as in Johnson, *Rasselas*, ch. 48.

20. From Abraham Cowley's *Davideis* (1656), Book I; already cited by Johnson, *Lives of Poets*, I. 53.

21. For a draft of this sentence, see *LC*, p. 234.

22. See Young, p. 277.

23. A more extended version of these ideas can be found in a piece printed in L/T, I. 115.

24. Compare JR's statement that Johnson 'may be said to have formed my mind' (*Portraits*, p. 66).

DISCOURSE XII

1. Delivered on 10 December 1784. Johnson was to die on 13 December; JR's notebook reads, 'Dr Johnson dyed at 7 in the afternoon.' He had visited Johnson together with Bennet Langton on 29 November: described by JR (L/T, II. 459; see also *LSJ*, IV. 413–14). He attended Johnson's funeral at Westminster Abbey on 20 December.

For some reason Horace Walpole thought that this Discourse was 'much more incorrect in the style than any of his former'; for a defence, see F. W. Hilles, 'Sir Joshua's Prose' in *The Age of Johnson* (New Haven, 1949), p. 51.

2. The most famous and influential work was certainly John Locke's *Some Thoughts concerning Education* (1693), but hundreds of manuals, conduct-books, vade-mecums, essays on study and so on had appeared. Rousseau's *Émile* had been translated more than once, whilst Lord Chesterfield's letters to his son had been published in 1774.

3. Drawing on a passage from Bacon's essay 'On the Nature of Men,' which JR had transcribed: see *LC*, p. 214.

4. Raphael was summoned to Rome by Pope Julius II in 1508, when he was twenty-five, and given the commission to paint the frescoes for the Stanza della Segnatura in the Vatican.

5. See Discourse III, note 17.

6. Possibly Joseph Wilton once more; see Discourse X, note 10.

7. Pietro Trapassi (1698–1782), who grecified his name to Metastasio, a leading poet and the most important librettist in the age of opera seria. JR's information comes directly, in places almost word for word, from Charles Burney's conversations with Metastasio in Vienna during September 1772 (Burney, II. 78–82, 101–7). For the '*Improvvisatore*', see also Smollett, pp. 231–2.

8. For JR's view that by studying the works of great masters, young artists can achieve 'congenial excellencies', see L/T, I. 115. He continues, 'Study, indeed, consists in learning to see nature, and may be called the art of using other men's minds. By this kind of contemplation and exercise we are taught to think in their way, and sometimes to attain their excellences.'

9. JR copied out the relevant section of Bacon's *Advancement of Learning* (1605) in a manuscript preserved at the Royal Academy: see *LC*, pp. 140, 214.

10. From Bacon's dedication to his *Essays* (not used, but often reprinted with his letters, as pointed out by Wark, p. 215). This is an addition made during revising the collected Discourses for publication, apparently indicating that JR reread Bacon in his last years (see *LC*, p. 190).

11. As pointed out by Fry, p. 438, 'All the figures here described as Masaccio's occur in that part of the work which was done by Filippino Lippi, who, however, adapted his style to that of the earlier master.' The reference is to the frescoes in the Brancacci Chapel of S. Maria del Carmine, Florence (*c.* 1425). JR saw them in 1752, but had probably not yet seen the Raphael cartoons (L/T, I. 61).

12. One of the cartoons. '*Admiranda*' refers to plates of Roman sculpture published by Pietro Bartoli, with text by Giovanni Bellori (1693).

13. Another added passage, which draws on JR's rereading of *Lives of Poets* (I. 57); for JR's note made in 1783, see Hilles, 'Sir Joshua's Prose' (see note 1 above), p. 58.

14. Traditional humanist thinking, challenged assertively by Young, who regards such borrowings as plagiarism.

15. Taken by JR from Bacon's essay 'On Fortune': see *LC*, pp. 109, 214, where, however, the essay is not correctly identified. The expression was an old proverb quoted in Erasmus's *Adages* (Tilley, S228). ('A serpent unless it has devoured a serpent does not become a dragon.')

16. *Barbarous*: primitive, undeveloped.

17. Vasari, I. 268, 'Masaccio di S. Giovanni'.

18. Again this part of the fresco is by Lippi (see note 11 above).

19. *Costume*: this was a recent word which had been used by Jonathan Richardson senior in 1715, but still had a slightly exotic ring. It referred originally to drapery in art and is not recorded in a general everyday sense until 1802 (*OED*).

20. *Othello*, v. ii. 345.

21. Again directly contrary to Young's view of genius as disdaining imitation or borrowing, relying instead of native originality (see, for example, Young, p. 274).

22. *Pasticcio*: a picture made up of fragments 'pieced together or copied with modification from an original, or in professed imitation of the style of another artist' (*OED*).

23. JR deleted a passage in the original lecture, where he stated that it would have been easy to have regaled his audience 'with a rhapsody about genius and inspiration, of the enthusiasm and divine fury necessary to possess the soul of the Artist'.

24. *Whether it is . . . depend upon accident*: for a draft version of this passage, see *LC*, pp. 240–41.

25. Partially fulfilled in Discourse XIII.

26. *Put them out*: put them off.

27. For Boucher, see Biographical Index. JR could have met him in Paris in the autumn of 1752 or the autumn of 1768. Boucher had died by the time of JR's visit in 1771.

28. In later life Boucher is said to have objected to nature as being 'too green and badly lit'. He bore the brunt of Diderot's criticism in the 1760s.

29. From the second Collect for Peace in the Order of Morning Prayer in the Anglican rite.

30. Milton, *Comus*, ll. 74–5.

DISCOURSE XIII

1. Delivered on 11 December 1786.

2. Similarly Hume had argued in his essay 'Of the Standard of Taste' (1757) that 'To check the sallies of the imagination, and to reduce every expression to geometrical truth and exactness, would be the most contrary to the laws of criticism, because it would produce a work, which by universal experience, has been found the most insipid and disagreeable . . . All the general rules of art are founded only on experience and on the observation of the common sentiments of human nature.'

3. *Conceit*: imagine, fancy.

4. *Plato*: principally *The Republic*, x. 596.

5. The epitaph by Pietro Bembo (1470–1547), poet and cardinal from 1539, was cited at the end of Vasari's life of Raphael (Vasari, II. 249). Also quoted in the 'Ironical Discourse'. Pope's version of the distich appears in his epitaph on Kneller (*c.* 1730), ll. 7–8:

> Living, great Nature fear'd he might outview
> Her works; and dying, fears herself may die.

Pope, who considered it 'the worst thing I ever wrote in my life', added a note indicating the source in Bembo; but JR probably discovered the link from *Lives of Poets*, III. 265.

6. *New Holland*: Australia. The 'banks of the Ohio' suggest the largely unexplored areas of North America between the Mississippi and the thirteen colonies, especially the region formerly controlled by France until British victories in the Seven Years' War: JR of course has in mind the native American people. Australia was in the forefront of British minds because of Cook's first voyage (1768–71). Joseph Banks, a friend and fellow-Clubman of JR, was on this voyage. On 26 February 1772 JR had hosted an occasion when Banks and his travelling companion Dr Daniel Solander discussed their experiences in the Pacific with Johnson: see *The Letters of Samuel Johnson*, ed. R. W. Chapman (Oxford, 1952), I. 274–5.

7. Pliny, *Natural History*, XXXV. XXXVI. 85, tells us of a cobbler who was able to correct the painter Apelles on the shape of a sandal.

8. The well-known story that Molière would test the effect of his plays by giving a preliminary reading of the text to his cook, La Forêt. Already semi-proverbial, the story probably reached JR through the *Spectator*, 70 (21 May 1711).

9. The standard doctrine of *ut pictura poesis*, set out, for example, in Jonathan Richardson's *Essay on the Theory of Painting* (see Hagstrum, *passim*).

10. For this vein of criticism, see John Dennis, *Essay on the Operas* (1706): 'When I affirm that an Opera after the *Italian* manner is monstrous, I cannot think that I deal too severely with it; no not tho I add, that is so prodigiously unnatural, that it could take its beginning from no Country, but that which is renown'd throught [*sic*] the World, for preferring monstrous abominable Pleasures to those which are according to Nature.' Closer to hand was Lord Chesterfield, writing to his son on 23 January 1752: 'As for operas, they are essentially too absurd and extravagant to mention . . . When-

ever I go to an Opera, I leave my sense and reason at the door with my half-guinea, and deliver myself up to my eyes and my ears.'

11. *Macbeth*, I. v. 57–8.

12. See Discourse VI, p. 169.

13. Wark reproduces the picture from the Rijksmuseum, Amsterdam, and it is this that JR probably has in mind (Wark, plate VIII).

14. Thomas Hobbes's versions were *Homers Odysses* (1675) and *Homers Iliads* (1676).

15. For the *camera obscura*, a device for projecting the image of an object through an aperture on to a flat screen, see also the poem from 1746, quoted in W. K. Wimsatt and C. Brooks, *Neo-Classical Criticism* (1970), p. 279. Leonardo da Vinci had described an early model, but the peak of popularity (especially for the portable kind) came in the middle of the eighteenth century. Canaletto made extensive use of it.

16. For Bourdon's Egyptian scenes, see also Discourse XIV, p. 311.

17. Johnson had written warmly of these two poems in his recent life of Milton, as 'two noble efforts of imagination': see *Lives of Poets*, I. 165–7.

18. *Hamlet*, III. ii. 26.

19. For a draft version of this paragraph, see *LC*, p. 242.

20. A well-known section of Fielding's *Tom Jones* (XVI. v), where Tom and Partridge visit the theatre to see Garrick perform Hamlet – perhaps based on actual performances in late 1748.

21. JR obviously has in mind Johnson's argument in the *Preface to Shakespeare* that 'the spectators are always in their senses and know, from the first act to the last, that the stage is only a stage, and that the players are only players. They come to hear a certain number of lines recited with just gesture and elegant modulation.' More generally, Johnson contends that 'imitations produce pain or pleasure, not because they are mistaken for realities, but because they bring realities to mind'. See Wimsatt, pp. 70–72.

22. Compare *Portraits*, p. 157, on the way in which theatrical representation imitates nature.

23. The last sentence was added during revision, and again quotes Bacon's *Advancement of Learning* (1605 – see *LC*, p. 110): 'For what is more deformed than something lifted from the stage to real life?'

24. *For though they . . . in the meanest style*: for a draft version of this passage, see *LC*, p. 242. The argument here has some similarities with Lessing's *Laokoon* (1766), although there the central distinction is that between poetry and painting.

25. Pope, *Essay on Criticism* (1711), l. 297 (of wit).

26. The stimulus for JR to include landscape gardening in this argument probably came from Horace Walpole's 'Essay on Modern Gardening', first published in the fourth volume of his *Anecdotes of Painting in England* (1780). This was one of the earliest attempts to create a serious aesthetic for the new 'English' style of gardening.

27. See Discourse VII, note 41. The degree of JR's interest in architecture is hard to assess: he subscribed to Robert Adam's *Ruins of Diocletian at Spoleto* (1764), but perhaps out of duty.

28. The 'age of chivalry', adopted by Burke almost as a talisman in opposition to the revolutionary movements of his time, was also used as a quasi-technical term for the medieval era, for instance by Thomas Warton in his *History of English Poetry* (1774–81): the modern use of 'medieval' had not yet evolved. Warton was another friend and fellow-Clubman of JR. See also the influential *Letters on Chivalry and Romance* (1762) by Richard Hurd, who was an ally of JR's friends William Mason and Thomas Warton: Hurd claims that the *Faerie Queene* follows 'the ideas and usages of chivalry'.

29. Milton, *L'Allegro*, ll. 77–8.

30. Vanbrugh used actual Gothic motifs in such a *jeu d'esprit* as Vanbrugh Castle and the Mince-Pie House at Greenwich (1718 onwards), but JR is probably thinking of a kind of sublimited Gothicism in the turrets and towers of houses formally classical in layout. JR was unusual in admiring the then unfashionable style of Vanbrugh's architecture, though it may not be a coincidence that one of his most valuable aristocratic contacts was the fifth Earl of Carlisle (later a pallbearer at JR's funeral), the owner of Castle Howard.

31. William Hodges (1744–97), who had acted as draughtsman on Cook's second expedition and then went to India at the invitation of Warren Hastings. Engravings of his views of Indian scenery were published in 1786. He had been elected an Associate of the Academy in the year of this Discourse.

32. Wren's original plans for the restored city involved a symmetrical grid-plan. See T. F. Reddaway, *The Rebuilding of London after the Great Fire* (1940).

33. Charles Perrault (see Biographical Index), who was associated with Lebrun and Le Vau on the commission appointed by Louis XIV in 1667 to draw up plans for the east front of the Louvre. Vanbrugh worked at Blenheim (1705–16) – until superseded by others, including Hawksmoor – and at Castle Howard (1700–1726). JR had been at Blenheim several times, including stays in 1777 and 1779 whilst painting his monumental portrait of the Marlborough family (see Penny, pp. 279–81).

DISCOURSE XIV

1. Delivered on 10 December 1788. According to the *Morning Post*, it was given 'before a very large auditory amongst whom were many gentleman of conspicuous talents ... In the course of this attempt to ascertain and record the genius of an eminent painter Sir Joshua entirely effaced the opinion, which is too prevalent in the world, that a mean jealousy subsisted between him and Gainsborough' (Whitley, II. 104–5). JR's friend William Seward added, 'On pronouncing the eulogium at the Royal Academy his praises of Mr Gainsborough were interrupted by his tears.'

2. Gainsborough had died on 3 August 1788. A few weeks earlier (around July) he had written to JR 'after lying in a dying state for 6 months' (Hudson, p. 205); see note 9 below.

3. Batoni had died in 1787 and Mengs in 1779. JR's relations with neither were cordial. Batoni did indeed suffer from a 'meteoric' fall in reputation among the British: see Anthony M. Clark, *Pompeo Batoni* (1985), pp. 43–4.

4. Proverbial, used in *Julius Caesar*, v. iii. 99; and used by Johnson of Dr Heberden (*LSJ* IV. 399).

5. Gainsborough developed slowly in his native Suffolk, until his move to Bath in 1760, where he developed a much freer style. He settled in London in 1774, where he further refined his light and rapid brushwork into his recognizable mature manner. JR had known Gainsborough probably from the early 1760s, if not even earlier.

6. For further documentation of this practice, see J. Lindsay, *Gainsborough: His Life and Art* (1982), pp. 77–8.

7. According to JR's friend Ozias Humphry, Gainsborough began to paint by candlelight in his Bath years (Lindsay – see previous note – p. 70).

8. Pope, *Epistle to Cobham* (1734), l. 263.

9. For the letter, see Gainsborough, *Letters*, ed. M. Woodall (1963), p. 127. See also note 2 above. In it Gainsborough asks JR to come and see his picture *The Woodman* (1787), which he considered his best, and concluded, 'I can from a sincere Heart say that I always admired and sincerely loved Sir Joshua Reynolds.'

10. *Fancy pictures*: Most often rural scenes involving idealized peasants or genre scenes treated in a playful manner; Gainsborough's *Girl with Pigs* (1782), which JR bought for a hundred guineas, is representative.

11. JR refers to Hogarth's attempts at grand historical subjects, such as *The Pool of Bethesda* (1735–6) and *Sigismunda* (1759). Charles Lamb defended Hogarth against Reynolds in his essay 'On the Genius and Character of Hogarth'. By the 'new species of dramatick painting' JR means the sequences and progress-pieces such as *Marriage à la Mode*, *The Election* and *The Rake's Progress*. For JR's observations on Hogarth, left in manuscript, see Hudson, p. 66.

12. JR met Richard Wilson (see Biographical Index) in Rome in 1752. He was a founder-Academician in 1768 and succeeded Hayman as librarian in 1776. Wilson died in 1782 in relative poverty, which JR did a little to alleviate.

13. Perhaps the picture JR means is *The Destruction of the Children of Niobe*, which was exhibited at the Society of British Artists in 1760 (now at the Yale Center for British Art).

14. Rosa, *Jacob's Dream* (Chatsworth); Bourdon, *The Return of the Arc* (National Gallery). As Malone notes, JR owned the picture at this time. See also Hudson, pp. 56–7.

15. Gainsborough wrote to the Academy in 1783 threatening to cease exhibiting if his heads and busts were hung 'above the line along with full-lengths' (Jack Lindsay, *Gainsborough*, 1982, pp. 157–8).

16. *Dead-colour*: the first or preparatory layer of colour in a painting.

17. *Candour*: generosity, kindness.

18. JR saw this picture in the church of S. Gudule, Brussels, in 1781: he observed, 'The characters heavy without grace or dignity . . . The name of Rubens would not stand high in the world, if he had never produced other pictures than such as this' (*Works*, II. 259).

DISCOURSE XV

1. Discourse XV was delivered on 10 December 1790. For the events on the occasion of this final Discourse, see Introduction, pp. 1–4. A quarrel had erupted in the previous year concerning the election of a new Professor of Perspective to succeed Samuel Wale. JR had supported Giuseppe Bonomi, an Italian architect, whilst most of the members preferred the painter Edward Edwards. Bonomi had first to be elected a full Academician, but at a stormy meeting on 10 February 1790 he was rejected and the painter Henry Fuseli elected instead. The professorship was not filled and Edwards

continued in a stop-gap role. JR promptly resigned as president. After much toing and froing, and press comment, he was persuaded to withdraw his resignation on 16 March. See L/T, II. 553–86, Hudson, pp. 215–21, Whitley, II. 125–7, and especially *LC*, pp. 249–76, for JR's apologia.

2. JR had a mild stroke in 1782 and then in 1789 he was forced to stop painting because of a loss of sight in his left eye, probably the result of detachment of the retina. The sight in his other eye was gradually impaired and by 1790 he feared that he would become totally blind. In July Boswell reported to a friend, 'he can amuse himself by mending a picture now and then' (letter to Sir William Forbes, 2 July 1790, National Library of Scotland). JR had passed his sixty-seventh birthday on 16 July.

3. Virgil, *Georgics* IV. 147: 'spatiis exclusus iniquis' ('bound by these narrow limits').

4. Most notably the Society for the Encouragement of Arts, Manufactures and Commerce, founded in 1754. JR was elected in September 1756, and Johnson in December 1756. JR served on the committee which organized the first public exhibition of paintings to be held in England, which took place in April 1760. See J. L. Clifford, *Dictionary Johnson* (1979), pp. 226–31.

5. Slightly obscure, but JR may allude to the secession of artists from the Incorporated Society of Artists to form the Academy. See Introduction, pp. 8–9.

6. Clearly a nudge in the direction of the unfilled chair of Perspective; see note 1 above.

7. JR made a note for this Discourse: 'Review the Discourses and add to them' (*LC*, p. 178).

8. As usual, JR makes the target of his criticisms discreetly vague, but he probably had in mind such works on aesthetics as Daniel Webb's *Inquiry into the Beauties of Painting* (1760).

9. Horace, *Ars poetica*, l. 34 ('laying out the whole subject').

10. Hilles suggests (*LC*, p. 129) that JR is referring to published works by Dufresnoy, Richardson and others, rather than to consultations with fellow-members of the Academy, but this is conjectural.

11. Adapting the ideas of de Piles (see Barrell, p. 83), closely paraphrased in turn, in one of the manuscript lectures of J. M. W. Turner, now in the British Library.

12. *Hamlet*, I. iii. 65; II. ii. 474.

13. A stock phrase, used for example in Pope, *Epistle to Jervas* (1716), l. 13, and adumbrated in the first two Latin lines of Dufresnoy's *De arte graphica*. See Hagstrum, *passim*.

14. Johnson had written in *Rambler*, 92 (2 February 1751): 'It is . . . the task of criticism to establish principles; to improve opinion into knowledge . . . Criticism reduces those regions of literature under the dominion of science, which have hitherto known only the anarchy of ignorance, the caprices of fancy, and the tyranny of prescription.'

15. Not identified. Among the artists JR might just have caught during his stay was Fragonard, who went to Rome in 1752, but he does not seem likely to have uttered these views.

16. 'A celebrated picture by Parmegianino of St Roch was for long in S. Petronio at Bologna, and Reynolds probably refers to this' (Fry, p. 439). However, Parmegianino did not go to Bologna until the age of twenty-four in 1527. JR made notes on the painting of S. Roch in 1752 (L/T, I. 472).

17. Frescoes over the altar in S. Maria della Steccata, Parma, begun *c.* 1531, uncompleted; see Hagstrum, plate XXXI.

18. See Thomas Gray to Edward Bedingfield, 27 August 1756: '(if you have been at Parma) you may remember Moses breaking the Tables by the Parmegiano, which comes still nearer to my meaning' (*Correspondence of Thomas Gray*, ed. P. Toynbee and L. Whibley, rev. H. W. Starr, Oxford, 1971, II. 476–7). The reference is to Gray's poem 'The Bard' (1757), ll. 19–20. Gray's notes on the *Moses*, made on his visit to Parma in December 1739, survive in the British Library.

19. JR wrote in his planned essay on Shakespeare that he possessed 'a mind that conceived vigorously and impressed that conception of his readers'. For the essay, see *Portraits*, pp. 110–22.

20. An ancient proverb, cited by Erasmus and generally attributed to Socrates (see Tilley, T206: 'Things that are above us are nothing to us').

21. Source not traced. For Pellegrino Tibaldi as master of the Caracci, see also Burney, I. 158.

22. Jan van Bisschop (1628–71), Dutch lawyer and draughtsman, who made engravings of paintings on his travels, published as *Paradigmata graphices* (1671). JR's copy of this was in the sale of his library.

23. JR saw this picture at Bologna in July 1752 (L/T, I. 475), as did Burney in 1770.

24. Identified by Wark (p. 274) as part of the wall of the sybils in S. Maria della Pace, Rome.

25. Based on a passage in draft (*LC*, p. 245), where, however, there is no mention of Johnson. The views expressed chime in those of the life of Pope: 'Pope wrote for his own age and his own nation: he

knew that it was necessary to colour the images and point the senti-
ments of his author; he therefore made him graceful, but lost him
some of his sublimity' (*Lives of Poets*, III. 240). Johnson discussed
Pope's Homer in the drawing-room after dinner at JR's house on 9
April 1778 (*LSJ*, III. 256–7).

26. *That great era of our art*: that is, the 1530s and 1540s. For
'Hemskerck' see Biographical Index (under 'Heemskerck'); little is
known about the individuals named here.

27. The opposite point of view is expressed in the 'Ironical Dis-
course.' Burney (I. 291) and Smollett (p. 284) comment on Mich-
elangelo's work in the Sistine Chapel.

28. Raphael, *Isaiah* (*c*. 1512), S. Agostino, Rome and *The Vision of
Ezekiel* (*c*. 1511), Palazzo Pitti, Florence. For the latter see Hag-
strum, pp. 311–12.

29. Fra Bartolommeo, *St Mark* (*c*. 1513), also in the Pitti. JR noted
these pictures in the gallery in 1752 (L/T, I. 59).

30. A draft of the ideas expressed in this paragraph, is printed in
LC, p. 248.

31. Dryden, prologue to *The Tempest* (1670), adapted by Dryden
and Sir William Davenant (the reference is to Shakespeare).

32. From *Philological Inquiries* (1781), pp. 234–5, by James Harris
of Salisbury (1709–80), a friend of JR as well as one of Henry
Fielding's closest friends.

33. The sixteenth century, in fact.

34. Vasari, IV. 111.

35. Michelangelo does not appear to have attempted a rendition of
Samson; for a possible confusion, see Fry, p. 440.

36. Titian, *The Battle of Cadore* (1537–8), later destroyed (copy in
the Uffizi).

37. Petronius, *Satyricon*, 11.

38. Traced back to a Greek saying in Xenophon's *Memorabilia*; the
Latin proverb evolved, 'Dii laboribus omnia vendunt.' But see also
Proverbs, 14:23: 'In all labour there is profit.'

39. Found in a draft, *LC*, p. 248: taken from Ascanio Condivi's
Vita de Michelangelo Buonarroti (first published in 1553). Condivi
(see Biographical Index) was a painter who knew Michelangelo per-
sonally.

40. Again referring to Condivi, as shown by the draft in *LC*, p. 248.

41. On 23 February 1792, after steadily declining health, caused by
a liver complaint, which was at the root of his eye trouble. He had
time to do more revision on the *Discourses*, but did not live to see the
full collected edition.

APPENDIX A: THE IRONICAL DISCOURSE

1. Pope, *Essay on Criticism*, l. 216.
2. *Cast accounts*: perform calculations, count.
3. Alluding to Bacon's dedication to his *Essays*.
4. See Discourse VI, note 6.
5. See Pope, *Dunciad Variorum* (1729), III. 159, concerning the miscellaneous writer James Ralph (*c.* 1705–62). See also *Peri Bathous* in the *Miscellanies* (1727) of Pope and Swift, ch. 15.
6. See Discourse III, note 12.
7. See Discourse XIII, note 5.
8. See Discourse XIII, notes 7 and 8.
9. Pliny, *Natural History* xxxv. xxxvi. 65–6.
10. See Vasari, I. 72, for the story of Giotto's drawing a perfect circle freehand as a proof of his identity.
11. The Comte de Mirabeau (1749–91), Jacobin leader and orator, here instanced as a type of the destructive revolutionary.
12. Virgil, *Aeneid*, II. 521: '[we need] no such help as this'.
13. For a number of years J R had wished to see St Paul's Cathedral adorned with sculptures comparable to those in Westminster Abbey, as well as with historical paintings by contemporary artists. The Bishop of London had successfully opposed the latter scheme. J R had wanted Johnson's monument to be placed in the cathedral, as he thought the abbey overcrowded. Eventually in 1791 permission was given for monuments to be erected in St Paul's; one of the first to go up there was a statue of J R by John Flaxman (1813).
14. See Discourse XII, note 19.

BIOGRAPHICAL INDEX OF ARTISTS

THIS list comprises painters, engravers, sculptors, architects, art critics and historians who are mentioned in the text of the *Discourses* (or, in a few cases, identified in the Notes). Where authorities disagree, the information is generally based on U. Thieme and F. Becker (eds.), *Allgemeines Lexikon der bildenen Künstler* (Leipzig, 1907–50). Throughout this index standard 'modern' spellings/versions of artists' names are given; Reynolds's spellings are generally recognizably similar, if not always identical, to these. For those few instances where he uses spellings/versions that might be less easy to identify, cross references are given.

Albani (Albano), **Francesco** (1578–1669), Bolognese painter.

Algarotti, Francesco (1712–64), Italian art critic and aesthetician, author of *An Essay on Painting* (English translation, 1764).

Amman, Jost (1539–91), Swiss illustrator and engraver.

Andrea del Sarto (1486–1531), Florentine painter.

Apelles (fourth century BC), Greek painter.

Bamboccio, Il (Pieter van Laer) (1592–1642), Dutch painter.

Bandinelli, Bartolommeo (1488–1559), Florentine sculptor.

Barocci, Federico (1526–1612), Italian mannerist painter.

Bartolommeo della Porta, Fra (*c.* 1472–1517), Florentine painter.

Bassano, name adopted by Da Ponte, family of Italian painters, especially Jacopo (*c.* 1517–92), who worked in Venice.

Batoni (Battoni), **Pompeo** (1708–87), Italian painter who worked chiefly in Rome.

Bellini, Giovanni (1430–1516), Venetian painter.

Bernini, Gianlorenzo (1598–1680), Italian sculptor, painter and architect who worked chiefly in Rome.

Bologna, Giovanni (da) (1529–1608), Flemish sculptor who worked in Florence.

Borgognone, Il (Jacques Courtois) (1621–75), French painter who worked in Italy.

Bosch, Hieronymus (Jerome) (*c.* 1450–1516), Flemish painter.

Bouchardon, Edmé (1698–1762), French sculptor.

Boucher, François (1703–70), French painter.

Bourdon, Sébastien (1616–71), French painter.

Braemer, Leonaert (1596–1674), Dutch painter.

Bramante, Donato di Angelo (1444–1514), Italian architect.

Brouwer, Adriaen (*c.* 1605–38), Flemish painter.

Cantarini, Simone (1612–48), Italian painter.

Carracci, Annibale (1560–1609), Italian painter.

Carracci, Lodovico (1555–1619), Italian painter and cousin of Annibale.

Carvaggio, Polidoro da, *see* Polidoro.

Cavedone, Giacomo (1577–1660), Italian painter.

Caylus, Comte Claude de (1692–1765), French collector and antiquarian.

Chambers, Sir William (1723–96), English architect, treasurer of RA.

Chéron, Élisabeth-Sophie (1648–1711), French painter.

Chiari, Giuseppe (1654–1727), Italian painter.

Claude Gellée (Claude Lorraine) (1600–1682), French painter.

Conca, Sebastiano (1680–1764), Italian painter.

Condivi, Ascanio (d. 1574), Italian painter and author of a life of Michelangelo (1553).

Correggio, Antonio Allegri (*c.* 1489–1534), Italian painter.

Cortona, Pietro da, *see* Pietro da Cortona.

Coypel, Antoine (1661–1722), French baroque painter.

Diepenbeeck, Abraham van (*c.* 1596–1675), Flemish painter.

Domenichino (Domenico Zampieri) (1581–1641), Bolognese painter.

Dufresnoy, Charles-Alphonse (1611–68), French painter and author of the verse treatise *De arte graphica* (1668).

Dürer, Albrecht (1471–1528), German painter.

Dyck, Sir Anthony van (1599–1641), Flemish painter who worked for a long period in England.

Eeckhout, Gerbrandt van den (1621–74), Dutch painter.

Euphranor (fourth century BC), Greek painter and sculptor of Corinth.

Falconet, Étienne-Maurice (1716–91), French sculptor and critic.
Félibien des Avaux, André (1619–95), French architect and writer.
Ferri, Ciro (1634–89), Italian painter.
Flinck, Govert (1615–60), Dutch painter.
Franco, Battista (1510–80), Italian painter.
Fresnoy, *see* Dufresnoy.

Gainsborough, Thomas (1727–88), English painter.
Ghiberti, Lorenzo (1378–1455), Florentine sculptor.
Giordano, Luca (1634–1705), Italian decorative painter.
Giorgione (Giorgio Barbarelli) (1475–1510), Italian painter.
Giulio Romano (*c.* 1499–1546), Italian mannerist painter.
Goyen, Jan van (1596–1656), Dutch painter.
Guercino (Gianfrancesco Barbieri) (1591–1666), Bolognese painter.
Guido, *see* Reni.

Hals, Frans (*c.* 1581–1666), Dutch painter.
Heemskerck, Maerten van (1498–1574), Dutch painter.
Heyden, Jan van der (1637–1712), English painter.
Hogarth, William (1697–1764), English painter.

Imperiale (Francesco Fernandi) (*fl.* 1720/5), Italian painter.

Jansens, Cornelius, *see* Jonson.
Jonson van Ceulen, Cornelius (1593–1661), Dutch painter who worked chiefly in England.
Jordaens, Jacob (1593–1678), Flemish painter.
Junius, Franciscus (François du Jon) (1589–1677), German-born antiquarian who spent most of his life in England, author of *De pictura veterum* (1637).

Kneller, Sir Godfrey (*c.* 1649–1723), German-born painter who worked in England.

La Fage, Raymond (1656–90), French draughtsman.
Lanfranco, Giovanni (1582–1647), Italian baroque painter.
Lebrun, Charles (1619–90), French decorative artist.
Legros, Pierre II (1666–1719), French baroque sculptor, worked in Rome.

Leonardo da Vinci (1452–1519), Florentine universal artist and writer, author of *Trattato della pittura* (first published 1651).

Le Sueur, Eustache (1616–55), French painter.

Leyden, Lucas van, *see* Lucas.

Lint, Hendrik Frans van (1684–1763), Flemish painter who worked in Rome.

Lorraine, Claude, *see* Claude.

Lucas van Leyden (1494–1533), Dutch painter.

Mantegna, Andrea (1431–1506), Italian painter.

Maratti, Carlo (1625–1713), Italian painter of Roman school.

Masaccio, Tomasso di Mone (1401–28), Italian painter.

Masucci, Agusto (1691–1758), Italian painter.

Mazola-Bedoni, Girolamo (1500–1569), Italian painter.

Mazzuoli, Jeronimo, *see* Mazola-Bedoni, Girolamo.

Mengs, Anton Raffael (1728–79), German painter who worked in Rome and Madrid.

Michelangelo Buonarroti (1475–1664), Florentine painter, sculptor, architect and poet.

Miel, Jan (1599–1663), Flemish painter, worked in Rome.

Ostade, Adriaen van (1610–84), Dutch artist.

Paolo, *see* Veronese.

Parmigianino (Francesco Mazzola) (1503–40), Italian painter.

Parrhasius (fifth century BC), Greek painter.

Perrault, Claude (1613–88), French architect.

Perugino (Pietro Vannucci) (*c.* 1450–1523), Italian painter.

Phidias (fifth century BC), Athenian sculptor.

Pierino del Vaga (1500–1547), Italian painter.

Pietri, Pietro da, *see* Pietro.

Pietro da Cortona (1596–1669), Italian painter and architect.

Pietro da Pietri (*c.* 1663–1716), Italian painter, worked in Rome.

Piles, Roger de (1635–1709), French art historian and theorist, author of *L'Art de la peinture* (1706) and *Un Cours de peinture par principes* (1708).

Polidoro da Carvaggio (*c.* 1500–1543), Italian painter of Roman school.

Pollio, Vitruvius, *see* Vitruvius.

Poussin, Nicolas (1594–1665), French painter who worked chiefly in Rome.

Primaticcio, Francesco (1504–70), Italian painter and decorator.

Vouet, Simon (1590–1649), French painter and decorator.

Watteau, Antoine (1684–1721), French painter.

Werff, Adriaen van der (1659–1722), Dutch painter chiefly of historical subjects.

Wilson, Richard (1714–82), English landscape painter, member of RA.

Wilton, Joseph (1722–1803), English sculptor, member of RA.

Wren, Sir Christopher (1632–1723), English architect, astronomer and mathematician.

Zeuxis (fifth century BC), one of the the greatest painters of ancient Greece.

INDEX

Entries are provided for the main subjects of discussion and for principal individuals or named works of art; occasional passing references to less significant subjects/individuals have not been included. It should also be noted that entries are confined to the Introduction and Reynolds's text.

READ MORE IN PENGUIN

In every corner of the world, on every subject under the sun, Penguin represents quality and variety – the very best in publishing today.

For complete information about books available from Penguin – including Puffins, Penguin Classics and Arkana – and how to order them, write to us at the appropriate address below. Please note that for copyright reasons the selection of books varies from country to country.

In the United Kingdom: Please write to *Dept. JC, Penguin Books Ltd, FREEPOST, West Drayton, Middlesex UB7 OBR*

If you have any difficulty in obtaining a title, please send your order with the correct money, plus ten per cent for postage and packaging, to *PO Box No. 11, West Drayton, Middlesex UB7 OBR*

In the United States: Please write to *Penguin USA Inc., 375 Hudson Street, New York, NY 10014*

In Canada: Please write to *Penguin Books Canada Ltd, 10 Alcorn Avenue, Suite 300, Toronto, Ontario M4V 3B2*

In Australia: Please write to *Penguin Books Australia Ltd, 487 Maroondah Highway, Ringwood, Victoria 3134*

In New Zealand: Please write to *Penguin Books (NZ) Ltd,182–190 Wairau Road, Private Bag, Takapuna, Auckland 9*

In India: Please write to *Penguin Books India Pvt Ltd, 706 Eros Apartments, 56 Nehru Place, New Delhi 110 019*

In the Netherlands: Please write to *Penguin Books Netherlands B.V., Keizersgracht 231 NL–1016 DV Amsterdam*

In Germany: Please write to *Penguin Books Deutschland GmbH, Friedrichstrasse 10–12, W–6000 Frankfurt/Main 1*

In Spain: Please write to *Penguin Books S. A., C. San Bernardo 117–6° E–28015 Madrid*

In Italy: Please write to *Penguin Italia s.r.l., Via Felice Casati 20, I–20124 Milano*

In France: Please write to *Penguin France S. A., 17 rue Lejeune, F–31000 Toulouse*

In Japan: Please write to *Penguin Books Japan, Ishikiribashi Building, 2–5–4, Suido, Bunkyo-ku, Tokyo 112*

In Greece: Please write to *Penguin Hellas Ltd, Dimocritou 3, GR–106 71 Athens*

In South Africa: Please write to *Longman Penguin Southern Africa (Pty) Ltd, Private Bag X08, Bertsham 2013*

READ MORE IN PENGUIN

A CHOICE OF CLASSICS

George Herbert	**The Complete English Poems**
Thomas Hobbes	**Leviathan**
Samuel Johnson/	
James Boswell	**A Journey to the Western Islands of Scotland** and **The Journal of a Tour to the Hebrides**
Charles Lamb	**Selected Prose**
Samuel Richardson	**Clarissa**
	Pamela
Richard Brinsley	
Sheridan	**The School for Scandal and Other Plays**
Christopher Smart	**Selected Poems**
Adam Smith	**The Wealth of Nations**
Tobias Smollett	**The Expedition of Humphrey Clinker**
Laurence Sterne	**The Life and Adventures of Sir Launcelot Greaves**
	A Sentimental Journey Through France and Italy
Jonathan Swift	**Gulliver's Travels**
Thomas Traherne	**Selected Poems and Prose**
Sir John Vanbrugh	**Four Comedies**

READ MORE IN PENGUIN

A CHOICE OF CLASSICS

John Aubrey	**Brief Lives**
Francis Bacon	**The Essays**
George Berkeley	**Principles of Human Knowledge** and **Three Dialogues between Hylas and Philonous**
James Boswell	**The Life of Johnson**
Sir Thomas Browne	**The Major Works**
John Bunyan	**The Pilgrim's Progress**
Edmund Burke	**Reflections on the Revolution in France**
Thomas de Quincey	**Confessions of an English Opium Eater**
	Recollections of the Lakes and the Lake Poets
Daniel Defoe	**A Journal of the Plague Year**
	Moll Flanders
	Robinson Crusoe
	Roxana
	A Tour through the Whole Island of Great Britain
Henry Fielding	**Amelia**
	Jonathan Wild
	Joseph Andrews
	Tom Jones
Oliver Goldsmith	**The Vicar of Wakefield**